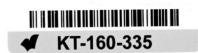

TITIAN

ESSAYS BY CHARLES HOPE

JENNIFER FLETCHER JILL DUNKERTON

MIGUEL FALOMIR

CATALOGUE EDITED BY DAVID JAFFÉ

WITH CONTRIBUTIONS FROM

NICHOLAS PENNY CAROLINE CAMPBELL

AMANDA BRADLEY

NATIONAL GALLERY COMPANY, LONDON

DISTRIBUTED BY YALE UNIVERSITY PRESS

This book was published to accompany an exhibition
at the National Gallery, London 19 February – 18 May 2003

Exhibition supported by Barclays PLC

© 2003 National Gallery Company Limited
Reprinted (twice with corrections) 2003

First published in Great Britain in 2003 by
National Gallery Company Limited
St Vincent House, 30 Orange Street, London WC2H 7HH
www.nationalgallery.co.uk

ISBN 1 85709 904 4 Hardback
525095

ISBN 1 85709 903 6 Paperback
525085

British Library Cataloguing-in-Publication Data
A catalogue record is available from the British Library
Library of Congress Catalog Card Number 2002116003

Publisher Kate Bell
Editor Paul Holberton
Designer Peter Campbell
Editorial Assistance Jane Ace, Tom Windross
Production Jane Hyne, Penny Gibbons
Picture Researcher Xenia Corcoran

Printed and bound in Great Britain by
Westerham Press Ltd., St Ives plc

Cover:
TITIAN *The Andrians,* about 1523–4 (detail)
Oil on canvas, 175 × 193 cm, Museo Nacional del Prado, Madrid
(cat. 14)

Frontispiece:
TITIAN *Ranuccio Farnese,* 1542 (detail)
Oil on canvas, 89.7 × 73.6 cm, National Gallery of Art, Washington, D.C.,
Samuel H. Kress Collection, 1952
(cat. 25)

When '*Sacred and Profane Love*' (cat. 10, pp. 92–5) was found to be
unfit to travel the Italian Government generously offered the following two loans:
Salome, about 1511–15, Galleria Doria Pamphilj, Rome, (fig. 40, p. 73)
Christ on the Cross with the Virgin, Saint John and Saint Dominic, 1556–8,
Pinacoteca Comunale (on temporary loan from the church of San Domenico), Ancona
(fig. 65, p. 153, detail and fig. 76, p. 180)

This generous loan was confirmed too late to be catalogued:
The Flaying of Marsyas, about 1570–6, The Archbishop's Palace, Kromeríz, (fig. 63, p. 152)

TITIAN

CONTENTS

CATALOGUE

David Jaffé, Nicholas Penny, Caroline Campbell, Amanda Bradley

SPONSOR'S FOREWORD

BARCLAYS IS DELIGHTED to support the National Gallery's *Titian* exhibition, a landmark display of the greatest painter of sixteenth-century Venice.

Barclays has a proud legacy of philanthropy and community involvement, donating 1 per cent of UK pre-tax profits to community involvement programmes each year, with the arts being a long-standing beneficiary. Through our current two-year sponsorship programme, *Invest and Inspire*, we aim to open up the arts to new audiences.

Barclays is excited by the opportunity to break down some of the barriers and stereotypes traditionally associated with the arts through a creative sponsorship programme that increases accessibility, and inspires and educates new audiences. Our determination to bring the arts to a wider public will be achieved through the funding of a special Barclays late night opening when a unique programme of events and activities will take place between 6pm and 9pm on every Thursday throughout the exhibition.

Invest and Inspire sees the largest ever business sponsorship of the Royal National Theatre and sole sponsorship of three major exhibitions: *The Queen of Sheba: Treasures from Ancient Yemen* at The British Museum, *Titian* at the National Gallery and *Turner and Venice* at Tate Britain.

We look forward to working with the National Gallery throughout *Titian* and hope that you enjoy the exhibition.

Matthew W. Barrett
Group Chief Executive
Barclays PLC

BARCLAYS

DIRECTORS' FOREWORD

TITIAN WAS, AND REMAINS, one of the greatest of Renaissance painters. He painted for Europe's most powerful ruling families and the presence of his works in collections worldwide is a mark of his repute. Despite the traditional British love for the work of Titian, this country has never seen a monographic exhibition, although the Royal Academy's *Genius of Venice* showed the brilliance of the sixteenth-century Venetian school, with Titian as its brightest star.

Titian has been a central focus in the development of British collections since the early seventeenth century. Charles I's elder brother Henry formed the earliest collection of Venetian paintings in England. However, the paintings amassed by the Earl of Arundel made a larger impact; Arundel may already have owned Titian's *Flaying of Marsyas* by 1622. Through Arundel Van Dyck discovered Titian, and in his later years owned a 'Titian room', which included *Perseus and Andromeda* and *The Vendramin Family*. Charles I as Prince of Wales received the 'Venus del Pardo' (Louvre) as compensation when he failed to secure a Spanish bride in 1621. His purchase of the Gonzaga collection in 1628 gave this country an amazing holding of Italian Renaissance paintings, in which Titian took pride of place, including *Jacopo Pesaro*, the Louvre *Entombment* and Vienna's *Girl in a Fur Wrap*.

Another superb group of paintings belonged to the Duke of Hamilton, a member of Charles I's circle. Through his brother-in-law Lord Fielding he acquired – among others – the 'Gypsy Madonna' and 'The Bravo'. Both Charles's and Hamilton's collections were dispersed during the Civil War. The final great influx of Titians into British collections came in 1798, with the sale of the Orléans collection in London. The first Duke of Sutherland, his uncle the third Earl of Bridgewater and the fifth Earl of Carlisle jointly acquired the Orléans Italian and French paintings. Sutherland inherited his uncle's share, and the paintings have descended through his heirs. These works, including *The Three Ages of Man*, the Diana *poesie* and *Venus Anadyomene*, have all been on loan to the National Gallery of Scotland since 1946.

At the end of the nineteenth century, a generation of less elevated collectors purchased Titians – *Ranuccio Farnese* and 'La Schiavona' were owned by Herbert Cook – but the great age of Venetian collecting in Britain was over. Titian's *Rape of Europa* from the Darnley collection was lost to Boston in 1896, and the Bellini/Titian *Feast of the Gods* was sold by the Duke of Northumberland in 1916, and is now in Washington. However, heroic government intervention secured *The Vendramin Family* in 1929 and a spirited public appeal saved *Diana and Actaeon* for the nation in 1972.

Beyond Italy, only one other country has had a longer infatuation with Titian than Britain, and that is Spain. Significantly it was the marriage of Philip II to Mary Tudor that brought the first two Titians to England: a portrait of *Philip II* and the *Venus and Adonis*. This exhibition is a collaboration between the National Gallery and the Museo Nacional del Prado in Madrid, the keeper of the Habsburg legacy. The idea of a joint Titian venture was first proposed by Nicholas Penny in 1999, and we are delighted that it has come to such handsome fruition.

Finally, we would like profoundly to thank all the lenders for their extraordinary generosity in permitting their pictures to come to our exhibition.

Charles Saumarez Smith
Director, The National Gallery

Miguel Zugaza
Director, Museo Nacional del Prado

CURATOR'S INTRODUCTION

THE NATIONAL GALLERY is fortunate to count some eleven paintings by Titian in its collection. The driving force behind this exhibition was to place these works within a meaningful context, making confrontations that will lead to an enhanced understanding of the nation's pictures. Whilst we have endeavoured to represent works by Titian from other British collections, we have strived to maintain a balanced selection of images, in terms of dating, quality and attribution.

The strengths of the collection – in the early works of Titian in particular – are very much reflected in the exhibition. The unique opportunity to set the exquisite *Three Ages of Man* with other early works is one highlight; the assembly of Alfonso d'Este's Camerino is another.

It was necessary to re-unite *Bacchus and Ariadne* with its counterparts from both the Prado and Washington in London, for the precarious state of the *Bacchus* prevents it from travelling. Alfonso d'Este's Camerino survived intact for only a short period (1529–98) but this exhibition, whilst proposing a new configuration for the room, hopes to elucidate exactly how these works interacted on a visual level. Titian's bar bills confirm that he spent over a year of his career, accompanied by his assistants, in Ferrara working on this commission, not counting the time he spent in Venice. Such a Herculean effort spread over nine years was to create a rejuvenating sanctuary for one of the most active warrior dukes of his time. Titian's uncharacteristic application to this project might indicate a rapport with his patron, but the only trace of these lost conversations are the whisperings across the images, back through the texts, and out into our space.

It is inevitable that some of these paintings, nearly five hundred years old, have been tarnished by repainting and injudicious conservation. Such hazards, however, are not confined to more recent times. Crowe and Cavalcaselle described how Titian was obliged to repaint one of the Camerino canvases after an accident with some 'pernicious varnish'. Relinings, in flattening the paint surface, minimise our appreciation of the artist's own brushwork, now mostly visible in surfaces composed of resilient lead white. However, the comparatively well-preserved landscapes of the Palma Vecchio *Holy Family,* which were painted by Titian, is one of our best examples of his ability to evoke pastoral scenes. From the Camerino, *The Worship of Venus,* with the exception of the top right part of the canvas, is remarkably well-preserved in comparison with the *Bacchus and Ariadne* (its cleaning caused a storm in the 1840s) and *The Andrians.* Nevertheless, it is a credit to Titian's ability that the magic of his creation still emanates from these abused surfaces. The magnitude of Titian's creative power is witnessed in this exhibition, demonstrating how he stayed at the pinnacle of artistic achievement throughout his life. His ability to reinvent ideas and styles, sustained over so long a period, has remained uncontested since his death.

This exhibition represents the team effort of many National Gallery staff, past and present. I would also like to thank our international scientific committee: Jean Habert, Giovanna Nepi Sciré, Antonio Paolucci, Nicola Spinosa, Claudio Strinati; and the many other scholars who have helped: Irina Artemieva, Sorcha Carey, Philip Conisbee, Roberto Contini, Ruth Crawley, David Ekserdjian, Miguel Falomir, Jennifer Fletcher, Michael Hirst, Jacqui McComish, Mikhail Petrovsky, Earl A. Powell III, Elizabeth Stephen and Aiden Weston-Lewis. Finally, I am indebted to Charles Hope for his generous assistance in the preparation of this catalogue.

David Jaffé
Senior Curator, The National Gallery

CHARLES HOPE

TITIAN'S LIFE AND TIMES

TIZIANO VECELLIO, known in English as Titian, was the first Venetian painter to achieve European fame in his lifetime, and the first to be employed, at least from his middle years onwards, primarily by clients outside Venice. As a result of his success, his work was represented at an early date in major collections throughout Italy, as well as in Spain and even France. Well before he died he had acquired the reputation of being one of the greatest of all painters, a reputation which has never diminished. His generation of Venetian artists is also the first that is relatively well documented, and it is possible not only to say with some certainty what he painted and when, but also to know more about his personal life, his friends and his family, and even about his character, than is the case with any earlier Venetian painter, or with most of his contemporaries.

Unfortunately it is not known for certain when he was born, and this is one reason why his early career is still the subject of intense controversy. For well over a century the Vecellio family had been prominent in Cadore, a Venetian territory in the Dolomites not far from Cortina d'Ampezzo. Many of the artist's relatives were notaries, including his grandfather Conte, who lived in Pieve di Cadore and died around 1513. Titian's father, Gregorio, who died in about 1530, served as superintendent of the castle of Pieve and supervisor of mines in the area. With his wife Lucia he had four children: Titian, Francesco, Dorotea and Orsa. Francesco, also a painter and later a timber merchant in partnership with his brother, acted as Titian's assistant in 1511 and joined the army by 1513, suggesting that he was born not long after 1490.[1] Dorotea married in early 1508, again implying a date of birth not much before 1490.[2] Orsa seems to have been somewhat younger, since her children were born around or after 1520.[3] That leaves Titian, who was evidently the eldest of Gregorio's children and who was named after the family's patron saint. A date of birth in or just before 1490 would fit with the known facts of his early life, although it was widely believed in his old age that he had been born ten or fifteen years earlier. At the age of about ten or twelve, either accompanied by or soon joined by Francesco, he was sent to Venice to live with an uncle, with the idea of being trained as a painter. With the help of a minor painter named Sebastiano Zuccato, who was probably a family friend and whose children were later the leading mosaicists in Venice, and lifelong friends of Titian, he was apprenticed to Gentile Bellini, but then moved to the studio of Giovanni Bellini, the foremost painter in the city. In or soon after 1506 Titian became impressed by the work of another of Bellini's pupils, Giorgione, who at about that time had adopted a freer and more naturalistic style of painting; and when in 1508 Giorgione was commissioned to paint some frescoes on the Fondaco dei Tedeschi, the warehouse of the German merchants in Venice, on the façade facing the Grand Canal, Titian was given the job of painting a side façade.[4]

Only a few fragments of Titian's frescoes survive, in a very damaged state, as well as a single, barely legible figure by Giorgione, so it is difficult to judge what these decorations looked like. But every observer who wrote about them until their virtual disappearance in the eighteenth century agreed that Titian's contribution was superior to that of Giorgione. This is something that many scholars have been inclined to discount, claiming instead that Giorgione was the leading young painter in Venice until his death in the autumn of 1510. One

TITIAN
The Miracle of the Speaking Child, 1511 (detail of fig. 3)

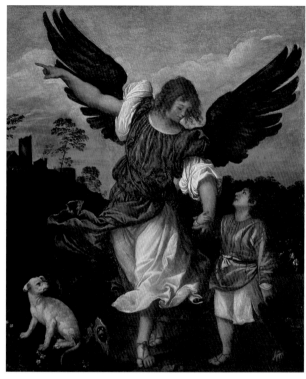

FIG. 1

TITIAN
Christ carrying the Cross,
1508–9
Oil on canvas, 70 × 100 cm
Scuola di San Rocco, Venice

FIG. 2

TITIAN
Raphael and Tobias,
about 1507–8
Oil on panel, 170 × 146 cm
Gallerie dell'Accademia,
Venice

consequence of this attitude has been the tendency to attribute to Giorgione the damaged painting of *Christ carrying the Cross* (fig. 1), now in the Scuola di San Rocco in Venice, which was almost certainly painted between 1508 and 1509.[5] This was given to Giorgione by Giorgio Vasari in the first edition of his *Lives of the Artists*, published in 1550, on the strength of notes that he had made in Venice in 1541–2, when he knew very little about Giorgione's work. In the second edition, of 1568, the attribution to Giorgione remained unchanged, but the picture was also given to Titian in the biography of Titian. The contradiction may be explained by the fact that the biography of Giorgione was printed in 1565 and that of Titian in 1567.[6] Between these two dates Vasari had visited Venice and obtained new information. Unless we suppose that Titian or one of his friends claimed that he had painted a picture that was not by him, which seems unrealistic, then we must accept the revised attribution. In a slightly garbled passage, Vasari also implied that even before he worked at the Fondaco Titian had painted a small and now damaged altarpiece of *Raphael and Tobias* (fig. 2). These two paintings suggest that already by 1508 Titian had a distinctive style, and in particular an ability to endow his figures with life and movement unmatched by Bellini. Probably even earlier, in about 1506 or 1507, he had painted *Jacopo Pesaro before St Peter* (cat. 3), in which the figures, in both drapery and pose, still seem very much in Bellini's manner.[7]

By the summer of 1511, when, assisted by Francesco, he painted three frescoes illustrating miracles of Saint Anthony in the Scuola del Santo in Padua (fig. 3), Titian's style showed

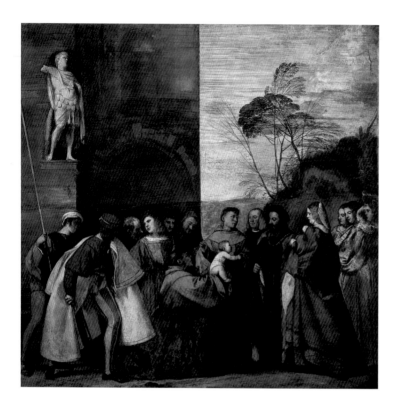

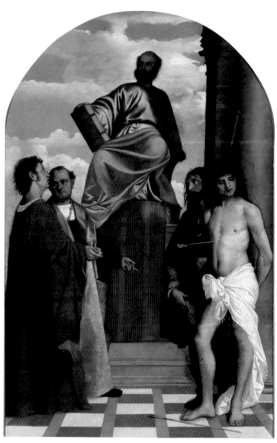

FIG. 3

TITIAN
The Miracle of the Speaking Child, 1511
Fresco, 320 × 315 cm
Scuola del Santo, Padua

FIG. 4

TITIAN
Saint Mark enthroned, with Saints Cosmas, Damian, Roch and Sebastian, 1511–12
Oil on panel, 230 × 119 cm
Santa Maria della Salute, Venice

no trace of uncertainty. The grouping of the figures is life-like and informal, but grand, the characterisation is vivid and the forms have a naturalness and monumentality unmatched in the work of any other artist working in or around Venice at that period. Similar qualities appear in his small altarpiece of *Saint Mark enthroned* (fig. 4), probably painted no earlier than 1511, since it is evidently associated with a plague that turned into an epidemic in that year.[8]

There are several other oil paintings by Titian which are generally accepted as being from around these years, but their precise date is more controversial. *A Man with a Quilted Sleeve* (cat. 5) is almost certainly no later than 1512, when the composition was used by another artist, and the '*La Schiavona*' (cat. 4) is also likely to be early, given that the woman served as the model for one of the figures in the Padua frescoes. The landscape of the *Venus* in Dresden (fig. 45, p. 87) is likely to be of late 1510 or 1511, because the figure is by Giorgione, who presumably left the picture unfinished when he died. But with works such as *The Three Ages of Man* (cat. 8), *Noli me tangere* (cat. 7), *The Holy Family with a Shepherd* (cat. 2) and *The Virgin and Child and Saint Catherine with Saint Dominic and a Donor* (cat. 9) the chronology is less clear. Some scholars place them all towards about 1514, the probable date of '*Sacred and Profane Love*' (cat. 10), which is usually thought to have been commissioned in connection with the marriage of the patron in that year, but others would date some or all of them earlier, in some cases even in the lifetime of Giorgione. These pictures have similar colour schemes and share an emphasis on landscape, painted in the manner of Giorgione rather

than of Bellini. They also include common features. Thus the buildings in *Raphael and Tobias* reappear in *The Baptism of Christ* (Museo Capitolino, Rome), and those in the *Venus* are repeated with small variations in *Noli me tangere* and *'Sacred and Profane Love'*. But the scale and proportions of the figures, as well as the confidence of the drawing, vary from picture to picture. This could mean that Titian changed his figure style quite considerably over a relatively short period, or that it altered more gradually over a longer period.

The main reason why scholars have puzzled so much over this issue is that it has a bearing on perhaps the most contentious problem of attribution in the whole of Italian Renaissance art. This involves the authorship of the *'Concert champêtre'* in the Louvre (fig. 5) and a small group of other pictures which closely resemble it in style, such as *The Virgin and Child with two Saints* (Prado, Madrid). Until the late nineteenth century these paintings were almost never attributed to Titian, but to Giorgione; but, as more was discovered about

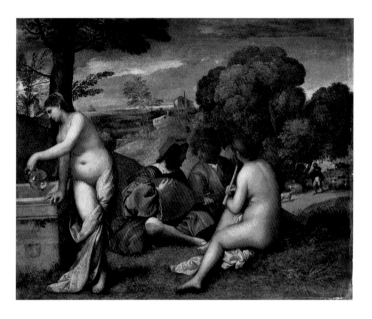

FIG. 5
TITIAN?
'Concert champêtre', about
1510–11 or later
Oil on canvas, 110 × 138 cm
Musée du Louvre, Paris

Giorgione, the traditional attribution seemed increasingly unrealistic. Instead, they were more and more frequently given to Titian, not so much because of any very compelling resemblance to his undisputed early works – which would surely have been noticed before – as because he seemed a less implausible candidate than Giorgione. But no one has been able to create a coherent sequence of Titian's early works that includes these ones, in a way that commands general support and fits the known facts of his career. An alternative proposal is to assign the *'Concert champêtre'* and the other pictures like it to a third artist, the very obscure Domenico Mancini, who is known only as the author of one signed altarpiece.[9] Most art historians are reluctant to do this, not least because it implies that there was at least one painter of real talent working in or around Venice in the early sixteenth century about whom we know almost nothing. That would mean that the historical record about Venetian art of this period is much less complete than is usually supposed; and this idea is more troubling to many scholars than the notion that Titian worked in widely differing styles at almost the same date.

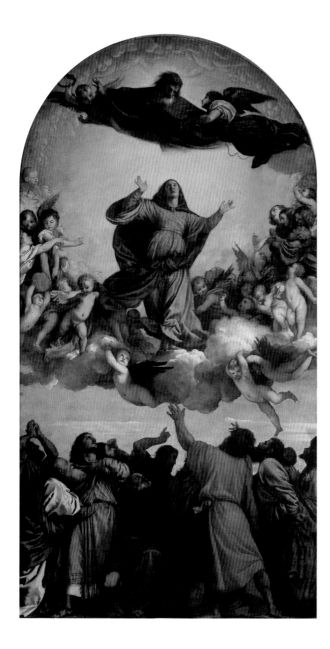

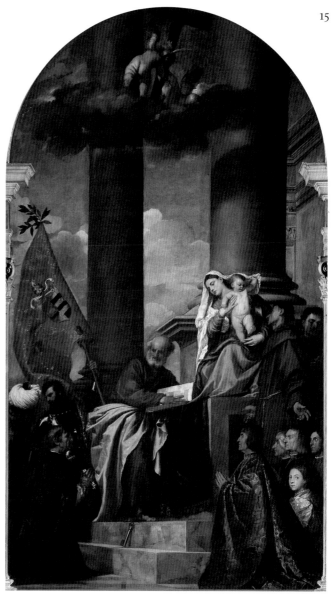

While the controversy about early Titian, up to the time of '*Sacred and Profane Love*', seems destined to continue, the rest of his career does not present the same kind of intractable problems. This is largely because he soon became famous in Venice and is often mentioned in contemporary sources. Already in 1513 he was given a commission to paint a picture in the Hall of the Great Council in Venice, which was destroyed by fire in 1577. Most of the leading painters in the city worked on the project, but Titian was the youngest to be given such a responsibility. Three years later, on the death of Giovanni Bellini, he was awarded a government sinecure previously held by his old teacher, which enabled him to enjoy a steady income from the state for the rest of his life. His pre-eminence was further underlined in May 1518, with the unveiling of his *Assumption of the Virgin* (fig. 6) above the high altar of the Frari, one of the most important churches in the city. This was not only the largest altarpiece yet painted in Venice, but also profoundly different in appearance from any that had ever been seen there before. Instead of static, hieratic figures, Titian's are larger than life and all in movement, focused on the ecstatic Virgin flying up to heaven against a great gold burst of celestial light.

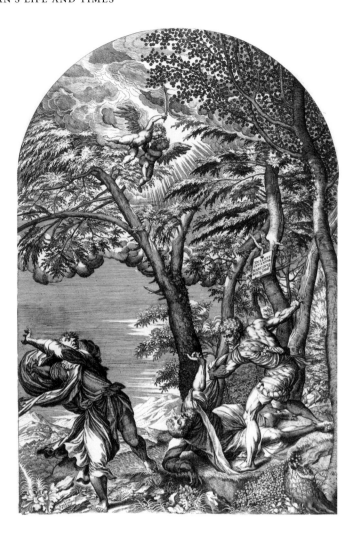

FIG. 8
MARTINO ROTA
after TITIAN
The Death of Saint Peter Martyr (painted 1526–30),
about 1568
Engraving, 40 × 27.1 cm
The British Museum, London,
P&D 1857-6-13-338

In the seventeenth century it was claimed that initially this radically new conception was unacceptable to the artist's Franciscan patrons. This may well be true, given the conservatism of most religious art, but the picture was nonetheless a marvellous advertisement for the novelty of Titian's style and his mastery in the depiction of the human figure. How long it took him to paint is unknown, but it was probably begun before 1516, the date inscribed on the massive stone frame.

In 1526 he completed another major altarpiece for the same church, '*The Madonna of the Pesaro Family*' (fig. 7), begun in 1519. Faced with the difficult requirement of accommodating an unprecedented number of kneeling donors, he transformed the standard, strictly symmetrical Venetian format for paintings of the enthroned Madonna with saints by rotating the entire arrangement of figures and by violating the convention that the painted architecture should be linked to the real architecture of the frame. As with *The Assumption*, what mattered was not so much the rational arrangement of figures and objects in three-dimensional space as the pattern of colours and areas of light and dark on the picture plane. In these two pictures Titian introduced a new approach to painting, while at the same time creating a new ideal type, both sympathetic and impressive, for his figures.

Titian accepted a relatively low fee for the Pesaro *Madonna*, perhaps because of the

publicity value of a work in such a prominent public location. He received about the same amount for his next major altarpiece, *The Death of Saint Peter Martyr* (fig. 8), begun in 1526 and completed in 1530, which was for the other great Venetian church, Santi Giovanni e Paolo, founded by the Dominicans. Until its destruction by fire in 1867, this was his most famous and widely admired picture. From the many surviving copies it appears that he adopted a highly rhetorical figure style, with an emphasis on exaggerated movement, foreshortening and prominently displayed musculature, which shows that he was fully aware of the latest artistic innovations in Florence and Rome. But the idea of making a vast and wind-blown tree almost a protagonist in the action, thus heightening the dramatic mood, was entirely his own. This altarpiece, even more than the two previous ones, seems to anticipate the ideals of the art of the seventeenth century. But the colours were probably rather brighter than the copies imply, because all of these seem to date from the seventeenth century or later, by which time the picture may well have darkened. There is some reason to suppose that, like *The Assumption*, it was initially too novel for the patrons. At any rate, Titian had the greatest difficulty in collecting his fee.

Some idea of the probable colouring of the picture is provided by the three mythological paintings which he painted for Alfonso d'Este, duke of Ferrara, in the years after 1518. These were part of a series of canvases commissioned by Alfonso to decorate a room in his private apartments. The earliest of them was supplied by Giovanni Bellini in 1514 (cat. 15), and the duke then tried to obtain pictures from Fra Bartolomeo in Florence and Raphael in Rome, but both artists were prevented by death from carrying out their commissions. In 1518 Titian was commissioned to paint the subject previously given to Fra Bartolomeo, *The Worship of Venus* (cat. 16), which was completed in 1520. Between early 1521 and 1523 he painted *Bacchus and Ariadne* (cat. 13), and probably in 1523–4 *The Andrians* (cat. 14), although there is a remote possibility that this was not executed until 1529.[10] These paintings were seen by relatively few people in the sixteenth century, but after they were taken to Rome in 1598 they decisively influenced the way in which subjects from classical mythology were represented by artists such as Rubens and Poussin.

At this early date Alfonso's project was extremely unusual, especially in North Italy, since very few patrons had the inclination or resources to commission a series of large mythological paintings from the leading artists of the day. Most art at that time, as indeed later, was supposed to be in some sense edifying, but this scheme was entirely without moral content, and evidently prompted by a desire on Alfonso's part to possess a series of masterpieces. The subjects that he commissioned from Titian were all ones which had been represented in classical antiquity. He probably chose them not because of a particular antiquarian interest on his part, for which there is no other evidence, but because the ancient world was the most prestigious model for most types of activity, from philosophy and architecture to warfare. Moreover, Titian's approach was by no means narrowly archaeological. The subjects of *The Worship of Venus* and *The Andrians* were taken from the *Imagines* of Philostratus, a description of a probably imaginary ancient picture gallery, dating from the third century AD. But Titian did not attempt to follow these texts with pedantic fidelity, adding, for example, figures in contemporary dress. Likewise, although some of the figures are clearly based to some degree on surviving examples of ancient sculpture, there is no reason to suppose that he was attempting to recreate the style of ancient painting, of which no major examples were then

known. What he did instead was to provide an extraordinarily compelling interpretation of pagan myth, emulating the supposed lifelikeness of the paintings described by Philostratus. This interpretation has proved so seductive that we still see mythology through the eyes of Titian and his later imitators.

Particularly in his great altarpieces and mythologies, by 1530 Titian had transformed the language of Venetian painting, creating new conventions which were to be regarded as definitive for more than two centuries. He was also developing a new figurative style, idealised but plausible, and a new type of painted landscape. But perhaps his greatest contribution was to extend the expressive range of oil-based pigment. Whereas the leading artists of Florence and Rome devoted their main creative effort to elaborating their inventions through drawings, Titian by contrast thought with his brush, and as a result his paintings have a beauty of surface unsurpassed by those of any of his contemporaries.

One other aspect of his work should be singled out, his activity as a portraitist. His earliest portraits, such as the *Man with a Quilted Sleeve*, seem to have been mostly for Venetians, but by the 1520s he was attracting wealthy patrons from elsewhere in North Italy. Thus he painted Alfonso d'Este and his mistress some time before 1529, and in 1523 he was invited to Mantua by the Marquis Federico Gonzaga, Alfonso's nephew. On that occasion he probably painted Federico's younger brother Ferrante, who is perhaps shown in the *Man with a Glove* in the Louvre. More certain is the identification of a portrait Titian painted in 1529, that of Federico himself, which is now in the Prado. Both paintings show Titian's unsurpassed skill in conveying a characterisation both flattering and sympathetic. While evidently showing his sitters as they would want to appear, he succeeded in creating portraits that are also entirely convincing. In doing so, he established compelling models for aristocratic portraiture which remained influential for centuries. It is indicative of his high reputation that in 1529 Federico invited him to paint the Emperor Charles V, an offer which Charles rejected at that time, but accepted in 1532, after having had the opportunity of seeing Titian's portraits for himself. Unfortunately, the portrait that the artist painted on that occasion, showing Charles in armour, does not survive. It was evidently very well received, because in 1533 the emperor granted the artist a patent of nobility, on the strength of his skill as a portraitist, and from then onwards remained in regular contact with him, inviting him to Spain and ensuring that he saw him every time that he passed through Italy.

By the early 1530s Titian, then in his early forties, had therefore established himself as the most fashionable and admired painter of North Italy. Perhaps as a mark of his new status, in 1531 he moved to a new house, with a garden, in the northern part of Venice, where he was to live for the rest of his life. At that time he was bringing up two children, Pomponio and Orazio, who had been born some time before November 1525, when he had married their mother Cecilia.[11] She came from a village near Pieve di Cadore, but died in August 1530. During the 1530s Titian remarried, but the name of his second wife, who seems to have died in the late 1540s, is unknown.[12] They had a daughter named Lavinia, who married in 1555.[13] Titian also had another daughter, Emilia, who was illegitimate, and who seems to have been born in the early 1550s.[14]

While the artist's domestic arrangements can only be pieced together with difficulty, much more is known of his social life from around 1530. His closest friends were the writer Pietro Aretino, who had arrived in Venice from Mantua in 1527, and the sculptor Jacopo

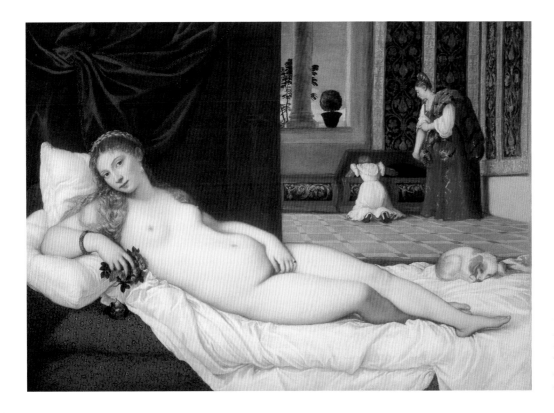

FIG. 9
TITIAN
'*The Venus of Urbino*',
before 1538
Oil on canvas, 119 × 165 cm
Galleria degli Uffizi, Florence

Sansovino, who had arrived from Rome in the same year. Aretino played an important role in spreading Titian's reputation well beyond the confines of Venice through his published letters, of which six volumes appeared by 1557, incorporating more than two hundred references to the artist. These circulated very widely, ensuring that rulers and courtiers throughout Western Europe were aware that Titian was the leading painter of his day and, above all, the greatest portraitist of modern times. Aretino's correspondence also shows that Titian's friends in Venice included ambassadors, musicians, courtesans and writers. According to several contemporaries he was extremely charming, and evidently socially astute. Like Aretino himself, he was seldom intimidated by even the most powerful patrons, recognising that they needed him more than he needed them.

From about 1530 onwards Titian worked increasingly for aristocratic clients outside Venice, who evidently paid better than the Venetians. Thus throughout the 1530s he was employed on a regular basis by Federico Gonzaga, for whom he painted more than thirty pictures, almost all of which have been destroyed. One of the few exceptions is '*The Madonna of the Rabbit*' of 1530 (cat. 18), in which the shepherd seems to have the features of Federico. It was probably through him that Titian was introduced to his brother-in-law Francesco Maria della Rovere, duke of Urbino and commander of the Venetian forces, for whom he painted a number of pictures in the 1530s, including the portrait of the duke himself (1536; fig. 18, p. 35) and that of his wife Eleonora (1536 or 1537; both Uffizi, Florence).[15] Early in 1538 Francesco Maria's son and heir Guidobaldo, then duke of Camerino, paid a visit to Venice. While he was there he inevitably had his portrait painted, and evidently saw and admired a painting of a naked woman in Titian's studio, which he immediately tried to acquire.[16] It is not known who had originally commissioned the work in question, the so-called '*Venus of Urbino*' (fig. 9), or

why it had remained on Titian's hands. But such overtly salacious paintings, without even the pretext of a mythological subject-matter, were extremely rare at this time, and probably would only have been considered acceptable by members of the high aristocracy who could afford to disregard conventional notions of propriety, which would become more rigid after the Counter-Reformation.[17] Titian was later to make something of a speciality of works of this type, usually for his most socially prominent patrons.

Even though after 1530 Titian worked more and more for non-Venetians, especially as a portraitist, he did not entirely cease to produce works for Venetian clients. However, he now charged much more for his services, gradually pricing himself out of the local market. Many of his most important works in the city were painted for the Ducal Palace, and were destroyed in two disastrous fires, in 1574 and 1577. Of his surviving Venetian paintings of the 1530s, the finest is *The Presentation of the Virgin* (fig. 11), executed between 1534 and 1538, in which it is possible to see, for the first time, indications of a less high degree of finish, a symptom of a wider change in the approach of Venetian artists which began at this period and which

FIG. 10

TITIAN
Saint John the Almsgiver,
before 1541
Oil on canvas, 229 × 156 cm
San Giovanni Elemosinario,
Venice

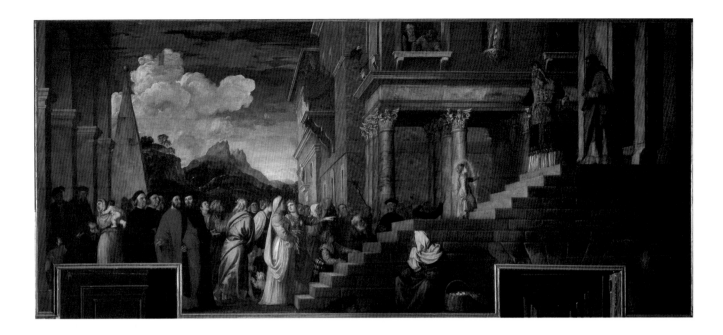

FIG. 11

TITIAN
The Presentation of the Virgin,
1534–8
Oil on canvas, 335 × 775 cm
Gallerie dell'Accademia,
Venice

became much more apparent in the following decade, especially in the works of painters younger than Titian, such as Andrea Schiavone and Tintoretto. The new approach is also more evident in some of Titian's own works of the 1540s, such as the portrait of Pietro Aretino, of 1545 (cat. 27). Here the lack of finish is so glaring that Aretino himself, who sent it as a present to Cosimo de' Medici, duke of Florence, felt it wise to make a joke of the fact in a letter to Cosimo, to whom this style of painting would have been entirely unfamiliar. Yet it is precisely the apparent spontaneity and looseness of the brushwork that give the picture its vitality.

The chronology of Titian's works in the years around 1540 is still not well understood. Thus the Venetian altarpiece of *Saint John the Almsgiver* (fig. 10) is conventionally dated to 1545 or even 1550, but it was certainly installed before the end of 1541, and probably by 1538, because it was already mentioned by Vasari in the first edition of his *Lives*, which were written on the basis of information collected while he was in Venice.[18] Likewise, the ceiling paintings of Old Testament subjects for the Augustinian church of Santo Spirito in Isola (fig. 12), now in the sacristy of the church of the Salute, which are usually dated around 1542, are likely to be eight or nine years later. Titian had been commissioned to paint the high altarpiece for this church as early as 1529, and had delivered it unfinished in 1541, but his fee had still not been paid in 1545, when he and the patrons went to law about the matter. That he would have supplied three large ceiling paintings to the same patrons soon after 1542, as Vasari implied, and thus even before he was paid for the altarpiece, is entirely unrealistic.[19] As it happens, he was once more in dispute with the Augustinians in 1552, and it is probable that this later litigation concerned the ceiling paintings.[20]

Such changes in chronology indicate that attempts to date Titian's work simply on the basis of supposed changes in style, such as the adoption of types of figures particularly close to Michelangelo, or the use of a looser type of brushwork, are liable to produce misleading results. This is partly because Titian, especially as he grew older, was quite capable of chang-

ing aspects of his style to suit the type of subject or the tastes of the patron. Another conse-quence of the re-dating of these particular pictures is to underline that in the 1540s Titian produced fewer large-scale paintings of high quality than at any other period in his career. In the second half of the decade he did paint a substantial altarpiece for the principal church of Serravalle, on the road between Venice and Cadore, where he was then investing in land and buying a small house, but this is evidently in part the work of assistants. The same is true of a very damaged small altarpiece of about the same period for the village church of Castello di Roganzuolo, where his house was located.

It was at this period that the demand for his portraits was at its height. In 1542 he en-tered into contact with the Farnese, the family of Pope Paul III, and in the following year painted the pope himself at Bologna (cat. 26). During the same trip he was present at Busseto, near Parma, when Paul met Charles V, who also gave him a portrait commission. Thus he found himself employed simultaneously by the pope and the emperor. Then in the winter of 1545–6 he visited the papal court in Rome, at the invitation of the Farnese, who were at-tempting to persuade him to enter their service on a permanent basis. Titian, who was anx-ious to obtain a rich benefice for his son Pomponio, hinted that might be prepared to move permanently to Rome, but it is doubtful whether he had any serious intention of doing so. While he was there he completed one major picture for Cardinal Alessandro Farnese, Paul's grandson, namely the *Danaë* in Naples (cat. 23). As a contemporary remarked, this was a work that 'made [the nude] which your Reverence saw in the collection of the duke of Urbino look like a nun'. In this case, too, the woman originally does not seem to have had any distin-guishing attributes, and was shown in a modern room, accompanied by servants; but, per-haps in Rome, she was then transformed into a character from classical mythology.

Although Titian continued to maintain a relationship with the Farnese after his return to Venice, this ceased in early 1548, when he travelled to Augsburg at the invitation of Charles V, to spend about nine months at the imperial court. From this time onwards the im-perial family, the Habsburgs, had first claim on his services, and for the remainder of his life he was in effect their court painter. At first he was employed almost exclusively as a portraitist. While at Augsburg he painted more than a dozen portraits of members of the Habsburg family and their closest associates. Most of these were intended to form part of a kind of dy-nastic picture gallery, a project in which Charles V was jointly involved with his sister Mary of Hungary. At the same time Titian was employed by the emperor's brother Ferdinand, King of the Romans. Unfortunately, most of the portraits from this period are lost, with the no-table exception of the equestrian portrait of Charles V (Prado, Madrid). It is not known who was responsible for the conception of this portrait, the largest that Titian ever painted and one for which there were no close precedents in Italian art. Without any hint of triumphal-ism or bombast, it provides the most compelling and sympathetic image of Charles's con-ception of his imperial rôle, as a responsibility to be borne with courage and a sense of duty; and it comes as no surprise to discover that the emperor regarded the artist as a personal friend, to a degree that surprised and even scandalised his contemporaries.

At the end of 1548, shortly after his return to Venice, Titian set out again, this time to Milan, where he met and painted the future Philip II, the son and heir of the emperor. Titian's first portrait of the prince, showing him full-length in armour, is probably the picture now in the Prado.[21] Shortly afterwards he sent him a very different kind of painting, a variant of the

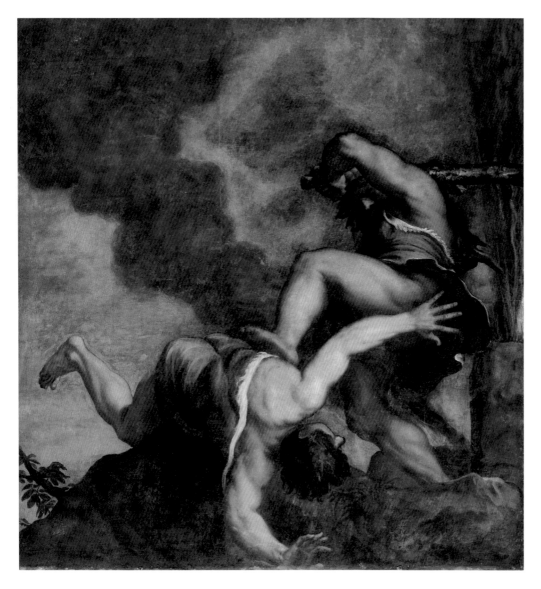

FIG. 12

TITIAN
Cain slaying Abel, before 1553
Oil on canvas, 298 × 282 cm
Santa Maria della Salute,
Venice

Danaë which he had completed in Rome for Alessandro Farnese.[22] The success of these works led to a second invitation to Augsburg, this time from Philip, and during his visit, in the winter of 1550–1, Titian completed still more Habsburg dynastic portraits. He also entered Philip's service on a permanent basis, apparently undertaking to supply him with about ten further pictures at regular intervals in return for a pension, which he received, admittedly often after many delays, for the rest of his life. Together with pensions that he had already been awarded by Charles V and his Venetian sinecure, he could count on an annual income roughly double that of the most senior government official in Venice, quite apart from anything that he earned from other patrons.

The most famous paintings by Titian for Philip were the so-called *poesie*, a series of mythologies similar to the *Danaë*, but slightly larger. The first of them, *Venus and Adonis* (Prado, Madrid), was sent to Philip in London late in 1554, shortly after his marriage to Mary Tudor. This was followed by *Perseus and Andromeda* (fig. 69, p. 166) in 1556, *Diana and*

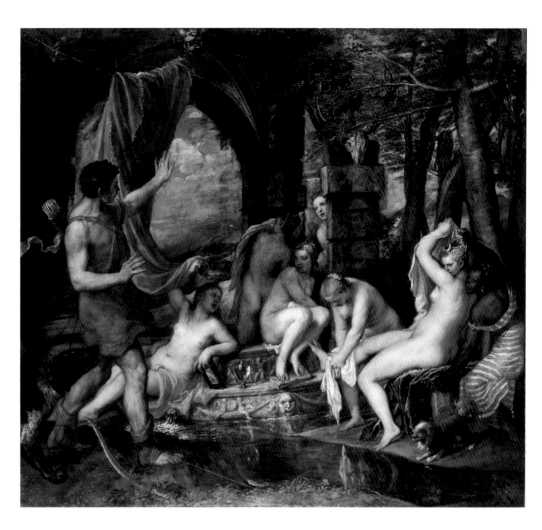

FIG. 13

TITIAN
Diana and Actaeon, 1556–9
Oil on canvas, 184.5 × 202.2 cm
Duke of Sutherland
Collection, on loan to the
National Gallery of Scotland,
Edinburgh, NGL 58.46

Actaeon and *Diana and Callisto* (figs. 13, 14) in 1559 and finally by *The Rape of Europa* (fig. 15) in 1562. The technique of these pictures is very different from that of Titian's earlier works, in that there is no attempt at a precise definition of forms, which are suggested rather than described by the apparently very free brushwork. This effect had been anticipated in some parts of a few earlier paintings, such as the portrait of Pietro Aretino, but now it was applied consistently to the entire picture surface. The result, as was noted at the time by Vasari, was that the paintings 'seemed alive'. Vasari added that the appearance of spontaneity in the handling of paint was misleading, since Titian's technique was extremely laborious.

He was not the only Venetian artist at this period to experiment with such effects. As has been mentioned, something similar had already been attempted in the 1540s by younger painters in Venice, but none of them had been able to combine an apparent freedom of handling with a strength of modelling in the way that Titian did, so that in comparison their works seem sketchy and insubstantial. The technique of the *poesie* was to have an immense influence on later artists, notably Rubens and Velázquez, who saw these pictures in the Spanish Royal collection. They mark a decisive change in European painting, in that now the way in which an artist manipulated paint in order to evoke natural appearances became as much a part of the aesthetic interest of the pictures as the underlying form. In the terminol-

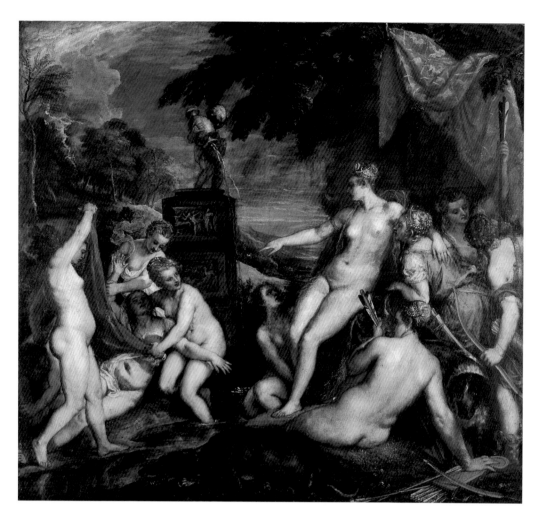

FIG. 14

TITIAN
Diana and Callisto, 1556–9
Oil on canvas, 187 × 204.5 cm
Duke of Sutherland
Collection, on loan to the
National Gallery of Scotland,
Edinburgh, NGL 59.46

ogy current in Titian's day, he was the great exponent of *colorito*, referring to the handling of pigment rather than the use of brilliant colours, whereas Central Italian masters such as Raphael and especially Michelangelo were preoccupied instead with *disegno*, the creation of idealised forms through drawing. In fact, the later *poesie* are notably rich in their colouring, too, and this adds to their appeal. Yet for all the seductiveness of their appearance, the mood is far more serious and the figures are more richly characterised than in the earlier mythologies for Alfonso d'Este. These representations of mythological themes have an emotional range and conviction unprecedented in post-classical art, and in this respect too the *poesie* provided a crucial model for later artists.

Although the *poesie* are the most famous of Titian's works for Philip II, they are by no means the only ones. While he was painting them, that is to say between 1551 and 1562, he also sent the king a number of substantial religious paintings in much the same technique, including *The Crucifixion* of 1556 (Escorial), *The Entombment* (cat. 31) of 1559 and *The Agony in the Garden* (Prado) of 1562. In that year Titian informed Philip that he had fulfilled all his obligations, but declared that he intended to continue to send him pictures as long as he was able to do so. The works he sent to Spain after that time, therefore, were painted primarily for his own satisfaction, since his pensions were paid for work already completed, and,

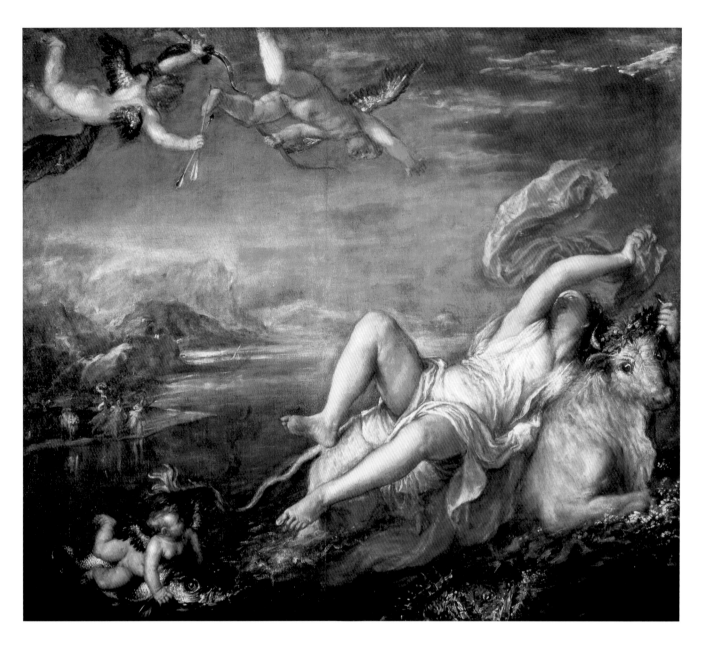

because of Philip's improved finances, they were actually paid more regularly than before.

The paintings sent to Philip after 1562 are very similar in style to those produced before that time. This applies, for example, to *The Martyrdom of Saint Lawrence* in the Escorial (fig. 74, p. 178), completed in 1567, which is the largest picture of Titian's later years, but now much damaged; to *The Tribute Money* of 1568 (cat. 32), *Tarquin and Lucretia* of 1571 (cat. 36) and the *Saint Jerome* of 1575 (cat. 40), the last completed work known to have left the artist's studio before his death in August 1576. Especially in the works from the last decade of Titian's life, when he was in his late seventies or early eighties, there is a certain loss in colouristic brilliance and in the definition of form. This is probably due to the failing eyesight and waning physical powers that were noted by several contemporaries. But there is no change in Titian's artistic ideals or approach. The style that he perfected in the works for Philip of the 1550s was

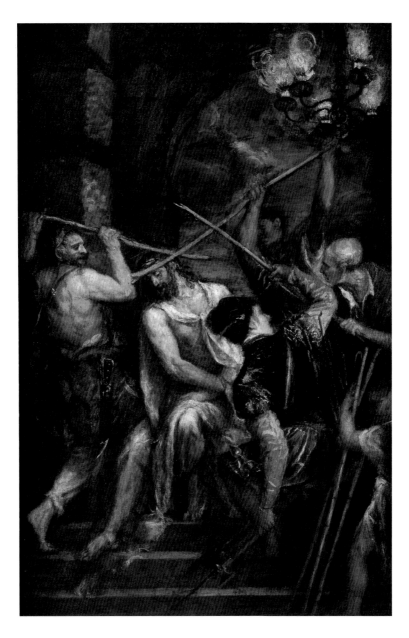

FIG. 16
TITIAN
The Crowning with Thorns,
about 1572–6
Oil on canvas, 280 × 181 cm
Alte Pinakothek, Bayerische
Staatsgemäldesammlungen,
Munich

one that he continued to use in all his later paintings for the king.

Many art historians, however, have supposed that in his last years Titian developed a somewhat different style, characterised by a narrow colour range, a very sketchy type of brushwork and an emphasis on tragic themes. The parallel that has often been made is with the late Rembrandt. Yet none of the works supposedly representative of this late style are known to have left his studio in his lifetime, and one of them, *The Crowning with Thorns* in Munich (fig. 16), was certainly unfinished at his death. Another work in this category is *The Death of Actaeon* (cat. 37). Titian was proposing to send a picture of this subject to Philip in 1559, when he stated that it was already begun. In the event Philip never received it, but in 1568 Titian offered a painting of the subject to the emperor and to the duke of Bavaria, together with versions of the other *poesie*.[23] Again, there is no clear indication that the picture was ever

completed, but it seems reasonable to suppose that it is identical with the one in the National Gallery. It is highly finished in some areas, notably the head and arms of Diana, and only very roughly sketched in others, such as the legs of Actaeon or the dogs. Probably the picture was still in Titian's studio on his death; the more finished areas may have been worked up subsequently in order to make it saleable.

If Titian really did regard the paintings in his supposed late style as finished, it is difficult to explain why they look so different from those he sent to Philip II. Some scholars have tried to solve this problem by assuming that the *Saint Jerome*, although sent to Spain only in 1575, was painted a decade or more earlier;[24] but there is no evidence for such an assumption. On the other hand, there is plenty of indication that Philip received the cream of Titian's production, so that in the last decade of his life other patrons, including ones as powerful as Alessandro Farnese, had to be content with replicas of works already owned by the king, or with paintings in part at least by assistants. The works for Philip, in short, provide the best indication of Titian's artistic intentions even in his last years; and this implies that the more sketchy works in his so-called late style, however strong their appeal to modern taste, are unfinished.

Associated with the idea that Titian had an intensely personal, tragic late style is the widespread belief that in his last years he was lonely and isolated. This would certainly be consistent with romantic notions about artistic genius, but it is not compatible with what is known about Titian's circumstances. Given that he died at over eighty-five, it is not surprising that he outlived some of closest friends, but in most cases not by a great margin. Pietro Aretino died in 1556, but Jacopo Sansovino only in 1570 and the mosaicist Francesco Zuccato in 1572, while Francesco's brother Valerio survived until late 1576 or early 1577.[25] And while friends may have died, Titian still had a large and flourishing family. His daughter Lavinia, who died some time after January 1574, perhaps a victim of plague, had six children;[26] his other daughter Emilia, who outlived him, had three children.[27] His son Orazio, who also survived him, shared his house in Venice throughout his life. Titian was estranged from Pomponio, a priest, who only communicated with him through lawyers after the mid-1560s.[28] This was evidently distressing to him, but the two men had been on bad terms for at least a quarter of a century. In his last years, therefore, Titian could not realistically be described as isolated and his circumstances were far from tragic. He was rich and famous, he had a flourishing studio, nine grandchildren, and an extended family, spread between Venice, Serravalle and Cadore.

Titian died on 27 August 1576, during the greatest plague to strike Venice in the sixteenth century, followed about a month later by Orazio. There followed a long and bitter dispute between the heirs, with Pomponio, also acting for Emilia and her children, attempting to stop Lavinia's husband Cornelio from claiming the entire estate, on the grounds that his children alone were the legitimate heirs of Titian and Orazio.[29] After much wrangling, including claims from each side that the other had stolen property from Titian's house, a settlement was finally reached, by which the artist's assets in Venice and Cadore went to Pomponio, who distributed them among various relatives, while those in Serravalle went to Cornelio and his descendents.[30] Titian's artistic legacy, in the form of his paintings, was scattered across Europe, much of it already in the princely collections which were later transformed into the great museums where it can still be seen today.

JENNIFER FLETCHER

TITIAN AS
A PAINTER OF
PORTRAITS

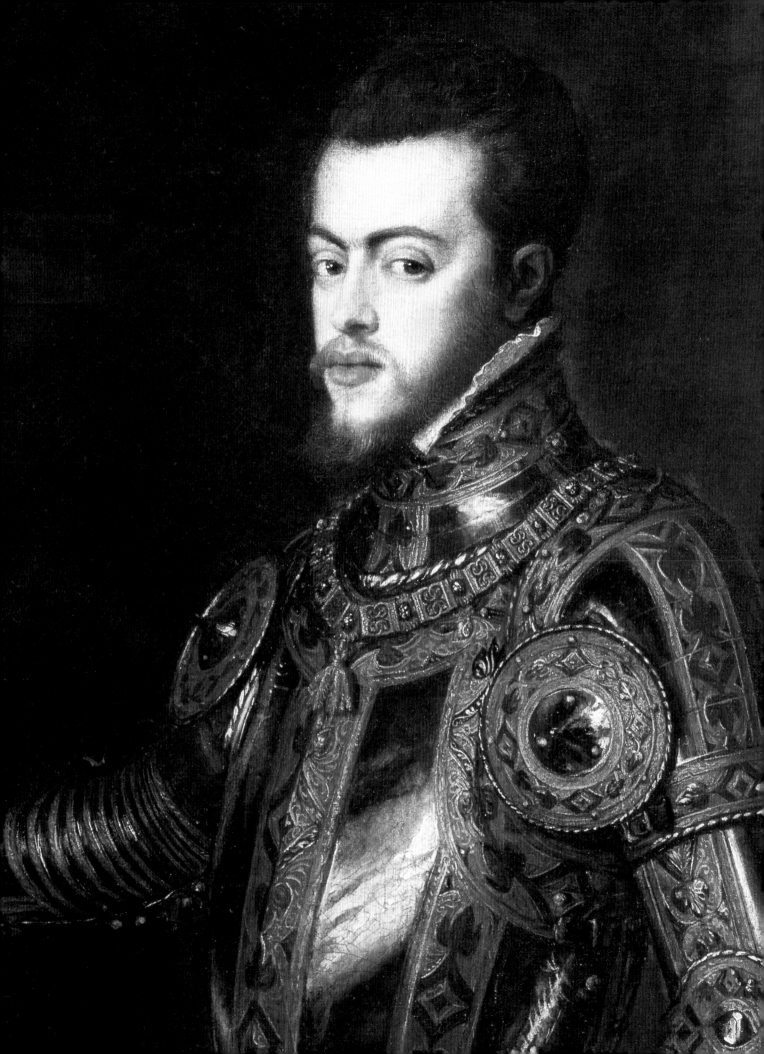

Jennifer Fletcher TITIAN AS A PAINTER OF PORTRAITS

IN 1553 A PORTRAIT OF PHILIP II was sent from Brussels to London for inspection by his future bride, Mary Tudor. With it came instructions from Philip's aunt, Maria of Hungary. It should be hung in a suitable light and be viewed at a distance, as Titian's paintings were not always decipherable from close up.[1]

This episode is instructive, for it shows that Titian's broad brushstrokes were appreciated in sophisticated circles but needed explaining to a recipient more used to the higher finish of contemporary Netherlandish painting. It reminds us that portraits played an important part in international alliances and were often mobile, passing from court to court. Sitters might be educated into an artist's style by this means. Titian was by no means a specialist portraitist, but it was through portraits that he won the wider patronage of his major patrons, the Emperor Charles V, King Philip II of Spain, and other members of the Habsburg family. Titian's portraits seem also to have aroused more debate about his art than his religious or mythological pictures, perhaps because patrons felt better qualified to express an opinion when confronted by their own likeness or those of friends or relatives. The question of the broadness or the lack of finish in Titian's portraits frequently crops up, and it is not always a quality that even his supporters view positively. Thus we find Philip II in 1551, quite early on in his association with Titian, complaining about the armour in his portrait. If there had been time, he wrote, he would have had Titian re-do it.[2]

In contrast to the isolated reactions of his patrons that have been preserved, there are the writings of Pietro Aretino, who from 1527 until his death in 1556 was one of Titian's closest friends, watched him at work, shared many of his patrons, and even acted as his *amanuensis*.[3] Aretino was a highly experienced sitter, who boasted of the frequency with which his face appeared in a variety of contexts and a wide range of media.[4] His correspondence is an invaluable source for Titian's portraits, showing how he came to realise that a true likeness could be captured by a few strokes, and that it took more than the ability to imitate velvet and belt buckles to make a good painter.[5] The force of his response is best illustrated by his partly contradictory comments on his portrait by Titian now in the Pitti Palace (cat. 27). To the artist, with whom he was annoyed because he had not made a portrait from a deathmask of Giovanni dalle Bande Nere which Aretino wanted to present, together with his own portrait, to Giovanni's son Cosimo de' Medici, he complained that it 'was sketched rather than finished'. To Cosimo he apologised for the lack of detail in the clothing, humorously suggesting that, had Titian been paid more, he would have made more effort. To Paolo Giovio, who collected images of famous persons, he praised it as a '*terribile meraviglia*' (an awesome marvel).[6]

Titian painted portraits more often than any other type of picture and painted them throughout his long career. In this catalogue *Jacopo Pesaro being presented by Pope Alexander VI to Saint Peter* (cat. 3) may be his earliest surviving work, while *Jacopo Strada* (cat. 38) of 1567–8 is a rare yet brilliant late example. Increasing steadily in the 1520s, Titian's portrait production peaked from the 1530s through to the early 1550s, when he was engaged by both the Habsburg and the papal courts in Augsburg and in Rome. After 1551 Titian did not paint Philip II again from life and in 1556 he was relieved of the task of producing dogal portraits and *ex-votos* for the Doge's Palace.[7] Titian's travels, international fame, high status

TITIAN
Philip II in Armour, 1550
(detail of cat. 30)

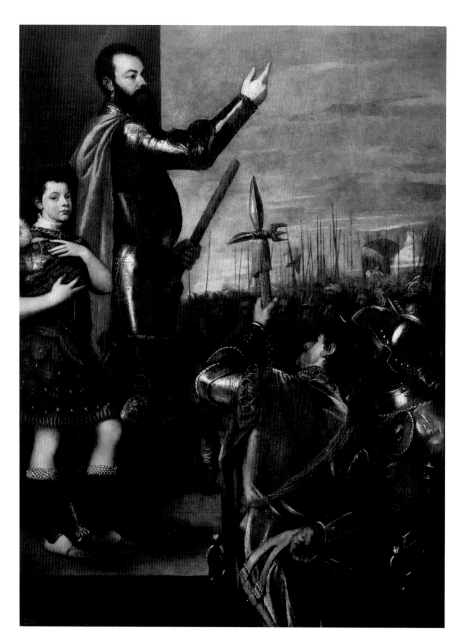

FIG. 17
TITIAN
The Allocution of Alfonso d'Avalos, Marchese del Vasto, to his Troops, 1539–41
Oil on canvas, 223 × 165 cm
Museo Nacional del Prado, Madrid, inv. 417

and income were greatly dependent on portraiture, which earned him his knighthood, pension and lucrative perks, such as the right to export grain from Naples and to legitimise bastards.[8] It enabled him to play a second Apelles to Charles V's Alexander, although his refusal to follow the emperor to Spain preserved him from over-exposure to a narrower range of patrons and expectations.[9]

Some patrons, notably Charles V, were interested in Titian mainly as a portraitist, while in other cases portraits led to other types of commission.[10] Titian mainly portrayed aristocratic men – imperial Habsburgs, the papal Farnese, the ruling Venetian élite, and members of the d'Este, Gonzaga and della Rovere courts. He painted far fewer women, even counting in several portraits of female Habsburgs that were destroyed,[11] his pictures of *belle donne* like the *Flora* (cat. 11), which were certainly popular, and several much publicised images of girl-

friends and mistresses of influential protectors that are now lost.[12] Titian's portraits impressed contemporaries like Vasari and Ludovico Dolce both in their quality and in their quantity.[13] They include, of course, donors in altarpieces and portraits inserted in religious and historical narratives. The range of his sitters embraced numerous professions – writers, scholars, lawyers, diplomats, military leaders, ecclesiastics and fellow artists; and Titian also portrayed friends, family and himself.

Many portraits lack identifying inscriptions, coats of arms or an early provenance. It has been suggested that some of the handsome, well-dressed young men in his early works belonged to his own social set and a generation in reaction against the established dress code favoured by their more conservative fathers, and that they formed part of an emerging group of connoisseurs.[14] This is hard to prove, although according to Vasari Titian portrayed friends at many different stages in his career.[15] One such is the sitter in a portrait in San Francisco, who holds a letter identifying him as a special friend of Titian, and since he proffers it with his left hand he might be the Francesco Sinistro whose portrait was known to Vasari.[16]

Rulers required regular updating of their image, but others only slightly less eminent were portrayed by Titian more than once. For example, he painted the notorious Aretino on at least four occasions, and the Venetians Cardinal Pietro Bembo, Grand Chancellor Andrea dei Franceschi and Bishop Jacopo Pesaro twice.[17] Bembo was a close friend of Raphael and owned his double portrait of Bembo's Venetian friends Andrea Navagero and Agostino Beazzano; an opinionated critic, he compared Raphael's *Baldassare Castiglione* (Louvre) unfavourably with his *Antonio Tebaldeo* (lost).[18] Knowledge of innovations in style and iconography could spread swiftly up and down Italy. Alfonso d'Este, who liked watching artists at work and himself practised pottery and bronze casting, owned Raphael's cartoon for his *Isabelle de Requesens*, which influenced Titian's portrait of his niece Eleonora, Duchess of Urbino (Uffizi, Florence).[19] The sculptor Alessandro Vittoria, who acquired Parmigianino's celebrated Vienna *Self-portrait in a Mirror*, had a small portrait by Titian of a woman which was part of a looking glass and may have been designed to hang as a pendant to it.[20] Through service to the emperor Titian was also introduced to iconographic types and formats then more common in northern Europe, such as full-length and equestrian images and double portraits of man and wife.[21]

Titian's training in Venice helped equip him for his rôle. His teachers, the Bellini brothers, were both celebrated as portraitists; their prime achievements, Giovanni's *Doge Leonardo Loredan* and Gentile's *Mehmet II*, are both in the National Gallery. Titian's early association with Giorgione and Sebastiano del Piombo, who were both so inventive in the genre, alerted him to new solutions and possibilities such as the use of dramatic close-up, super-reflective armour, turning figures and self-regarding heads tilted back – like the youth in 'The Bravo' (cat. 12), so very like Giorgione's *Self-portrait as David*. Long after Sebastiano's departure to Rome in 1511 Titian used his *Carondolet and Secretary* (Thyssen Collection, Madrid) as his prototype for *Georges d'Armagnac, Bishop of Rodez, with his Secretary* (cat. 22). Cosmopolitan Venice was a good market for portraiture, for members of its large ruling nobility like Senator Nicolò Zen (cat. 39) celebrated promotion to political office with portraits in uniform. Rich citizens, foreign residents and visiting diplomats all required portraits. In this exhibition alone we find a Florentine toddler (cat. 24), the brother of a Genoese doge (cat. 21) and a French bishop (cat. 22). In sixteenth-century Venice painting was regarded as

the primary art and salaried painters in Government service, such as Titian, were expected to produce portraits and *ex-votos* of doges. Proximity to the Este court in Ferrara and the Gonzaga court in Mantua, which owed feudal allegiance to the emperor, facilitated Titian's introduction to his most enthusiastic portrait patron, Charles V.[22]

Although he never liked leaving Venice, Titian was lured to Rome in 1545 by a Farnese promise of a benefice for his eldest son, Pomponio, who had become a priest.[23] It is noticeable how in his first portrait of Paul III (cat. 26) the pope's hand is spread over his purse. Titian made shrewd use of his gift for portraiture. On other occasions he used portraits in trade-offs. He promised one to a musical instrument-maker in return for a harpsichord,[24] and he was prepared to work *gratis* for Bembo in expectation of future favours.[25] But most striking of all was his deal with Jacopo Strada, the imperial antiquary: his portrait (cat. 38) in return for help in passing off as autograph to the emperor Maximilian workshop versions of mythological paintings Titian had made for Philip II.[26]

There are no detailed descriptions of Titian at work on a portrait. His cousin Cesare Vecellio, eager to learn, watched him painting the Elector of Saxony's armour in Augsburg, but his account is brief.[27] We hear more frequently of reactions to damage sustained immediately after completion or during transit – like the equestrian portrait of Charles V (Prado, Madrid), blown over while the varnish was drying in the garden of the Fugger palace and gashed on a stake.[28] Valuable evidence is, however, provided by unfinished works, such as the *Self-portrait* in Berlin (cat. 28) and *Paul III with his Grandsons* (fig. 62, p. 138), and by a growing number of conservation reports, proving that Titian approached portraiture in substantially the same way as his other paintings.

Titian usually worked directly on the prepared support, drawing the compositional guidelines in either paint or black chalk. He sometimes painted over discarded portraits of other sitters[29] and he often made substantial revisions during execution. He naturally tended to work up the head to a higher degree of finish first. Elsewhere (see pp. 52–3) readers can find an analysis of his procedure in *The Vendramin Family* (cat. 29), where the very large scale, the low viewing-point and the local patron's well-documented connoisseurship combine to encourage a virtuoso display of broad brushstrokes, which might have been less appreciated elsewhere.[30] Recent examination of *Charles V on Horseback* shows that, among many revisions, the most major were the moving of the emperor's body higher up the canvas and the decision to turn his head away from a near frontal view to a more profiled off-side gazing, giving the impression of a thoughtful leader, with his close-up features set poignantly *alla veneziana* against the immensity of a far-away sunset sky.[31] Such changes took time and Titian admitted that this portrait had occupied him longer than anticipated.[32]

One can detect with the naked eye the late addition of the fictive relief in '*La Schiavona*' (cat. 4), where the red dress now shows through the parapet. The change may have been prompted by the contemporary '*paragone*' debate on the representational strengths of painting versus sculpture. It could be a witty compliment to the sitter, who may have been named after a Roman empress. It reflects Titian's response to Mantegnesque simulations of sculpture of the kind visible in some of the frescoes in the Scuola del Santo in Padua, to which Titian contributed, and in which he used the features of this sitter for a virtuous mother wrongly accused of adultery (fig. 3, p. 13).

Given the large number of portraits produced by Titian and his workshop it is

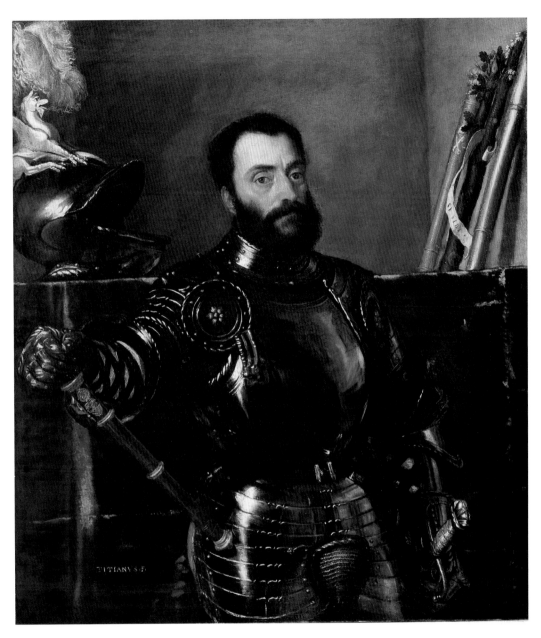

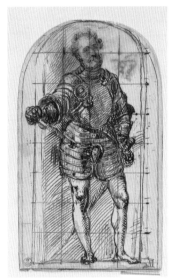

FIG. 18

TITIAN
*Francesco Maria della Rovere,
Duke of Urbino*, 1536
Oil on canvas, 114 × 103 cm
Galleria degli Uffizi, Florence

FIG. 19

TITIAN
*Man wearing the armour of
Francesco Maria della Rovere,
duke of Urbino*, 1536
Pen and ink on paper,
24 × 14.2 cm
Gabinetto dei Disegni e delle
Stampe, Galleria degli Uffizi,
Florence

surprising how rarely drawings can be associated with them. When a drawing survives or a painted *modello* is documented, it seems likely that they were made at the patron's request. For instance, Titian made a pen-and-ink sketch (fig. 19) for the duke of Urbino, who sat for Titian in May 1536 (fig. 18). The duke asked for a *carta* (a sheet of paper) from Titian and since this drawing has an early Urbino provenance it is likely to be the item requested.[33] The duke later loaned Titian his favourite suit of armour so that he might represent it accurately and study how its weight would affect the figure's *contrapposto*. As it was summertime, the stand-in, in posing for a three-quarter-length portrait, had no need of shoes or stockings.[34] It is significant that Federico Gonzaga, twice portrayed by Titian, who was accustomed to his court painter Giulio Romano's heavy dependence on drawing in his creative process, should order Titian to make a chalk drawing after a portrait of the Turkish sultan.[35]

More complex circumstances caused Aretino to promise the Marchese del Vasto a 'quadruzzo' (a painted sketch) as a foretaste of his Titian portrait (fig. 17).[36] This patron was exceptionally powerful and equally important to Titian and Aretino, who actually appears in Titian's painting.[37] He was also a highly experienced connoisseur and was impatient for a pre-view of a work which featured all'antica imagery (adopting the classical format of the imper-ial adlocutio) unusual for Titian and outside his normal repertoire.[38] The marchese's instruction that an up-to-date suit of 'white' (silver-coloured) armour should be procured, from which his own should be painted, may have been prompted by Aretino's description of his picture, which emphasises that his son's costume is derived from figures on triumphal arches.[39] Del Vasto, while not wanting to be depicted in Roman dress, may also have been determined to prevent any repetition of the now old-fashioned dark, gilded armour that he wears in his earlier portrait by Titian in the Louvre.[40]

Titian's patrons were often too busy to give long or repeated sittings, while others were disinclined to pose. Indeed Titian rather prided himself on his ability to get a good likeness without direct access.[41] His extremely life-like Ranuccio Farnese (cat. 25) was especially ad-mired by his tutor because it was made 'partly in his presence and partly in his absence'.[42] While some subjects lived far away, others were long dead. Thus Francis I (Louvre) was based on a medal of the king by Benvenuto Cellini,[43] and Titian's posthumous portrait of the Empress Isabella was derived from a mediocre painting – 'di trivial penello'.[44] Giulio Clovio provided Titian with a drawing of a Roman prostitute favoured by Cardinal Farnese,[45] while in her absence Giulia Varano's husband, Guidobaldo della Rovere, literally talked Titian into a likeness. She collaborated by first sending sleeves and later a dress, although it seems that it was Titian himself, set on a certain colour-scheme and texture, who insisted on red or pink velvet, which caused problems, as she did not have one that exactly matched his specifica-tion.[46] It is not known whether it was Titian or the Venetian noblewoman Giulia da Ponte who decided that she be depicted in blue. Her father's accounts show that Titian spent five ducats on expensive ultramarine and that she would be painted at home while he himself was to pose in Titian's studio.[47] Chaperoning was customary and one wonders whether Clarissa Strozzi, the first-born child of exiled parents, was portrayed in her family's palace at San Canciano in Venice or in Titian's house in the same parish.[48]

On the all important subject of colour, precious insight into Titian's thought processes when he was engaged on his equestrian portrait of Charles V (Prado, Madrid) is provided by his instructions that a courier bring him half a pound of red lake from Venice, 'so burning and so splendid' in its colour 'so that in comparison the crimson of velvet and silk will become less beautiful'. This pigment, made from kermes, was indeed used to dye garments.[49]

Unlike certain Tuscan artists, such as Michelangelo and Vasari, who denigrated por-traiture and were committed to highly idealised form derived from classical art, Titian was temperamentally suited to portraiture.[50] Vasari recognised Titian's aptitude, knowing many of his portraits at first hand. But he abandoned an attempt to list them chronologically, claiming that the order of their execution did not matter.[51] Titian, moreover, could be easy to deal with.[52] His wit is proved by his promise to paint all the Farnese, even their cats.[53] Charles V so enjoyed his company that he had his apartment placed near his own in Augsburg so as to facilitate secret and frequent meetings.[54] Courtiers were alarmed by the extent to which Charles took Titian into his confidence, deeming it unseemly that an artist should be

so privileged.[55] Such conversations helped to animate sitters and it is significant that one of Titian's few reported failures concerned a teenage archduchess who got bored while posing.[56]

Titian knew who to oblige and when. He offered to retouch portraits judged unsatisfactory. He travelled to Bologna in a heatwave to portray Cornelia Malaspina, a maid of honour beloved by Charles V's secretary, Francisco de Los Cobos.[57] In Rome he copied Raphael's *Pope Julius II* (National Gallery) for his descendent the duke of Urbino.[58] He could do portraits quickly, although he was often slower with other works. It took only three days' labour to complete a portrait of Aretino for his publisher Marcolini,[59] but, according to a contemporary, he would not finish *Jacopo Strada* (cat. 38) until he got what he wanted, that is, Strada's help in passing off workshop products as autograph.[60] Titian was promised a fur as part of the deal and it is noticeable that Strada's seems about to slip off his shoulder.

Titian's portrait practice was founded on the support of a well-organised workshop which included family members, his son Orazio and cousin Cesare, who were both practised in the genre and could accompany him on portrait missions.[61] In Augsburg in 1548 Titian claimed expenses for a team of seven.[62] He was thus able to meet the demand for replicas and versions and sometimes after only very preliminary sketching-in would delegate completion to a reliable assistant.[63] Some indication of Titian's practical experience is provided by his criticism of a sculpture of Hannibal sent by the duke of Urbino to serve as a prototype. He objected to an arm covered by a shield, dismissing it as a labour-saving device.[64]

Titian's outstanding quality was his ability to produce a convincing likeness, and, through choice of pose and attributes and by the allocation of exactly the right amount of surrounding space, to arrive at a decorous yet perceptive characterisation. His art is not based on repetitive formulae. Deeply interested in individual appearance and specific optical effects, he varied his touch, the size and direction of his brushstrokes, according to the scale, intended location and tastes of the patron. His compositions were tailor-made for each sitter and, except in workshop replicas, not repeated.

These powers of characterisation are fully demonstrated in the portrait of *Jacopo Strada* (cat. 38), whom he disliked and regarded as a charlatan. He was in Venice to try to buy antiquities from the Vendramin collection, and in Titian's portrait is made to look like a salesman dealing on the side. He manhandles a *Venus*, whose *pudica* gesture is wittily cancelled out by his hand clamped on her breast. As a shady character, he has an exceptionally heavy *chiaroscuro* on his face. His crowning achievement, his works on numismatics (a mixture of erudition and nonsense), are significantly placed above his head. His social ambition is emphasised by Titian's late decision to flatter him by doubling the loops of his chain.[65]

Concluding a letter to Charles V's minister Granvelle, Titian declared himself 'your perpetual slave'.[66] Such obsequiousness was customary in his correspondence with high-ranking patrons, whom in his portraits he flattered by subtler means. One prime example is the toning down of Charles V's disfiguring lantern jaw by soft focus. This idealisation can be observed developing in slow motion by comparing Titian's Prado *Charles V standing with his Dog* (fig. 20) and Jacob Seisenegger's portrait in Vienna which he was required to follow. Titian magnified his lord by broadening and elongating his body, and his image carries greater conviction because he better understood the details of his dress – for instance, the weight of the Order of the Golden Fleece determines the hang of the supporting ribbon.[67]

Avoidance tactics were often part of the idealisation process. Aretino's hands were

badly slashed in an assassination bid. In Titian's portraits they are gloved, clenched or omitted.[68] Women then as now liked to look young. At the request of the sixty-two-year-old Isabella d'Este, Titian painted a rejuvenated, retrospective image based on a portrait by Francesco Francia made some thirty years earlier, which in its turn was based on an even earlier portrait.[69] *Philip II* (cat. 30), who was puny in life and no military hero, is transfigured by light from the left, which gives him an aura and hints at a halo. The perspective of his right arm is deliberately distorted to strengthen his claim to the helmet, while the colossal base of the pillar stands in for a palace and for the columns of Hercules, which were a Habsburg *impresa*.[70]

Titian was armed with many devices that enabled him to manipulate facial expression. He may over-foreshorten a nostril, enlarge eyes or break the curve of an arched eyebrow. He was susceptible to the beauty of spread fingers, to the gleam on a gold chain, and good at handling receding hairlines. He swiftly exploited the opportunities presented by changing fashion, for example one for lower-necked shirts, which added allure to glances over the shoulder and turning heads and invited comparisons between the texture and colour of linen and warm flesh.

Contemporaries found his portraits not only like but alive, for he could create the illusion that some sitters approximating the scale of life could see the viewer and respond. 'La Schiavona' (cat. 4) looks pleased and affable but *A Man with a Quilted Sleeve* (cat. 5) seems disdainful, his sleeve edging over the ledge so that he emerges from shadow as though by chance. Like many of Titian's compositions this seems inevitable and natural, and yet the basic triangle of the pose, which is echoed in analogous smaller shapes, required great artifice, as did the simulation of padded silk and the suggestion of the whole hand by the sight only of the small fingerless part.

That Titian was expert at conveying rank is demonstrated in *D'Armagnac and Philandrier* (cat. 22). The servant looks up to the master, hanging on every word, and social distance is achieved literally by the cancellation of his once overlapping sleeve.[71] If it is he, Gabriel Vendramin (in cat. 29), as the patron, is appropriately nearest to heaven and the miraculous relic. His hand proprietorially grasps the altar, his gesture allowing the display of the wide dogal sleeve indicative of his nobility, wealth and (according to both Italian Renaissance and modern parlance) generosity.[72] *Nicolò Zen* (cat. 39), aristocratic holder of many prestigious offices, turns energetically while fingering his stole, the unmistakable attribute of high political status.[73]

Immensely flexible, Titian adopts different standards for noble children, who may play with pets or, like a young Vendramin, wear stockings that wrinkle. Even a pope's grandson, the twelve-year-old *Ranuccio Farnese* (cat. 25), in a portrait

FIG. 20

TITIAN
Charles V standing with his Dog, 1533
Oil on canvas, 192 × 111 cm
Museo Nacional del Prado, Madrid, inv. 409

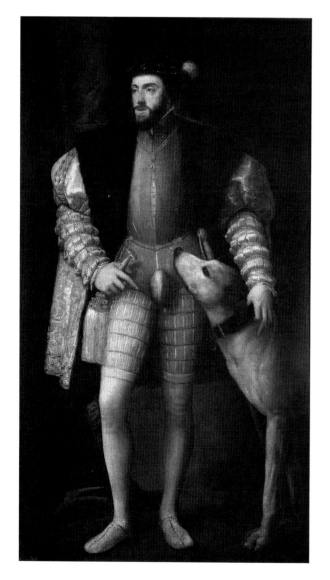

destined for his mother, appears all sweetness and light and a little shy, so different from his younger brother Orazio, who swaggers with hand to sword in his more conventional portrait by Jacopo del Conte in the National Gallery.[74] In 1542 Titian also painted the two-year-old *Clarissa Strozzi* (cat. 24) – too young for character but charm incarnate. He makes it look as if she believes that her dog is his real subject. Her small size is advertised by the full-length format, an exception among Titian's female portraits. Suitable for a child whose granny was a Medici and to whose father Michelangelo presented his *Slaves* is the fictive relief with Donatellesque putti. The grandiose setting would have appealed to her exiled parents, who always hoped to return to their magnificent Florentine *palazzo*.[75]

Titian's fame generated a demand for his own image. However, he was more often portrayed by others – by artists as different as Cranach and Veronese – than by himself.[76] Titian was not narcissistic, nor has it been proved that he practised on his own features.[77] Several art historians have recently claimed that his Berlin *Self-portrait* (cat. 28) was deliberately left unfinished and that the uncompleted hands are a manifesto of *non-finito*, an attribute of his art, but it is more likely

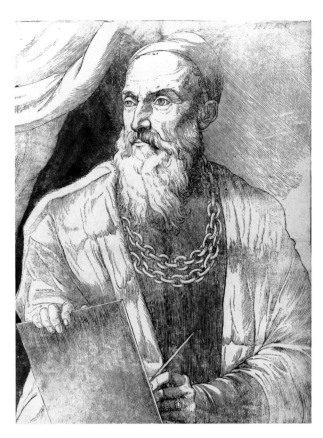

either that he was dissatisfied with the awkward, under-occupied pose or that he had neither time nor the financial incentive to finish the portrait.[78] At this period a Venetian doctor, Nicolò Massa, questioned Titian about his erratic application to work and frequent devotion to pleasure. Titian admitted that sometimes, following a good day, he felt insufficiently inspired to paint.[79] It is just possible that the Berlin *Self-portrait* reflects this side of his temperament. Old age and ageing are a regular theme in Titian's correspondence and in patrons' reactions to him,[80] and it may be no accident that he is only recognisable when he is quite old and his image was highly consistent. His skullcap and the chain awarded for portrait services rendered appear almost like trademarks.

Titian painted himself on request. Vasari saw a portrait done for his children.[81] For Gabriel Vendramin, who collected drawings, self-portraits and antiquities, he provided a workshop piece tailor-made to reflect those interests, a tondo in which he appears drawing, backed by a statuette of Venus.[82] Also, as a means of self-advertisement, when Philip II was still regent Titian presented him with a small picture of himself holding a portrait of this prince who was to become his most important patron. It was hung with the royal portraits in the Pardo Palace, where fire destroyed it in 1604.[83] Its appearance is reflected in a medal attributed to Agostino Ardenti, in which Orazio replaces Philip. In a prefiguration of the *Allegory of Prudence* (cat. 34), the artistic son and heir, at one with the light and the lion, takes centre stage while Titian himself, cadaverous, only half his face visible, recedes into shadow. His honorific red signals his high status and identification with *colore*. Inspired by consecutive symbolical illustrations in that most beautiful of all Venetian Renaissance books, the *Hypnerotomachia Poliphili*, Titian hopefully sets himself in a context, as the founder of a

FIG. 22
PIETRO ANTONIO NOVELLI
(1729–1804)
*The Emperor Charles V stoops
to pick up Titian's paintbrush*
Pen, ink and wash,
35.8 × 48.7 cm
Private collection

Venetian family firm that may endure for generations.[84]

Around 1550 Titian was the first Venetian painter to see his image appear in print, in a woodcut executed by Giovanni Britto, a German (fig. 21). This very large engraving was to have a sonnet by Aretino appended, which named Titian's most important living sitters. The reversal of the design in the printing process resulted in Titian looking left-handed, which probably accounts for the small number of surviving impressions.[85] Titian managed his publicity better when he included himself in a print after his Prado *Gloria*, made by Cornelis Cort under his personal supervision. While he was doubtful about the propriety of including non-royals in the altarpiece of the *Gloria* itself – like ambassador Vargas, who had demanded insertion – he had no qualms about featuring in an engraving designed to boost his international reputation.[86]

In contrast, the Prado *Self-portrait* (cat. 33) is non-virtuoso, private and austere. The archaic profile, chosen for its commemorative associations, concentrates our attention upon the artist's absorption in the creative act. In Antonio Persio's account of the aged artist at work he is described as lost in inspiration before the model.[87] When Vasari met Titian for the last time in 1566 he appeared brushes in hand and painted.[88] It is significant that his portrait was made at a time when doubts were expressed as to whether he had the desire or capacity personally to execute commissions.[89]

Titian's image has played an important role in his immortality. The Prado *Self-portrait* once belonged to Rubens, whose many copies of destroyed Habsburg portraits has preserved knowledge of their appearance for posterity. It was bought from his estate by Philip IV to hang in the Alcázar, together with so many of Titian's masterpieces.[90] Its impact was felt in England in the nineteenth century, when George Frederick Watts modelled his actual appearance and his last self-portrait upon it.[91] In the 1950s the American Ben Shahn, fascinated by the indivisibility of form and content in the *Allegory of Prudence* (cat. 34), caricatured himself in his drawn homage.[92] More recently the playwright Alan Bennett, intrigued by a triple portrait in the Royal Collection representing Titian, Andrea dei Franceschi and the special friend (mentioned above) produced an art historical 'whodunnit' entitled *A Question of Attribution*.[93]

Titian's reputation as a master portraitist was established in his own lifetime. In September 1533 Charles V's ambassador in Venice tried unsuccessfully to persuade the doge to grant Titian leave of absence by arguing that while other painters could complete the narrative cycle in the Great Council Chamber only Titian could adequately portray the emperor.[94] In the following century Titian's prestige continued to grow and in his life of the artist published in 1648 Carlo Ridolfi first related that much illustrated, artists' status-boosting anecdote in which Charles V stooped to pick up Titian's brush (see fig. 22).[95] Fiction apart, during the seventeenth century the break-up of so many major collections in Venice and the dispersal of the art treasures of the Este and Gonzaga spread knowledge of Titian's portraits even further afield, while great portraitists such as Rubens and Velázquez were painting Habsburgs directly descended from Titian's sitters.[96] Rubens's equestrian *Philip IV* was hung alongside Titian's equestrian image of his great-grandfather in Velázquez's re-hanging of the Hall of Mirrors in the Madrid Alcázar.[97]

Van Dyck's passion for Titian emerges from his British Museum *Sketchbook*, which shows him hunting down Titian's works in Italy. On his drawing after *Jacopo Pesaro being presented to Saint Peter* (cat. 3) he made several notes on the colours.[98] In England Van Dyck worked for Charles I and the Whitehall group which favoured the Venetian style, and he formed his own collection of Titian's works, among them some twenty portraits, including *The Vendramin Family* (cat. 29) and *A Man with a Quilted Sleeve* (cat. 5).[99]

As the international art market became increasingly competitive, ambitious owners, abetted by cunning dealers, invented new, more famous identities for many Titian sitters. For example, by 1671 *Georges d'Armagnac with his Secretary* (cat. 22), which so deeply influenced Van Dyck's *Earl of Strafford with Sir Philip Mainwaring* (fig. 23), had become the Earl of Northumberland's '*Duke of Florence and Machiavel*'.[100] Captions on a growing volume of reproductive prints fostered the belief that Titian was erotically involved with his painted women. His *Flora* (cat. 11), upon which Palma Vecchio modelled his more vulgar National Gallery *Blonde Woman*, also inspired several paintings by Rembrandt, including the National Gallery's *Saskia van Ulenborch in Arcadian Costume*.[101] Titian's *Flora* was a type, not a portrait. She may have started off as a not so plain nymph, for she is first christened 'Flora' in a

FIG. 23
ANTHONY VAN DYCK
(1599–1641)
Thomas Wentworth, Earl of Strafford, with Sir Philip Mainwaring, 1639–40
Oil on canvas, 123.2 × 139.7 cm
Credited to the Trustees of the Rt. Hon. Olive, Countess Fitzwilliam's Chattels Settlement, by permission of Lady Juliet Tadgell

seventeenth-century print by Sandrart which spells out Titian's attraction to his subject in Latin verse. This may have prompted Rembrandt's use of his wife in his interpretations, although he also saw the original in Alfonso Lopez's Amsterdam collection, together with *A Man with a Quilted Sleeve*, on which he based his National Gallery *Self-portrait at the Age of Thirty-Four*.[102]

Responses to Titian in England were shaped by the fact that portraits were the dominant national artistic product and by a proliferation of treatises on how to paint them, participating in the growing concern with physiognomic expression and 'the speaking likeness'. These fuelled curiosity as to how animation might be technically achieved.[103] Reynolds's scraping-down of paintings is notorious, and this search for 'the Venetian Secret' culminated in the scandal satirised in Gillray's 1797 *Titianus Redivivus*, which mocks the Royal Academy's purchase of a manuscript purporting to be a copy of a Venetian Renaissance painting manual – the property of a Miss Provis, a miniaturist who demonstrated 'the Titian Shade' to Benjamin West and is shown in the print daubing a hideous portrait of Titian.[104]

It is fitting that in this exhibition so many fine portraits should be brought together in a gallery that houses so many examples of their influence. It is good to see back in the capital *Georges d'Armagnac with his Secretary* (cat. 22), before which Inigo Jones almost knelt in adoration in Buckingham House,[105] and *Philip II* (cat. 30), 'great king of England', who soon after his marriage to Mary Tudor obtained his first view of Titian's *Venus and Adonis* in London.[106] But most moving of all is the image of the elderly Titian so treasured by Rubens (cat. 28), for it confirms the truth of Aretino's verdict that Titian grasped the essence of things through painting: '*il senso de le cose ha nel pennello*'.[107]

TITIAN AT WORK

JILL DUNKERTON

TITIAN'S PAINTING TECHNIQUE

MIGUEL FALOMIR

TITIAN'S REPLICAS AND VARIANTS

INTRODUCTION Titian's technique has long fascinated artists and commentators on painting; even in his own lifetime it was more widely discussed than that of any other painter. By the eighteenth century it was so admired, yet so little understood, that Sir Joshua Reynolds is supposed to have taken a Titian that he owned and scraped it down layer by layer so that he could rediscover its 'secrets'.

Modern techniques of scientific analysis and examination are able to reveal Titian's particular methods as never before, while demonstrating that his materials were no different from those used by other sixteenth-century artists. By the late fifteenth century, when Titian was training as painter, drying oils had become the principal medium for working on both panel and canvas. In Venice canvas was already widely used as a support, both by Gentile and Giovanni Bellini and by Carpaccio. When working on canvas these painters generally employed relatively straightforward methods, using thin paint layers and simple paint structures, glazing with translucent pigments being restricted to deep shadows and specific colour effects. A more elaborate build-up of glazes can sometimes be seen on panel paintings of the period, especially those by Cima da Conegliano, whose glazing technique may have influenced that of the young Titian. Whether on canvas or panel, boundaries between different colour areas were carefully defined by underdrawing, and retained in the course of painting.

Most of Titian's pictures in this exhibition are on canvas, although he also used wooden panels, both for altarpieces such as the great *Assunta* (*Assumption of the Virgin*) in the Frari, Venice, and for the smaller *Madonnas* (for example cat. 1) and secular furniture paintings which he painted early in his career. Later on he also experimented with slate and polished-marble supports. He probably procured his linen canvas from specialist merchants who may well have supplied sail-makers as well – certainly Titian could obtain a wide range of textiles of different weights and weaves (see below, p. 52). They must have been stretched by nailing them to wooden strainers, but unfortunately they have all long since been separated from their original strainers as a result of the need to reinforce the decayed old fabric by backing it with new canvas. Over the centuries this process, known as lining, may have been repeated several times, often causing damage to the paint layers and surface texture of the picture.

In common with most sixteenth-century painters, Titian first prepared his canvases with a thin layer of gesso, no more than was sufficient to fill the interstices in the canvas weave; too thick a layer might crack and would fill in the textured canvas weaves that Titian seems to have sought out, especially in the later part of his career. In some of the earlier canvases a second preparatory layer, known as a priming or *imprimitura*, was applied, mainly to prevent the ground from absorbing too much oil from the paint layers, but later Titian seems to have abandoned this practice, choosing to paint directly on the gesso.

Analysis of samples shows that the oil Titian preferred was linseed oil, although he also occasionally painted with walnut oil, which was the oil in more common use among Italian painters of this period. Sometimes the oil was thickened by heating, accelerating the rate at which it set (or 'dried'), and small amounts of pine resin might be added to glazes – again normal practice at the time.

TITIAN
Tarquin and Lucretia, 1569-71
(detail of cat. 36)

FIG. 24

A Cross-section prepared from paint samples taken from *Bacchus and Ariadne* (cat. 13), showing overlapping paint layers where Ariadne's vermilion scarf was painted over her arm, which in turn overlaps the azurite blue of the sea (see D). At the bottom of the sample is the gesso ground.

B Detail of Joseph's head from an infra-red reflectogram mosaic of *The Holy Family with a Shepherd* (cat. 2)

C Detail of Joseph's head from an X-radiograph of *The Holy Family with a Shepherd*

D Detail of Ariadne from *Bacchus and Ariadne* (cat. 13)

E Detail of *The Tribute Money* (cat. 32)

F Detail from an X-radiograph of *The Tribute Money*

Titian's rich and colourful palette owed much both to the wealth of his patrons and to Venice's position as centre of the pigment trade in Italy. There are many documented cases of painters sending to Venice for colours (including Titian himself when working away from home; see p. 36), and such was the importance of painting and associated crafts in the city, that by Titian's time it had become possible to buy painting materials from specialist colour suppliers instead of the general apothecaries operating elsewhere in Italy. In Venice he could procure the finest and most costly grades of ultramarine (ground and refined lapis lazuli, imported from what is now Afghanistan) for use on paintings for dukes and kings, for example *Bacchus and Ariadne* (cat. 13; fig. 24A and D), *The Entombment* (cat. 31) and *The Tribute Money* (cat. 32; fig. 24E), as well as best-quality azurite (often known as German blue), brought in by German traders from across the Alps. Other mineral pigments to be imported included the yellow and orange arsenic-based colours, orpiment and realgar, much favoured by Venetian painters and used to vivid effect by Titian on many works, among them *Bacchus and Ariadne* and *The Holy Family with a Shepherd* (cat. 2). Pigments were also manufactured from imported raw materials, and Venice was well known for the quality of its vermilion, lead-tin yellow (one type of which was associated with glassmaking) and especially its lead white. The existence of an extensive dyeing industry meant that painters were able to obtain the best and most intensely coloured red lakes, pigments prepared from dyestuffs used in the production of luxury textiles. In oil these lakes formed sumptuous glazes, which could be built up to achieve a translucent depth of colour like that of stained glass. These red lakes, together with other translucent pigments, including green glazes based on verdigris, were essential to Titian's technique.

Cross-sections prepared from paint samples can reveal many paint layers (fig. 24A), although these are usually the result of Titian's overlapping of different colour areas rather than evidence of a deliberately complex technique. Although he seems always to have roughly indicated the outlines of his figures with an underdrawing (fig. 24B), even in early works he took little care to paint round these outlines: the broad horizontal strokes used to brush in the sky in the *Holy Family*, for instance, can be seen in an X-radiograph to encroach well into the area designated for Saint Joseph's head (fig. 24C). He also frequently made radical changes to the design, visible in X-radiographs when the paint of the covered-over earlier versions contains lead white and other pigments opaque to X-rays. In the X-radiograph of *The Tribute Money* (fig. 24F) the head of the Pharisee appears dark and shadowy; little lead-white pigment is present because it was thinly painted, the colours almost rubbed into the canvas, and few adjustments were necessary. Christ's head, on the other hand, appears as a white mask. This is because it was first painted inclined to the left and then changed to a more upright position. Also his face is turned to the light and so the flesh tints contain more lead white. The figure becomes sterner and more imposing, but the alteration preserves the moment of engagement between two figures, always a preoccupation of Titian's and often one that underlies the revisions that he made to his designs.[1]

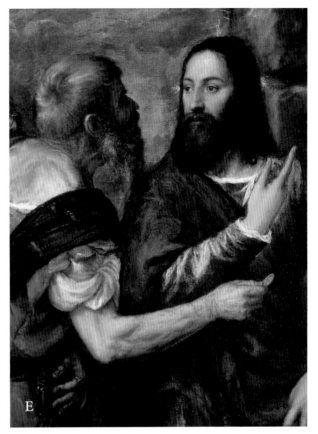

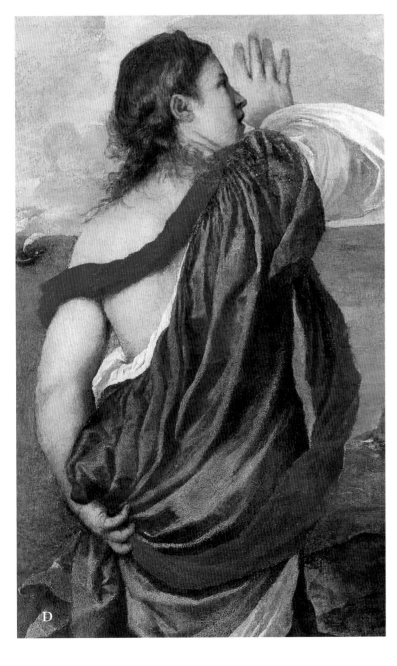

THE HOLY FAMILY WITH A SHEPHERD (cat. 2), in common with most other early works by Titian, is painted on a fine tabby (or plain) weave canvas. The canvas was prepared with a thin layer of gesso, followed by a priming of lead white in oil. A small amount of lamp black pigment was added to the priming, resulting in a dirty white colour, just visible at the left edge in the area around the head of the ass. By the second decade of the century several North Italian painters were beginning to work on tinted and coloured painting surfaces; Titian used a darker, more definitely grey priming for *Jacopo Pesaro being presented to Saint Peter* (cat. 3), a work which, following its recent cleaning and technical examination, can be dated shortly after the *Holy Family*.

Titian began the *Holy Family* by sketching the figures with broad lines of liquid black paint. He drew the heads in some detail, the eyes and direction of gaze indicated by solid black irises (fig. 25B); other forms were roughed in with rapid strokes, including the position of Joseph's right hand supporting the Child, even though it is covered by his legs and feet.

Many details of the design, however, were far from resolved at the underdrawing stage, and in the course of painting Titian made many changes. Initially he painted the Virgin's head in its underdrawn position – originally more in profile and not so tilted – but then changed it to the present pose. Joseph's head was first drawn slightly lower, and he had more hair (fig. 24B); in spite of the alterations, his head is still not convincingly attached to his shoulders. The folds of his orange mantle have also been altered: previously his knee was exposed and more drapery fell to the left (fig. 25C). Titian seems to have had most trouble with the shepherd, developing much of the pose while painting. As he repositioned the figure he made bold marks with lead white paint (revealed by X-rays), for example around the back of his head and across his shoulders.

The shepherd's barrel was an afterthought, painted over the creamy white of his breeches (fig. 25D). In painting the white textiles Titian relished the buttery texture of lead white in oil (here the paler, less yellowing walnut oil, while the other colours are all in linseed oil), contrasting broad strokes of thick paint with precisely observed detail such as the strained and gaping seams of the breeches. The white is set against rich, deeply glazed colours, although some have suffered from the effects of time and past restorations. The final red lake glaze on Joseph's purple tunic is faded and worn; originally it would have better balanced the intense orange of his cloak (based on an orange-red earth, modelled in the highlights with realgar and a little orpiment; fig. 25A). The lake of the Virgin's dress is also likely to have faded and her ultramarine mantle now appears blanched, especially in the shadows. The copper green glazes of the landscape and foliage, however, have retained much of their original brilliance; where the glazes are brown, as on the path in the foreground (fig. 25E), they were always so, for they were painted using a softwood pitch (a by-product of charcoal-making) in linseed oil. This forms a translucent brown glaze, quite commonly seen in Venetian painting but often in damaged condition; here it is so well preserved that the print made by Titian's fingers when he blotted the glaze can still be seen.[2]

FIG. 25

TITIAN
*The Holy Family with a
Shepherd*, about 1510
(cat. 2)

A Cross-section of a sample from Joseph's cloak showing an orpiment highlight over a layer consisting mainly of red earth. The black particles below this probably represent underdrawing on the greyish-white priming (the gesso layer is missing from the sample).

B Detail from an infra-red reflectogram mosaic

C Detail from an X-radiograph showing Joseph and the shepherd

D Detail of the shepherd's barrel

E Detail of plants in foreground

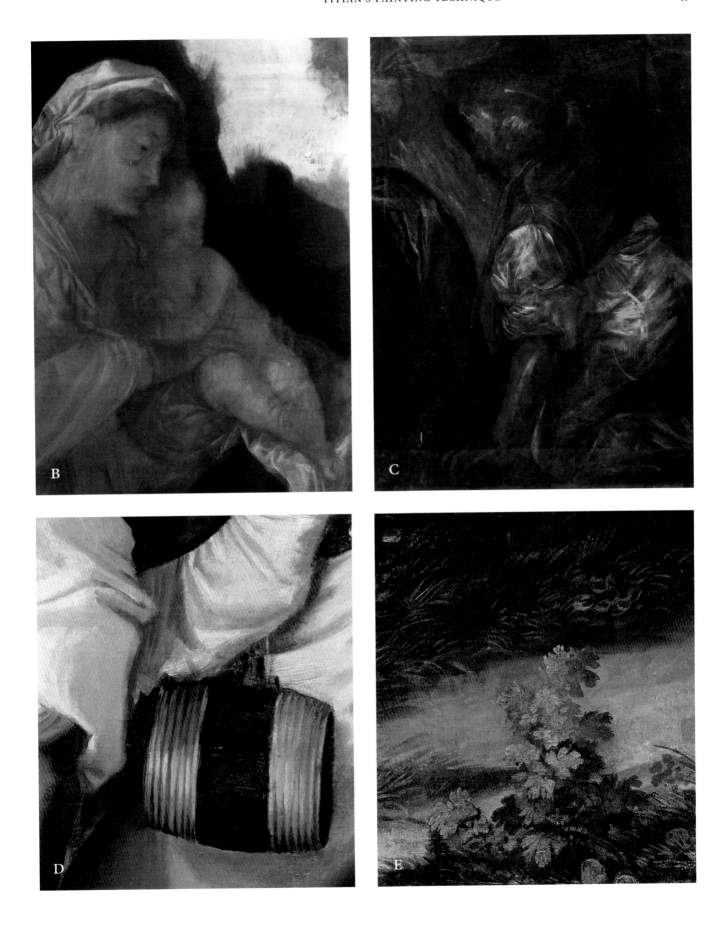

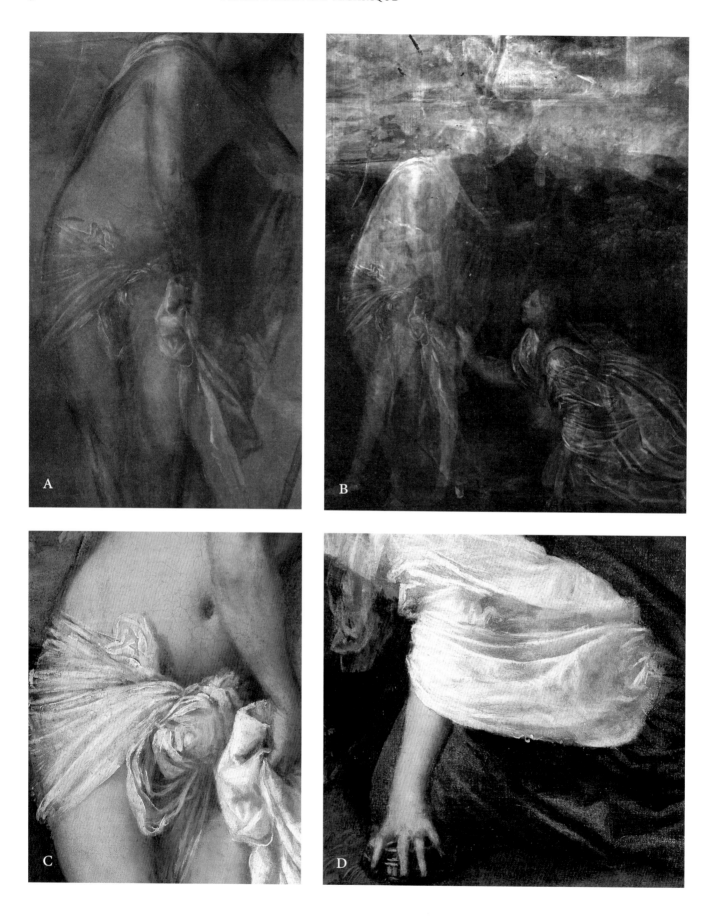

NOLI ME TANGERE (cat. 7), of about 1514, one of the most delicate and refined of all Titian's works, was painted on a canvas with an appropriately fine and regular tabby weave. It was prepared with a thin layer of gesso, and if any priming is present it is likely to be thin and light in colour.

Titian must surely have developed the complex poses of the figures and their relationship to one another through many preliminary sketches and studies on paper. With cursory, freehand strokes he then drew the principal elements of the design on to the prepared canvas. The lines are finer than those to be seen on the larger-scale *Holy Family*, but are equally rapid and fluent, whether describing the curves of Christ's back, hip and thigh (fig. 26A) or establishing the position of a bush with a scribbled flourish. Any details such as the extremities of figures were left incomplete, either because Titian was confident in his ability to paint without such guidelines, or because he wanted to refine them during painting, perhaps even after making additional studies on paper. For example, Christ's right hand and forearm are only roughly indicated in the underdrawing, and their appearance in the X-radiograph (fig. 26B) suggest that Titian may have determined their exact arrangement only as he painted.

The X-ray image is dominated by a significant change to the design. At first Titian painted a hill crowned with buildings on the left side of the composition. In places the vertical edge of a building or the slope of a pitched roof can be distinguished, but only with difficulty, because Titian obliterated this first version with a layer of lead white paint. The loops and curves to be seen in the X-radiograph at the lower edge of this cancellation layer (approximately level with Christ's shoulders) indicate that it was probably applied using some form of palette knife rather than a brush – the grey priming on *Jacopo Pesaro being presented to Saint Peter* (cat. 3) seems also to have been applied with a knife. In making the correction Titian may have wiped the surplus paint from the knife across the lower part of the picture, resulting in the strange white shapes in the X-radiograph which, in the past, have been misinterpreted as an earlier position for Christ's legs.

In order to achieve a perfect balance between figures and landscape further adjustments were made to the tree, which once had an extra branch to the right. It has been suggested that its leaves, and other areas of foliage in the picture, have been affected by the tendency for copper green glazes to turn brown. However, examination of the brown leaves under magnification shows that the main pigment present is a red-brown earth and that only small amounts of green pigment were added to the mixture.

Titian displays his mastery of the optical properties of lead white oil paint in his depiction of white fabrics, every one of a different weight, ranging from the heavy linen of Christ's grave cloth through the finer and more diaphanous fabrics of the Magdalen's sleeves and Christ's loincloth (figs. 26C and D) to the translucent wisp of the Magdalen's scarf. Her crimson dress was glazed over a pale pink or white underlayer using a red lake, applied thickly in the shadows and thinly over the highlights. Although fading and damage may now exaggerate the unevenness of the glaze, its tendency to accumulate in the depressions of the canvas weave gives a soft vibrancy to the colour, an effect that Titian was to exploit more fully in later paintings.[3]

FIG. 26
TITIAN
Noli me tangere, about 1514
(cat. 7)

A Detail from an infra-red photograph

B Detail from an X-radiograph

C Detail of Christ's loincloth

D Detail of the Magdalen's sleeve

THE VENDRAMIN FAMILY VENERATING A RELIC OF THE TRUE CROSS. By the 1540s Titian had increasingly come to favour canvases of a rougher, more marked texture than the finely woven linens used for his earlier works. For *The Vendramin Family* (cat. 29) he chose an unusual canvas with a complex twill weave (fig. 27A), which forms a diamond-shaped pattern like that sometimes seen in depictions of damask tablecloths in paintings of subjects such as the Last Supper. One of the advantages of these damask weave canvases seems to have been their size: they were woven on looms double the width of those used for other canvases, which would have had to be sewn together for a painting of these dimensions. The canvas was prepared in the usual way with a thin layer of gesso, but Titian omitted to apply a second over-all priming, partly perhaps because he did not want to suppress the texture of the canvas weave, but also because a slightly absorbent support seems to have come to suit his technique.

The underdrawing in *The Vendramin Family* is characteristically bold, and the present transparency of the paint of Andrea Vendramin's cloak means that the black lines of the figure's covered-over legs, sketched in so as to establish his pose on the steps (fig. 27B), can be seen with the naked eye as well as in infra-red. Although the painting of the central figures more or less followed the underdrawing, several subsequent revisions were made to the figure groups comprising the younger members of the family (see further p. 146).

The surface of this painting has been much flattened and damaged by past conservation treatments, and the sky in particular is badly abraded. Nevertheless some of Titian's original breadth and boldness of handling survives, for instance in the impasto of the candles and reliquary on the altar, and in the thickly applied glazes of pure red lake and red lake mixed with ultramarine used for the crimson and purple (*pavonazzo*) cloaks worn by Andrea Vendramin (fig. 27C) and the older man to his left (still not identified with certainty – see p. 146). In places these glazes are so thick and rich in oil that they have dried badly, wrinkling and cracking, a problem exacerbated by Titian's use of walnut oil as a binder for all the colours in this picture, for it does not dry as well as the linseed oil that he more commonly employed.

When a brushstroke is made with a quick light touch over a layer of oil colour that is already dry, the fresh paint, especially a stiff paint containing lead white, may be slightly re-pelled by the underlying layer. This results in a so-called 'broken' brushstroke, in which the underlying colour shows through the breaks in the upper paint film. A coarse canvas texture will also allow the brush to skim across the tops of the canvas weave to lively and vibrant effect. Titian exploited these broken textures for the painting of fur in *The Vendramin Family*, for example the linings of the cloaks (fig. 27C) and the fluffy ears of the little dog held by the youngest child (fig. 27D), where they contrast with the the creamy impasto of the highlight on the dome of the dog's skull.

FIG. 27

TITIAN
The Vendramin Family vener-
ating a Relic of the True Cross,
about 1545–55 (cat. 29)

A Detail of canvas weave,
actual size

B Detail from an infra-red
reflectogram mosaic

C Detail of lining of fur cloak

D Detail of dog

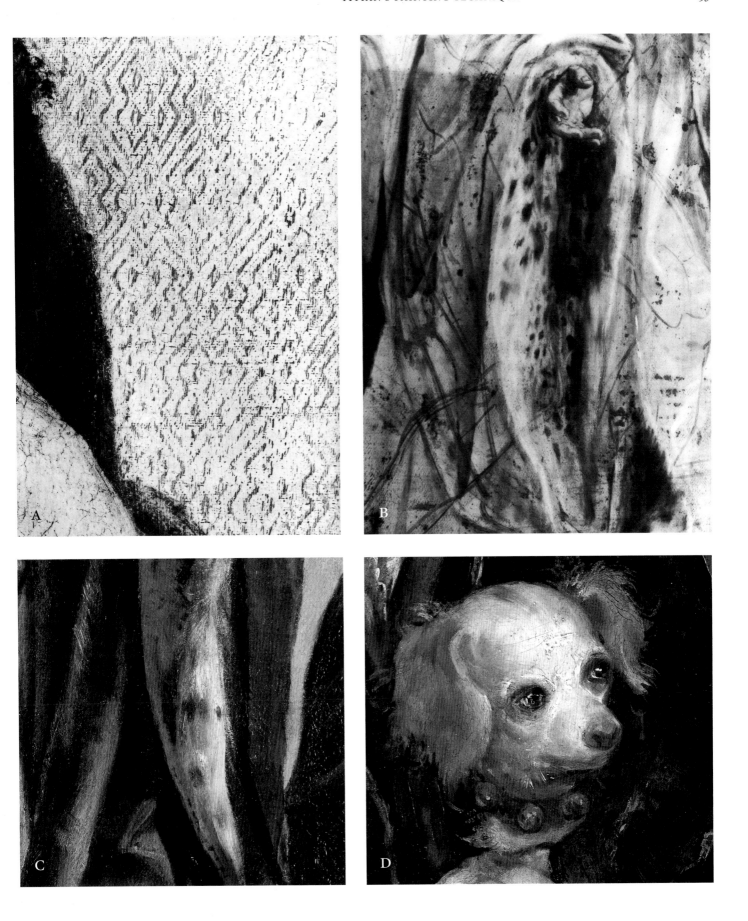

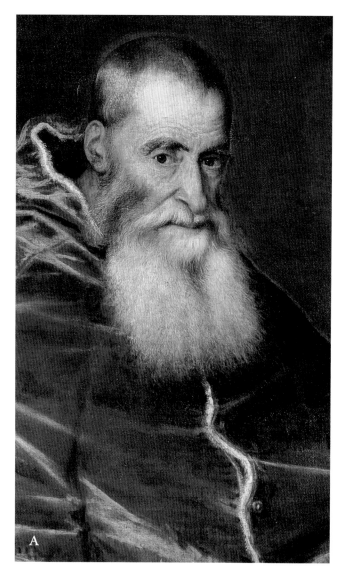

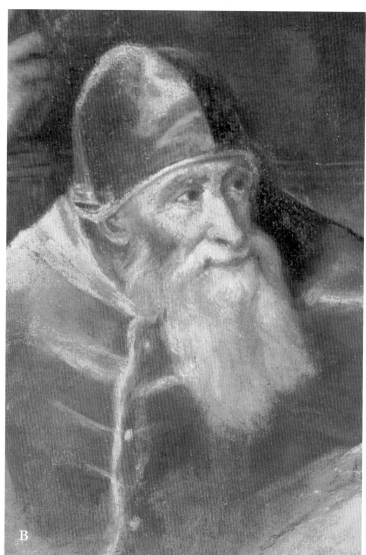

POPE PAUL III (cat. 26), painted in 1543, therefore close in date to *The Vendramin Family* (see previous page), was a smaller-scale work and intended for more intimate viewing. The canvas is a medium-weight diagonal twill. The pope's head and hands (fig. 28A, C and D) demonstrate how Titian could paint delicate and carefully observed detail; many of the hairs of the pope's beard and bushy eyebrows were depicted with individual strokes made with a fine brush.

Evidence of the way Titian built up the paint layers of this highly refined work can be obtained from his unfinished portrait of the same sitter with his grandsons, Alessandro and Ottavio Farnese, painted in Rome over the winter of 1545–6 (figs. 62, p. 138, and 28B). However, even if it had been completed, it is unlikely that Titian intended to work up this larger-scale painting to the same level of finish as the earlier portrait; more probably it would have resembled *The Vendramin Family* in this respect. Indeed *Pope Paul III with his Grandsons* is painted on a canvas with the same damask weave as the Vendramin picture, and it may even have been cut from the same roll of fabric (the two paintings are also close in height, corresponding to the width of the canvas roll).

In the unfinished painting all the important elements have been blocked in over a broadly brushed underdrawing, still visible in many areas, demonstrating the economy of line with which Titian described the structure of forms such as the pope's left hand and wrist (fig. 28E). Missing from the painting are final details such as the short strokes of white which would indicate fur lining, here left as rapidly brushed stripes of white along the edges of the red *mozzetta* (fig. 28B) and, above all, the glazes. Nevertheless the modelling of the *mozzetta* was already established, using a light, opaque red, probably a mixture of vermilion, red lake and lead white, and the highlights have been placed with bold zigzags of almost pure lead white. A similar underpainting must be present for the *mozzetta* in the finished portrait (fig. 28A), although it has been given rather more detail by such touches as the little dashes of pink or white paint that indicate the puckering of the shoulder seam. The whole area of the *mozzetta* was then overlaid with a red-lake glaze, thinly covering the highlights (and here it may have faded slightly) and built up to an opulent intensity in the shadows. At the lower edge Titian took a brush loaded with lake and applied vertical dabs of glaze which suggest wonderfully the texture of the thick velvet. Along the right edge of the *mozzetta* the red glaze has bled slightly out over the paint of the background; this was almost certainly intended, for the contour gains a soft vibrancy. This practice anticipates the blurring of colour boundaries that was to become increasingly characteristic in Titian's later painting.

FIG. 28
TITIAN
Pope Paul III, 1543 (cat. 26)

A Detail of face and body

B Detail of *Pope Paul III with his Grandsons Alessandro and Ottavio Farnese* (fig. 62, p. 138)

C Detail of right eye

D Detail of outstretched hand of *Paul III* (cat. 26)

E Detail of hand of *Paul III with Grandsons* (fig. 62)

TARQUIN AND LUCRETIA. The support of the *Tarquin and Lucretia* in Cambridge (cat. 36), completed in 1571, consists of one large piece of canvas, approximately as wide as a normal loom (just under a metre), extended on the left with a narrower strip made up of two joined pieces, each cut from the width of the fabric roll so that no material was wasted. The weave is a medium to coarse tabby, distinguished by irregularities such as raised threads and slubs – Titian seems almost to have sought out canvases with such textures for his later paintings. The canvas was prepared with a simple layer of gesso, and no priming.

A characteristic brush underdrawing, made with a blackish-brown paint containing charcoal, is revealed in infra-red and can also be seen with the naked eye in some places, particularly around Lucretia's back and at the tops of her thighs. Here the paint is so thin and contains so little lead white that it barely registers in the X-radiograph (fig. 29A and B). The colour seems almost to have been rubbed into the canvas weave. Smears of the same greyish-brown flesh tint extend over the contours of her back on to the blue-grey paint of the pillow; the softened outline and the warm tint of the cast shadow give an impression of living flesh in motion.

Contrary to the belief that Titian's late works became more muted in palette, the colours are notably brilliant, especially the bright vermilion of Tarquin's stockings (fig. 29C), which contrasts with the purple red of his breeches, boldly underpainted with lead white in the highlights (very apparent in the X-radiograph) and finished with red-lake glazes. The dyestuff of the lake has been identified as kermes, the most costly and prized of all red dyestuffs (see also p. 36). The red is set against large areas of green (there is no blue, apart from small amounts of azurite added to some colours, for example to give a blue cast to the white linen). Although the greens were finished with the usual translucent copper-green glazes, they were underpainted with warm orange or red browns, modelled with dark green-brown mixtures in the shadows. This was probably to avoid the somewhat cold emerald and bottle-green hues that can result from underlayers based on verdigris. For the valance some of the pinkish brown underpainting was left exposed to suggest a shot-silk effect. The bedspread is decorated with blobs of white impasto, a technique similar to that used for a similar textile in *Jacopo Pesaro being presented to Saint Peter* (cat. 3), painted more than fifty years earlier.

To overlay colours in this way and obtain vibrant broken brushwork, it was necessary to allow each layer to dry before the next was applied. Palma Giovane, describing the aged painter at work, claimed that once he had laid in the composition he 'used to turn his pictures to the wall and leave them there, sometimes for several months'. Particles of dirt have been found trapped between the paint layers in samples from *Tarquin and Lucretia*, suggesting that such delays did indeed occur.

Titian himself described this painting as 'an invention involving greater labour and artifice than anything perhaps that I have produced for many years'. Although there are relatively few changes (the most notable being those to Tarquin's knife hand), he certainly worked hard on the detail, proving that he could still paint with delicacy and precision, above all in the depiction of Lucretia's tear-streaked face and her hand stretched in front of Tarquin's gorgeous gold-embroidered doublet (fig. 29B and D). *The Tribute Money* (cat. 32), sent to Philip II three years before *Tarquin and Lucretia*, includes passages of similar refinement. Other late works, however, have a very different finish.[4]

FIG. 29

TITIAN
Tarquin and Lucretia, 1569–71
(cat. 36)

A Detail from an
X-radiograph

B Detail of Lucretia's head and shoulder

C Detail of Tarquin's stockings

D Detail of Lucretia's hand

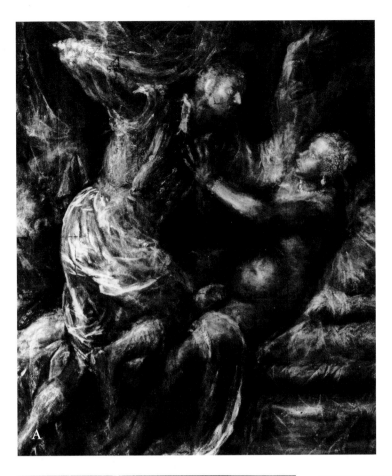

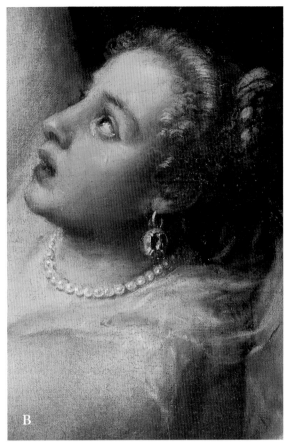

THE DEATH OF ACTAEON (cat. 37), a picture Titian had promised to Philip II, was probably still in his workshop when he died; certainly it remained in Venice, rather than being sent to Spain. In the 1630s it was described as 'not quite finished', but by then viewers may no longer have appreciated Titian's approach to the completion of this and other late canvases, including *The Flaying of Marsyas* in Kroměříž (fig. 63, p. 152) and the Vienna *Tarquin and Lucretia* (fig. 68, p. 162). The latter has often been compared with the Cambridge canvas, with the inference that Titian had not completed work on it. However, on the evidence of the X-rays, the underpainting of the Cambridge picture does not display brushwork of the agitated and precipitate character of the Vienna canvas, and so it would be wrong to assume that such paint handling was always intended to be refined in the later stages of execution. Moreover, paintings with passages of similarly 'unfinished' brushwork, for example the *Saint Jerome* in the Escorial (cat. 40), were definitely dispatched to their intended destinations; they must have been considered acceptable to their patrons. It seems to be the case, therefore, that in his last years Titian chose to paint with different degrees of refinement and finish.

The preparatory stages for *The Death of Actaeon* were conventional. The canvas consists of two widths of a fairly coarse twill-weave linen, joined vertically, with, for some unknown reason, a small triangular piece of canvas inserted at the top of the seam (the lower right corner of the original canvas is missing and a piece of coarse tabby weave canvas inserted there). A thin layer of gesso was applied and traces of a rough underdrawing are visible, especially in the more thinly painted areas of Diana's costume. Here the colours were applied sparingly, almost as though rubbed into the coarse canvas, the rose pink of her dress spreading over into the landscape to the right (fig. 30D). Changes to the position of Diana's arms are easily identified in X-rays, and much of this figure has been worked up to a level approaching that of Titian's more polished later works (some have credited this to a member of the workshop, improving the picture for sale after Titian's death, but assessment of this hypothesis is complicated by restorers' retouchings, especially around her face).

In the case of the hounds attacking Actaeon, however, it is impossible to disentangle the many alterations. The hounds that we now see emerge from a flurry of energetic brushwork visible in X-ray (fig. 30A), the paint perhaps applied with 'the large brushes, almost like brooms' recorded by a Spanish visitor to Titian's studio, and in places probably worked with the fingers, as reported by Palma Giovane. Indeed for much of the painting the traditional sequence of underpainting followed by glazes, still evident in *Tarquin and Lucretia* (cat. 36), no longer applies. Opaque and translucent colours overlap in random order (fig. 30E). Titian seems to have ranged over the whole surface, with at one moment a brush loaded with the acid opaque yellow (fig. 30B and C), with which he made the dry broken strokes of foliage, and the next with a more liquid red-brown glaze. One cannot claim that the painting is incomplete simply because of the absence of final glazes, as was the case with *Pope Paul III with his Grandsons*. The explosively vigorous plant in the foreground may indeed lack an intended glaze (although it would take more than a glaze to subdue this brushwork), but it is equally likely that, had Titian considered it to be over-prominent, he would have decided to paint it out, as he did in the case of the foliage at the base of the tree on the right. We know from Palma that while painting the elderly Titian used to examine his works 'with the utmost rigour, as if they were his mortal enemies' before setting about correcting them; the many changes made to the *Death of Actaeon* testify to this continuous process of critical appraisal.[5]

FIG. 30
TITIAN
The Death of Actaeon, about 1565–76 (cat. 37)

A Detail from an X-radiograph

B Detail of hound

C Detail of plant in foreground

D Detail of Diana's dress and water

E Cross-section of a paint sample from the right-hand tree showing alternating translucent layers of dark green and brown, interspersed with a discontinuous opaque layer of lead-tin yellow. A trace of gesso – discoloured, no longer white – is visible at the base of the sample.

REQUESTS TO AN ARTIST for versions, copies or replicas of existing compositions, whether the artist's own or another's, were both frequent and widespread during the Renaissance, and meeting the demand for them did not in any way compromise the reputation or status of a leading painter.[1] In this Titian was no different from Giovanni Bellini, who had evidently satisfied a considerable clientele through his workshop. In the course of his career dozens of replicas of varying quality and encompassing all genres emerged from Titian's workshop bound for different European cities. Together with engravings, they contributed decisively to the dissemination of his oeuvre. Traditionally these replicas, versions and copies have been studied mainly to determine the degree of Titian's participation in them, but their analysis reveals another side of the artist, who was able by their means both to paint for princes and to play a leading part in the widespread commercialisation of art in Venice.

Titian can be seen borrowing from other artists or repeating his own compositions from the time of his earliest works. The landscapes of three pictures in this exhibition dating from shortly after 1510, 'The Gypsy Madonna' (cat. 1), *Noli me tangere* (cat. 7) and the 'Sacred and Profane Love' (cat. 10), contain elements that recur between them and in other works by Titian, including his contribution to Giorgione's *Venus* (fig. 45, p. 86). 'The Gypsy Madonna' itself is an adaptation of Bellini's Detroit *Virgin and Child* (fig. 42, p. 74); X-rays have revealed that a composition much closer to Bellini's design was its starting-point. Again, Titian evolved from the figure of the Dresden *Venus* the work now known as 'The Venus of Urbino' (fig. 9, p. 19), and another version of the same composition dating from 1545 (possibly a lost

FIG. 31 (opposite above)
TITIAN
The Entombment, about 1559
(cat. 31)
Museo Nacional del Prado,
Madrid, inv. 440

FIG. 32 (opposite below)
TITIAN
The Entombment, about 1572
Oil on canvas, 130 × 168 cm
Museo Nacional del Prado,
Madrid, inv. 441

FIG. 33
Tracing (by Ana González)
comparing the outlines of cat.
31 (1559) in blue and fig. 32
(1572) in red

FIG. 34

TITIAN
'Lavinia' (Girl with a Fan),
about 1555
Oil on canvas, 103 × 88 cm
Gemäldegalerie Alte Meister,
Staatliche Kunstsammlungen,
Dresden, inv. 179

FIG. 35

PETER PAUL RUBENS
(1577–1640) after TITIAN
'Lavinia' (Girl with a Fan),
about 1603
Oil on canvas, 96 × 73 cm
Kunsthistorisches Museum,
Vienna, GG 531

Venus sent to Charles V) was the basis of a well-known series of '*Venus with a Musician*' pictures. In this exhibition two more comparatively early examples are the closely related compositions of the Louvre and the National Gallery *Virgin and Child with Saints* (cat. 18 and 19). Finally, the Magnani-Rocca *Virgin and Child* (cat. 9) turns up (in X-ray) beneath *The Virgin and Child with Saints John and Dorothy and other Saints* in Dresden.[2]

Probably the earliest composition of which there are surviving replicas, rather than variants, from Titian's studio is that of *The Woman with a Mirror* in the Louvre, of about 1515.[3] The production of replicas increased substantially as Titian's reputation spread beyond Venice in the 1520s.[4] Such was Titian's international success that he soon became unable to supply original works for all his commissions. He was forced in effect to establish a hierarchy of his clientele. The high status of his patrons, who included aristocrats, kings, popes and emperors, in itself gave rise to a sizable demand for replicas, both of their portraits and of the compositions they commissioned. Quick to appreciate the appeal of the association of works belonging to prominent patrons, Titian presented replicas as gifts to other influential people, for example giving replicas of the *Ecce Homo* he painted for Charles V (Prado, Madrid, inv. 437) to Perrenot de Granvelle and Pietro Aretino in 1548. The painting of *The Magdalen* he sent to the duke of Alba in 1573 was probably a version of the one produced for Philip II in 1561.[5]

We may surmise that existing pictures are replicas of lost originals in two further cases, that of the Prado *Virgin and Child with Saints Catherine and George* and the Dresden *Girl with a Fan* (fig. 34).[6] The latter sheds interesting new light on the relationship between Titian and

Rubens. The Dresden picture is supposedly a portrait of Titian's daughter Lavinia, painted around 1555 for Alfonso II of Este and copied by Rubens (fig. 35). Differences between Rubens's copy and the Dresden picture suggest that Rubens copied not this but a lost work, perhaps one recorded in the 1636 inventory of the Alcázar: 'Another half-length portrait of a Venetian woman dressed in white satin, with gold embroidery, a palm-leaf fan in her right hand and the tip of a green leaf on her breasts; it is by the hand of Titian';[7] this might have been the portrait of Lavinia, 'she who is the absolute mistress of my soul and is dressed in yellow', that Titian sent Philip II in 1559.[8]

Titian did not always employ the same method for making replicas. Sometimes he made replicas of the original as soon as it was completed: to judge from surviving documents, this was the most common procedure for portraits. The most explicit testimony is a letter sent from Venice on 9 July 1549 by the Spanish ambassador Juan Hurtado de Mendoza to Prince Philip, as he then was: 'As regards Your Highness's instructions for sending the portraits, Titian has given me the first one, which I am sending with this letter. Another two have been made from it, which, in my opinion, are not so fine, though they are good and will be better after the final hand, because Titian is refining them each day; and I believe they will be completely finished in a few days.'[9] Again, Benedetto Agnello, the agent of the duke of Mantua in Venice, reported in February 1549 that Titian had not yet sent his portrait of the duke's wife, Catherine of Austria, as he was making a copy for Ferdinand, King of the Romans.[10] On other occasions a longer period elapsed between the execution of the original and of the replica, and the painter had to resort to some other form of record or even to rely on memory. An example of the latter is the portrait of Pedro González de Mendoza, which Titian had painted at the end of 1536. In April 1540 Diego Hurtado de Mendoza asked him for another, which the painter had to 'do from memory because he no longer had the original'. This caused some problems, as Hurtado de Mendoza reported: 'Titian never finishes this portrait of Pedro González as he has to paint it from memory'.[11]

The practice of making records (or *ricordi*) stemmed from both economic interest and practical need, especially after Titian had acquired clients throughout Italy and Europe and the risk of works being lost during transportation, as befell *The Entombment* sent to Philip II in 1557, grew accordingly. It is difficult to make assertions about how many or exactly what forms of record Titian used – were they drawings, or sketches on canvas, or smaller but comparatively finished versions of the painting? Although Titian had always kept such *ricordi*,[12] the existence of several replicas of originals dating from 1545 onwards suggests that he stocked them systematically, compiling a 'catalogue' that enabled the workshop to supply works to meet the demands of his clients. From approximately this date, furthermore, Titian's autograph production was almost completely monopolised by Philip II. It has been suggested that the nature of these *ricordi* depended on the size of the originals, and that Titian kept paintings of the smaller pictures and drawings of the larger ones.[13] There is documentary evidence of the use of drawings. For example, on 28 April 1549 Perrenot de Granvelle asked the painter for a copy of the portrait of Prince Philip painted in Milan, 'if you have kept a drawing of it',[14] and Titian himself referred to drawings in 1566 when he requested permission from the Council of Ten to make prints of some of his compositions.[15] As for the paintings, we know that Titian kept many at his house,[16] but do not know what purpose they served. Some were unfinished, such as the *Philip II* now in Cincinatti or the *Ecce Homo* in Saint Louis

FIG. 36
Tracing (by Ana González)
comparing the outlines of fig.
37 (1550) in blue and fig. 38
(1555) in red

FIG. 37 (opposite above)
TITIAN
*Venus with an Organist and a
Dog*, about 1550
Oil on canvas, 136 x 220 cm
Museo Nacional del Prado,
Madrid, inv. 420

FIG. 38 (opposite below)
TITIAN
*Venus with an Organist and
with Cupid*, about 1555
Oil on canvas, 148 x 217 cm
Museo Nacional del Prado,
Madrid, inv. 421

(cat. 41), but others were probably ready to be used as models for other compositions. More difficult to interpret are the '*abbozature*' that Ridolfi mentions, which may have been preparatory sketches or paintings in progress or even late works that Ridolfi took to be sketches.[17]

Titian certainly used tracings to transfer his compositions, a procedure already employed by Bellini.[18] The *Diana and Callisto* in Vienna is a same-size replica of the painting sent to Philip II in 1559 (fig. 14, p. 25), and one of the seven '*favole*' or fables Titian offered Maximilian II in 1568.[19] On the back of the Vienna canvas one can see the outlines of the transfered composition coming through from the front (and consequently in reverse).[20] The fact that the outlines correspond more closely to the Edinburgh original than to the Vienna picture itself indicates that it must have been based on a tracing of the Edinburgh painting to which Titian then introduced some changes.[21] Most Titian paintings where similar tracing has been found on the reverse are replicas (*Saint Jerome*, Thyssen Collection, Madrid) or copies of other artists' works (*Pope Julius II after Raphael*, Pitti Palace, Florence).[22]

X-radiography and infra-red can enable us to follow Titian's procedures, which, fascinatingly, differ, even though the result is apparently similar. In the Prado there are two examples of the reclining *Venus with a Musician* series already mentioned, both *Venus with an Organist* (inv. 420 and 421; figs. 37 and 38).[23] Inv. 420 was evidently the earlier, and was used as the model for 421, transferring the outlines of the main figures and elements of the setting – the organ, curtains, grove, fountain, animals and the strolling couple (see fig. 36). A similar operation (see fig. 33) was performed with the two *Entombment* paintings inv. 440 (cat. 31, fig. 31) and 441 (fig. 32; see pp. 60–1). The outline of inv. 440, which is dated 1559, was transferred to make inv. 441 around 1572; the contours of the cave, tomb and main figures coincide. What cannot be ascertained is the technique used to transfer the composition from cartoon to canvas, as no traces were found of *spolvero* or pouncing, spreading powder along scored lines to produce a dotted outline – the procedure employed by Giovanni Bellini.[24]

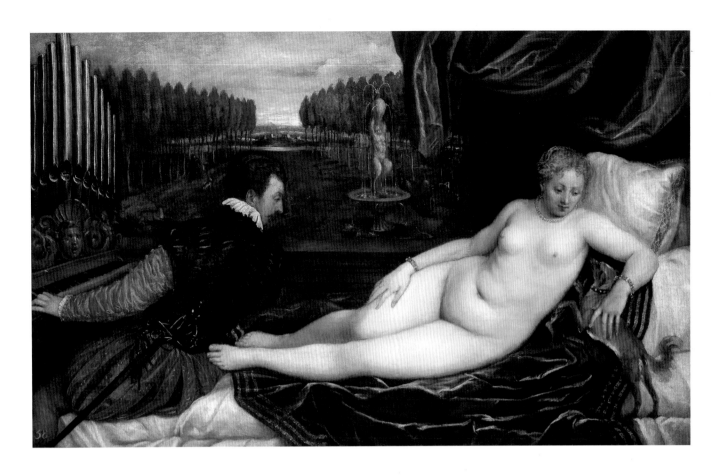

Although Titian would have entrusted the mechanical task of transferring the compositions to assistants, he himself must also have been involved in their subsequent preparation, since none of the replicas is an exact copy of the original: they display changes introduced after the tracing process that we may attribute to Titian himself. The most significant change in inv. 421 is the inclusion of Cupid and the removal of the dog, which made it necessary to alter the upper part of Venus's torso and the position of her head and left hand. More minor changes are to be found in the musician (his face only), the landscape (the enlargement of the tops of the cypresses), and the arrangement of the folds of the curtains and velvet cloth on which Venus is lying. The second *Entombment* displays analogous variations, chiefly the different position of Christ's head and legs and the inclusion of a young man (Saint John?) behind Nicodemus. Titian put the finishing touches to both later works, displaying an ability acknowledged by his contemporaries, admirers and critics alike to turn his assistants' work into his own.[25] This 'appropriation' is corroborated by the pentimenti found in the later stage of execution, such as in the position of the necklace or the fingers of Venus's left hand in inv. 421, or in the position of the Magdalen's arms in inv. 441.

It is particularly likely that tracings of a similar kind were used where there are two or more versions of the same picture with the same dimensions. Examples include the two versions of *The Supper at Emmaus* (Brocklesby Park and the Louvre), of *Venus and Cupid with a Lute-player* (Fitzwilliam and Metropolitan), of *Christ carrying the Cross* (Prado and Hermitage), and the several known paintings of *The Penitent Magdalen* (fig. 74, p. 176).[26] To these should be added works displaying an inverted composition on the reverse, discussed above.

It is evident that the replicas were never exact reproductions of the original painting (no more than they had been for Giovanni Bellini).[27] The differences are of various kinds. Most are mere additions or eliminations of some figure or object and do not amount to noteworthy iconographic or compositional alterations; rather, the artist sought to dignify his work by eschewing the production of mere copies, reflecting Titian's aesthetic concern and pride in his craftsmanship. More interesting are the changes aimed at 'depersonalising' the replicas in order to make them more commercial. Few works illustrate the standardisation of a composition better than the two Prado paintings of *Venus with an Organist*. Inv. 420, the earliest surviving rendering of the theme, reveals in X-rays the greatest differences between the initial idea and the end result. Titian's original idea was more audacious, as it showed the figures exchanging glances, as they no longer do in the finished version. The posture of the woman, who appears to be offering herself to her lover, is closer to that of the later version of the *Danaë* (fig. 61, p. 132).[28] Either because the client found it too provocative, or on his own initiative, the painter altered the composition, including the dog, which became the sole object of the woman's attention. The painting thus lost much of its eroticism, as the woman became entirely passive.

Inv. 420 is the only member of the *Venus and Musician* series in which both figures have individualised features. Venus's physiognomy in subsequent versions (Prado inv. 421 and Berlin), as well as in the Uffizi *Venus and Cupid*, in the *Venus with a Mirror* in the National Gallery, Washington, and recast as Lucretia in *Tarquin and Lucretia* (cat. 36), is generalised. This suggests that the first Prado painting was a portrait, perhaps of a married couple. The wedding ring on the ring finger of the woman's right hand may be significant. By contrast to

all other versions on the *Venus and Musician* theme she is not accompanied by Cupid, nor does she display any attributes identifying her as the goddess. Interestingly, this is the only version of which the original owner is known (the lawyer Francesco Assonica),[29] and in the garden several elements – the dog, ass and turkey and so on – could be read as epithalamial or marriage symbols.[30]

Such a reading would be much more difficult for inv. 421. Nothing is known of its provenance. Someone may have seen inv. 420 in the workshop and asked for a replica (as is known to have happened more than once), or it may have been Titian's initiative to offer the composition to whoever might bid for it. Apart from stereotyping the features of the female figure, Titian included a Cupid, thereby identifying the woman with Venus, and eliminated the wedding ring and the little dog. Although the garden remains, its potential symbolism is much less clear. Many replicas seem to exemplify this 'depersonalisation' process, but some might undergo a new 'personalisation'. Titian never had recourse to intermediaries and usually knew for whom his compositions were destined. Replicas of other paintings, such as the Berlin *Girl with a Dish of Fruit* (or *Pomona*, about 1555)[31] and the Prado *Christ carrying the Cross* (inv. 438), in which Simon of Cyrene may be a portrait,[32] seem to have been specific commissions. Automatically to attribute the same meaning to different paintings of similar appearance is to ignore the social and material circumstances of each one.

In terms of quality, many replicas stand comparison with the originals, for example the Prado *Salome* with respect to the Berlin *Pomona*, or the later (fig. 75, p. 178) to the earlier version of *The Martyrdom of Saint Lawrence*; others fall far short. Many replicas are simplified compared to the original, for example the Prado *Entombment* no. 441 (fig. 32), in which the elaborate sculpted relief of the tomb in inv. 441 (cat. 31, fig. 31) has been replaced by marbling, and the velvet robes of Joseph of Arimathea by a striking, yet standard polka-dot pattern.

Unfortunately, our information about Titian's workshop is fairly meagre. We do not know whether, for the purpose of making replicas, Titian, like Giovanni Bellini,[33] had his assistants specialise in particular themes or motifs (landscape, animals, the human figure), or indeed specialise at all. What can be inferred from the early sources is that certain assistants were more heavily engaged in the task of making replicas than others – such as Girolamo Dente, whose talent for copying is mentioned by Vasari, and Orazio Vecellio, the painter's son, who made small replicas of the *Venus and Adonis*.[34] The fact that both were very close to Titian suggests that he entrusted this task to them in the knowledge that these replicas would constitute the workshop's greatest asset after he died, as would be the case for the longer-surviving heirs of Veronese, Tintoretto and Bassano.[35] Indeed Titian jealously guarded his works: to Ridolfi's anecdote that he would lock the room where they were kept so that his assistants could not copy them should be added the testimony of Spanish ambassador Guzmán de Silva, who noted in February 1575, 'I have been in Titian's house and grow more certain every day that not much can be expected of what he is doing these days but only of what has been done, which he guards so well that much subtlety is needed to see it'.[36]

What view did the recipients of replicas or works of lesser quality take towards them? Although Titian on more than one occasion attempted to pass off as autograph works in which his involvement was actually limited, for example those sent to the town council of Brescia in 1564, clients who requested or received replicas were usually aware of what they were getting and sought them indeed precisely as replicas. They embodied the prestige Titian

had attained and his special relationship with some of the most powerful individuals of the age. Even though it was known that very few were entirely autograph – as sometimes the painter himself admitted[37] – replicas satisfied the desire to own works by Titian (they were often the only means to do so), allowing their owners to emulate the taste of popes, emperors and kings. It mattered little that he had contributed scarcely more than a few brushstrokes; it was sufficient to know that they had come from his workshop and bore the seal of his approval, often expressed in his signature, which, like Giovanni Bellini's earlier, became more of a brand name than a certificate of autograph authorship.

The two Prado versions of *The Entombment* illustrate perfectly the social and even diplomatic dimensions of Titian's replicas. The higher-quality work, signed *Titianus Aeques Caesarius* – a form that Titian perhaps reserved for autograph paintings – was sent to Philip II, while the inferior version, signed *Titianus Fecit*, was given to Antonio Pérez by the Venetian authorities.[38] Pérez modelled his collection on that of his sovereign and therefore included in it works by the king's favourite painter.[39] All three parties would have been aware of the difference in quality. Neither Titian nor Philip II nor probably even Pérez could have conceived that a painting sent to a secretary might be of the same or higher than the one sent to a king.

CATALOGUE

I FOUNDATIONS

DEFINING THE BEGINNINGS of a painter's style is often speculative, and Titian is no exception. His reported formation under the influence of Gentile and Giovanni Bellini and Giorgione remains uncharted (and many dates given in the captions and elsewhere are necessarily speculative). Did he begin by painting small panels for the decoration of furniture, such as those by Andrea Previtali in the National Gallery? A few such decorative panels are attributed to him; they were the perfect medium for developing the pastoral genre for which Titian later became famous. According to Ridolfi, writing in the seventeenth century, Giorgione had started life as a painter of furniture panels, and it is possible Titian did the same.[1] What we do know is that he had gained sufficient status while still quite a young artist to work on the Fondaco de' Tedeschi on the Grand Canal in 1508 beside Giorgione and to be commissioned to paint three narratives in the Scuola del Santo (the confraternity associated with Saint Anthony) in Padua in 1510.

It is perhaps surprising, given that Titian is known above all for what he could do with oil paint, that these two earliest documented works by him were executed in fresco, a medium anyway unsuited to the Venetian climate.[2] By the time that Titian entered his studio, Giovanni Bellini had perhaps phased out the use of tempera altogether and had adopted oil paint for paintings both on panel and on canvas. As Vasari reports, using oil-based pigments Titian could refine his compositions during the act of painting, rather than colour in a plan preconceived primarily as a drawing. As Johannes Wilde remarked, this 'improvising method seemed appropriate to his new pictorial ideas'.[3]

These 'pictorial ideas' were imbued with an ebullient energy which compensated for the passages of uneven or incompetent drawing that are quite evident in Titian's early work. The Hermitage *Flight into Egypt* (fig. 39), the Accademia *Raphael and Tobias* (fig. 2, p. 12) and the National Gallery's *Holy Family with a Shepherd* (cat. 2) share a lack of anatomical definition, concealed by billowing drapery. The National Gallery's *Noli me tangere* (cat. 7) presents a more confident figuration thanks to Titian's adaptation of a design by Raphael for Christ's pose, but Mary Magdalen has no rational body.[4] A similar imprecision of modelling and instability of composition are evident in the Capitoline *Baptism of Christ* (fig. 40), in which Saint John risks toppling over and the incongruously positioned patron, Giovanni Ram, forms an uneasy alliance with the other figures – as again does Pesaro in the Antwerp *Jacopo Pesaro being presented to Saint Peter* (cat. 3). These early inaccuracies demonstrate, however, not simply the artist's lack of experience but also his desire to absorb and his ambition to reinterpret Central Italian ideas and motives – and indeed classical art, for it is possible that the unbalanced Baptist was inspired by a Hellenistic statue of a *Crouching Persian* known to Titian through prints.

Despite such defects, for which Vasari damned the whole Venetian school, the language of Titian's painting is impressive and articulate from the outset. The features of Giovanni Ram, for example, are finely modelled, the drapery confidently rendered, and the fall of light makes for a solid and navigable landscape. The foreground draperies are a masterpiece of still-life painting. These not only imply an earlier narrative (the disrobing of Christ) but, in

TITIAN
The Three Ages of Man, about 1512–13 (detail of cat. 8)

FIG. 39
TITIAN?
The Flight into Egypt,
about 1506–8
Oil on canvas, 206 × 336 cm
The State Hermitage Museum,
St Petersburg, GE 345

transgressing the picture plane, implicate the viewer. This sense of physical proximity and involvement of the viewer is also evident in portraits such as the *Man with a Quilted Sleeve* (cat. 5). Paintings now mimic the sense of presence found in life-size sculpted busts (Bellini's *Doge Leonardo Loredan* in the National Gallery of 1501–4 is a breathtaking pioneer). Titian was quick to develop this sense of visual engagement into one of tactility. In paintings such as the Doria *Salome* of about 1515 (fig. 41), expert handling of the malleable oil medium enabled the artist to evoke the sensation of softly spun hair upon creamy flesh. Pietro Aretino records that women deliberately let a loose curl fall over their faces, allowing lascivious eye-fluttering. Salome's lock of hair, and her downcast eyes, must have been as provocative as her pulled-up sleeve and décolletage.[5]

The ability to create a dialogue between figures seems to have been innate in Titian. The frieze-like construction of the Santo *Speaking Child* (fig. 3, p. 13) is impressive, with its tight interaction between figures amplified through patterns of colour, in this case tones of red. The figures of the crowd, executed in broad, confident strokes, converse, counteract and counterbalance. The same mastery of procession is evident in the fictive bas-reliefs of *Pesaro being presented to Saint Peter* (cat. 3) and 'Sacred and Profane Love' (cat. 10), as well as in Titian's *Triumph of Christ* woodcuts, for which the early date of 1508 given by Vasari, though 1518 is preferred by some scholars, should not be dismissed.

These early works must be seen against the rapidly evolving styles of Giorgione and Sebastiano del Piombo. It is reported that Sebastiano and Titian were pupils of Giorgione, or at least were highly influenced by his style. Vasari described them as '*duo suoi creati*', which

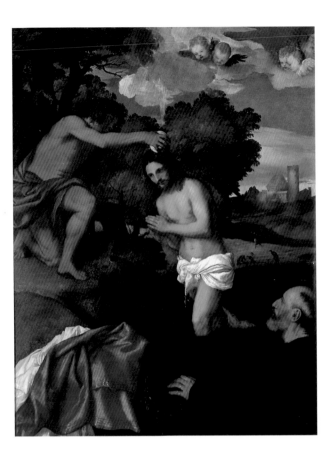

explains why the attribution of works such as the '*Concert champêtre*' (fig. 5, p. 14) has never been entirely resolved. Paintings by Sebastiano such as *The Judgment of Solomon* of about 1510 (The National Trust, Kingston Lacy) suggest that Titian might have struggled to establish himself against such talented competition. By the end of 1511, however, all competition had been eliminated: Giorgione had died in 1510, Sebastiano del Piombo had left for Rome, and Giovanni Bellini was more than eighty years old. Indeed, Titian's repainting of Giorgione's *Sleeping Venus* (fig. 45, p. 86) represents a symbolic 'passing of the baton', in which Giorgione's rôle as a painter of pastorals was assumed by Titian. Perhaps aided by the artistic vacuum that had been created, he managed both to fulfil and to exceed the promise manifest in these early works and by 1516 he had received a sinecure from La Serenissima. His fame spread, and with the unveiling of the Frari high altar (fig. 6, p. 15) in 1518, when he was perhaps around thirty, he was attracting the attention of courts on the mainland.

Whether painting one of the largest altarpieces to be produced in the Italian Renaissance, or working on the relatively small *Three Ages of Man* (cat. 8), Titian displays virtuoso brushwork. His abbreviation of hair and cloth in the latter show his trademark economy. A few white slashes define her shoulder while a beguiling cascade of eddies and curves create a signature terminal that echoes the tumbling locks of hair. Titian's willingness to show the raw energy of his brushwork recalls woodcuts: strongly 'cut' lines of paint coalesce into coherent forms as the viewer steps back. By the early 1510s Titian had perfected this kind of optical enchantment, and such energetic and descriptive brushstrokes remain characteristic of the rest of his career. DJ

FIG. 40

TITIAN
The Baptism of Christ, about 1508–12
Oil on panel, 116 × 91 cm
Pinacoteca Capitolina, Rome

FIG. 41

TITIAN
Salome, about 1511–15
Oil on canvas, 89.3 × 73 cm
Galleria Doria Pamphilj, Rome, inv. 137

1. *The Virgin and Child ('The Gypsy Madonna')*
about 1511

Oil on panel, 65.8 × 83.8 cm
Kunsthistorisches Museum, Vienna, GG 95

Select Bibliography: Crowe and Cavalcaselle 1877, I, pp. 54–6; Cook 1907, p. 97; Wilde 1932, pp. 151–4; Richter 1934, pp. 278–81; Klauner and Oberhammer 1960, no. 709, pp. 135–6; Wethey I, p. 98, no. 47; Wilde 1974, pp. 113–5; Hope 1980A, pp. 22–3; Washington 1990, p. 62; Pedrocco 2001, p. 96, no. 28; Joannides 2001, pp. 141–4

Titian's young Virgin has traditionally been called the 'Gypsy' Madonna on account of her dusky complexion and her dark hair and eyes. Mary, little more than a child herself, supports her infant son as he stands unsteadily on a parapet. Both mother and son seem lost in thought. However, their communication goes beyond words: with his left hand, in what is a very natural and engaging attitude for a young child, Christ plays with his mother's fingers, while with his right he toys with the gold-green fabric lining of her mantle.

This harmonious composition is indebted to Giovanni Bellini's late Madonnas, particularly *The Virgin and Child* in Detroit (1509; fig. 42) and the Brera *Virgin and Child* of 1510. X-rays of the Vienna panel show that initially it was extremely close to the Detroit painting in reverse, only differing in the placement of the Christ Child on a ledge, rather than on his mother's lap. However, the meditative style is so reminiscent of Giorgione that the *Gypsy Madonna* was regularly attributed to him (at least in part) during the first half of the twentieth century. The Virgin's demurely lowered head and half-closed eyes are pure Giorgione, as is the figure beneath the tree at the left. The early evening landscape, suffused with a golden glow, repeats almost exactly the far mountains at the left of the *Sleeping Venus* (fig. 45, p. 86), which Titian brought to completion after Giorgione's death in 1510.

Through his use of gently contrasting colours Titian unites these pictorial borrowings into his own recognisable style, distinct from those of Bellini and Giorgione. The solidly plastic figures and the clearly defined cloth of honour, with its crisp folds, recall the Santo frescoes (1510–11; fig. 3, p. 13), while the Christ Child resembles the infant in the National Gallery's *Holy Family with a Shepherd* (cat. 2). Although less ambitious, 'The Gypsy Madonna' is equally beautiful, and as effective at conveying emotion, as other private devotional works of Titian's early maturity such as the *Noli me tangere* (cat. 7) and *The Virgin and Child and Saint Catherine with Saint Dominic and a Donor* (cat. 9).
CC

2. *The Holy Family with a Shepherd*
about 1510

Oil on canvas, 106.4 × 143 cm
The National Gallery, London, NG 4

Select Bibliography: Crowe and
Cavalcaselle 1877, II, p. 428; Ricketts 1910,
p. 44; Holmes 1929, p. 190; Wethey I, pp.
94–5, no. 43; Gould 1975, pp. 267–8; Hills
1999, p. 150; Pedrocco 2001, p. 98, no. 31;
Joannides 2001, pp. 145–6 ; Wilson 2001
(for Saint Joseph)

The painting must be one of Titian's
earliest surviving works. It retains at least
one artistic device much favoured by
Giorgione: the dark foil of a rocky bank
with shrubs and weeds silhouetted against
a dawn sky. But it is more monumental
in figure and drapery style and bolder in
handling than anything Giorgione is
known to have painted. Joseph's shadowed
head, balding but fringed with tiny tangled
threads of hair and beard, recalls that of
Saint Mark in Titian's early altarpiece
now in the Salute (fig. 4, p. 13) and the
treatment of the translucent white linen is
similar to that in *The Three Ages of Man*
(cat. 8). In the latter painting we also find
a similar patch of pink drawing the eye
to the distant landscape and the same
creasing at the wrist of a sunburnt male
arm in the foreground.

Titian's subject is not the Nativity, in
which the Virgin venerates her new-born
child, although the Virgin does kneel and
the ox and ass, just detectible behind her,
make it clear that the Holy Family is
shown at the birthplace of Christ.
The subject is rather the Adoration of the
Shepherds, to whom the angel announces
Christ's birth in the distance. It is,

however, unusual that only one shepherd
should be in attendance in the foreground.
The reason for this is probably that Titian
wished to emphasise the importance of
Joseph, who is here given a central rôle in
the composition. Indeed, the painting was
surely made for a patron with a special
veneration for Joseph, whose cult was
vigorously promoted in north Italy at
this date: altarpieces commissioned by
confraternities dedicated to Joseph often
give him similar prominence.

Much of the landscape, especially on the
left, has been abraded. The shadows in
the Virgin's blue cloak have none of their
original depth. Joseph's cloak has been
deprived of its purple glaze. But the effect
of warm shadowed flesh enclosed by soft
white linen is preserved, as is the tender
expression of mother and child. Titian
balanced this white with the shepherd's
shirt and leggings – the latter, as Paul
Hills has observed, highly improbable in
a rural labourer. The composition and
colour are thus thought of together.
A lack of thorough training in drawing
the figure is clear from the size of Joseph's
head in relation to his torso, and none
of the figures is convincingly articulated –
further evidence that this is a very early
work.
NP

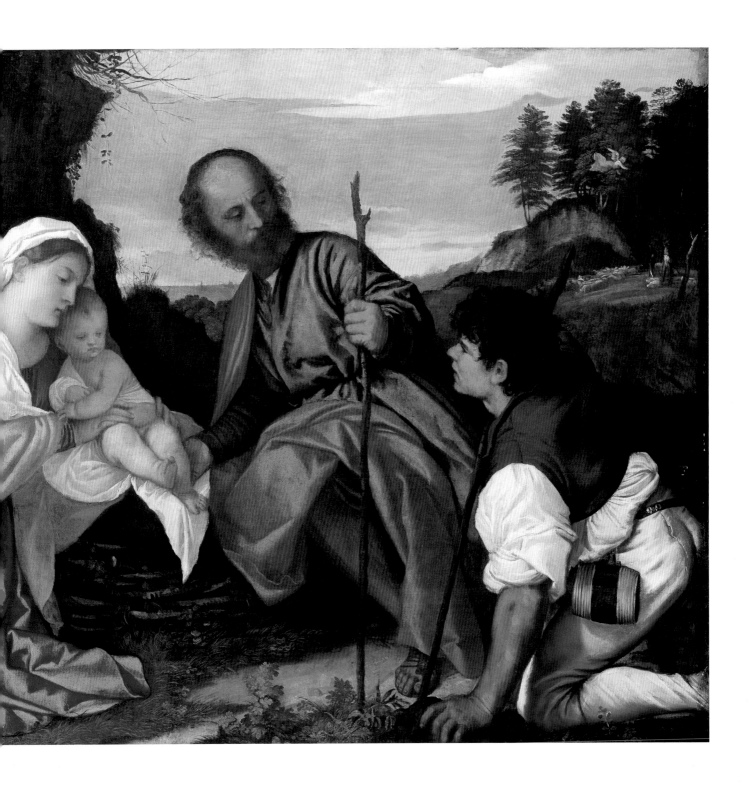

3. *Jacopo Pesaro being presented by Pope Alexander VI to Saint Peter*
about 1506–11

Oil on canvas, 145.5 cm × 183.5 cm
Koninklijk Museum voor Schone Kunsten,
Antwerp, inv. 357

Select Bibliography: Crowe and
Cavalcaselle 1877, I, pp. 66–77; *Antwerp*
1948, p. 254; Wethey I, pp. 152–3, no. 132;
Hope 1980A, pp. 23–6; London 1983, p. 219,
no. 113; Washington 1990, pp. 59–61, 148,
no. 4; Paris 1993, pp. 368–74, no. 40;
Pedrocco 2001, p. 85, no. 17; Joannides
2001, pp. 151–5; C. Campbell 2003

Jacopo Pesaro being presented to Saint Peter
is an ambitious synthesis of what Titian
had learnt from the Bellini brothers and
Giorgione. The composition adapts the
format of the traditional Venetian votive
portrait in which the donor is presented
by his patron saint to the Virgin and
Child, as in the National Gallery's *Doge
Giovanni Mocenigo* (NG 750). Here, Jacopo
Pesaro, bishop of Paphos and papal legate,
is shown before Saint Peter. His inter-
mediary is the Borgia pope Alexander VI.

The painting was presumably
commissioned for display in Pesaro's
Venetian home, and it remained with his
descendants until the early seventeenth
century. It commemorates his career in the
service of this notorious pontiff (whom
most of his servants preferred to forget).
The kneeling Jacopo is presented by his
papal patron (whose banner he holds) to
Saint Peter, who sits upon a raised daïs
decorated with *all'antica* sculptural reliefs.
The main, lower relief probably involves
Venus, to whom Paphos was once sacred.
The naval battle in the background
alludes to Pesaro's greatest triumph, his
involvement in the recapture of the Greek
island of Santa Maura (modern Lefkas)
from the Ottoman Turks in 1502.

There is considerable disagreement
over the dating of Jacopo Pesaro's votive
portrait. The figure of Saint Peter is
reminiscent of comparable figures in

Giovanni Bellini's later work, such as Saints Peter and Paul in *The Virgin and Child with Saints Peter and Paul* of 1505 (Birmingham, City Museum and Art Gallery). Alexander VI's static appearance – he was dead by the time of Titian's painting – makes a marked contrast with the lively Jacopo Pesaro. The archaic style of Saint Peter and the pope has led to the suggestion that the painting dates from about 1506–8, which would be just after Titian's probable emergence from Giovanni Bellini's studio. However, in compositional terms it seems closest to the monumental style Titian developed around 1510–11, seen in the altarpiece of *Saint Mark enthroned* (fig. 4, p. 13), the Padua frescoes (fig. 3, p. 13), and even in a smaller-scale work like the National Gallery's *Holy Family with a Shepherd* (cat. 2). Recent restoration of *Jacopo Pesaro* (which is shown here for the first time since its cleaning) has made its relationship to works of this period more obvious. The composition is related to that of the Magnani-Rocca *Virgin and Child and Saint Catherine with Saint Dominic and a Donor* (cat. 9), while the relief of Venus is only marginally less sophisticated than the sarcophagus in '*Sacred and Profane Love*' (cat. 10).

In *Jacopo Pesaro being presented* Titian creates a sense of engagement between his three subjects, almost convincing the viewer that this imaginary meeting took place. It is unfortunate that some compositional shortcomings, such as the unconvincing perspective of the tiled floor and the less than satisfactory relationship between the foreground and the marine background, thwart the painting's absolute success. The patron at any rate was satisfied, for Titian was subsequently commissioned by Jacopo to paint one of his most important altarpieces, the monumental '*Madonna of the Pesaro Family*' in the Frari (1519–26; fig. 7, p. 15). CC

4. 'La Schiavona'

about 1510–12

Oil on canvas, 119.2 × 100.4 cm
The National Gallery, London, NG 5385

Select Bibliography: Sala 1817; Crowe and Cavalcaselle 1877, II, p. 58; Bonomi 1886 (for seventeenth-century documents); Berenson 1897, pp. 278–82 (as Licinio); Venturi 1900, pp. 133–4 (as Licinio); Cook 1900, pp. 74–81 (as Giorgione); Berenson 1903, pp. 70–89 (as copy of Giorgione); Holmes 1914; Cook 1915 (as Giorgione); Richter 1937, p. 236; Gould 1961; Wethey II, p. 139, no. 95; Gould 1975, pp. 287–90; Thomson de Grummond 1975 (for VV); Caroselli 1983 (for Caterina Cornaro), pp. 47–57; Pedrocco 2001, p. 79, no. 11; Fiorenza 2002 (for VV); Holberton 2003 (for VV)

The name 'Schiavona' (Dalmatian woman) was attached to the picture when it was described in the seventeenth century. There may have been a tradition that the sitter came from the Venetian colonies. By 1817 the idea that it might represent Caterina Cornaro, Queen of Cyprus, had been advanced and, although it had been abandoned even by the picture's owners by the later nineteenth century, it was fervently believed by a later owner, Herbert Cook, and has occasionally been revived. It is, however, very unlikely that Caterina, who retained her rank in exile at Asolo, would have been depicted without obvious evidence that she was a queen. The clothes may, however, have seemed more opulent to contemporaries than they do to us. There is gold thread in the silk hair-bag, and the dress, although evidently of wool, may have been dyed with expensive kermes. Tiny tufts of blue and red at the neckline suggest that it is woven from these two colours. Certainly it is painted with a crimson glaze (doubt-less now somewhat faded) over a pale ultramarine, that is with pigments which appear in pure form as the stones in the woman's rings. The woman also seems remarkably self-possessed and she commands a vista as no woman in any earlier European portrait. The originality of the portrait indeed consists not only in its apparent life-size, three-quarters format but in its being painted to make an impact from a distance. Portraits of women were unusual in Venice and uncommon also in Titian's oeuvre – those whom he did paint, with the exception of anonymous beauties, were the consorts of great princes.

The style of both dress and hair is very similar to that of the women depicted by Titian in his fresco of *The Miracle of the Speaking Child* (fig. 3, p. 13), which is documented to 1511. The similarity between the profile of the marble relief portrait in the National Gallery's portrait with that of the mother in the fresco has long been noted, but the same person cannot be intended, since in the fresco she has auburn hair. That the same model was employed does, on the other hand, seem likely – especially since the mother's companions in the fresco also have similar features. That may suggest that the portrait was not a commissioned portrait of some great Venetian patrician but a painting made by Titian to encourage such commissions.

The painting was much revised during painting. Changes were made to the woman's headdress and to the veil on her right shoulder, for instance, and part of a circular window was painted in the upper right portion of the canvas (perhaps preceded by a rectangular one). The shape of the parapet was also drastically altered, and the woman's dress may now be discerned beneath the raised portion decorated with the profile relief. The woman's left arm was not originally raised. A skull has been detected here and also a foreshortened dish but it is not clear that anything was painted with any finality. There can be no doubt that Titian meant to place something beside the woman, and there is no space for a husband (especially if the projected window is considered). A child may have been intended. And the child's death may have created the need for an alternative solution.

The profile bust portrait, inspired by ancient Roman sculpture, appears to represent the sitter herself but may commemorate a member of her family (perhaps her mother). In any case it must have prompted Titian's more educated public to think of the *paragone*, the rival claims made for the arts, particularly painting and sculpture. (Titian shows that the painter can imitate both life and sculpture, whereas sculpture could not imitate the colours of life – or of painting – and he also shows that the painter can represent a figure from more than one point of view at the same time.) If the painting were not a commissioned work but made perhaps from a model in the artist's household, then it may always have been intended as a painting about the powers of painting.

Before he painted the relief bust Titian decorated the raised parapet with a large V, traces of which can be seen to the left of the profile: another V may also have been intended. V or VV or VVO appears on other portraits made in Venice at this date. The initials have been interpreted as standing for '*virtus vincit (omnia)*', i.e. virtue is victorious (over everything), or for '*vivens vivo*', i.e. from life by the living. More recently '*virtù e verità*', i.e. virtue and truth, has been proposed. These were the qualities which the influential author Pandolfo Collenuccio felt should appear abbreviated as VV in the mirror of the soul. We may be more sure that *T.V.* below the woman must stand for Tiziano Vecellio. Despite this, the painting was attributed to Licinio and to Giorgione – or regarded as a copy of a lost Giorgione, or as a work partly by Giorgione and partly by Titian – in the period in which it hung in the Crespi collection in Milan, about 1890 to 1911.

By the time it entered the Cook collection in 1914 it was generally agreed to be by Titian – although Herbert Cook himself was convinced that it was by Giorgione.
NP

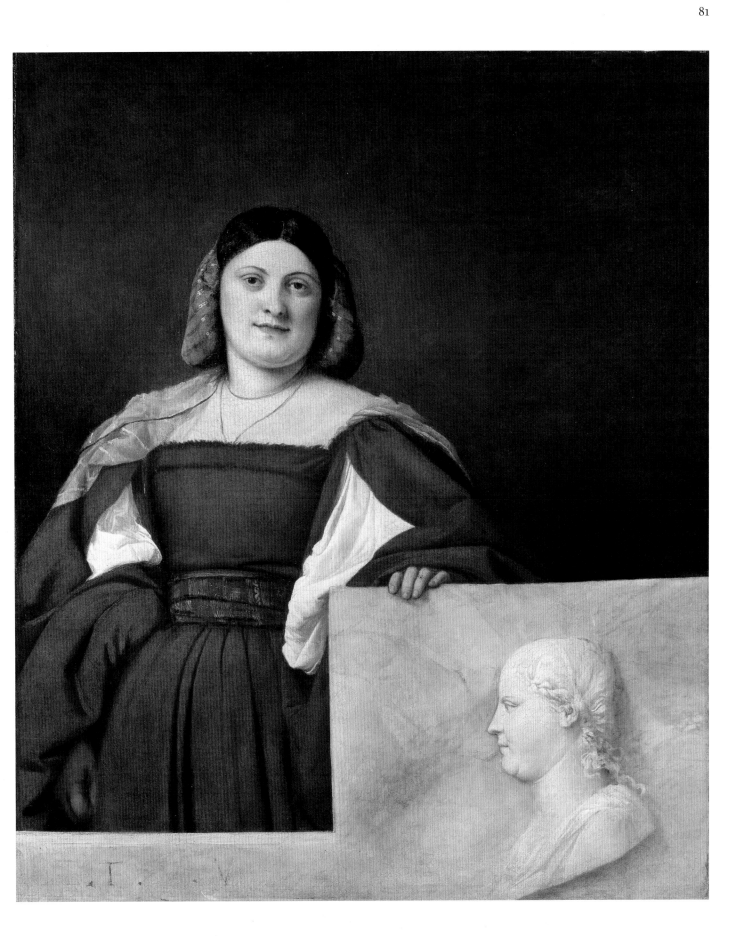

5. *A Man with a Quilted Sleeve*
about 1510

Oil on canvas, 84.6 × 69.5 cm (the original painted surface 81 × 66 cm)
The National Gallery, London, NG 1944

Select Bibliography: Cook 1907, pp. 69–74; Richter 1937, pp. 224–5; Wethey II, pp. 103–40; Gould 1975, pp. 280–2; Brown 1980; Pedrocco 2001, p. 72, no. 5; Artemieva 2001, pp. 60–1 (for Hermitage portrait)

The painting must have been completed by 1512, the date on a portrait in the Hermitage which was obviously inspired by it. Among generally accepted portraits by Titian only the *Knight of Malta* in the Uffizi is likely to be earlier, but a painting at Alnwick Castle long given to Palma Vecchio (fig. 43), which resembles the Uffizi painting, also looks like Titian's work and seems to represent the same sitter as the National Gallery's portrait.

The portrait of a youth in a violet jerkin by Giorgione (Berlin, Gemäldegalerie) is of a similar format, but there the sitter's bulky garment is entirely behind the parapet whereas here it projects over it into our space. Titian's man is also more dramatically posed. The solidity and balance of the composition is such that the movement – the decisive turn and slight tilt of the head – has great effect, as does the raised brow above the right pupil, which is placed midway across the picture. The fading of fine red lines on the grey-blue fabric and the blanching of the hollows and dimples in it have reduced the volume of the sleeve, and as a result of abrasion the forms around the sitter's right hand, where something like a fur muff is represented, are difficult to make out. The merging of the shadowed portions of the figure with the grey atmospheric background was, however, certainly intended, and is one of the most innovative and influential aspects of the painting.

FIG. 42
GIOVANNI BELLINI (about 1430–1516)
The Virgin and Child, 1509
Oil on panel, 84.8 × 100 cm
The Detroit Institute of Arts, Detroit
City of Detroit Purchase, inv. 28.115

Gould justly observed that the pose is appropriate for a self-portrait made in a mirror, and it was adopted by Rembrandt and by Frans van Mieris the Elder when painting themselves. If this is a self-portrait then the Alnwick picture is one, too, and these are paintings in which Titian advertised his art. In the seventeenth century the portrait was believed to depict the poet Ariosto and was engraved as such when in the possession of Alphonso Lopez, the art dealer and jeweller of Amsterdam, from whose sale it seems to have been purchased by Van Dyck shortly before his death in December 1641. Throughout the nineteenth century the painting was still regarded as the portrait of Ariosto, and was famous as such, although no more so than the

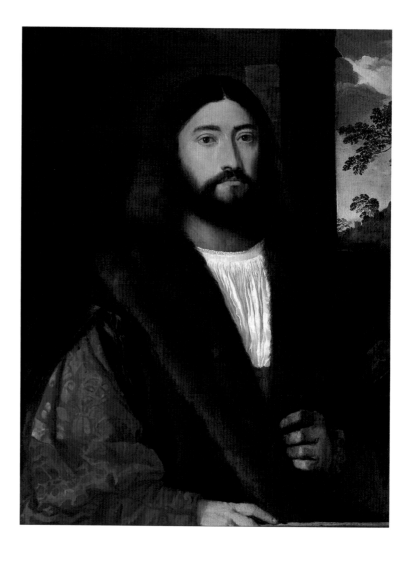

version in the Manfrin collection in Venice (later at Mentmore), which is now regarded as a copy.

Shortly before and for some decades after its acquisition for the Gallery in 1904 the painting was believed to be by Giorgione or by Giorgione and Titian. Before cleaning in 1949 it was inscribed *TITIANVS* on the parapet. Originally only the *T* and *V* were there. Another *V* in the centre of the parapet emerges in infra-red reflectography, so there is a possibility that the painting once bore the mysterious abbreviation *VV* discussed in the entry for Titian's '*Schiavona*' (cat. 4).
NP

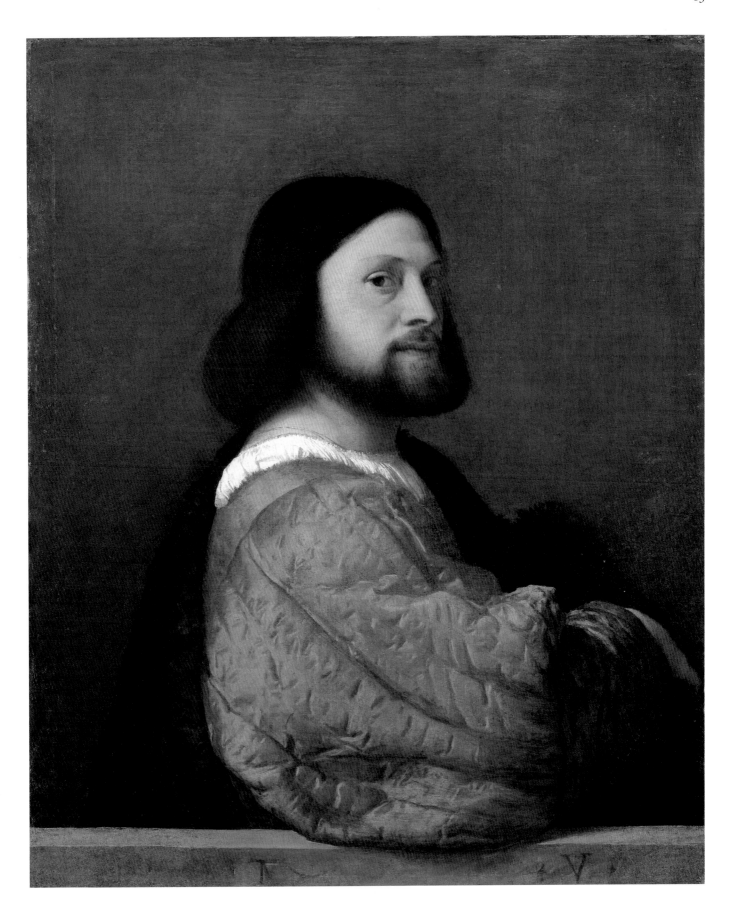

6. *Portrait of a Young Man*
about 1515–20

Oil on canvas, 100 × 84 cm
Halifax Collection, on loan to the National
Gallery, London, L611

Select Bibliography: Cook 1907, pp. 86–7;
Suida 1933, pp. 33; Tietze 1936, II,
p. 293; Berenson 1957, p. 186; Wethey II,
pp. 14, 149, no. 115; Wethey III, p. 269;
Gould 1976, p. 6; A. Paolucci, R. Valcanover
in Washington 1990, pp. 10, 106, 164; Paris
1993, pp. 369–70, no. 52; Joannides 2001,
pp. 220–3; Pedrocco 2001, p. 95, no. 26

This portrait of an unknown man is one
of Titian's more complex early works. The
badge on the large hat held by the sitter,
which might have provided clues to his
identity, is indecipherable. His dress
suggests he was an Italian, probably from
North Italy, but not from Venice. The
plunging neckline displaying a white
chemise can be paralleled in numerous
contemporary works, notably Titian's
Knight of Malta in the Uffizi.

The sitter's removal of one of his kidskin
gloves implies a pre-narrative, a sense of
time having evolved. The imprints of the
man's fingernails are still visible on the
glove, suggesting either that they were
very tight or that a nail-like motif was
incorporated into the fabric (the same
device can be seen in a Bellinesque double
portrait in a private collection).

The paint is worn in parts, notably in the
man's red sleeve. The white shirt, however,
is sensitively portrayed with thick
striations of paint, comparable to those
on Christ's loincloth in *Noli me tangere*
(cat. 7). Titian employed a similar, though
softer technique in the hair, especially
in the strands framing the face. This has
resulted in a quality frequently called
'Giorgionesque', an aura of detached

melancholy. However, the dynamic
application of paint, as well as the pose
of the sitter, exclude any connection with
Giorgione's style. Such chiselled features
are not typical of Titian's early portraits,
which usually feature fleshier visages, but
parallels can be found, notably in the
features of the right-hand donor group in
'*The Madonna of the Pesaro Family*'(fig. 7,
p. 15), which suggests a dating towards 1520
and later than the usual mid-teens. Here,
the modulation from pink flesh to delicate
grey stubble (men at this date did not
shave every day) is delicately rendered,
whereas stronger strokes are used to
convey the outline of the nose and the
slight sagging of flesh underneath the eye.

The sitter is placed within a fictive niche
and flanked to the left by an ornate relief.
Architecturally, the niche does not make
sense: its upper curve does not join with
the pilaster and instead rises from the
picture plane at a steep vertical. Many
details on the relief are now difficult
to read, although a screaming head, a
serpent rising from foliate decoration
and a cartouche or *impresa* supported by
a barely visible putto are visible. A very

similar relief can be seen in Giovanni
Cariani's half-length allegory known
as '*Seduction*' in St Petersburg (fig. 44).
Probably the two artists were reproducing
the same antique prototype, which they
would have known either at first hand or
through drawings or engravings. It may
have served to represent the *all'antica*
taste of Titian's sitter.

It is worth noting the difference between
the painting of this stonework and that of
the reliefs in *Jacopo Pesaro being presented
to Saint Peter* (cat. 3) and '*Sacred and
Profane Love*' (cat. 10). In contrast to
the painterly highlights suggesting three
dimensions and the fall of shadow in these
works, here the hair of the screaming head
is conveyed with thick, even insensitive,
strokes which, while suggesting move-
ment, do little to convey the qualities of
carved stone. Other passages in the relief
in the portrait are more effective, notably
the foliate decoration to the right, but the
possibility remains that this background
setting was carried out, at least in part, by
a workshop assistant.
AB

FIG. 43
TITIAN?
Portrait of a Man, about 1508–10
Oil on canvas, 82 × 65 cm
Collection of the Duke of Northumberland,
Alnwick Castle, inv. 3349

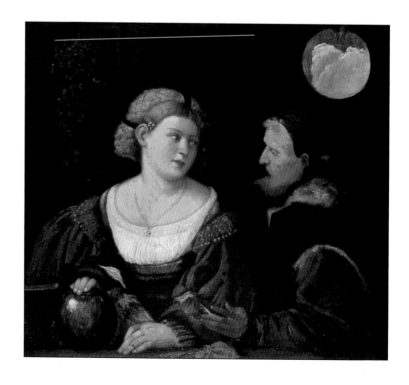

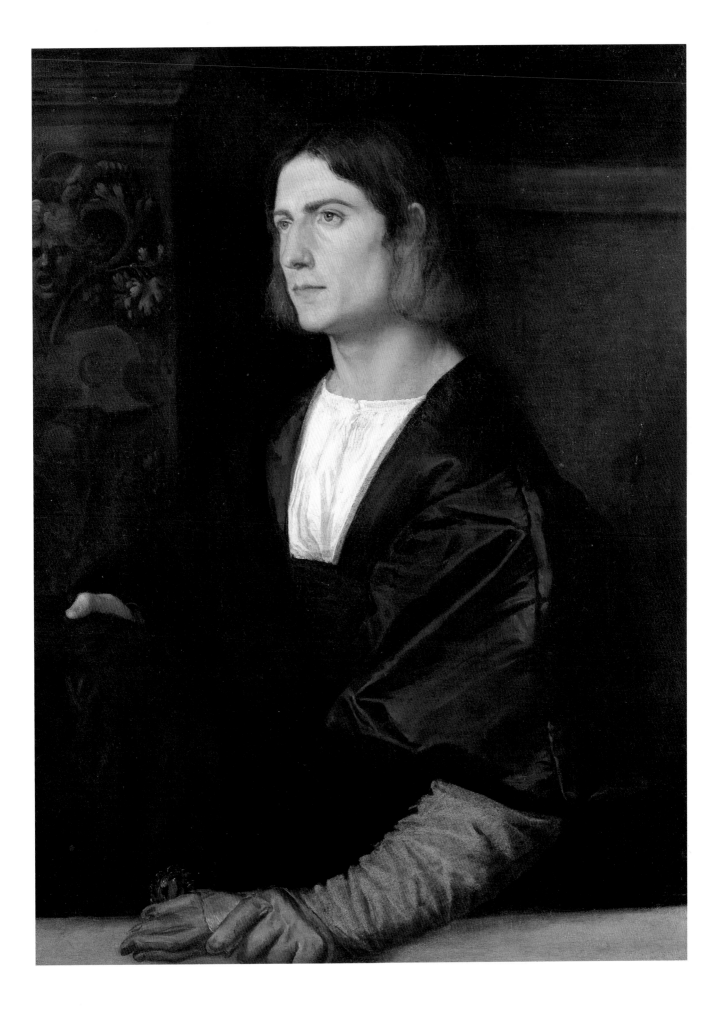

7. *Noli me tangere*
about 1514

Oil on canvas, 110.5 × 91.9 cm
The National Gallery, London, NG 270

Select Bibliography: Crowe and Cavalcaselle 1877, II, pp. 208–10; Ricketts 1910, p. 45; Holmes 1929, pp. 363–4; Wethey I, p. 119, no. 80; Gould 1975, pp. 275–8; Rome 1995, pp. 364–67; Pedrocco 2001, p. 84, no. 16; Joannides 2001, pp. 175–6

The figure of Christ has a grace, a sweep and a spring which reveals a new understanding by Titian of the nude and of its dynamic potential that is partly due to his study of prints after Raphael. Through the movement of his body, Christ responds, 'Touch me not' (*Noli me tangere*) to the Magdalen, who kneels before him, overwhelmed by the desire to touch him, having recognised him in the Garden on Easter morning. As a painting of a quiet but electric drama it is as breathtaking as Titian's slightly later intense close-up picture of *The Tribute Money* in Dresden (fig. 47, p. 98). Here the figures are not only united with the landscape, as was already achieved in *The Holy Family with a Shepherd* (cat. 2) about five years before, but the hills and trees and shrubs play a part in the drama, continuing the contours, drawing our attention to the line of eye contact, mimicking the quivering excitement of the kneeling Magdalen. They anticipate Titian's great altarpiece of *The Death of Peter Martyr* completed in 1530 (see fig. 8, p. 16), where the trees play an heroic part in the action. The way that the foliage here seems to sympathise with the Magdalen reminds us, in Ricketts's words, that here European painting has 'become the richer by a new aerial quality due to nimbleness or expression in the touch itself' – a quality dear to Van Dyck and Delacroix in later centuries.

The painting is very close to Titian's '*Sacred and Profane Love*' (cat. 10), which is dated fairly securely around 1514, both in large ways (notably colour balance) and small details (the spread left hand of the Magdalen). It may be earlier, because the group of buildings on the right here appears with less precision (and in reverse) in the Borghese picture. This group of buildings is also included in the landscape Titian added to the *Venus* (fig. 45) which Giorgione left incomplete at his death in 1510. Although Titian's work on the Dresden *Venus* is generally dated earlier, the buildings seem more likely to have been designed for the National Gallery's painting in which, to give only one example, the winding path is more effective in the composition. X-radiographs (see further pp. 50–1) reveal that Titian made numerous changes to the landscape, but he never seems to have shown the empty tomb or Golgotha, included by almost all other artists treating this subject.
NP

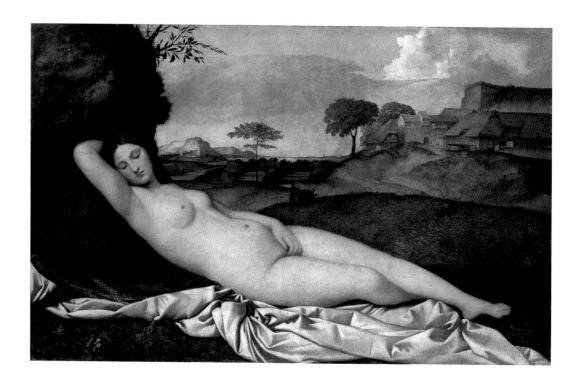

FIG. 45
GIORGIONE (died 1510) and TITIAN
Sleeping Venus, begun about 1510
Oil on canvas, 108 × 175 cm
Gemäldegalerie Alte Meister, Staatliche Kunstsammlungen, Dresden, inv. 185

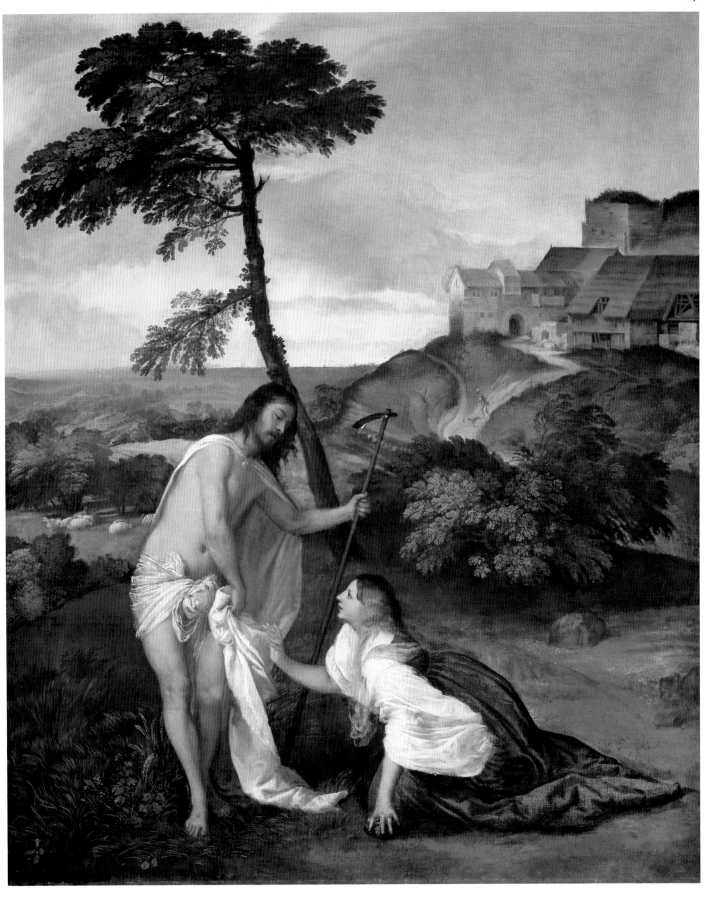

8. *The Three Ages of Man*
about 1512–13

Oil on canvas, 90 × 150.7 cm
Duke of Sutherland Collection, on loan
to the National Gallery of Scotland,
Edinburgh, NGL 68.46

Select Bibliography: Vasari (1568) BB, VI,
p. 159; Sandrart (1675), pp. 25 and 272;
Crowe and Cavalcaselle 1877, pp. 204–6;
Panofsky 1969, pp. 94–9; Robertson 1971;
Wethey III, pp. 182–4, no. 36; Hope 1980A,
pp. 18–23; Joannides 1991; Holberton 1993,
pp. 245, 249; Brigstocke 1993, pp. 172–7;
Hirst 1994 (for Michelangelo's *Cupid*);
Weston-Lewis 2000, pp. 32–3; Joannides
2001, pp. 193–201; Pedrocco 2001, p. 99,
no. 32

The Three Ages of Man has been loaned in
exceptional circumstances. Not normally
permitted to travel, the painting has
been given special dispensation for this
exhibition by the Duke of Sutherland in
honour of his ancestor, Francis Egerton,
a Trustee of the National Gallery in the
1830s.

This is a bitter-sweet love story set in an
enchanting landscape. The lovers gaze
languidly into each other's eyes, although
we know from X-rays that the girl had,
at one time, been angled towards the
spectator. The couple have just finished
making music, and the suggestive position
of one pipe, apparently protruding from
the youth's groin, implies that they have
also been making love. This sensuality
is clothed in Renaissance conventions:
notably the male's amorous engagement
is indicated by his crossed legs and her
overlapping arms, positions that were
'read' as the intertwining of lovers, and
were again used by Rubens in the National
Gallery *Samson and Delilah*. The girl's
myrtle wreath, forever green, was symbolic
of everlasting love, and in particular,
conjugal fidelity.

The juxtaposition of a female more fully
dressed than the male goes against
Venetian pastoral tradition. Perhaps in
depicting the girl *deshabillé* rather than
nude Titian has rendered the image more
provocative: her white shift, an
undergarment not usually exposed,

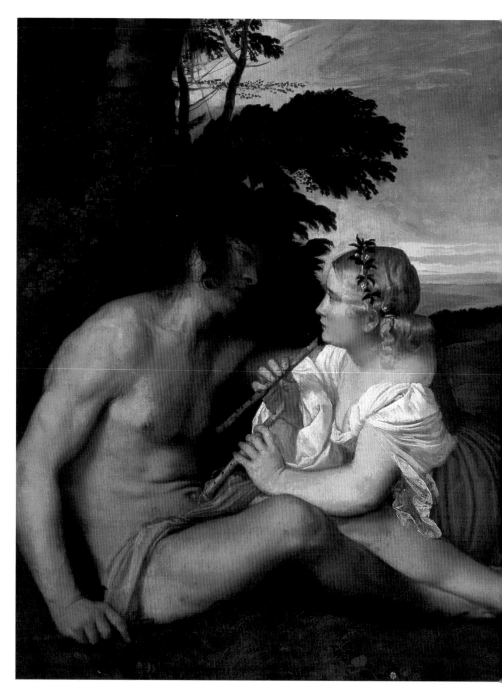

suggests an intimate narrative involving
the process of undressing. She sensuously
caresses his leg with the bare flesh of
her arm.

The other figures in the composition refer
to the couple's past and future, the flow
between them aided by the subtle
undulations of the landscape and the
movement of striated to cumulus cloud
formations above. To the right, an impish
Cupid attempts to arouse a pair of babies
who sleep on arid earth, kickstarting the

love that is to flourish. Distinguished by
her centrally parted hair, it is a girl who
slumbers on her mate's shoulder. The pair
recall a print by Mantegna showing
Bacchic revels, but the male child at full
length also suggests the pose of Cupid
sleeping, as depicted in ancient Roman
marbles; Mantegna's patron Isabella
d'Este owned one such genuine antique
Cupid, as well as a version of one by
Michelangelo. We find the motif used
again in a drawing in Chatsworth by
Titian's contemporary Domenico

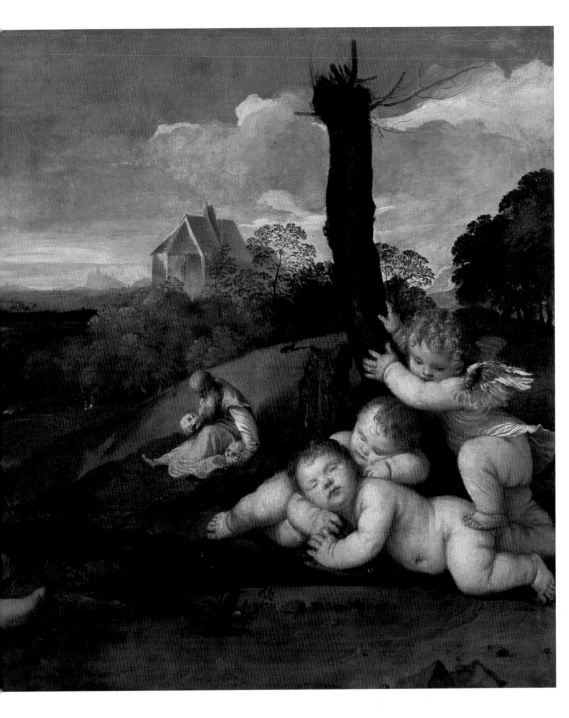

Campagnola, again set in a landscape – attesting to the appeal the image held for artists and connoisseurs alike.

In the countryside beyond, an old man contemplates two skulls; originally two further skulls had been placed at his feet. Titian therefore sought to refine the narrative by correlating the lovers with the skulls. In this way, the painting assumes the status of a *memento mori*, whilst illustrating the promise of regeneration not only through renewal of human life

but also spiritually, suggested by the church in the background. Sleep, death (and sex) were commonly equated during the Renaissance.

The old man's demeanour and appearance is reminiscent of an engraving by Giulio Campagnola, adoptive father of Domenico, in which a similar old man meditates upon eclipse and catastrophe. The painting's current title is an invention of the late seventeenth century (when it was described as such by Sandrart).

Subsequently it has been tempting for art historians to attach classical titles to the painting which do not wholly conform with the image. However, Titian's composition seems inspired by the genre of pastoral romance, evoking a mood rather than a specific text. The ease of narrative combined with the quality of execution suggests a dating of about 1512–13, later than the Paduan frescoes, which were Titian's first truly successful attempt at a grand narrative. DJ

9. *The Virgin and Child and Saint Catherine with Saint Dominic and a Donor*
about 1512–13

Oil on canvas, 138 × 185 cm
Fondazione Magnani-Rocca, Corte di
Mamiano di Traversetolo, Parma, inv. 3

Select Bibliography: Crowe and
Cavalcaselle 1877, II, p. 417; Morassi 1946;
Wethey I, p. 106, no. 61; Hope 1980A, p. 34;
Reggio-Emilia 1984, pp. 102–3; Washington
1990, pp. 162–4, no. 9; Paris 1993, pp. 412–3,
no. 47; Pedrocco 2001, p. 99, no. 32

Titian's painting shows on the left-hand
side Saint Catherine, clasping the sword
that martyred her and sitting above the
broken wheel that failed to dispatch her.
Her hair is down as befits an unmarried
virgin, and seems darker at the roots,
suggesting she has bleached it. She wears a
mauve dress with short puffed sleeves and
a loose white undergarment, which allows
an attractive décolletage. Although the
golden threads are harder to see today, the
rose sleeves of her dress were embroidered
with gold so that the glistening of her
hair would have resonated across the
transparent cloth covering her shoulders.
Her green cloak is casually hung over her
left shoulder and wraps around her body.

The Christ Child is loosely draped in
what might be the Virgin's own veil and,
unusually, turns away from the donor,
who is being presented by Saint Dominic
(presumably his name saint) to the Virgin.
She gazes down at him, as he looks directly
at Saint Catherine. The landscape at the
right appears to mimic the profiles of the
donor and his intermediary. This, and
their strongly individualised features,
heightens the sense of their separation
from the sacred sphere of the idealised
Virgin, Catherine and the Christ
Child, who are placed before a dark
backdrop. Titian would further develop
this device of depicting the Child as
belonging to another world.

One has a sense of the influence of central
Italian sculpture in the way the Virgin
dominates the centre. It has been observed
that this painting is one of the earliest
attempts by Titian, following the Paduan
frescoes of 1511, to explore the illusion of
moving from inside to outside space. The
donor is plausibly a member of
the Balbi family, called Domenico: the
painting is first certainly recorded in
the Balbi collection in Venice in 1761.

Colour is also essential to the composition
and to the focus of the picture on the
Virgin and Child. She wears a deep vermil-
ion dress, with a blue cloak draped around
her, and against this the naked Christ
Child stands out clearly. To their right,
Saint Catherine's white shift contrasts
with the Virgin's blue cloak. Their bright
colours divide the holy group

from Saint Dominic and the donor,
dressed simply in black and white at
the right.

The Magnani-Rocca *Madonna* is one of
Titian's most lyrical private devotional
paintings. Its assured composition is full
of movement and emotion, demonstrating
how far Titian had progressed since *Jacopo
Pesaro being presented to Saint Peter* (cat. 3)
and *The Holy Family with a Shepherd*
(cat. 2), which both look rather laboured
in comparison.
CC, DJ

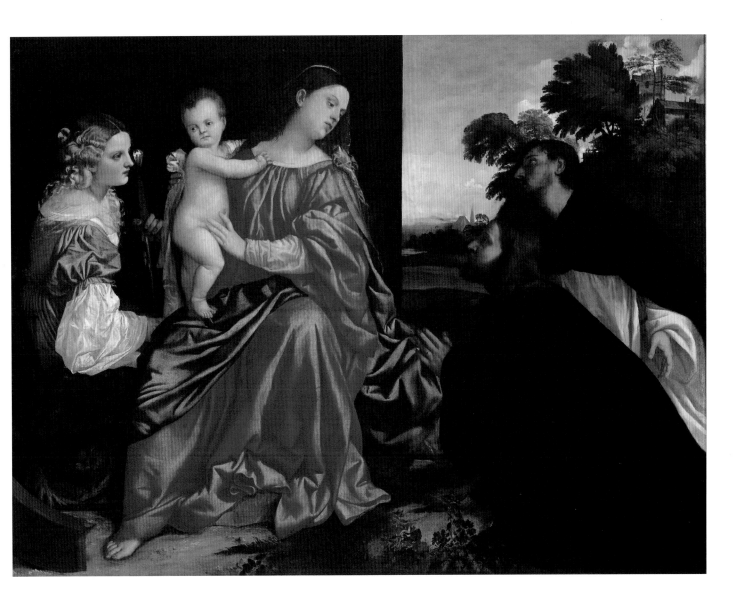

10. 'Sacred and Profane Love'
1514

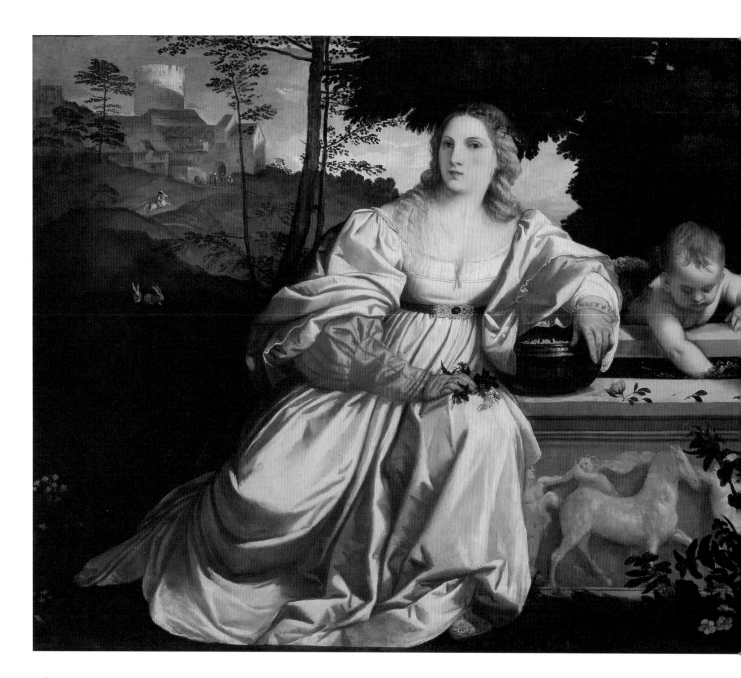

Oil on canvas, 118 × 279 cm
Museo Galleria di Villa Borghese, Rome,
inv. 147 NOT EXHIBITED

Select Bibliography: Ridolfi (1648), I,
p. 197; Crowe and Cavalcaselle 1877, I,
pp. 62–7; Ricketts 1910, pp. 42–4 (Medea
legend); Friedländer 1938, pp. 320–4
(*Hypnerotomachia Poliphili*); Mayer 1939,
p. 89 (*impresa* of Nicolò Aurelio); Suida
1933, pp. 28–9; Tietze 1936, II, p. 307;
Cantelupe 1964, pp. 218–27; Panofsky 1969,
pp. 110–19 (twin Venuses); Wethey III,
pp. 20–2, 175–9, no. 33; Hope 1980A,
pp. 34–7; Robertson 1988 (historio-social
reading); Goffen 1993 (Bagarotto as
patron); Rowlands 1996, pp. 160–2 (for
Bernardino da Asola's quotation of the
putto); Rome 1995; Joannides 2001,
pp. 185–93; Pedrocco 2001, pp. 105–7,
no. 41

Early descriptions of this painting, one of
Titian's most enigmatic works, give little
indication of its meaning or function.
In 1648 Ridolfi described it as 'two women
beside a fountain in which a putto looks
at himself'; its current, misleading title
is first recorded in 1693. Much ink has
been spilt by art historians attempting to
decipher the iconography of the painting.
It has been established that the patron was
probably Nicolò Aurelio (1453–1535),
whose coat of arms appears on the
fountain. He was a prominent *cittadino*
(the rank below patrician or noble) of

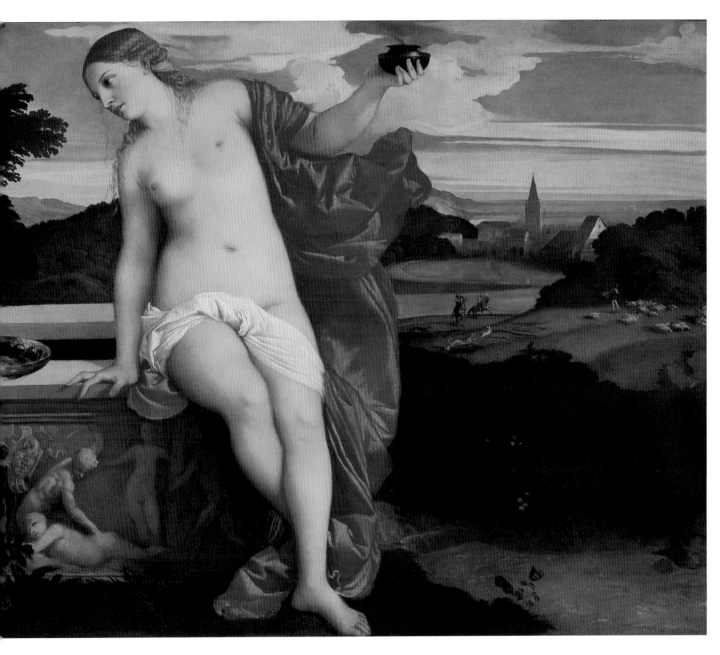

Venice, who married a wealthy widow from Padua, Laura Bagarotto, in May 1514. The diarist Marin Sanudo suggests that the union raised eyebrows, no doubt because Laura's father, and probably also her husband, had been executed by the Venetian state for treason in 1509. Indeed the marriage required the permission of the authorities, but the state had perhaps already been convinced of the Bagarotto family's innocence, for they were reprieved a few years later. In any event, Laura bore Nicolò a

son and a daughter, siblings to his illegitimate boy.

It has been claimed that the Bagarotto *stemma* was painted in the centre of the silver bowl resting on the fountain, although this cannot be proven. The absence of the coat of arms does not, however, negate the suggestion that the commission served to commemorate the marriage between Bagarotto and Aurelio. It is not a conventional marriage portrait, as the husband

is not included, and indeed it is unlikely that it is a portrait at all. Rather, it is an evocation of a mood, principally amorous, and in part ambiguous. Such images, set in a pastoral landscape, appealed to Venetian connoisseurs and it perhaps useful to compare this picture in concept with the Louvre '*Concert champêtre*' (fig. 5, p. 14) and *The Three Ages of Man* (cat. 8).

That the painting reflects Neo-Platonic theories of 'sacred' and 'profane' love is

untenable; Titian was not versed in such matters, and there is no precedent for the representation of such ideas in Venetian painting. It has been suggested that Pietro Bembo, who was an acquaintance of Aurelio, might have devised the programme, but there is nothing didactic about the painting, which is, rather, intensely private in nature.

The figure to the left, dressed in traditional wedding clothes and crowned with myrtle (sacred to Venus and a traditional marital accoutrement) looks speculatively into the distance. We may consider her a mortal, contemplating love and marriage, whose thoughts are fuelled by Venus, encouraging and enrapturing her, though invisible to her. Elizabeth McGrath has suggested comparing this juxtaposition of the two women with votive works in which the donor is presented to Christ (usually invisible to him) by a patron saint. Titian has apparently adapted an older formula to secular purposes, in response to a taste inspired by classical pastoral and lyrical texts.

The Venus is accompanied by traditional attributes, the red rose and Cupid. Again, the rôle of Cupid is open to interpretation, but what is most striking is the naturalism of his appealing naïvety. Just as he shows Clarissa Strozzi embracing her dog (cat. 24), so Titian chooses to depict Cupid as an inquisitive child, transfixed by the qualities of water. The significance or otherwise of the reliefs on this 'fountain of Venus' remains elusive, although Friedländer's hypothesis that they reflect woodcuts in the *Hypnerotomachia Poliphili* (published in Venice in 1499) is, particularly for the right-hand part, plausible; that the image in its entirety refers to the Aldine text is less convincing.

The low viewpoint of the painting encourages the viewers' close engagement,

as does the concentration on details such as the flowers and butterfly to the right of Venus's feet. In contrast, the two lovers in a rapturous embrace in the background, like the shepherd and the rider on horseback, are conveyed with the minimum of strokes, very much in the manner of Canaletto two centuries later.

The Venus can perhaps be regarded as a prefiguration of the Edinburgh *Venus Anadyomene* (Venus rising from the sea; fig. 46), figured in more sculptural mode. As Lodovico Dolce, for one, was well aware, the Venus had been the subject of a famous painting by Apelles; Titian would also have wished to present a critique of Giulio Romano's fresco of the same subject for Federico Gonzaga in the Sala delle Cariatidi in Mantua. Titian was working on a bathing scene for Alfonso d'Este in 1518, and offered a 'woman

bathing' to his nephew, Federico, in 1530. Titian drew upon Antonio Lombardo's treatment of *Venus* (Victoria and Albert Museum), and on a print by Marcantonio Raimondi of *Pan and Syrinx*.

It is convenient to date the painting to the moment of Aurelio's marriage to Laura Bagarotto, but it shows certain awkwardnesses that are characteristic of Titian's earlier years. He has had difficulty in foreshortening the right hands of the bride and of Cupid; the lower half of the bride's body is lost in her drapery and does not conform with her upper half, much like the Magdalen in *Noli me tangere* (cat. 7). An earlier dating cannot be ruled out; possibly Aurelio had been married before. AB, DJ

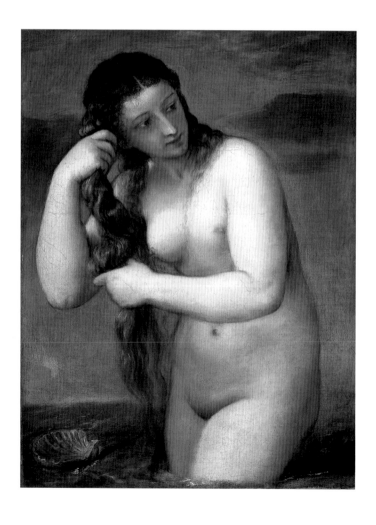

FIG. 46

TITIAN

Venus Anadyomene, about 1530
Oil on canvas, 75.8 × 57.6 cm
Duke of Sutherland Collection, on loan to the
National Gallery of Scotland, Edinburgh, NGL 60.46

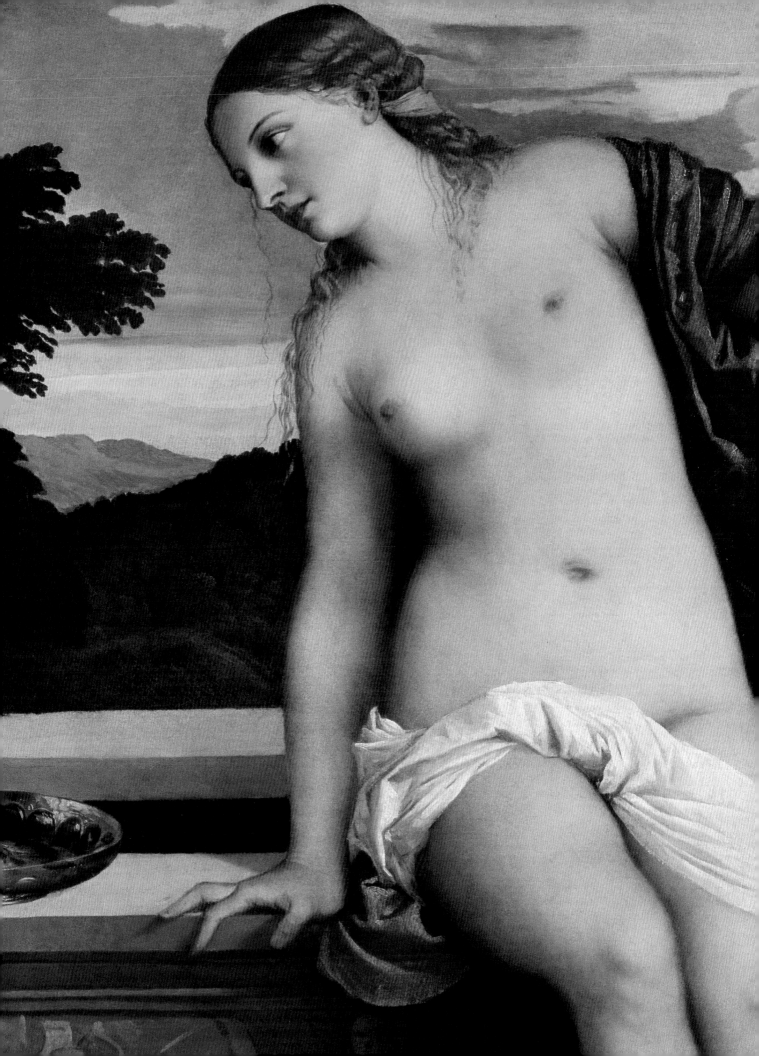

11. *Flora*

about 1515–20

Oil on canvas, 79.7 × 63.5 cm
Galleria degli Uffizi, Florence,
inv. 1890n.1462

Select Bibliography: Aretino [1972]; Dolce (1557), p. 135 (on beauty); Crowe and Cavalcaselle 1877, I, pp. 270–3; Wethey II, pp. 154–5, no. 17; Hope 1980A, pp. 62, 81; Paris 1993, pp. 363–5, no. 45; Rome 1995, p. 360; Pedrocco 2001, p. 104, no. 40

Flora is perhaps the supreme example of a genre developed in early sixteenth-century Venice showing '*belle donne*', beautiful women, for the sake simply of their beauty. They were neither portraits – as such they would have seemed improper – nor did they usually have allegorical significance or mythological references. The influence of this sort of painting is most evident in the work of Palma Vecchio. Images of this kind became the mainstay of his secular work, and the inventory of Palma's estate lists a number of such paintings. Titian did not invent the type, but developed the tradition represented by works such as Giorgione's '*Laura*' (Kunsthistorisches Museum, Vienna).

The painting is a magnificent evocation of sensuality. The tumbling locks of hair, sometimes minutely described, trail down across her cheek and shoulder to her undergarment, which laps her breast and shoulder in undulating waves (merely suggesting what lies beneath) before ebbing into the barely supported rose cloth which she gathers, or is perhaps discarding. All this frames her gently glowing flesh which, out of the subtlest of shadows, curves, moves and beguiles. This restraint offers the viewer a powerful fantasy and no more. Titian has therefore contained the provocative elements in the painting: as if taking the advice of Aretino's midwife in his novel *I Dialoghi*, Flora does not flaunt her breasts or even bare much of her arms, both areas of flesh considered erotic in sixteenth-century Venice. Again, when Aretino's experienced courtesan Nanna instructs her pupil how to present her breasts, she tells her: 'Remember, you should be grudging about showing them off … and not making them jump out of their stays and bodices'.

The image may be read as a generalised 'Venus' type. The flowers, perhaps roses, suggest an identification with Flora. Renaissance restorers often made up ancient female torsos into *Flora*s.

Lodovico Dolce (quoting Ariosto) specifically praises golden hair and dark eyes and eyebrows as marks of extraordinary beauty. However, Titian's ideal beauty may well have been painted from life rather than his imagination. The dark roots of her hair-parting and dark eyebrows, together with the realistically awkward grip on the flowers and the descriptive authenticity of the ring (down to the small jewel set into it) all suggest a specific model. It is tempting to speculate that Titian may have used his own wife, Cecilia, as a model for this work. They were married in 1525, but had been partners long before (see essay by Charles Hope, p. 18).
DJ

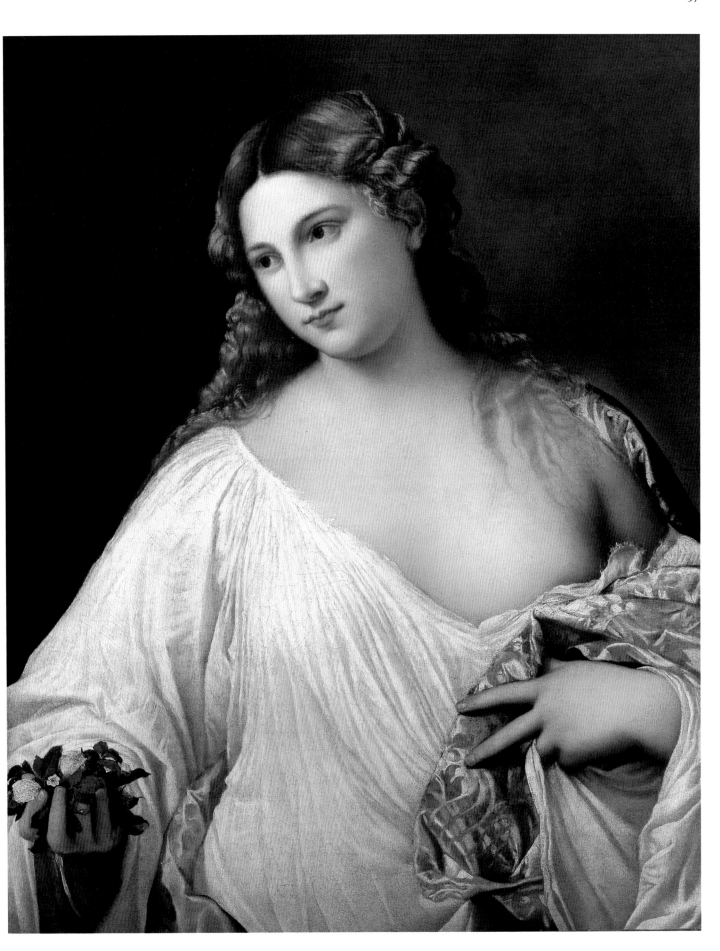

12. 'The Bravo'

about 1516–17

Oil on canvas, 75 × 67 cm
Kunsthistorisches Museum, Vienna, inv. 64

Select Bibliography: Michiel [1884], p. 98; Ridolfi (1648), I, p. 101; Klauner and Oberhammer 1960, pp. 135–6, no. 709; Wind 1969, pp. 7–11; Wethey III, pp. 130–1, no. 3; Holberton 1986A, pp. 190–2; Washington 1990, pp. 178–80, no. 13; Sutherland 1993; Pedrocco 2001, p. 112, no. 49; Joannides 2001, pp. 104, 247–8, 254, 267

This depiction of a moment of explosive tension between two men (called 'The Bravo' since the seventeenth century) may be 'the two half-figures attacking each other by Titian' recorded in the house of the Venetian patrician Zuanantonio Venier in 1528. It is an early example of the high drama more readily associated with Titian's later career, though the composition is still indebted to Giorgione. As Jennifer Fletcher has noted (p. 33), the figure of the youth probably derives from Giorgione's *Self-portrait as David* (copy in Brunswick, Herzog Anton-Ulrich Museum). Giorgione's *Warrior* (Kunsthistorisches Museum, Vienna), which seems also to have belonged to Venier, and also features two half-length male figures, is a still more significant precedent.

The structure and style of 'The Bravo' suggests that it should be dated close to Titian's first version of *The Tribute Money* (fig. 47), of 1516, which is also based around two male half-figures. However, 'The Bravo' is already far removed from the more static narrative of the holy picture. The composition is anchored by the older man in armour, seen from behind. The sword hilt in his left hand and his taut back show he is resolved on attack. He grasps the shoulder of the younger man before him, who turns to face him, also clutching a sword (glimpsed below his sleeve). The drama is heightened by contrasting colours – the assailant in red,

his quarry in blue – and strong lighting. Light hits the older man's back (shown by highlights on his breastplate and the swirls of red fabric on his sleeve) and the face of the youth, whose body is in shadow.

Most discussion of the *Bravo* has concentrated on its subject-matter. Ridolfi described the painting as 'Caelius Plotius assaulted by Claudius' (from the section on chastity in Valerius Maximus's *Memorable Sayings and Deeds*). Wind refined this, identifying the narrative as another lapse of classical male virtue: the lustful Caius Lucius's attack on the beautiful youth Trebonius, from Plutarch's *Lives*. Sutherland's suggestion that 'The Bravo' shows Pentheus's arrest of Bacchus' devotee Acoetes from Book III of Ovid's *Metamorphoses* is tempting, because it explains the presence of the vine leaves (sacred to Bacchus) in the youth's hair – an odd adornment for a virtuous young Roman. The youth's swivelling body and blond curls are also reminiscent of Bacchus in the *Bacchus and Ariadne* (cat. 13). Ultimately, Ovid's telling of this meeting is not close enough to the picture we see. More probably, the figures were not intended to be identifiable from myth or history, but, in Giorgione's mode, were inventions representative only of themselves.
CC

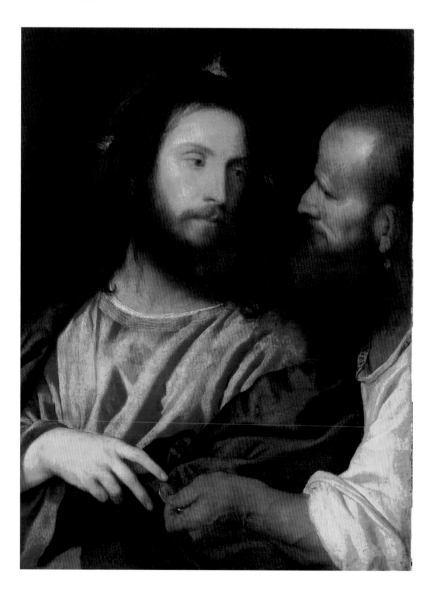

FIG. 47

TITIAN
The Tribute Money, 1516
Oil on panel, 75 × 56 cm
Gemäldegalerie Alte Meister, Staatliche Kunstsammlungen, Dresden, inv. 169

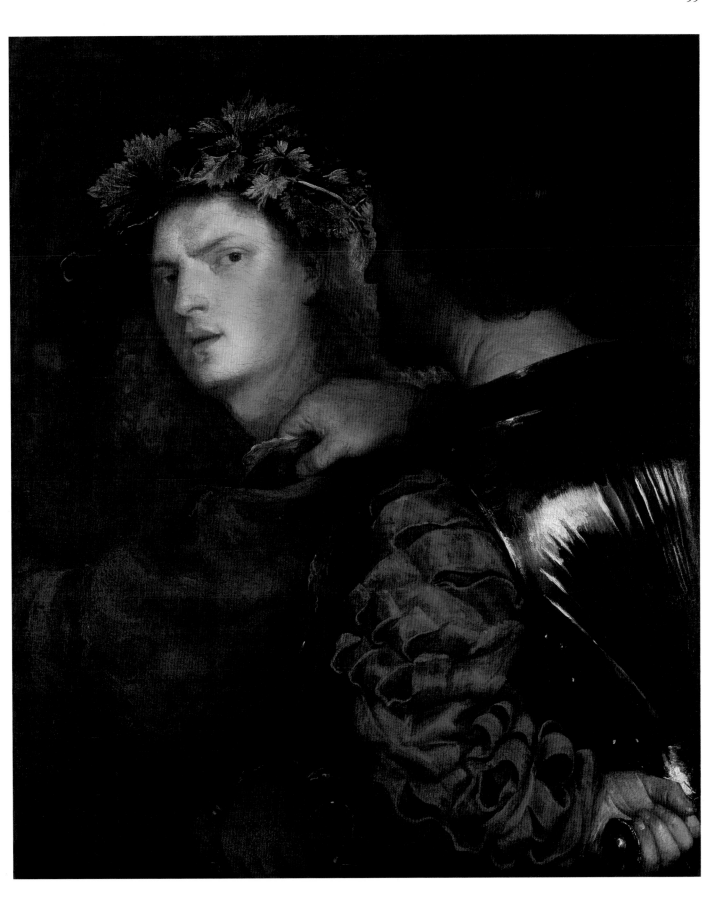

II ALFONSO D'ESTE'S CAMERINO

IN THE YEARS BETWEEN 1518 AND 1524, Titian was commissioned by Alfonso d'Este (1476–1534) to paint three mythological scenes for a 'study' or *studiolo*, known as the Camerino, one of a series of private rooms created by the duke for his main residence in Ferrara. Much remains uncertain about the decorative scheme and even the precise location of the Camerino, which, in 1598, when the pope had reasserted his rights over the territory, was stripped of its paintings by Cardinal Pietro Aldobrandini, the pope's nephew.

Alfonso was an enthusiastic lover of art (he had visited Michelangelo as he painted the Sistine Chapel ceiling, and begged for a painting from his hand), and a letter to the duke's sister Isabella d'Este in 1513 from the court humanist, Mario Equicola, declared that Alfonso 'cared only for commissioning pictures and seeing antiquities'. The duke's intention may have been to re-create an ancient picture gallery in his Camerino: two of Titian's paintings, *The Worship of Venus* (cat. 16) and *The Andrians* (cat. 14), take their subjects from Philostratus' *Imagines*, a series of descriptions of fictive paintings (*ekphraseis*) imagined hanging in a gallery in Naples.¹ However, the fact that Alfonso did not engage a single artist to decorate the room, but instead commissioned works from a range of painters, suggests that he was equally concerned to acquire a collection of paintings by the greatest masters of the day. The project had begun with Giovanni Bellini's *Feast of the Gods* (cat. 15), which was completed in 1514, and was to continue with works by Fra Bartolommeo and Raphael. But Fra Bartolommeo, who had been commissioned to paint *The Worship of Venus*, died in 1517 and Raphael had submitted no more than a drawing of *The Triumph of Bacchus* before his death in 1520.¹ Alfonso's favourable response to Titian's 1516 *Tribute Money* (fig. 47, p. 98) and the demise of these rivals led to the duke giving Titian almost free rein to complete the decoration of the Camerino, although the Ferrarese court painter Dosso Dossi was also involved, contributing a *Bacchanal with Vulcan* for the series (now lost) and ten oblong canvases depicting scenes from Virgil's *Aeneid*, that probably formed a frieze above the main canvases (figs. 49–51).²

This exhibition reunites, for the first time since their dispersal in 1621, Titian's three paintings and Bellini's *Feast of the Gods*. The chronology of these works, though not documented in detail, has been generally agreed upon by scholars. Titian's *Worship of Venus* is assumed to be the first of the series, and was probably completed by January 1520. The Bellinesque treatment of soft, lingering light contrasts with the bravura of the *Bacchus and Ariadne* (1520–3) and *The Andrians* (1523–4). In these images, Titian displayed his mastery of archeological minutiae and naturalistic detail set within a grandiose scheme. Quite how the paintings were displayed remains a matter of debate; in our diagram (fig. 48), we have slightly modified Charles Hope's widely accepted reconstruction in order to take into account the direction of light in *The Worship of Venus*.³ In the catalogue, the paintings follow not their chronological order but their hypothetical order round the room.

Titian's contribution became central to the unity of the Camerino's decoration, so much so that he was required (probably on a visit to Ferrara in 1529) to repaint the left background of Bellini's *Feast of the Gods* in order that it might tune harmoniously with his own mythological landscapes. The reclining female nude which dominates the foreground of *The Andrians* not only echoes, but competes with, the figure of Lotis in Bellini's painting, reflect-

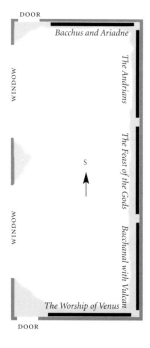

FIG. 48

Reconstruction of Alfonso d'Este's Camerino, showing location of pictures

TITIAN
The Worship of Venus, 1518–20
(detail of cat. 16)

ing the competitive spirit engendered by Alfonso's policy of using a variety of artists. The figure wreathed in snakes in *Bacchus and Ariadne* is a double quotation: of the *Laocoön*, perhaps the most famous antiquity to be unearthed during Titian's lifetime (two bronzes of the same subject were owned by Isabella), and of Antonio Lombardo's own citation of the *Laocoön* in his relief depicting *The Forge of Vulcan* (fig. 52, p. 104).[4] The relief was one of a series (one of which bears the date 1508) carved by Lombardo for the ducal palace, and, while most were probably displayed in the adjacent room, *The Forge of Vulcan* may well have been displayed over one of the Camerino's doors.

We may never know precisely what the Camerino's programme meant to Alfonso, but, given the predominance of Bacchic themes, it is interesting to note that certain ancient accounts, notably Diodorus Siculus' *Bibliotheca Historica,* stress Bacchus as an exemplary conqueror and ruler. Raphael's *Triumph of Bacchus* would have fitted well with such an allegorical reading, as would the subject-matter of Dossi's frieze. Illustrating scenes from Virgil's epic account of the foundation of Rome, it may have been intended as a reflection of Alfonso's military prowess, and the peace and prosperity that would ensue from it.

Alfonso's Camerino was not intended solely for personal glorification (although there was surely an element of competition with his sister Isabella's *studiolo* at Mantua), but to offer a space for enjoyment and quiet contemplation. An inscription on one of the Lombardo reliefs notes that the duke had created the rooms for the purpose of '*otium*' and rest; another reminds us that he who rests should take action and he who acts should take rest.[5] In his will Titian's Venetian patron Gabriel Vendramin declared that his art collection served to bring 'a little peace and quiet to my soul during the many labours of mind and body that I have endured in conducting the family business'.[6] The Camerino served a similar function, to provide a restful diversion from state matters.

It is worth noting that Isabella was informed in 1517 of a marble room with a mix of figures and reliefs adorned with vases and antique and modern figures.[7] This may well have been Alfonso's Camerino, which probably included *all'antica* bronzes as well as casts after statues such as the *Laocoön*. Alfonso had also acquired the head of Michelangelo's destroyed bronze statue of Pope Julius II in Bologna, as well as cartoons for two paintings by Raphael, and many antiquities. He had inherited a great collection of Netherlandish paintings as well as jewel-like works by Ercole de' Roberti, including the National Gallery's diptych of *The Adoration of the Shepherds* and *The Dead Christ*.[8] We do not know whether any of these – or the vases he himself turned – were in the *camerini*. We do know that Alfonso's son Ippolito later owned a very beautiful ancient relief of *Hercules in the Garden of the Hesperides* (now in the Villa Albani, Rome), which matches the taste of Antonio Lombardo's reliefs,[9] and may possibly have been inherited from his father. In its reference to 'antique and modern' figures, the report to Isabella recalls the names of the early sixteenth-century sculptors 'Antico' and 'Moderno', the former of whom worked for the Gonzaga court (Isabella may have given both their nicknames). Aretino's description of a later Gonzaga court artist, Giulio Romano, as making the ancient seem modern and the modern seem ancient is a reminder of the humanistic climate of these northern Italian Renaissance courts, nowhere more exquisitely manifest than in the hellenising taste of Alfonso d'Este's *camerini*.

13. *Bacchus and Ariadne*
1520–3

Oil on canvas, 176.5 × 191 cm
The National Gallery, London, NG 35

Select Bibliography: Campori 1874, pp. 581–620 (documents); Venturi 1928, pp. 111–15 (documents); Thompson 1956, pp. 259–64 (literary sources); Hope 1971–2 (Camerino); Hope 1973, pp. 805–10 (documents); Gould 1975, pp. 268–71; Wethey III, pp. 148–51, no. 14; Lucas and Plesters 1978 (condition and technique); Holberton 1986B (for another view of Titian's sources); Holberton 1987 (Camerino); Hope 1987 (Camerino); Shearman 1987 (Camerino); Shearman 1992, pp. 251–4; Pedrocco 2001, p. 135, no. 71

Bacchus and Ariadne is generally agreed to have been painted after *The Worship of Venus* (cat. 16) but before *The Andrians* (cat. 14), although there is no documentation for it. The latter seems closer in style to *The Worship of Venus* and it is both less ambitious in character and less original in its use of sources than is *Bacchus and Ariadne*. Whereas *The Andrians* and *The Worship of Venus* follow closely the descriptions of paintings in the *Imagines* of Philostratus, *Bacchus and Ariadne* depends upon two ancient texts, imaginatively combined. These texts are by great poets, writers of far greater stature than Philostratus, and the painting depicts a dramatic episode in the lives of gods and heroes, not merely idyllic scenes enlivened by amorous and comic incidents.

From Catullus, Titian took the description of Ariadne deserted on the shore of Naxos and the wild train of Bacchus, elsewhere on the island seeking for her, whereas he depended upon Ovid's description of the meeting between the desperate, dishevelled, barefoot heroine and the god. Bacchus, who, having promised her the stars (literally, for he assures her that she will be immortalised as a constellation,

visible here in the sky above her), leaps from his chariot, fearing that the beasts which draw it will frighten her, and clasps her to his breast. Only foreground elements, notably the lapdog yelping unheard by the intoxicated satyr-child, are not in these classical sources. And this particular detail conveys best the artist's ambition to paint something both comic and alarming, familiar (the dog was perhaps a court pet) and exotic (the cheetahs were no doubt studied from the Duke's menagerie) and antique. But Titian also painted something heroic – the twisting movement of Ariadne's body, which the artist much revised, is not undignified in its desperation – and something magical – his long-haired young god flies through the air. Few artists had previously attempted to represent a figure in movement of this kind.

The room for which the painting was made was a small one and the painting is full of details which could be relished when it was examined closely. The bronze vessel signed *TICIANVS* may well have been one of the antiquities kept in the room. The very deep blues of Ariadne's cloak, the sea and the sky are condensed in the beautiful iris and columbine among the vegetation on the right. These flowers, however, had often been painted by other artists, whereas the little white caper

flower was much more unusual. It was doubtless chosen as appropriate for the setting (it favours the rocky shore) but is witty and erudite since it is related etymologically to the goat-boy capering beside it. Some beautiful passages of painting have been damaged because of abrasion (notably the view of the distant shoreline) and there have been many losses to the painted surface, especially in the sky.

Although the location of the Camerino and the exact arrangement of the works of art within it (which included a painting by Dosso which has not been identified) remain the subject of scholarly dispute, it is clear not only that the nature of the landscape but also the composition and its direction were calculated by Titian in relation to the other paintings in the room. Although not easily accessible before it was taken to Rome in 1598, the painting's influence on European art was very great. With it the loves of the gods ceased to be a subject associated chiefly with furniture decoration and villa frescoes and became a subject, indeed the most popular subject, for the gallery picture – first and most notably in the *poesie*, the Ovidian narrative paintings which Titian himself began to paint for the King of Spain over twenty years later. NP

FIG. 52
ANTONIO LOMBARDO (1458–1516)
The Forge of Vulcan about 1508–16
Marble, inlaid with coloured marble, 83 × 107 cm
The State Hermitage Museum, St Petersburg, inv. ESPN.sk.1771

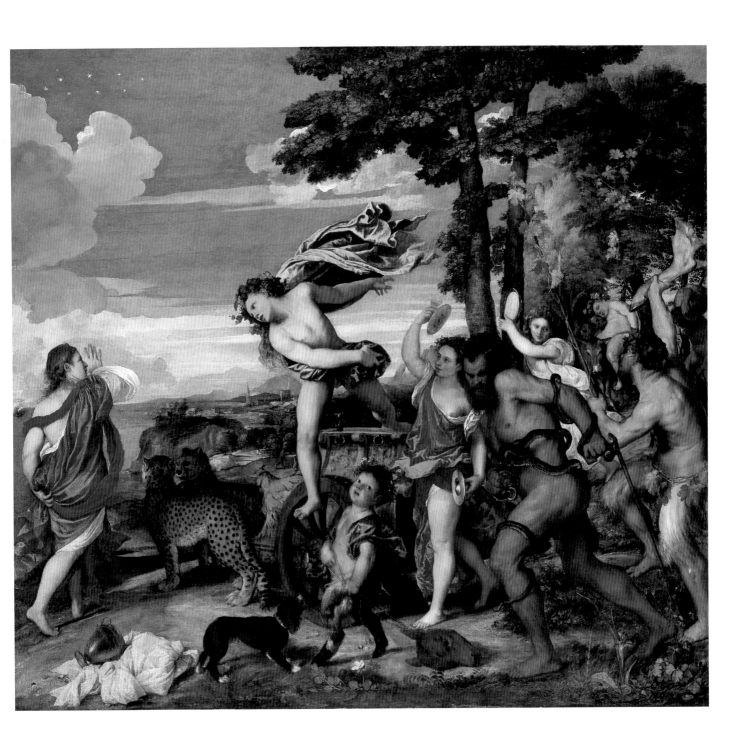

14. *The Andrians*

about 1523–4

Oil on canvas, 175 × 193 cm
Museo Nacional del Prado, Madrid,
inv. 418

Select Bibliography: as previous; Wethey III, pp. 151–3, no. 15; Rubinstein 1984 (river-gods); Bober and Rubinstein 1986, nos. 53 (urinating putto), 90c (funerary relief); Newton 1988, pp. 63, 132 (dress); Pedrocco 2001, p. 140, no. 78

This scene is devoted to a celebration of the pleasures of wine and its effects. It is the most spatially complex of the series, with its carefully orchestrated vistas, such as the man making wine accompanied by his dog in the central background, and its beautifully integrated sky, land and trees, all in a convincing envelope of light. Titian describes a world where winds blow rolling clouds and a ship to a plentiful land of grape-laden vines, with a well-fed guinea fowl perched high in sun-dappled leaves – a land where every appetite could be sated. The muscular excesses and overly self-conscious antiquarianism of *Bacchus and Ariadne* has given way to a more harmonious, less ostentatious choreography of pose and gesture in this golden age of pleasures.

The smart yellow trousers with slashed strip of the man in profile holding the tree trunk suggests that he and his companion may be portraits of two court favourites. Clothes were a courtier's biggest investment and it would have been obvious to a contemporary audience if these figures were dressed in Este livery. (Titian dresses Pesaro in similar yellow and black hose in the Pesaro altarpiece, fig. 7, p. 15, though here it is the family livery). The dress of the dancing maenad, however, is distinctly classical – chiton-like. The earrings she wears would have been associated with the East, until around 1526, when they became popular with Venetian women (Jane Bridgeman kindly drew my attention to the evidence for this).

There is remarkable energy in the swirling dancers, whose costumes are perhaps gently blown by the same breeze that brings a boat into shore, while others are less animated. Titian weaves together distinct activities in a narrative cycle: it begins with the exuberant dancers, who succumb to a more languid activity of exchanging intimacies, finally abandoning themselves to sleep. Amidst this a small boy is urinating into the river of wine which replenishes the revellers' vessels. This circular rhythm of both dancers and wine-makers is contained by the slumbers of the recumbent figures on the right. To complete the mood Titian's own signature is in a note tucked into the front of the chemise of the auburn-haired beauty who leans across to chat to her companion while her bowl is refilled in keeping with the words of the song beside her: 'Who drinks and does not drink again does not know what drinking is'.

In *Imagines* I, XXV Philostratus describes the island of Andros, where the inhabitants find a river of wine created by Bacchus on his arrival by boat.
'For by the act of Bacchus the earth of the Andrians is so charged with wine that it bursts forth and sends up for them a river; if you are thinking of water, it is not great, but if you think of wine it is indeed a great river – great and divine This, I believe, is what the Andrians are singing to their wives and children, crowned with ivy and sage; some of them are dancing on either bank, some reclining They sing as well that this river alone is not disturbed by the feet of cattle or horses, but is a draught drawn from Bacchus, and is drunk unpolluted, flowing for men alone. This is what you should imagine you hear some of them singing, with their voices thick with wine. Consider, then, what is to be seen in the picture. The river lies on a bed of grapes, pouring forth its stream ...; thyrsi grow about it like reeds around bodies of water, their branches wound with tendrils of vine Bacchus himself sails to the revels of Andros and, his ship now moored in the harbour, leads a throng of satyrs and bacchantes and sileni. He leads Laughter and Revel, who are the most spirited gods and ready to join the drinking, so that the river's bounty may be most sweetly enjoyed.'

Philostratus's text is definitely the scene set for the painting, but the drinking song may be informed by Ovid's *Fasti,* III, 523–40, describing the feast of Anna Perenna in which 'common folk' pair up and drink and pray 'for as many years as they take cups of wine ... they sing and dance and the spruce sweetheart skips about with streaming hair'. Titian used a variety of visual sources for the painting, both contemporary and classical. The male nude reclining in the central foreground, to the right of the woman raising the cup, is based on a figure in Michelangelo's cartoon for *The Battle of Cascina*. Further to the left, the reclining female seen from the rear may derive from a Roman funerary relief in the Sassi collection which was well-known in early sixteenth-century Rome, entering the Farnese collection in 1548. The small child raising his robe to urinate was certainly a familiar type in ancient sarcophagi. The beguiling dancer recalls an ancient torso in the Grimani collection, but re-cast by Titian from the living model.

The more distant male sprawled on a bed of vines is the god responsible for the river of wine; when copying this work Rubens was confused by Titian's ignorance of the ancient convention for representing river-gods, then being adopted by other artists, so he deleted this figure and re-cast the foreground nude as the nymph of the stream.

Venetian connoisseurs believed that painters should aspire to imitate nature; here Titian has transcended imitation to conjure into being a plausible and enchanting pagan world. The figures in contemporary dress may, by a pastoral convention, only be aware of the spirits cavorting around them, without being able to see them; the yellowed varnish of the painting now helps to veil from them both these pagans brought back to life and the physical damage the painting has suffered. When the paintings are reunited the contour of the hill joins the mountain of the adjacent Bellini (cat. 15) just as the wine carrier reappears around the corner in *Bacchus and Ariadne* (cat. 13).
DJ

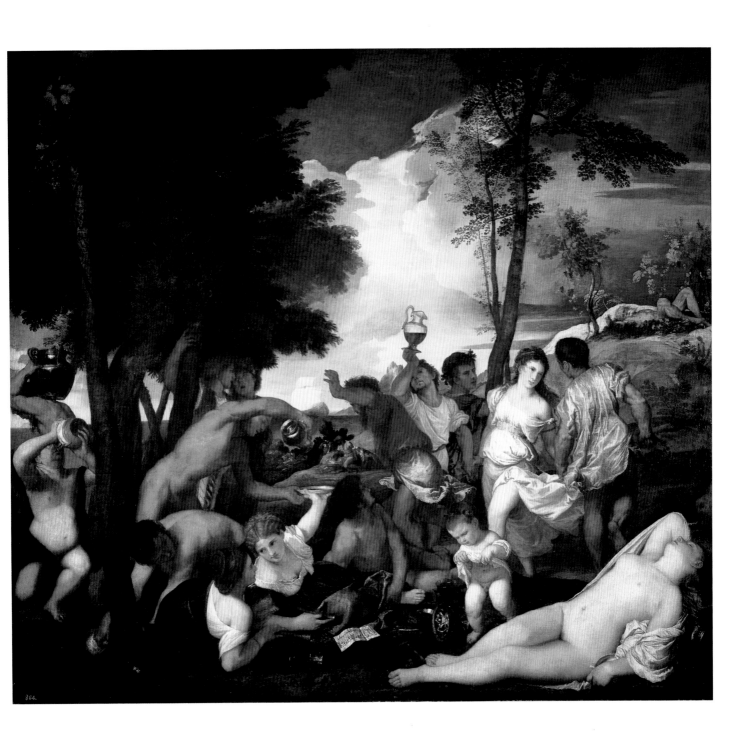

15. Giovanni Bellini (about 1430–1516), with additions by Titian *The Feast of the Gods*
1514–29

Oil on canvas, 170.2 × 188 cm
National Gallery of Art, Washington, D.C.,
Widener Collection, inv. 1942.9.1

Select Bibliography: as previous; Vasari
(1568)A, VI, p. 158; Fehl 1974; Wethey III,
pp. 143–5, no. 12; Colantuono 1991;
Pedrocco 2001, p. 144, no. 80

The Feast of the Gods was the first painting
to be installed in Alfonso's Camerino,
although Antonio Lombardo (see figs. 52,
53) had been working for the duke since
1506. The relief-like structure of Bellini's
picture – like a sarcophagus front in paint
– fits well with Antonio's creations, and
highlights the way Titian's contributions
to the Camerino, including the repainting
of the background of Bellini's work,
represent a revolutionary break with these
earlier commissions.

Bellini's painting shows the events which
ensued when Cybele, goddess of harvest
and fertility, summoned the Olympian
deities to a feast. Silenus, accompanied
by his faithful ass, was an uninvited
guest. The wine was supplied by Bacchus
(unusually here shown as a child, drawing
wine from a cask), and flowed in lavish
quantities. Most of the guests fell asleep,
giving Priapus an ideal opportunity to
seduce the nymph Lotis. However, the
braying of Silenus' donkey disturbed
Lotis's slumbers. She pushed away her
unwelcome suitor. The animal paid for
his noise with his life, inaugurating the
annual sacrifice of an ass to Priapus.

The Feast of the Gods is a conflation of two
episodes from Ovid's poetic calendar or
Fasti concerning Priapus, the god of
gardens and the countryside, and his
attempted seductions of the nymph Lotis
and the goddess Vesta (*Fasti*, I, 391–440;
VI, 319–48). Fehl has argued that Bellini's
painting was originally based on an *Ovidio
volgarizzato*, a free translation of the
Metamorphoses which set the scene not at
a feast of the gods but at a gathering of the
citizens of Thebes. Bellini must later have
been directed to the authentic text of the
Fasti, and then reworked the picture to
transform the Thebans into immortals –

from left to right a satyr, the priest now
become Silenus, tethering an ass, Bacchus
as a boy, Silvanus, Mercury (with
caduceus), another satyr, Jupiter (with
eagle), a nymph, Cybele, Pan (with pipe),
Neptune (with trident), two nymphs,
Ceres, Apollo, Priapus and Lotis – at the
same time lowering the female neck lines.

In the light of Fehl's hypothesis, it is not
surprising that Titian slavishly followed
the text provided for *The Worship of Venus*.
In his later works for the Camerino Titian
instead cherry-picks elements of ancient
descriptions that would translate well
into imagery, for example in the figure
wreathed in snakes which dominates the
foreground of *Bacchus and Ariadne*.
While Ovid's *Ars Amatoria* seems the most
important textual source for this work,
Catullus' reference to a bacchant wreathed
in snakes in his description of an em-
broidered bedspread showing Bacchus'
encounter with Ariadne must have
prompted Titian to incorporate this figure.
Similarly, the branch wrapped in vine
leaves carried by a bacchant represents
Titian's highly visual response to the
ancient sources. In Moscus' translation
of Philostratus' *Imagines* which the duke
had borrowed from his sister Isabella, and
which provided the text for *The Andrians*,
Moscus wrongly explained a thyrsus as 'a
vine-wrapped branch'. The tree encircled
with a vine which grows in the foreground
of *The Andrians* may be a response to

Moscus' interpretation, and Titian's
portrayal of the bacchant in *Bacchus and
Ariadne* is indebted to these encounters
with Renaissance commentaries on
classical texts.

That Titian had a rôle in *The Feast of the
Gods* has been known since Vasari's
report, but the true extent of Titian's
intervention has only become clear in
the last fifteen years. The old-fashioned
elements of *The Feast* must have become
increasingly obvious as Titian's works
were installed in Alfonso's *studiolo*, for
they endowed ancient subjects with a
modern feeling and energy quite lacking
in the earlier master's composition. In
order to harmonise Bellini's contribution
with the rest of the ensemble, the
Ferrarese court artist Dosso Dossi may
have been asked to repaint the landscape,
probably before 1519. If he made alter-
ations, they did not have the desired
effect, and subsequently Titian undertook
a wholescale revision of the landscape and
sky (see p. 114). This interpolation dis-
rupted the uniform row of figures, gave
the composition greater depth, and made
the improbable meeting of the gods more
believable. Now *The Feast* harmonised
with the neighbouring *Andrians*, comple-
menting the rhyme already created by the
reclining nudes on the right-hand edge of
both paintings.
DJ, Sorcha Carey

FIG. 53

ANTONIO LOMBARDO
Minerva and Neptune (?)
about 1508–16
Marble, 83 × 105 cm
The State Hermitage
Museum, St Petersburg,
ESPN.sk.1770

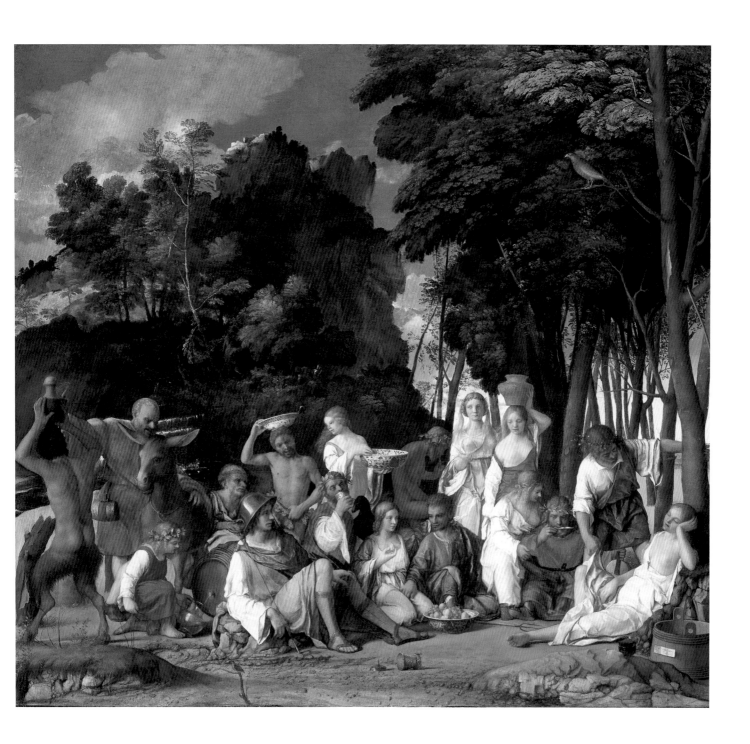

16. *The Worship of Venus*
1518–20

Oil on canvas, 172 × 175 cm
Museo Nacional del Prado, Madrid,
inv. 419

Select Bibliography: as previous; Wethey
III, pp. 146–8, no. 13; Pedrocco 2001, p. 126,
no. 54

Ovid (*Fasti*, IV, 133–50) describes a rite
of worship dedicated to Venus which took
place on 1 April in the Roman calendar.
Women would make offerings of incense
to a statue of Venus in order to cleanse
'every blemish on their bodies'.
Philostratus describes an ancient painting
which must have depicted this event. It is
on this text, *Imagines*, I, VI, that *The
Worship of Venus* must be based. The text
is almost exactly reproduced:
'See cupids are gathering apples: and
if there are many of them, do not be
surprised The cupids' quivers are
studded with gold, and golden also are
the darts in them ... they have hung their
quivers on the apple trees; and in the
grass lie their broidered mantles Ah,
the baskets into which they gather the
apples! What abundance of sardonyx, of
emeralds, adorns them, and the pearls
are true pearls; but the workmanship
must be attributed to Hephaestus! But
the cupids need no ladders wrought by
him to reach the trees, for aloft they fly
even to where the apples hang As for
the cupids further away, surrounded by
many spectators, they have come at each
other with spirit and are engaged in a
sort of wrestling-match One has
caught his opponent by lighting on his
back, and seizes his throat to choke him,
and grips him with his legs; the other
does not yield, but struggles upright and
tries to loosen the hand that that chokes
him by bending back one of the fingers
till the others no longer hold or keep
their grip. In pain the cupid whose finger
is being bent back bites the ear of his
opponent And let not the hare yonder
escape us, but let us join the cupids in
hunting it down ... the cupids hunt it
from place to place and make it dash
headlong, one by clapping his hands,
another by screaming, another by waving
his cloth'

On the right Titian illustrates a young
woman and a matron beautified by Venus
checking the results in a mirror before a
shrine crowned with a statue of Venus and
surrounded by votive tablets seeking
enhancements. The statue, like the similar
back view in the relief in *Jacopo Pesaro
being presented to Saint Peter* (cat. 3), is
inspired by antique statues and coins
which showed just such a low waistline.
Alfonso's sister Isabella owned a statuette
by Antico after the Belvedere *Venus* in gilt
bronze (now Kunsthistorisches Museum,
Vienna), which is a mirror image of
Titian's painted Venus. Alfonso may have
had another cast of the sculpture, which
originally seems to have held a mirror. The
rest of the painting is devoted to
Philostratus's throng of putti, who
variously gather apples, chase a hare, climb
a tree and share affectionate attentions
with each other, as described. This
perspectival river of putti terminates in a
wild dancing circle in the middle distance.

The central hair-parting on the kissing
putto on the right may indicate she is a
girl (compare the putto in cat. 8). One
suspects that Titian, in bringing to life an
ancient picture, is also translating the
many Roman sculptural reliefs of putti
that were known into this convincing
painted form. Titian has gone to
enormous trouble to depict fine detail,
down to the decoration of the basket with
antique cameos – highly prized princely
accessories in the Renaissance. The
cornelians and pearls were specified in the
text but Titian has given them authentic
antique designs. The colour scheme of red,
white and blue in both this painting and
The Andrians might be taken as a reference
to the Este colours.

From the 1518 correspondence we know
that Titian thought this painting was
destined for the long wall of the Camerino
but, unlike the *Andrians* (cat. 14), no effort
has been made to join its apple grove to
the landscape Titian added to the Bellini
(cat. 15) on that wall. Like *Bacchus and
Ariadne* (cat. 13) it has an angled
composition (lit from opposite sides)
which suggests side wall positions. Lorne

Campbell has noted that the cupid archer
even appears to be shooting across the
space when viewed from the right. Titian
may have left, or added, the Dossoesque
tree with a bird on the right of the Bellini
as a link to the now lost work by Dosso.
Two of the present Dossos (figs. 49, 51, p.
103) are also lit from the right suggesting
they too hung on the *Worship of Venus*
wall.

This painting is the best preserved of the
Camerino series. Only the top right
quadrant seems to have suffered. One is
immediately struck by the vibrant energy
of the putti laughing, kissing, wrestling
and dancing. Titian has brilliantly
captured the literary description of their
to-ing and fro-ing – be it the earnest
conversation bottom left or the two
catchers (of arrows and apples) beside
them. Glances and gestures weave
throughout the composition, even in the
sky-diving ring of aerial putti above.
DJ

III THE 1530S: LANDSCAPES

IT IS GIORGIONE who is credited with introducing to Venetian collectors a new type of painting featuring mood landscapes. The popularity of these images was such that seemingly different versions of the same painting were created: on Giorgione's death, Isabella d'Este tried to acquire a '*notte*', or night scene (now lost), which, she was told, might be the painting owned by one Vittorio Bechario or one that a nobleman, Taddeo Contarini, possessed.[1] Giorgione's early death created a market where demand outstripped supply and stimulated the production of numerous imitations. The situation was not limited to Giorgione; there is evidence that another version of Titian's *Three Ages of Man* (cat. 8) at one time existed, suggesting the high esteem in which these images were held and anticipating the popularity of the mythologies or *poesie* created for Philip II.[2]

Landscape painting had been regarded in Italy as a prerogative of northern (Netherlandish or German) artists. The Venetian taste for northern-style landscapes was perhaps precipitated by Antonello da Messina, who arrived in Venice about 1475 after working for the court in Naples, where he had had contact both with Flemish work and with Flemish-trained artists. (His *Saint Jerome* in the National Gallery represents an Italian conception of the virtues of northern art). Albrecht Dürer, who was in Venice from the summer of 1505 to January 1507, served to increase enthusiasm for the northern tradition with his altarpiece *The Feast of the Rosegarlands* (commissioned for San Bartolomeo al Rialto, now in the National Gallery, Prague). Its mimetic and highly finished description of detail must have been a critical influence on the young Titian. The concise portrayal of fauna in his *Bacchus and Ariadne* (cat. 13) reflects this tradition, as Alfonso d'Este, himself a collector of northern works, would have appreciated. Attention to foreground detail is a consistent feature of Titian's pictures, notably the snails in the Louvre *Entombment*, the butterfly in '*Sacred and Profane Love*' (cat. 10) and the lizard in the Milan *Saint Jerome*. The meticulously painted trees on the left hand side of the Aldobrandini *Holy Family* (cat. 19) have a freshness indicative of first-hand study.

In depicting landscape backgrounds, Titian's technique is in marked contrast to the essentially linear, planar structures found in works by artists like Perugino and Raphael, since he creates depth and the illusion of spatial recession through the use of graduated chromatic intensities. His early *Flight into Egypt* (fig. 39, p. 72), if not a skilful pastiche, is a remarkable prefiguration of his ambition to capture sweeping panoramas of lakes, woodlands and hills.[3] The protagonists in both *Noli me tangere* (cat. 7) and '*Sacred and Profane Love*' (cat. 10) are set against an evocative passage of distant blue mountains interspersed with diagonal *sfumato* wooded glades, anticipating the recessional pastoral scenes for which Claude was renowned a century later.

Landscape was much more than a formal backdrop in Titian's pictures. His reworkings of landscape in his own and others' paintings indicates its importance to his compositional structures and the integration of figures within their setting. Around 1510–12 Titian either painted in or repainted the landscape in Giorgione's *Venus* (fig. 45, p. 86), transforming the tenor of the picture by so doing. His repainting of the background of Bellini's *Feast of the Gods* (cat. 15) illustrates the important rôle played by landscape in harmonising Bellini's

TITIAN
The Presentation of the Virgin,
1534–8 (detail of fig. 11, p. 21)

painting with his own works for the Camerino. The trees were shorn at the right, and the resulting grove resembles those in *Bacchus and Ariadne* and *The Andrians*. Bellini's arboreal screen, similar to that in his *Death of Saint Peter Martyr* in the National Gallery, was replaced with a rocky promontory and a sweep of sun-drenched grassland complete with hunting dogs and a satyr, which serve as pendants to the huntsman and dog sketchily transposed into the middle distance of *The Andrians* (cat. 14). The skyscape, with the sun attempting to break through the large cloud directly above the crags and the tree-tops, is particularly close to the clouds in Titian's earlier woodcut, *The Submersion of Pharaoh's Army* (1513–15). Details in Titian's re-working, such as the tiny stag silhouetted on a crag in the mountain and the foliage, confirm his microscopic attention to detail where he felt it appropriate. At a later date (after 1528) he completed a *Holy Family* (cat. 17) which had remained unfinished on Palma Vecchio's death. Here, Titian's opalescent touch in mountain and seashore successfully unified the sky with the figures.

Early in his career Titian had grasped the colouristic advantages of matching the azurite hues of the sky to the costumes of the protagonists (see *Bacchus and Ariadne*). Landscape was also used to enhance meaning or narrative. In the *Three Ages of Man* the fecundity of the couple is mirrored by their verdant backdrop, and the lushness of their setting gives way sharply to barren soil beside the putti and the old man.

Titian was also attentive to the dramatic possibilities of skyscape. Clouds were used in a sculptural manner, counterbalancing figures, fluttering drapery and even mountains and woodlands. *Bacchus and Ariadne* must have been even more spectacular when the clouds still held their corpulent spatial body, set above an enticing play of blues, greens and sunlit yellows.[4] The intended effect can be imagined by looking at comparative works such as the woodcut of *The Submersion of Pharaoh's Army* and prints after the lost *Battle of Spoleto* (1537–8; fig. 54). The preparatory drawing in the Louvre for the *Battle* shows a clear evocation of stormy atmospheric effects, much in the manner of the evocative cumulo-nimbus cloudscape in the 1538 *Presentation of the Virgin* (fig. 11, p. 21; detail p. 112).

Titian's later works show a more turbulent and free depiction of landscape. The broad scumbling horizontal strokes in his portrait of *Charles V at Mühlberg* (1548; Prado, Madrid) and the '*Venus del Pardo*' (fig. 56) mark the beginning of this development.[5] Copies of the destroyed *Saint Peter Martyr* (1530; fig. 8, p. 16) suggest a similarly loose handling of landscape elements. Sheaves of angled brushwork like those in the background of the Aldobrandini *Holy Family* can be read as shafts of light, mist or rain.

The evolution of Titian's representation of landscape can be traced in the sequence of vistas in the backgrounds to his portraits of *The Duchess of Urbino* (1538; Uffizi), *Clarissa Strozzi* (1542; cat 24) and *The Empress Isabella* (1548; fig. 55). In the last of these, the treatment of landscape is considerably more dynamic than in the earlier portraits. Titian's later works are increasingly dominated by agitated dusk skies, which create a more emotive atmosphere but nevertheless retain focus and structure in the landscape. *The Death of Actaeon* (cat. 37) demonstrates that devices seen in earlier treatments of the natural world are still in evidence: animated pools of water are set in a verdant landscape anchored by screens of bushes and a receding treescape, in an enduring vision of the pastoral tradition. DJ

FIG. 56
TITIAN
Detail of the landscape in
'*Venus del Pardo*',
completed 1553
Oil on canvas, 196 × 385 cm
Musée du Louvre, Paris,
inv. 752

17. Jacopo Palma il Vecchio (about 1480–1528) and Titian
The Holy Family with Saints Catherine and John
about 1528

Oil on canvas, 127 × 195 cm
Gallerie dell'Accademia, Venice,
inv. 147

Select Bibliography: Ridolfi (1648), I,
p. 140; Moschini Marconi 1962, pp. 161–2;
Rylands 1992, p. 85, no. 97; Nepi Sciré 1999,
pp. 157–9

This painting by Palma Vecchio was probably left unfinished on his death in 1528, even though it cannot be clearly identified with any of the paintings recorded in the inventory of his estate. That Titian had repainted parts of the picture was realised only in recent times, when the evidence visible to the naked eye could be supplemented by technical examinations. The latest of these have revealed that initially a donor knelt beside Saint Catherine, she and Saint John held rather different poses, and a landscape was planned on the right where there is now a

large column. It used to be supposed that Palma had 'borrowed' the column from Titian's '*Madonna of the Pesaro Family*' (fig. 7, p. 15), but it is now clear that Titian himself did so.

Titian also painted the entire figure of Saint Catherine as she now appears, as well as the feet, mantle and face of Saint John the Baptist. Saint Catherine has been damaged around her chin but is otherwise one of the most lively faces Titian painted in the 1530s. In dress and posture she is directly comparable to the 'bride' in '*Sacred and Profane Love*' (cat. 10). Her stance also recalls the woman at the foot of the stairs in *The Presentation of the Virgin* (fig. 11, p. 21), while her elaborate coiffeur is close to that of the female saint in the Aldobrandini *Virgin and Child* (cat. 19). Analysis reveals that Palma in the Madonna and Titian in Saint Catherine used the same materials, both for example

painting the cheeks of the two figures in lead white, vermilion and red lake, but while Titian went over Catherine's cheek six or seven times, Palma painted a single layer of lead white with mere traces of red lake and vermilion. Typically of Titian, Saint Catherine's red dress is laid in and built up in a number of complex layers, while the drapery of Palma's Madonna is composed of no more than three.

Making up unfinished paintings appears to have been common practice in Venice. Titian's most famous such intervention is probably his completion of Giorgione's *Venus* (fig. 45, p. 86), which again involved the entire landscape. It is likely that Titian felt his composition was a success, for later he largely repeated it – including the column – in a *Virgin and Child with Saint Agnes and the infant John the Baptist* in Dijon.
Giovanna Nepi Sciré, DJ

18. *The Virgin and Child with Saint Catherine and a Shepherd* ('*The Madonna of the Rabbit*')
1530

Oil on canvas, 71 × 87 cm (the canvas has been cut down on the left and almost certainly on the right)
Musée du Louvre, Paris, inv. 743

Select Bibliography: Crowe and Cavalcaselle 1877, I, pp. 336–41, 446; Wethey I, pp. 105–6, no. 60; Panofsky 1969, pp. 28–9; Hours 1976, pp. 12–15; Béguin 1980; Hope 1980A, pp. 74–5; London 1981, pp. 186–7, no. 155; Washington 1990, pp. 209–12, no. 23; Paris 1993, pp. 566–7, no. 160; Volle *et al.* 1993, pp. 58–60; Bodart 1998, pp. 17, 67–8, 207; Pedrocco 2001, p. 147, no. 83

This painting was sent to Federico Gonzaga, duke of Mantua, in 1530; Federico may be portrayed as the shepherd seated on the right-hand side. The female saint is usually identified as Saint Catherine as she appears to be kneeling on her wheel, but it could be read as a chest with a drawer. Like the equivalent saint in cat. 19 her identity is unclear but Jennifer Fletcher feels the latter is Saint Dorothy. The painting is one of the most highly finished jewels in Titian's oeuvre. Every blade of grass, flower and gold thread is lovingly described. Such attention to detail had long been typical of court art, and the figure of the Madonna of Humility, seated on the ground, was also popular among princes. The dappled, domesticated landscape, with its rushing stream and resting soldier, its house and its church spire, is laid out with great precision, demonstrating Titian's skill in capturing the effect of soft, dusky light. The basket containing grapes and an apple (perhaps alluding to the Eucharist and to the Fall) underlines the devotional intent of the image.

The clearly defined features of the figures are linked across the picture plane in a powerful interactive tension. Their exchange of glances, complemented by the energetic flow of the drapery, structures the composition. The swirl of cloth, however, serves to mask uncertainties in the Virgin's pose, especially her right leg – which has been criticised since the seventeenth century. The animated child, the most dynamic of the figures, is the focus not only of the viewer's attention but also the Virgin's and Saint Catherine's. He reaches towards the rabbit in a touching, naturalistic gesture, and the rabbit pricks up its ears. The Virgin's caress of the rabbit is echoed by the shepherd's patting a black animal usually identified as a sheep, and close examination does suggest a ram's horn just below the shepherd's hand. The shepherd's pose is a variation on the Virgin's. Similarly, Saint Catherine's half-kneeling stance is a variation on the posture of the man supporting Christ's legs in *The Entombment* (fig. 66, p. 154). In both pictures the characters read like a sculptural relief, constituting an expressive, rhythmical flow.

The royal status of Saint Catherine of Alexandria justifies her rich and fashionable attire, her puffed and slashed sleeves and fine silk scarf. Titian would have been especially sensitive to these details as Federico's mother was none other than the famous patron of both artists and dressmakers Isabella d'Este. It is not so obvious why the virgin saint should have her hair up, as befitted a married woman, unless Titian wished to recall her mystic 'marriage' to Christ. She carefully holds the child but does not touch his sacred skin.

The Virgin's gesture to support Christ's head is hardly less awkward than her right leg: her anatomy is strained, and she interferes with Christ's nimbus. X-rays show that she had originally looked towards the shepherd, with her arms crossed – indicating that Titian developed the composition as he worked on the canvas.

The painting invites direct comparison with the Aldobrandini *Virgin and Child* (cat. 19), possibly painted for the rival court of Ferrara. The high finish and resolved compositions tend to mask the fact that both paintings were, in their time, bold experiments in integrating figures into a coherent, light-filled landscape. The smaller scale of the present painting gives it a greater unity than the Aldobrandini picture, with its cool Bellinesque Madonna set against a more sumptuous Catherine. The broadly painted background in the *Virgin and Child* (cat. 19) suggests it may be four or five years later than those dated to 1530 (cat. 18) and 1531–2 (cat. 20).
DJ

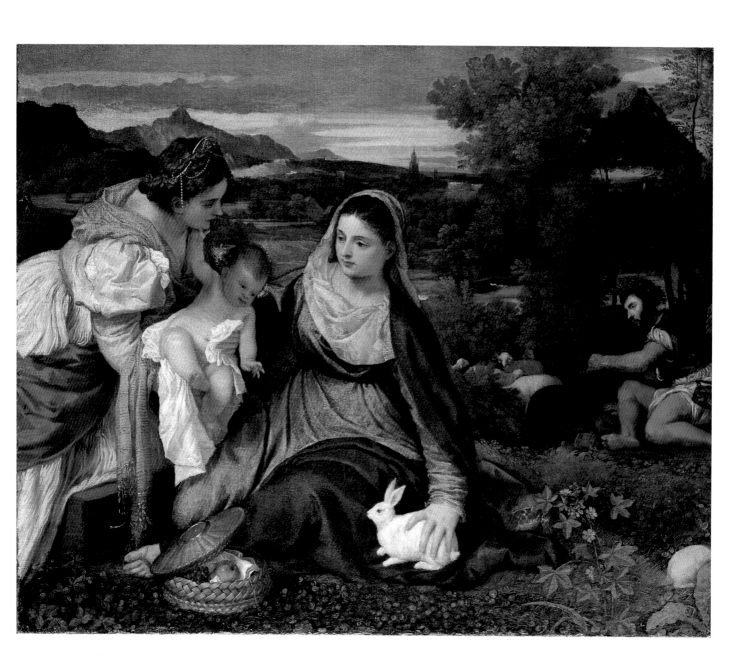

19. *The Virgin and Child with the Infant Saint John and a Female Saint or Donor ('The Aldobrandini Madonna')*
about 1532

Oil on canvas, 102.4 × 143.7 cm
The National Gallery, London, inv. NG 635

Select Bibliography: Michiel [1884], p. 159 (for Odoni); Crowe and Cavalcaselle 1877, I, pp. 206–8; Wethey 1969, pp. 104–5, no. 59; Gould 1975, p. 278; Christiansen 1987 (for Kimbell variant); Penny 1999; Pedrocco 2001, p. 148, no. 86

The kneeling woman has the attributes of Saint Catherine in other versions of this picture but cannot certainly be identified as the saint here. She gazes with earnest rapture at the delighted Christ Child. A seventeenth-century print is inscribed with lines from the Song of Songs on the pleasures of kissing, which is what seems to be on her mind. The shepherd and herdsman in the middle distance who gaze at the angel may suggest the birth of Christ, but the presence of the young Saint John, who presents the Virgin with fruit and flowers for his cousin, better suits the Rest on the Flight into Egypt, although Joseph should be there, too, if that episode were intended.

The painting has suffered in several respects: the yellow dress has been deprived of the purple glazes in its shadows and the darker passages in the Virgin's blue dress have blanched. The kneeling woman's dress was initially pink – the colour of her belt. A strip of canvas has been added at the left and the original canvas was also for a long while turned over along the top (no doubt in the seventeenth century when it served as an overdoor).

There are several unresolved features to the composition: we may ask how exactly Christ is supported and where the kneeling woman's arms are. Perhaps because he was dissatisfied with it, Titian allowed at least two variants of the composition to be made in his workshop: the canvas in Palazzo Pitti and the panel in the Kimbell Art Museum, Fort Worth. Titian himself may well have played some part in painting these (especially the second),

but the subtle shadows and beautiful expressions which transfigure the three principal heads in the National Gallery's painting have no equivalent in these works. This painting was perhaps the first of Titian's compositions to be repeated in this way. It must be close in date to '*The Madonna with the Rabbit*'

(cat. 18), which appears to be documented in 1530. The National Gallery painting may have been the one which was recorded in Andrea Odoni's collection by 1532. However, it seems formerly to have been inscribed with the date 1533.
NP

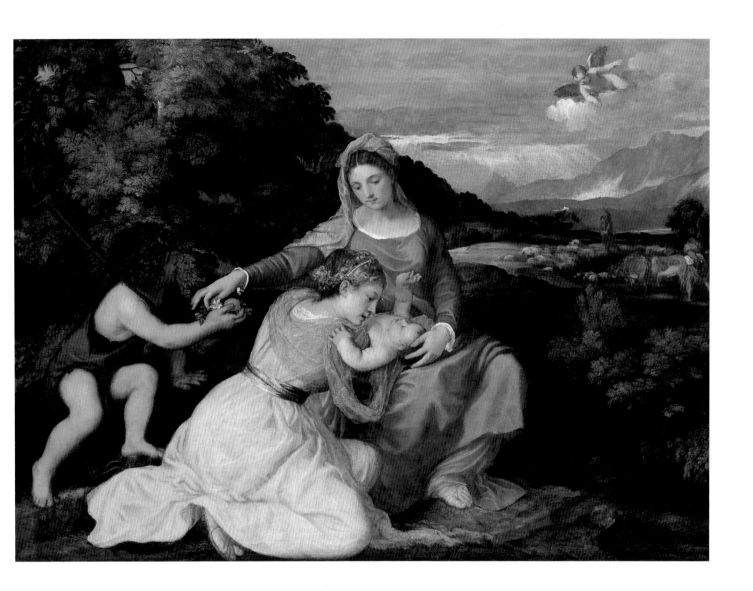

20. *Saint John the Baptist*
about 1531–2

Oil on canvas, 201 × 134 cm
Gallerie dell'Accademia, Venice,
inv. 314

Select Bibliography: Dolce (1557), p. 54;
Crowe and Cavalcaselle 1877, II, p. 251;
Wethey I, pp. 136–7, no. 109; Hope 1980A,
pp. 69–70; Perry 1980, pp. 187–91; London
1983, pp. 222–3, no. 119; Washington 1990,
pp. 240–3, no. 32; Humfrey 1993, p. 242;
Paris 1993, p. 527, no. 170; Boucher 1991,
p. 355, no. 63 (for Sansovino); Pedrocco
2001, p. 120, no. 55

The painting is decidedly sculptural in
conception. The Baptist's outstretched
arm recalls the *Apollo* Belvedere, and the
raised base that supports his bent leg can
be found in numerous classical proto-
types. The finely modelled torsion of the
figure, however, might be compared to a
bronze by Jacopo Sansovino. The fluidity
of influence and ideas between painter and
sculptor is demonstrated in a letter from
Aretino to Sansovino of 1545, in which
Aretino promises, 'As soon as Titian has
painted it with his colours … I will send
you the head of Giovanni dalle Bande
Nere for you to carve it in marble … he is
worthy to have his image reanimated with
the spirit of your chisel'. Any sculptural
resonance in the present *Saint John* is
indeed pertinent, because it served as a
pendant to a work of sculpture: it was
painted for Vincenzo di Giacomo Polani's
chapel in Santa Maria Maggiore in Venice,
situated to the right of the high altar and
flanked on the left side by a statue of *Saint
Francis*.

The question of the influence on Titian of
ancient and modern sculpture is a difficult
one. The Grimani family owned a highly
significant collection of antique sculpture
(subsequently bequeathed to the state
and the nucleus of the present Museo
Archeologico in Venice). Marilyn Perry
has, however, cautioned against assuming
that these works provided figural proto-
types for Titian. Many were acquired in a
fragmentary state and were reconstructed
by contemporary sculptors; it is possible
that Tullio Lombardo carved a head for
the *Cleopatra* in the Grimani collection.

Some seem to have been reconstructed
following Titian's inventions rather than
vice versa. The consistency of classical
iconography and associated figuration
through the classical period makes it
difficult to ascribe influence upon
Titian to any particular source; nor is
it clear whether there was a particular
'archeological' phase in his interest in
antiquity. Certainly the Gonzaga commis-
sion for *Eleven Caesars* in 1536–9 (lost)
must have caused Titian to study ancient
statuary again. When in Mantua earlier,
Titian must have seen Giulio Romano's
and other frescoes in the Palazzo del Té,
with numerous examples of *all'antica*
sculptural form.

What is certain is that, without slavishly
copying, Titian drew upon the spirit of
antiquity, thanks to a wide knowledge
of ancient art that extended to engraved
cameos and gems. An X-ray of *The Death
of Actaeon* (cat. 37) reveals that Diana's
right arm was formerly outstretched
behind her, in a pose which resembles
both an Ippolita Gonzaga medal by Leone
Leoni of the same subject and (with legs
reversed) an antique relief, the Tuscoli
Diana victrix, now known only through a
Renaissance drawing. Developing the
approach already evident in the Camerino
paintings (cat. 13–16) and *Saint Peter
Martyr* (fig. 8, p. 16), Titian here
considered and sought to refine still
further the expression of plastic energy in
the human figure. To it, however, he was
able to impart a textural vitality that
commentators frequently remarked upon.
Aretino described a variant of this subject,
showing a much younger Baptist, in a
letter of 8 October 1531: '… observe the
flesh tints so beautifully painted that they
resemble snow streaked with vermilion,
and seem to be warm and to pulsate with
the very essence of life. I will say nothing
of the crimson of the garment or of its
lining of lynx, for in comparison real
crimson and real lynx seem painted,
whereas these seem real. And the lamb he
bears in his arms is so lifelike that it

actually drew a bleat from a passing ewe.'
The forlorn expression of Saint John's
lamb is perhaps expressive of its symbolic
status, as the sacrificial lamb.

Themes of heroic muscularity, luminosity
and idyllic landscape are here combined.
Titian has silhouetted Saint John's body,
using thick, delineative strokes of dark and
light paint to create its sculptural three-
dimensionality against its landscape
setting. The way in which the land rises
behind the figure can be paralleled in
Correggio's work, which Titian must have
seen in Mantua in the 1520s. The waterfall
is one of Titian's most convincing
evocations of the movement of water; the
bold striations look as if they might even
have been achieved through the use of an
implement like a comb, and the effect is
further enhanced by the texture of the
herringbone canvas. John's face is all
rugged drama, and, with Christ's in the
Louvre *Crowning with Thorns*, one of
Titian's most significant essays in
physiognomical pathos.

The dating of *Saint John* is difficult.
Stylistic similarities, notably of John's face
with Christ's in the 1540–2 *Crowning with
Thorns* (Louvre) and in the 1543 *Ecce
Homo* (Vienna), might suggest a date in
the early 1540s. The *Ecce Homo* also
includes an antique statue in a niche
which closely mimics the pose of John.
However, the form of the signature, with
the 'c' rather than the 't' in *TICIANUS*,
seems no longer to have been used after
about 1533–35, which supports Charles
Hope's dating of the painting to around
the time of *Saint Peter Martyr*, about
1531–2. Titian returned to the template of
this painting in his late *Saint John* (cat. 42),
recalling its beckoning hand gesture as
well as the stance and the lamb.
DJ

21. *Giacomo Doria*
about 1533–5

Oil on canvas, 115.5 × 97.7 cm
Ashmolean Museum, Oxford.
In the memory of Professor Francis
Haskell with the help of the National Art
Collections Fund, the Heritage Lottery
Fund and other donors, inv. A1228

Select Bibliography: Wethey II, p. 94,
no. 25; Gould 1976, p. 12; Hope 1982, p. 158,
n. 3, 4; Hochmann 1992, p. 38, n. 82;
Boccardo 1997, p. 34, pl. 6; Christie's,
London, *The Wernher Collection*, 5 July
2000, lot 91; Pedrocco 2001, p. 172, no. 115

Giacomo Doria, a Genoese merchant
resident in Venice, belonged to the
most important family in his home city.
His coat of arms, probably added in the
seventeenth century, has recently been
concealed. Charles V's admiral, Andrea
Doria, was a close relative, and Giacomo's
elder brother and two of his sons held the
office of doge. Giacomo's energies were
directed towards the maintenance of the
family's commercial interests, especially in
Venice, where he lived from 1529 until 1541.
He is recorded in contact with at least
three members of Titian's circle, and
possibly knew Titian himself. Titian's
interest in Giacomo Doria was probably
prompted by his family's financial
connections with the Habsburg emperor
and the imperial court. It is hardly
coincidental that this portrait dates from
around the time of Titian' first contacts
with Charles V. Three decades later Titian
secured payment of his imperial pension
with Doria help.

Giacomo Doria is depicted half-length,
Titian's preferred format for non-regal
portraits from the mid 1520s onwards.
Possibly the more private status of this
commission encouraged Titian to
experiment with a compositional device
he had used to great effect in the Pesaro
Madonna for the Frari (1519–26; fig. 7, p.
15), the background column. The pillar
in the Ashmolean portrait helps to convey
the Genoese merchant's prestige and
self-possession. The device, here used in a
portrait for the first time, features
regularly in Titian's later male portraits,
for example *Philip II in Armour* (cat. 30).
It is possible he adopted it from Moretto
da Brescia, and Moretto's *Portrait of a
Gentleman* leaning beside a column
(National Gallery), dated 1526, may be
a significant precedent.

Giacomo Doria is most remarkable for
the strong sense it conveys of the sitter's
personality. Giacomo's fine black costume
and upright bearing draw attention to his
noble status. This is humanised by the
intelligent expression on his face. X-rays
of the painting show that Giacomo Doria
initially wore a hat, which Titian painted
out, possibly because it detracted from the
rather intimate nature of the portrait.
In the finished picture, Giacomo's alert,
penetrating eyes (sadly, these have been
repainted) and slightly open mouth give
the impression that he is looking with
interest at, and perhaps conversing with,
the members of his family who were the
intended audience for the portrait.

Another version of this painting survives
at Bari, further suggesting that it met with
a positive response from Doria and his
family.
CC

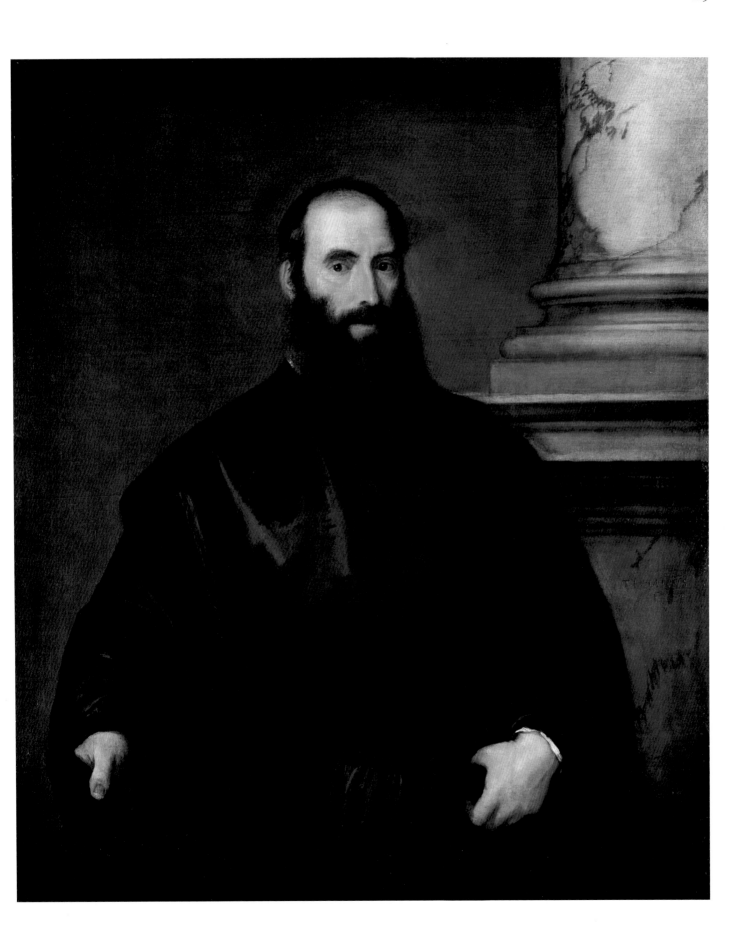

22. *Georges d'Armagnac, Bishop of Rodez, with his Secretary Guillaume Philandrier*
1536–9

Oil on canvas, 104.1 × 114.3 cm
Collection of the Duke of
Northumberland, Alnwick Castle,
Northumberland, inv. 3351

Select Bibiography: M. Jaffé 1966,
pp. 114–26; Gould 1966, pp. 49–50, fig. 3;
Wethey II, pp. 33, 78, no. 8; Pedrocco 2001,
p. 173, no. 116

This double portrait of a French
ambassador to Venice and his secretary
was one of the first paintings by Titian to
enter a British collection. The Duke of
Buckingham's agent Gerbier sent it to his
master from Boulogne in November 1624.
Subsequently it was appropriated, it seems,
by the 10th Earl of Northumberland after
some Parliamentarians threatened to burn
the 2nd Duke of Buckingham's confiscated
collection of foreign and immoral paint-
ings in York House in 1645. It certainly
belonged to the Northumberland family
by 1652, when Richard Symonds recorded
a painting by 'Titian: a Senator of Venice
and his Secretary by him, writing on a
Table' in Northumberland House. The
work bore a traditional attribution to
Titian, but until its cleaning in 1965–6 (and
subsequent publication by Michael Jaffé)
this was discounted by most scholars, who
tended to follow Berenson's suggestion of
Domenico Caprioli.

Various unlikely identifications have been
suggested for the sitters: Duke Sforza and
Machiavelli, Duke Cosimo de' Medici and
his secretary, and – rather more likely –
a Venetian senator and his secretary.
The resemblance of the principal sitter
to a portrait by Corneille de Lyon at
Waddesdon, sometimes said to be of
Georges de Selve, led to the intriguing (but
impossible) suggestion that Titian had also
painted one of Holbein's *Ambassadors*. The
mystery was solved by Jaffé, who identified
the men in the Alnwick portrait as
Georges d'Armagnac, Bishop of Rodez,
one of the French ambassadors to Venice
between 1536 and 1539, and his secretary

Guillaume Philandrier (a scholar of the
Roman rhetorician Quintilian and a pupil
of the architect Serlio).

D'Armagnac's pose recalls Titian's
portraits (one in the Louvre, and an
unfinished variant in Harewood House,
Leeds) of his master, the French king
Francis I, whom the painter never met,
and for whose likeness he relied on
a portrait medal by Benvenuto Cellini
(dated 1537). However, given that
d'Armagnac and Philandrier spent
three years in Venice, it seems unlikely
that they would not have sat to Titian.
D'Armagnac's strikingly impassive
expression is best explained by the rather
iconic French conventions for representing
men of his high rank. Titian was always
very receptive to the way his sitters might
wish to be seen. Not only this portrait
but also his portrayals of Charles V and
Philip II (cat. 30) are notably less lively
than those of Italian dignitaries like
Paul III (cat. 26), who would have been
more accustomed to Titian's flourishes
of colour and characterisation. However,
Titian's interests still shine through: the
secretary's sleeve, and the heraldic cloth
to d'Armagnac's right, are described with
his customary attention to fabric and
the play of light.

The painting is interesting for its clear
enunciation of the differences in rank
between the sitters. Titian knew at least the
composition of Sebastiano del Piombo's
portrait of *Cardinal Ferry Carondolet
and his Secretary* of 1511–12 (Thyssen
Collection), which was the closest
available precedent for showing sitters
from different social orders. Philandrier,
the inferior, is by far the livelier of the pair.

He is placed on a lower seat than his
master, whom he regards with almost
canine devotion. In contrast d'Armagnac
avoids any contact with either secretary
or viewer. Their sleeves – which X-rays
reveal once overlapped – are entirely
separate, to emphasise the social distance
between the sitters.

Titian's portrait had a distinguished
afterlife among painters in England.
Both Rubens and Van Dyck saw it in
Buckingham's collection. In his portrait
of *Thomas Wentworth, Earl of Strafford
with Sir Philip Mainwaring* (fig. 23, p. 41)
Van Dyck clearly adopted its composit-
ional formula. No subsequent double
portrait inspired by the Alnwick painting
matches Van Dyck in emulating the
original, although Reynolds's *Marquess
of Rockingham with Edmund Burke*
(Fitzwilliam Museum, Cambridge)
perhaps comes close.
CC

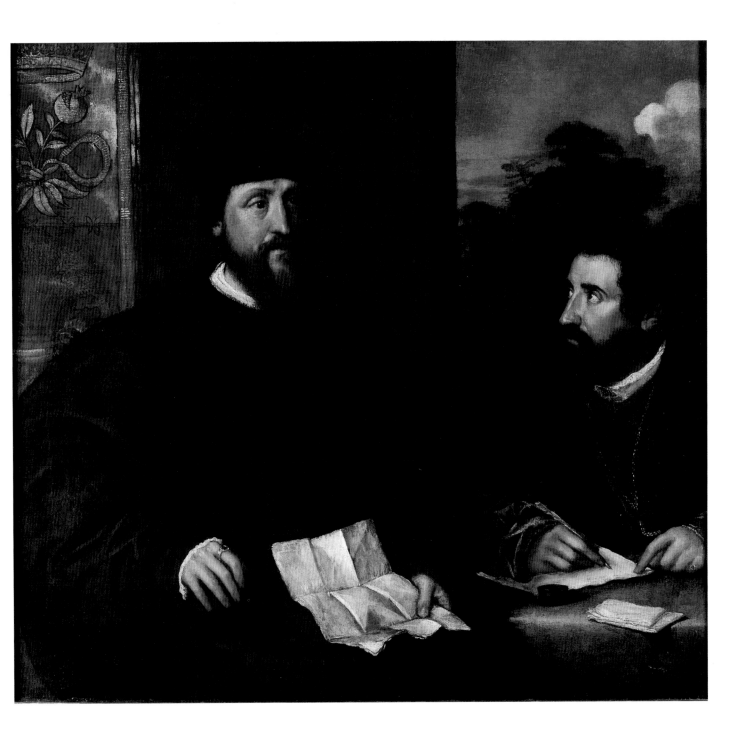

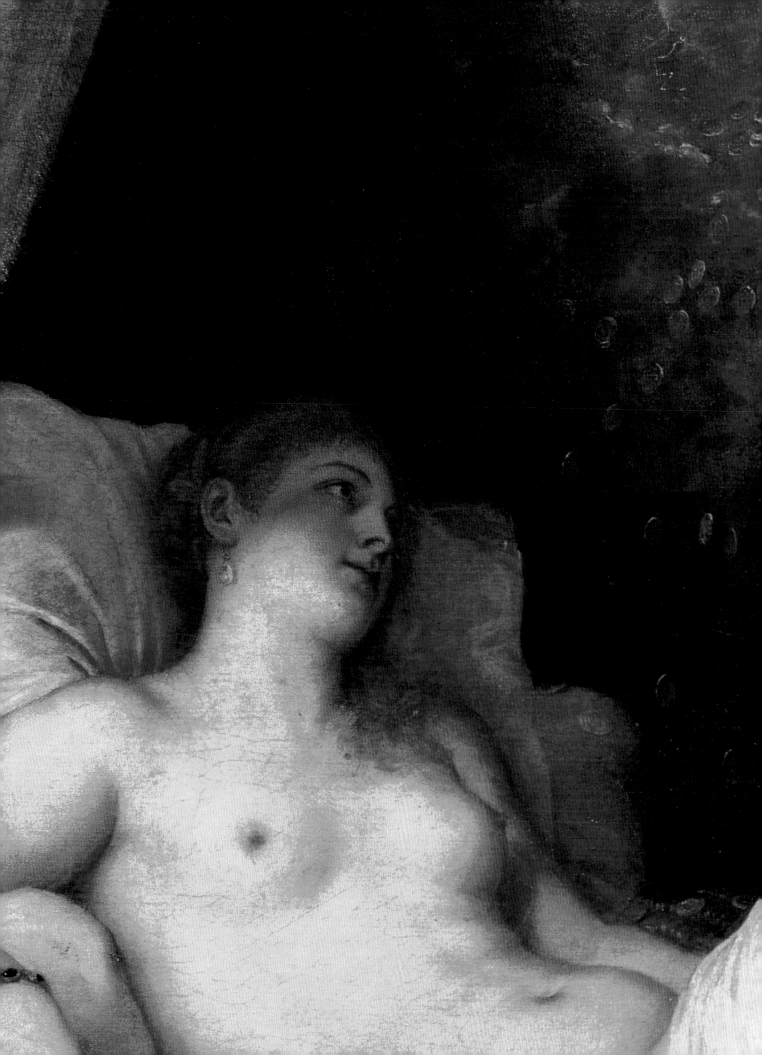

IV TITIAN IN THE 1540S

IN THE 1540S VENICE saw both the emergence of such painters as Jacopo Bassano, Jacopo Tintoretto and Andrea Schiavone – heralding a shift to a more theatrical, sketchy style of painting – and, at the beginning of the decade, an invasion of Florentines. In 1539 Francesco Salviati had decorated a room in the Grimani Palace and his assistant, Giuseppe Porta (also known as Salviati), became a permanent resident of Venice. Several years later Giorgio Vasari also came to Venice, painting a ceiling for the Corner Palace and designing a stage set for Pietro Aretino's comedy *La Talanta*.

In the same decade, Titian's own career flourished, as his reputation as the foremost painter of the Holy Roman Empire spread. Normally a reluctant traveller, he spent eight months at the papal court in Rome in 1545–6, followed by a visit to the Emperor Charles V in Augsburg in 1548. Whilst challenges arose from a new generation in Venice, Titian's travels for his important new patrons kept him abreast of other artistic currents, in Rome, Tuscany and northern Europe, in particular the work of Raphael, Michelangelo and Anthonis Mor.

During his eight-month stay in Rome, from 9 October 1545 to June 1546, Titian had ample opportunity to see the art of the city. Lodovico Dolce records that Sebastiano del Piombo took Titian to Raphael's Stanze in the Vatican, including the Sala di Costantino, where Titian admired the frescoes by Raphael's workshop, perhaps to the chagrin of his guide, who had failed to obtain this commission for himself.[1] Titian seems to have been particularly taken by Constantine's gesture of surprise when confronted by the vision of the Cross (fig. 58), for he re-worked it in his own *Diana and Actaeon* (fig. 57). The deliberate, almost ponderously slow language of gesture emerging in the work of Michelangelo and his followers, notably in Michelangelo's 1545 *Conversion of Saul* in the Cappella Paolina and Sebastiano's work in the Chigi Chapel in Santa Maria del Popolo, was also adopted by Titian: it can be seen in works such as *The Annunciation* in San Salvatore, Venice. Titian also experimented with the Roman taste for 'telescopic' compositions that left the principal figures in the background, notably in the *Gloria* and *The Agony in the Garden* (Prado, Madrid).[2]

Rome also provided Titian with a mine of classical sources. Venice could import antiquities from the mainland or from overseas, but Rome exuded them from its very soil: the Vatican Belvedere, the papal guesthouse and palace where Titian was staying, housed the *Laocoön* amongst its antique furniture. At the same time, Titian cannot have avoided the debate over the merits of the ancients and the moderns, and strove to respond to it in his own terms. During this visit to Rome Aretino begged Titian to recount his views on ancient sculpture and to compare it to contemporary works. 'I long for your return,' he wrote, 'that I may hear what you think of the antiques, and how far you consider them to surpass the works of Michelangelo. I want to know how far Buonarroti approaches or surpasses Raphael as a painter; and wish to talk with you of Bramante's Church of Saint Peter and the masterpieces of other architects and sculptors Contrast the figures of Jacopo Sansovino with those of men who pretend to rival him, and remember not to lose yourself in contemplation of *The Last Judgment* at the Sistine Chapel'[3] Paintings such as the *Gloria* (1552; Prado), *Tityus* (1553; fig. 59), *Saint Lawrence* (1557; Gesuiti, Venice) and *The Forging Arms of Brescia* (1568; lost) all demonstrate the extent to which Titian responded to both ancient and modern Roman artis-

TITIAN
Danaë, 1544–6
(detail of cat. 23)

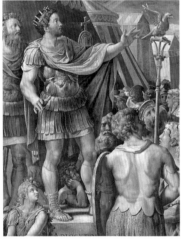

FIG. 57
TITIAN
Diana and Actaeon, 1556–9
(detail of fig. 13, p. 24)

FIG. 58
RAFFAELLINO DAL COLLE from a
cartoon by GIULIO ROMANO
(1499?–1546)
Detail of *Constantine's Vision of the True
Cross* , 1520–4
Fresco
Sala di Costantino, Vatican Museums,
Vatican City

tic practice. He had always shown a keen interest in antique sculpture, notably in the *Bacchus and Ariadne* (cat. 13) and *Saint Peter Martyr* (fig. 8, p. 16), but this earlier, more lyrical usage is in stark contrast to the powerfully rhetorical deployment of distorted figures set in complex perspectival views produced after his Roman sojourn. The Louvre *Crowning with Thorns* of 1540–2, painted before Titian's Roman visit, anticipates this tendency, but is less aggressive in its application.

At this time Titian's skills as a portrait painter were much in demand. Departing from earlier Renaissance traditions, he revolutionised the genre, capturing the personality of the sitter through stance and gesture in a way that actively engaged the viewer. Because these new conventions and solutions in portraiture are still current today, it is easy to lose sight of how profound these changes were. Contemporary sources describe instances in which these works were described as 'life-like' and even mistaken for the sitter himself. We read of Titian's *Pope Paul III* (cat. 26) causing people to doff their hats,[4] or his portrait of *Eleanora, Duchess of Urbino* (Prado) prompting a courtier to kiss her hand.[5] A vignette in Aretino's play, *La Talanta*, illustrates this phenomenon. Vergozo, a Venetian merchant, had travelled to Rome in order to secure a benefice for his son Marchetto (just as Titian did for his own son, Pomponio). The boy's tutor, Pizio, before a backdrop of the Forum designed by Vasari, describes the wonders of ancient and modern Rome. The young charge is encouraged to look at Michelangelo's *Last Judgment*, in which, according to Sebastiano del Piombo, it is impossible to tell the difference between those admiring the fresco and the fictive characters looking down at them.[6]

This sense of a shared reality is achieved by Titian himself in *The Vendramin Family* (cat. 29). The boy, identified as Federigo, clasps his dog awkwardly – a transient moment expertly captured by Titian. His brother looks towards the spectator and invites us, too, to revere the miraculous reliquary of the Scuola di San Giovanni Evangelista. The steps project into our space, providing further encouragement to join the bunched-up Vendramin entourage. Titian's setting of the event outdoors was perhaps inspired by Raphael's fresco of *The Mass of Bolsena* in the Vatican (fig. 60). Titian could have known it through engravings, but the monumentality of *The Vendramin Family* suggests first-hand experience of the work in November 1545. Raphael's example was certainly important to Titian, and is particularly evident in portraits: Raphael's *Leo X* inspired the Farnese group portrait (fig. 62, p. 138),[7] just as his *Julius II* served as a prototype for Titian's *Paul III* (cat. 26). Titian was too opportunistic a painter to ignore such metropolitan examples.

The motif of the dog and the consequent sense of suspended animation can be seen again in Titian's *Clarissa Strozzi* (cat. 24). The picture is generously praised by Aretino in one of his letters to Titian: he declares '… it is up to Nature to say if it is an illusion or alive', and singles out '… the dog she caresses, which is ready to move …'.[8] There are further brilliant portrayals of dogs in other works. A few years earlier in *The Presentation of the Virgin* (1534–8; fig. 11, p. 21) Titian had

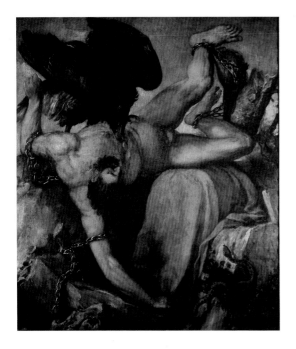

FIG. 59
TITIAN
Tityus, 1549
Oil on canvas, 253 × 217 cm
Museo Nacional del Prado,
Madrid, inv. 427

FIG. 60
RAPHAEL(1483–1520)
Detail of *The Mass of Bolsena*,
1512
Fresco
Stanza d'Eliodoro, Vatican
Museums, Vatican City

shown a dog jumping to eat a bread-ring similar to the one Clarissa holds in her hand. The 1542 *Ecce Homo* (Kunsthistorisches Museum, Vienna) depicts a more energetic interaction between a boy, who twists and shouts, and his canine companion.

Titian's mature sitters, however, are portrayed with a dignity and *gravitas* that befits their age and status. The seventy-four-year-old Paul III smoulders in his antiquity. Aretino gives a description of old age in which he specifies a beard of 'the finest silver, trembling arms and legs, [and a] sharp withered face';[9] but Titian even includes bloodshot eyes. By contrast, the black hair of his eyebrows, inside his ear and in the centre of his beard might have been read not only as vestiges of youth but also as signs of regeneration as Paul recovered from illness. His hair is used to convey residual youth and vitality: his eyebrow breaks the silhouette that defines the contour of his face, just as his beard flows over his collar. The same device is used in Titian's 1545 portrait of Aretino (cat. 27), who was elated to hear from Francesco Salviati that an acquaintance thought he looked no different from when he last saw him, ten years before.[10]

The portraits of Aretino and Clarissa Strozzi were intended to influence the taste of the Florentine court, demonstrating an assertively Venetian display of raw brushwork alongside precision in the details of the face. Aretino reported to Titian that Cosimo I, Salviati and Vasari were all impressed by the portrait, and, although the veracity of this account remains questionable, at least one Florentine responded to the challenge, namely Bronzino, in his Colonna portrait of 1546 (Galleria Barberini, Rome).

The more frigid climes of Augsburg, which Titian visited in January 1548 and from November 1550 to May 1551, exposed the artist to works by Cranach and Anthonis Mor. Paintings such as *Antoine Perrenot de Granvelle* (1548; Nelson-Atkins Museum, Kansas) and *Philip II in Armour* (cat. 30) are much indebted to Mor's hypnotic formulations. Comparison of Mor's portrait of Granvelle, now in Vienna, prompts us to question how far the two artists exchanged ideas.[11] Philip II had a gallery of court worthies painted by Titian and Mor, which obviously encouraged a pictorial dialogue between the two artists, perhaps fuelled by the unusual inclusion of Mor's and Titian's own self-portraits in the parade of courtiers. DJ

23. *Danaë*

1544–6

Oil on canvas, 120 × 172 cm
Museo Nazionale di Capodimonte,
Naples, Q 134

Select Bibliography: Dolce (1557), p. 161;
Vasari (1568), III, pp. 574–5; Ridolfi (1648),
p. 178; Crowe and Cavalcaselle 1877, II,
p. 119; Panofsky 1969, pp. 144–7; Wethey
III, pp. 132–3, no. 6; Ginzburg 1980,
pp. 125–6; Hope 1980A, pp. 89–90;
Washington 1990, pp. 267–9, no. 40;
Zapperi 1991A; Paris 1993, pp. 533–4,
no. 177; Pedrocco 2001, p. 192, no. 137

The legend of the seduction of Danaë,
daughter of Acrisius, king of Argos,
by Jupiter, who disguised himself as a
shower of gold, is recounted in Ovid's
Metamorphoses and in Boccaccio's
Genealogia Deorum.

On 20 September 1544 Cardinal
Alessandro Farnese was informed by the
papal *nuncio* in Venice, Giovanni della
Casa, that the nude in the picture now
known as the '*Venus of Urbino*' (fig. 9, p.
19) was 'a Theatine nun' compared to the
Danaë Titian was painting for him, which
would cause 'the devil to jump on the
back', or sexually arouse, even the Cardinal
of Silvestro, the famously austere reform-
ing Dominican Tommaso Badia. As X-rays
show, Titian adapted the composition
of the '*Venus*', which Alessandro had just
seen in Pesaro, to produce for the Farnese
cardinal a bespoke mythological heroine
whose features resembled those of his
mistress, Angela – whose likeness had
been supplied to him from Rome by the
miniaturist and illuminator Giulio Clovio.
Della Casa thought that this alone would
be enough to obtain for Titian the bene-
fice he sought for his son Pomponio.

As Crowe and Cavalcaselle pointed
out, the attendant Cupid is posed like
Lysippus's *Cupid bending his Bow*, a
famous antique statue known through
many Roman copies. Titian has humor-
ously unslung the bow, as Jupiter has
pre-empted the need for love's shafts.
Danaë's pose recalls that of a Roman river-
god, a commonplace in Renaissance art;
Bellini's *Feast of the Gods* (cat. 15) has an
earlier adaptation. As in all his borrowings
Titian surpasses his source, and Danaë's
dreamy expression (searching for the in-
visible source of pleasure) and the sense
of her sinking into the soft vortex of the
sheets in which she trails her hand conveys
her very un-nunnish pleasure. In contrast
Cupid looks up at Jupiter's cloud open-
mouthed with surprise, steadying himself
on Danaë's cast-off dress. The painting
rewards close scrutiny. Like *Flora* (cat. 11),
the royal princess Danaë wears a ring
with a blue gemstone, but also displays
a bracelet and flashing pearl earrings.

The beautifully controlled lighting which
casts half of Danaë's face in shadow
ingeniously catches the succession of
angled coins that rotate as they descend
in a shaft of light: one might perhaps
compare the effect with time-lapse
photography. The same light also caresses,
quite significantly, her parted legs. The
precision of the painting suggests the
work's 'ambassadorial' intention, to win
its author praise and further commissions
from the international court of Rome.

Titian's painting transports the world
of courtesans and carnal desire into
the loftier realm of myths and gods; his
depiction of desirable, milky flesh is
ambrosial. In his *Dialogues* Aretino
provides a literary equivalent to Titian's
rhapsodic depiction: 'She had coiled her
hair on top of her head without a veil, so
that her tresses formed a kind of balcony
over her lovely forehead. Her eyes burned
and laughed beneath the arc of her brows;
her cheeks actually looked like milk
sprinkled with flecks of the most delicate
colours imaginable …. My God, her neck!
And her breasts … those two tits would
have corrupted virgins and made martyrs
unfrock themselves …. The front of her
body drove me wild, but the wonder and
marvel which really maddened me were
due to her shoulders, loins and other
charms.' That contemporary viewers
responded also to pictures with similar
enthusiasm is evident from Lodovico
Dolce's description of Titian's *Venus and
Adonis* (Prado, Madrid), in which he
celebrated Titian's 'marvellous piece of
dexterity … in that one recognises in her
hindmost parts here the distension of the
flesh caused by sitting'. Dolce continues:
'I swear to you, my Lord, that there is no
man so sharp of sight and discernment
that he does not believe when he sees her
that she is alive; no one so chilled by age
or so hard in his makeup that he does not
feel himself growing warm and tender,
and the whole of his blood stirring in his
veins. And no wonder; for if a marble
statue could, with the shafts of its beauty,
penetrate to the marrow of a young man
so that he left his stain there, then what
should this figure do which is made of
flesh, which is beauty itself, which seems
to breathe?' Both Aretino's and Dolce's
viewers are driven to raptures by the
beauty of the female forms in front
of them.

According to Vasari, Michelangelo was
not so effusive when he saw the *Danaë* in
Titian's studio while he was staying in the
Vatican Belvedere in 1545–6. He lamented
the lack of '*disegno*' but acknowledged
Titian's 'most charming and lively style'.
It is important to remember, however,
that Vasari's *Lives* centralised an historio-
graphic scheme in which *disegno* was the
pinnacle of achievement (and *colorito* was
not), and the anecdote could perhaps have
been fabricated in order to lend the
scheme further authority.

In 1549–50 Titian revised this composition
for Philip II. In the new version (fig. 61),
Danaë now bares her teeth in climactic
pleasure. The folds of the bed linen and
the modelling of her arm have been
rendered in abbreviated strokes and even
the maidservant (a new addition) has
been painted in an almost perfunctory
manner. The coins fall in greater quantity
and with greater rapidity, striated strokes
demonstrating their velocity. Such
schematic handling raises the possibility
of workshop assistance, although, like the
molten coins, the line between Titian's
looser, mature style and imitations of
this manner is easily blurred.
DJ

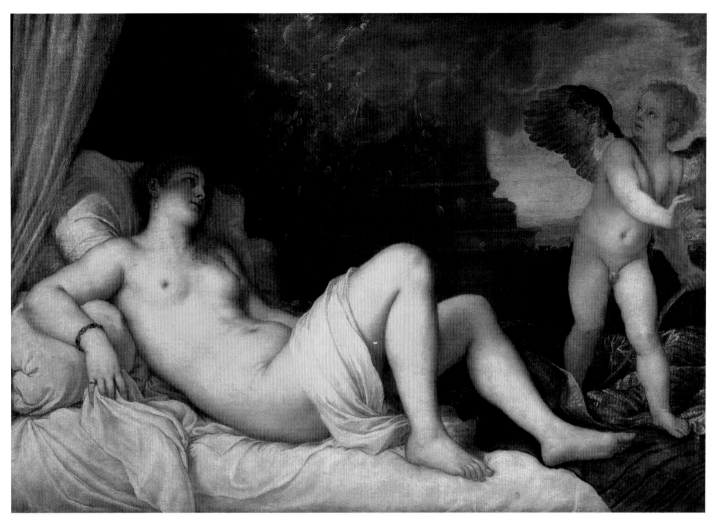

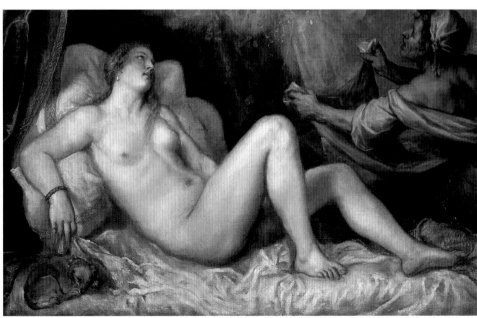

FIG. 61

TITIAN
Danaë with a Nurse (detail), 1549–50
Oil on canvas, 129 × 180 cm
Museo Nacional del Prado, Madrid,
inv. 425

24. *Clarissa Strozzi*
about 1542

Oil on canvas, 115 × 98 cm
Gemäldegalerie, Staatliche Museen zu
Berlin, inv. 160A

Select Bibliography: Crowe and
Cavalcaselle 1877, II, pp. 67–8; Wethey II,
p. 142, no. 101; Freedman 1989; Pedrocco
2001, p. 180, no. 123

Clarissa Strozzi was two years old when
Titian created this sensational and novel
image of childhood, here exhibited newly
cleaned and with the modern extensions
to the canvas covered. Clarissa was the
child of a rich Florentine banking family
exiled to Venice from 1536 to October
1542, when Clarissa's father Roberto was
expelled from the city because of his in-
volvement in a plot to bribe secretaries to
the Council of Ten to give state secrets to
the French ambassador and to send them
to the Turkish Sultan. Titian describes the
wealth and dignity appropriate to his
young sitter, with her adult adornments
of dog and jewellery; even her age is in-
scribed like a piece of ancient epigraphy
on a wall tablet on the left. Yet Clarissa
herself is not encumbered by these
conventions of presentation. She is
vibrantly alert, her curiosity aroused
by some activity which is out of view.

Pietro Aretino was surely right to marvel
at the remarkable vivacity and spontaneity
of the image. In July 1542 he wrote that
Titian's brush had improved with maturity
and if he, Aretino, had been a painter he
would be desperate faced with such an
image: only nature could judge if it was
an illusion or alive. 'I swear that it is
impossible to believe, much less carry
out such a thing; it deserves to be ranked
above all the paintings ever made, and ever
to be made, so natural is the image that
she seems to be alive. I would praise the
small dog the girl is caressing if remarking
on its qualities [of liveliness] could do it
justice.'

Clarissa is placed so as to be caught by the
intersection of wall and landscape, which
bisects her and the table on which her
dog sits. While details of her dress and
ornament are carefully described – the
slashed shoes, brooch and bracelet – other
features such as the texture of the dress are
indicated with summary bravura in a pink
underlayer in the illuminated part and a
blue shadow, enlivened with staccato white
flashes. Her pendant continues to swing
forward, implying the arrested movement
of the girl. The sense of movement is also
induced by the quickly sketched winged
putti, seemingly extruded from the
relief below the table, their impetuous
encounter heightened by the swept-back
curtain.

The landscape with its finely differentiated
variety of trees is characteristically articu-
lated by a crescent of sunlit grassland and
a regal pair of swans. The swans and
amours may be a reference to the sitter's

future rôle as dynastic marriage chip,
although it is hard to believe that her
own attention is yet caught by the thought
of a future husband. But to a learned
audience the similarity of her pose to the
ancient prototype of Cupid stringing his
bow may have implied her family's
aspirations for this budding beauty.
Clarissa sat for Titian as a banking heiress,
yet his portrait is one of the most engaging
images of childhood produced in the
Renaissance. Titian's ability to capture the
alert innocence of children is again
evident in many of his more formal
commissions such as the Pesaro and
Vendramin families in prayer (fig. 7, p. 15;
cat. 29), where in a wonderfully
naturalistic and effective device the
children turn away from the adults'
business to form a point of contact with
the viewer.
DJ

25. *Ranuccio Farnese*

1542

Oil on canvas, 89.7 × 73.6 cm
National Gallery of Art, Washington, D.C.,
Samuel H. Kress Collection,
inv. 1952.2.11 (1094)

Select Bibliography: Aretino I, pp. 129–31;
Crowe and Calvacaselle 1877, II, pp. 75–7;
Cook 1905, pp. 5–6; Borenius 1913, I,
no. 143; Fabbro 1967, p. 3; Pallucchini 1969,
I, pp. 99, 107; Wethey II, pp. 98–9, no. 31;
Shapley 1979, pp. 483–5; Washington 1990,
p. 244, no. 33; Parma 1995, pp. 204–6,
no. 26; Acidini Luchinat 1998, I, pp. 184–5,
pl. 49; Pedrocco 2001, p. 179, no. 122

The portrait of *Ranuccio Farnese*
inaugurated Titian's association with Pope
Paul III's family, who became his most
important patrons after the Habsburgs.
In 1539 (through the mediation of Pietro
Aretino) Titian had offered to portray the
'princes of the most illustrious Farnese
family'. An opportunity arose when the
pope's twelve-year-old grandson Ranuccio
(1530–1565) visited Padua and Venice in
1542. Ranuccio's portrait seems to have
been commissioned for his mother,
Girolama Orsini, by one of his tutors,
the bishop of Brescia. His other tutor,
Gianfrancesco Leoni, described the
portrait in a letter of 22 September 1542
to Ranuccio's elder brother, Cardinal
Alessandro Farnese: 'You undoubtedly
know that the Bishop of Brescia is pre-
paring to return to Rome, and that he
will bring with him a portrait of the
Prior [Ranuccio], which he has had done
by the divine Titian, intended for the
Duchess, in which Titian's excellence is
to be admired, particularly since he did
it partly in the presence of and partly
without Signor Prior'.

Like Alessandro, Ranuccio was destined
for the Church. He was a cardinal by the
age of fifteen, and had amassed the
bishoprics of Naples, Ravenna and
Bologna by the time of his death aged
thirty-five. In 1542 this was all before him,
and Titian's portrait shows a boy slightly
unaccustomed to his adult clothes and
sword. On Ranuccio's cloak the white
cross of the Knights of Malta stands out,
for he had come to Venice to be installed
as prior of the Knights' property of San
Giovanni dei Forlani. His expensive red
doublet, adorned with golden stripes
and embroidery, may allude to Farnese
hopes for his elevation to the College of
Cardinals. The strong lighting from the
left draws attention both to these rich,
heavy garments and to Ranuccio's alert,
intelligent eyes. All his facial features are
slightly enlarged in proportion to his
body, animating his face against the dark
background.

The portrait was well received by the
family, and resulted in further com-
missions – portraits of the pope alone
(including cat. 26) and with his *nipoti*
(fig. 62, p. 138); the first version of *Danaë*
for Cardinal Alessandro (cat. 23) – and a
trip to Rome by Titian (in pursuit of a
benefice for his son Pomponio). Ranuccio
remained attached to Titian's early likeness
throughout his short life. Taddeo Zuccaro

copied the portrait in his 1563–6 fresco of
*Pier Luigi Farnese appointed General of the
Papal Army* for the Sala dei Fatti Farnese
in the Farnese palace in Caprarola, com-
missioned by Ranuccio and his elder
brother.

After Ranuccio's death his portrait event-
ually disappeared from view. By the nine-
teenth century it was assumed to have
been lost, and when the portrait reappear-
ed around 1880 many questioned its
attribution. These doubts persisted until
the painting was cleaned in the late 1940s.
Today, *Ranuccio Farnese* is considered one
of Titian's most perceptive portraits. It is
seen here for the first time together with
Titian's other great images of children,
Clarissa Strozzi (cat. 24) and those in *The
Vendramin Family* (cat. 29). Titian's rare
ability to win his youthful sitters' trust
and to put them at their ease is evident
in all three pictures, but is perhaps most
apparent in his sensitive portrayal of
the precocious Ranuccio.
CC

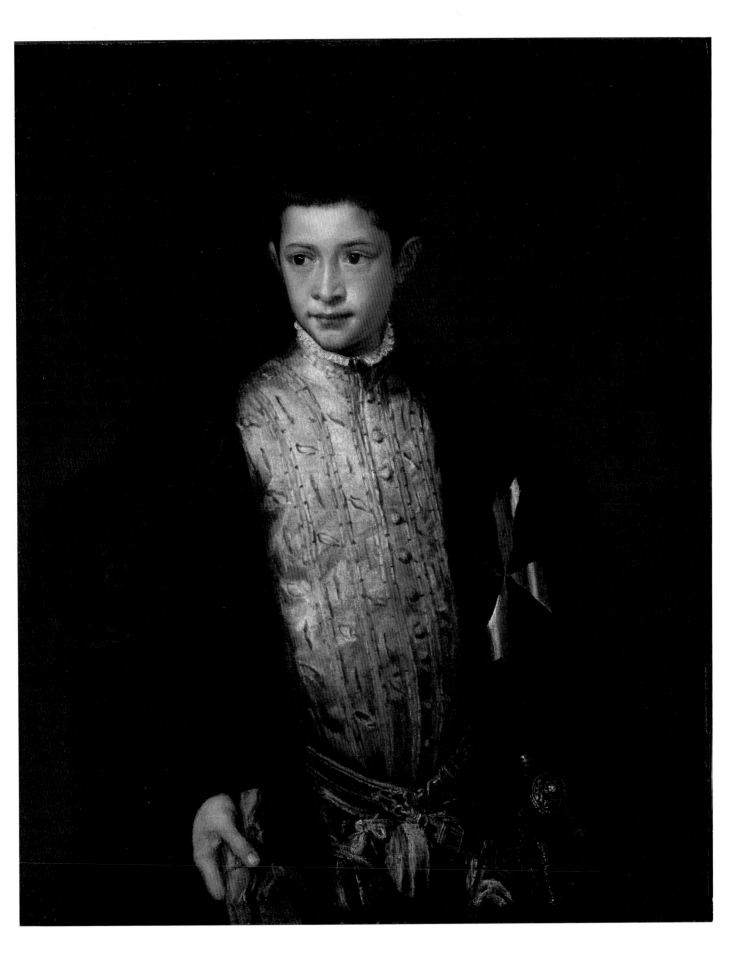

26. *Pope Paul III*

1543

Oil on canvas, 113.7 × 88.8 cm
Museo Nazionale di Capodimonte,
Naples, Q 130

Select Bibliography: Vasari (1568), VI,
pp. 162, 387–8; Crowe and Cavalcaselle
1877, II, pp. 86–8; Wethey II, pp. 28–9,
122–3; Mucchi 1977, p. 300, figs. 7–8;
Stinger 1985, pp. 53–7; Corti 1989, pp. 65–6,
no. 46; Zapperi 1990, pp. 28–9; Washington
1990, p. 246, no. 34; Paris 1993, p. 580,
no. 172; Parma 1995, pp. 206–8, no. 27;
Pedrocco 2001, p. 182, no. 127

Titian's portrait of Pope Paul III was not
his first commission from the Farnese
family: a year earlier he had painted Paul's
grandson Ranuccio (cat. 25) in the first
flush of youth – in distinct contrast to the
aged features of the pontiff, who would die
some five years later.

A payment of 27 May 1543 suggests that
Titian's portrait of Pope Paul III was
painted in April or early May of that year.
Titian had witnessed the pope's entry into
Ferrara on 22 April 1543 and had accomp-
anied the papal party to Bologna, where
he must have executed the portrait
very quickly. The pope then travelled to
Busseto, near Parma, where from 21 to 25
June he met the Holy Roman Emperor
Charles V. He subsequently sat to Titian
again when the artist visited Rome from
autumn 1545 to June 1546.

The present portrait differs from the
later ones in depicting the pope without
his *camauro* or cap but holding his *bursa*
or purse in his right hand. The absence
of headdress suggests humility: the
convention was that others who had
audience with the pope should be bare-
headed. The significance of the *bursa* is
difficult to pinpoint: it could be regarded
simply as a ritual prop, indicating status,
the equivalent of the *mappa* or napkin

held by Julius II in Raphael's portrait of
the earlier pope in the National Gallery.
The *bursa*, however, was associated with
the distribution of coins to the populace
during his coronation by the pope himself,
uttering the words 'Gold and silver are
yours'. The ceremony recalled ancient
imperial Roman practice, and under-
lined the temporal aspect of the pope's
authority, a significance that would not
have been lost upon Paul III, the first pope
of a Roman family for some hundred
years, and well known for his nepotistic
furtherance of Farnese influence. In 1546
Giorgio Vasari depicted Paul III with the
bursa, giving gold coins to the Virtues, in
his fresco of *Pope Paul III distributing
Benefices* in the Sala dei Centi Giorni in
the Cancelleria in Rome, executed for the
pope's grandson Alessandro Farnese;
significantly, Vasari records in his *Lives*
that he used Titian's *Paul III* as a pictorial
source. Given Titian's frustrating ex-
periences with the pope, the quotation
may not have best pleased him.

Paul's long, fur-lined sleeves, the folds of

which Titian has so lavishly arranged, are
typical of papal winter dress (which he
would still be wearing for an April sitting).
Titian perhaps unconsciously felt, in the
Venetian tradition, that wide sleeves
denoted status; he has massed the
mazzetta or cape in such a way that,
more than defining volume (especially
in the way the seams contour the form),
it suggests impressive bulk.

Like *Ranuccio Farnese*, *Paul III* met with
the family's approval: Vasari records this
portrait in Cardinal Alessandro Farnese's
guardaroba, his private chamber. In con-
trast, Titian's triple portrait of *Paul III
with his Grandsons* (fig. 62), painted in
Rome, may not have met with such a
positive reaction: certainly much of it was
left unfinished. However, the explanation
for this may lie not in its too naked por-
trayal of the pope's famed *terribilità* but
in Titian's success in obtaining a benefice
for his son Pomponio. On receipt of this
he had no further need to stay in Rome.
Titian captured Paul's small bright eyes,
but they missed his genius. DJ

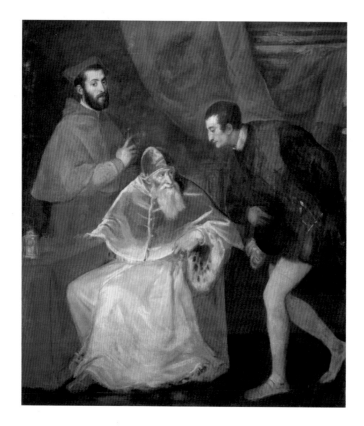

FIG. 62

TITIAN
*Pope Paul III with his Grandsons
Alessandro and Ottavio Farnese*, 1545–6
Oil on canvas, 210 × 174 cm
Museo Nazionale di Capodimonte,
Naples, inv. Q 129

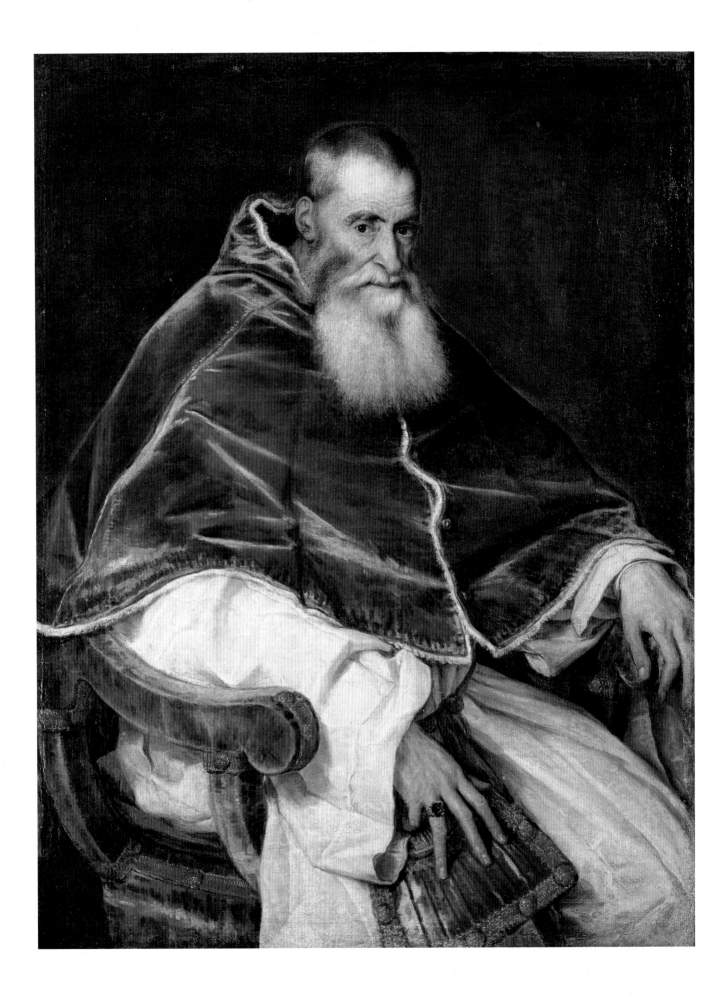

27. *Pietro Aretino*
1545

Oil on canvas, 108 × 76 cm
Galleria Palatina (Palazzo Pitti), Florence,
inv. 54

Select Bibliography: Aretino I, pp. 31–6,
42–3, 79–80, nos. 1, 3, 14; (for the chains)
pp. 22, 88–9, 147, nos. 8, 36, 86; II, p. 145;
III, pp. 70, 221; Crowe and Cavalcaselle
1877, II, pp. 109–10; Wethey II, pp. 75–6,
no. 5; Florence 1978, pp. 31–6, no. 1;
Mozzetti 1996, p. 30; Kaminski 1998, p. 55
(print with tongue-chain); Pedrocco 2001,
pp. 190–1, no. 127

Aretino sent this portrait of himself by
Titian to Florence in 1545 in order to
promote both himself and the artist to
Cosimo I de' Medici, duke of Florence.
The gift was an audacious and ambitious
attempt to plant Venetian art in the
territory of Pontormo, Bronzino and
Salviati. Indeed, like Titian's subsequent
dispatches to Cosimo of portraits of *Philip
II* and *Charles V* in 1553, it was not well
received. The lesser quality of the two
royal Spanish portraits sent to Florence
suggests that Titian had by then clearly
understood Florentine resistance.

The Aretino portrait, with its Venetian
abbreviations and flourishes, deliberately
sets up a challenge to the polished air-
lessness of the Medici face painters. The
staccato brushwork across the sleeve,
chain and cloak is barely contained by
the accurately observed seam and edges of
the understated costume. This lightning
attack of paint in Aretino's costume can
be compared with the sharp but more
restricted brushwork in the white dress in
the portrait of *Clarissa Strozzi* (cat. 24).
But nine months after he had sent the
portrait Aretino wrote that he was dis-
appointed it had not been shown to

Cosimo. Titian was about to visit Florence
on his return journey from Rome! It
seems that Pier Francesco Ricci, Cosimo's
controller of artistic patronage, did not
want his position usurped. His success is
indicated by the fact that Titian arrived in
Florence on 12 June 1546 but was already
back in Venice on 19 June.

Gold chains like the one prominent in
the portrait were often presented to this
'scourge of princes' in order to encourage
a friendly press from him, the massive one
that François I gave him in 1533 setting the
standard. In Aretino's play *Il Marescalco*
(The Chamberlain), begun in 1529 and
published in 1533, a groom tells a gold-
smith that in contrast to the flimsy ones
popular in Venice 'the chains want to be
like the one the king of France sent as a
gift to Pietro Aretino, as far as Venice,
which weighs eight pounds'. Aretino
used poetic licence, because in fact he
thanked the king of France by letter for a
five-pound chain. In the same letter he
mentions tongues in the links and red
enamel, but either Titian did not attend
to this detail or Aretino is wearing another
such substantial gift. There are prints
showing Aretino wearing both fleur-de-lys
chains and a tongued chain, which are
more likely to have been the one given
by the French king.

In what one suspects to be an
autobiographical reference Aretino has
one of the actors in his 1542 play *La
Talanta* note that the white hairs in his
beard are the result of stress, not age.

Although Titian has clearly indicated
white hairs in his beard in this portrait,
Aretino must have begun dyeing them out
very soon afterwards. In 1548 he wrote that
he had given up dyeing his beard, but we
do not know exactly when he started
manipulating his appearance.

This is one of many images Titian created
of his friend and promoter. It is partic-
ularly important as a successful demon-
stration of his skill in the loose manner
of painting that was to become so popular
in Venice. Aretino seems impatient to
move out of the painting to escape the
brush that is modelling him, drawn by
more pressing matters. The great critic
made several different comments about
the portrait: he praised its awesome power
to his correspondent Paolo Giovio, to
Cosimo he claimed he would have been
better dressed if he had paid the artist
more money, and Titian he rebuked,
frustrated that the artist had not also
made him a portrait of Cosimo's father,
Giovanni, declaring that his portrait
was no more than sketched.
DJ

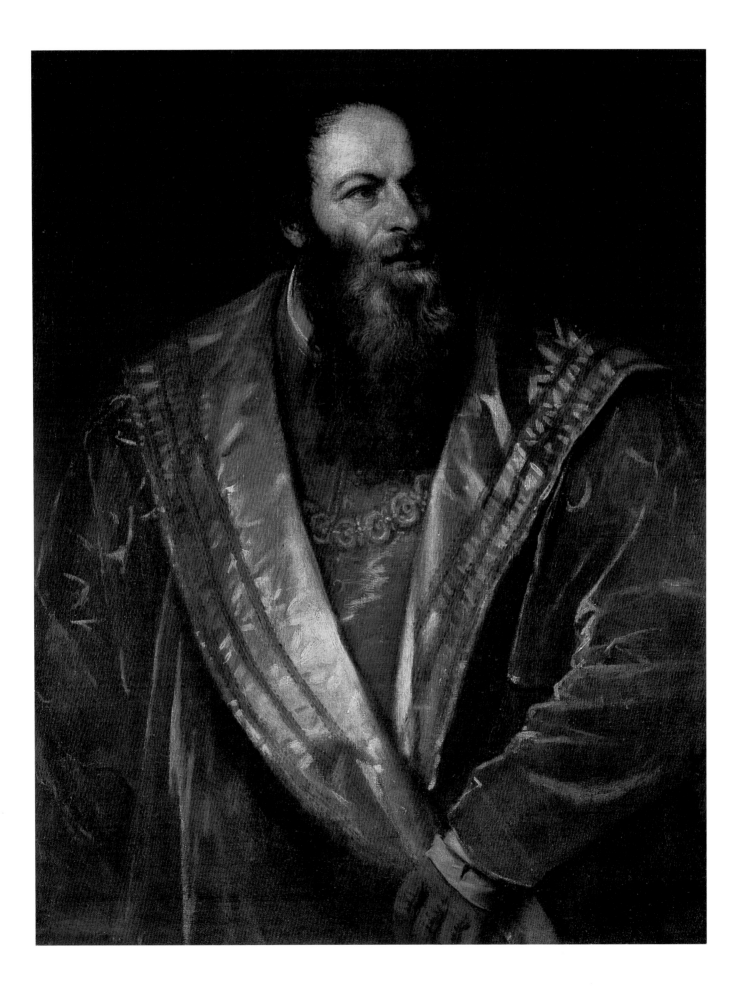

28. Self-portrait

about 1546–7

Oil on canvas, 96 × 75 cm
Gemäldegalerie, Staatliche Museen zu
Berlin, inv. 163

Select Bibliography: Vasari (1568), VII,
p. 446; Crowe and Cavalcaselle 1877, II,
pp. 60–2; Wethey II, pp. 143–4, no. 104 (see
also p. 179, no. X-92); Klinger 1991,
II, pp. 186–7, no. 347 (for Paolo Giovio);
Woods-Marsden 1998, pp. 159–67, 228;
Pedrocco 2001, pp. 272–3, no. 234

Self-imaging became a popular pursuit
for artists during the Renaissance. In 1553
Titian had sent a portrait of himself to
Philip II, which was hung in the Pardo
alongside an image of his other favourite
court painter, Anthonis Mor. Both of these
paintings were subsequently lost in a fire.
Although this can only remain speculative,
it is tempting to consider that Titian
might have chosen to paint this image
as a pendant to the *Aretino* (cat. 27), for
Aretino would have made the artist aware
of the propagandist possibilities of such
images.

It seems more probable that the present
portrait served a domestic purpose. Vasari
records that Titian had made portraits for
his family to remember him by; given its
lack of finish, it seems possible that this
was one such portrait. The *Allegory of
Prudence* (cat. 34) was a later expansion
on this theme, possibly incorporating
other members of the Vecellio family. This
was not, however, a tradition singular to
Titian, as Licinio's *Portrait of the Artist's
Family* (Louvre) suggests.

The dark aura around Titian's face
suggests that the portrait may have
originally been no more than a study of
the head. The unfinished status of the
drapery in particular provides a valuable
insight into the way in which Titian
developed form: an outline of strong
contouring is painted on to the canvas and
then enhanced with a painterly cascade of
highlights. These are evident not only in
the red touches on the gold chain and
fingers, but also in the treatment of
Titian's shirt, which seems to have been

modelled in much the same manner as
Clarissa Strozzi's dress (cat. 24).

Titian's cap seems to have become part of
his iconography, although it is difficult to
define its relevance with any precision.
A cap had scholarly connotations in the
Renaissance; as Denise Allen has pointed
out (verbally), from the fifteenth century
onwards Aristotle is often depicted with
a similar cap, and so is the scholarly
theologian Saint Jerome (for example
in a painting of him by Catena in the
National Gallery). In the sixteenth century
humanists such as Bindo Altoviti were
also depicted wearing similar attire,
notably on medals. Of course, it is also
possible that Titian chose to wear a hat
simply because he was balding (the ex-
voto image of himself and his son
included in the Accademia *Pietà* (fig. 64,
p. 152), though very sketchy, seems to
show hair loss). Otherwise his status is
illustrated in economic rather than intel-
lectual terms – in the sumptuousness of
his dress. The gold chain has often been
identified with that supposedly given to
the artist by Charles V in 1533, but chains
of this type were often worn as status
symbols.

The withdrawn positioning of the face
might be interpreted as a form of humility,
although the strong curve of the shoulders
and the alert glance counterbalance this
sentiment. Titian might have used mirrors
or even a wax image or terracotta (perhaps
modelled by Sansovino) in order to
capture this three-quarter viewpoint with
his gaze projected 'offstage'. The potency
of this formula is also explored in his
portrait of *Jacopo Strada* (cat. 38). The
slight backward incline of the head might
also represent a rethinking of papal
representations, such as that of *Paul III*
(cat. 26). X-rays show that Titian (or an
artist who might have 'completed' the
image) was worried about where to place
his left hand.

Titian's status might also be measured in
the number of portrait medals of him
produced in the sixteenth century.
Pastorino da Siena made a profile medal
of Titian in the 1540s and two other
medals survive representing the artist in
profile, following the Prado *Self-portrait*
(cat. 33). There is also a woodcut of 1550 by
Giovanni Britto (fig. 21, p. 39), for which
Aretino was to write accompanying verses
(he expressed irritation at being pestered
to complete the verses during a heatwave).

Though sometimes associated with the
Self-portrait mentioned in Vasari's 1568
Life of Titian, and supposed to have been
painted about 1562–4, the present painting
corresponds to a portrait of Titian that
Paolo Giovio had acquired for his col-
lection of portraits by May 1549 (Charles
Hope in communication with the author).
It has formerly been argued that Paolo
Giovio's portrait corresponded to the
original on which Britto's woodcut of
Titian (fig. 21, p. 39) was based, but Hope
has noticed that two copies of the picture
in Giovio's collection, in the Ambrosiana,
Milan, and the Uffizi, published by
Klinger, reflect the Berlin portrait, as
they show the white collar missing from
the Britto image. The Britto woodcut
corresponds instead (in reverse) with
a tondo formerly in the Kaufmann
collection that may be or reflects the self-
portrait formerly in Gabriel Vendramin's
collection, presumably before 1552, when
Gabriel died. A dating of about 1546–7 for
the present portrait seems plausible,
providing an interesting comparison with
the handling of the faces in the closely
contemporaneous *Vendramin Family*
(cat. 29).
DJ

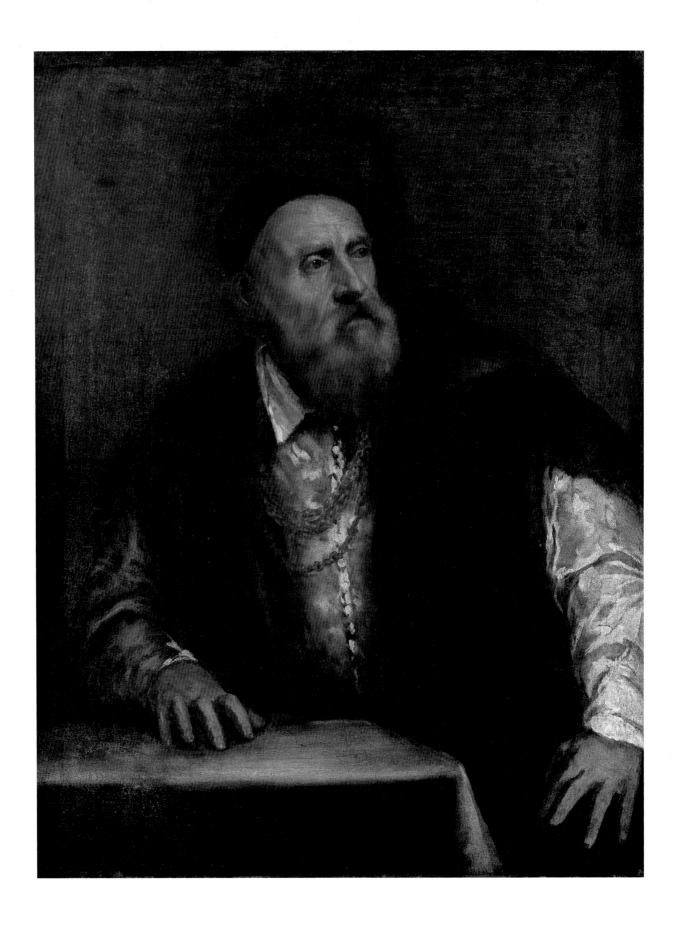

29. *The Vendramin Family venerating a Relic of the True Cross*
about 1540–5, re-worked perhaps about 1555

Oil on canvas, 206.1 × 288.5 cm
The National Gallery, London, NG 4452

Select Bibliography: Crowe and
Cavalcaselle 1877, II, p. 303; Bode *et al.* 1911,
pp. 72–4 (part of will); Ravà 1920, p. 177
(1569 inventory); Gronau 1925 (identity of
sitters); Suida 1933, p. 165; Pouncey 1939
(cross); Pallucchini 1969, I, pp. 118–19,
287–8; Wethey II, p. 147, no. 110; Gould
1975, pp. 284–7; Fisher 1977, p. 40
(workshop participation); Battilotti and
Franco 1978, pp. 64–8; Wood 1990,
pp. 680–95 (Northumberland); Anderson
1997, pp. 160–1, 172 (theory about Gabriel);
Pedrocco 2001, p. 199, no. 147

The painting was described in March 1569,
when in one of the Vendramin properties
in the parish of Santa Fosca in Venice, as a
'large picture in which there are depicted
the miraculous cross with Andrea
Vendramin with seven sons and Gabriel
Vendramin with its gilded frame made by
the hand of Titian'. The cross referred to
was a rock crystal and silver-gilt reliquary,
in the uppermost gabled compartment of
which were preserved splinters of wood
from the True Cross. It still belongs to the
Scuola di San Giovanni Evangelista in
Venice. It was received on behalf of the
Scuola (one of the great penitential
confraternities of the city) in 1369 by
Andrea Vendramin, then its *guardiano*,
from the scholar, diplomat and champion
of the Crusades Philippe de Mézières. It
was associated with several miracles, some
directly involving the Vendramin family;
these were depicted on the walls of the
Scuola in the last years of the fifteenth
century (and are now in the Accademia
in Venice). This Andrea Vendramin, a
merchant in oil and other commodities
and a manufacturer of soap, had been
admitted to the Venetian patriciate in
recognition of his contributions to the
Venetian war effort in 1381, shortly before
he died.

Andrea Vendramin's grandson, also named
Andrea, was elected Doge in 1476 and is
buried in one of the richest tombs made in
the Renaissance. The Andrea mentioned in
the document of 1569 must be the Andrea

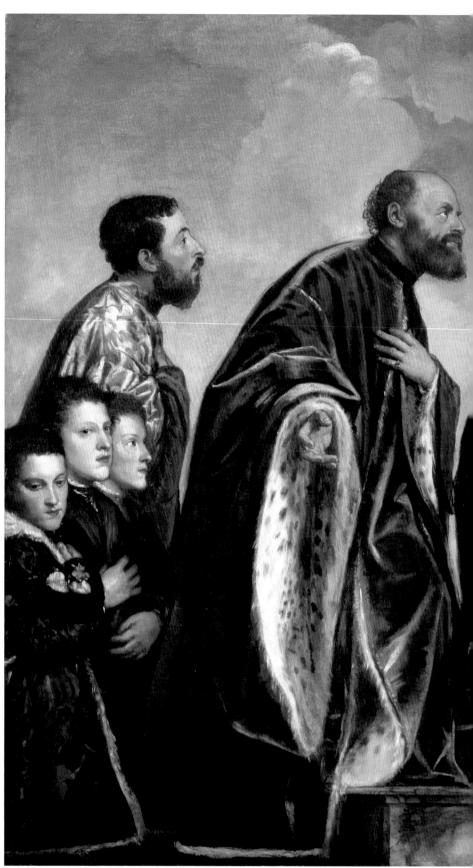

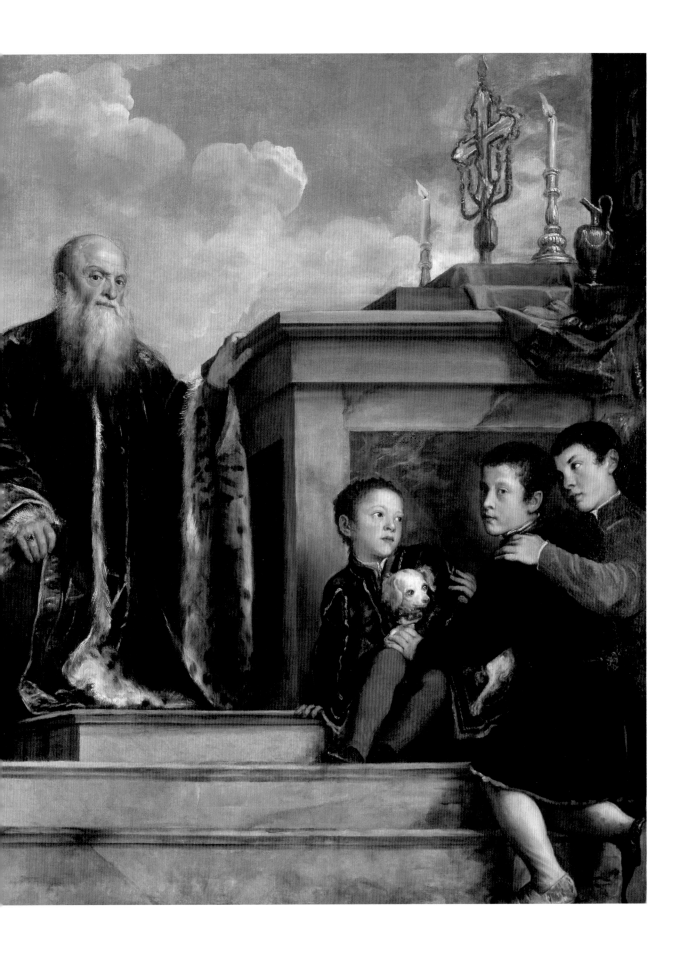

Vendramin who was one of the great-nephews of the doge. He was born in 1481 and died in 1547. He had seven sons, the eldest of them, Lunardo (Leonardo), born in 1523, and the youngest, Federigo, born in 1535. Andrea must be the man leading the elder male members of his family in veneration, that is, the balding, dark-bearded man in profile with his left hand on his chest. Lunardo must be the young bearded man behind him. Federigo must be the boy with the puppy seated on the right. And to judge from the latter's apparent age, the painting must have been made, or at least begun, between 1540 and 1542.

There is no stylistic problem with this dating, although before the sitters were identified most scholars preferred to place it in the 1550s. The painting of the little boy, and indeed the puppy, recall the portrait of *Clarissa Strozzi* (cat. 24) of 1542, whilst the bold modelling and penetrating stare of Andrea are found also in the portrait of *Pope Paul III*, a documented work of 1543 (cat. 26). But the identity of the oldest man beside the altar constitutes a major problem. It is natural to suppose that he must be Andrea's brother, Gabriel Vendramin, who is said to be present in the description of the picture made in 1569. He had, however, died in 1552 and none of his nephews, for whom the description was made, were old enough in the 1540s to be well informed about the painting. There has been a great deal of confusion about Gabriel's age, but he was born in 1484 and was thus three years younger than his brother Andrea. Responding to this information, some scholars (most recently Anderson) have proposed that the older man is Andrea, but this detaches him from his children and in any case it is surely clear that these men are not brothers who are close in age. Stefanie Lew, who is carrying out research on the family's palaces and properties in the sixteenth century, has advanced the

hypothesis that the old man is meant for the fourteenth-century Andrea – the ancestor who had established the family's fortune and nobility, and was so closely identified with the reliquary cross.

This interpretation becomes less extraordinary when we consider that the painting cannot be taken literally: there never was an outdoor altar of this type upon which this reliquary was displayed and it is not likely that Lunardo was eligible to wear the robe of a senator (his is of crimson damask, his father's of crimson and the older man's is of *pavonazzo*, a deep violet, now darkened). The other figures do not acknowledge the old man's presence. He grips the altar in what seems a somewhat proprietorial way. And his eye is fixed upon the viewers – intended originally to be his descendants.

If Gabriel is not included in the painting this does not mean that he had nothing to do with it. The document which records this painting also records the works of art in his great collection – antiquities of all kinds, ancient gems, exotic porcelains, paintings by Giorgione, drawings by Raphael – and we know that he was a friend of Titian, who witnessed one of the codicils to his will. This will provides extraordinary evidence of Gabriel's anxiety concerning the future of his family and the family business, given that his nephews, whom he had adopted as his heirs, were so young. And, as his will makes clear, he felt that the future of the house of Vendramin depended on the veneration of this relic. Perhaps he gave Titian the commission when he agreed to adopt the boys so that they and their descendants would grow up with it as an example.

The painting was subjected to a major revision by Titian and was not finished by him. It was originally meant to be longer, and the profile of Lunardo was painted further to the left (where it can be discerned with the naked eye). Presumably as a consequence of the change to Lunardo the three boys on the left had to be squeezed in in front of him, where they detract from the spatial effect of his pose. They are clearly workshop additions and may have been added after Gabriel Vendramin's death. Deaths in the family (Lunardo and his father Andrea in 1547) may well have disrupted work on the painting but so, too, may Titian's unprecedented obligations at the courts of both the emperor and the pope.

The painting was no doubt made for the *portego* (the central hall of the *piano nobile*) of a Venetian palace and the relatively low vanishing point (which is also off-centre) must relate to its original placing. It influenced many other family paintings of similar size and format in both Venice and the Veneto. When it came to England (where it is recorded in 1641, in the collection of Anthony Van Dyck, whence it was acquired in 1645 by the Earl of Northumberland), it was felt to epitomize the power and solemnity of the ruling class in the maritime Republic and was known simply as the 'Senators of Venice'.
NP

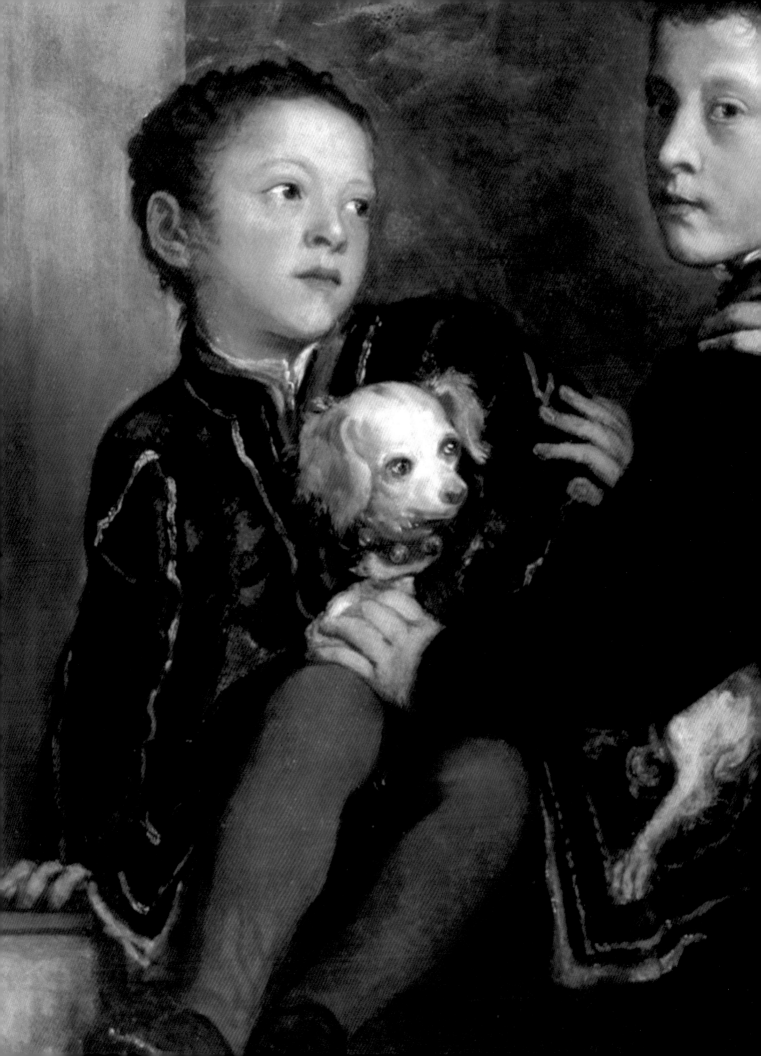

30. *Philip II in Armour*

1550

Oil on canvas, 193 × 111 cm
Museo Nacional del Prado, Madrid,
inv. 411

Select Bibliography: Aretino II, p. 277, no. XDVIII; Crowe and Cavalcaselle 1877, II, pp. 204–11; Cloulas 1967, p. 213; Pallucchini 1969, I, p. 296; Wethey II, pp. 126–8, no. 78; Hope 1980A, pp. 109–10; Hope 1990, pp. 53–9; Campbell 1990, p. 236, n. 25, 241; Checa 1992, pp. 102–3; Molina 1999, pp. 47–51; Pedrocco 2001, pp. 216–7, no. 171

At the end of 1548 Titian travelled to Milan to meet the future Philip II of Spain, Charles V's heir. Primarily he undertook this journey to secure the payment of his Habsburg pensions. However, the visit also resulted in a portrait of the prince, possibly the present painting. A letter from Aretino to Philip, dated February 1549, includes a sonnet in praise of Titian's portrait.

X-rays have shown that *Philip II* was painted over an earlier full-length portrait of his father the emperor. In common with Titian's surviving portraits of *Charles V*, this state portrait conveys the sitter's extremely high status, as well as a measure of his character. The prince, aged in his early twenties, stands before a table covered with a red plush hanging. A shaft of light to his left draws attention to his head, suggestive of a surrogate crown. Philip reaches out to touch his ceremonial helmet, placed below a column looming up at the far left, which probably refers to the Habsburg emblem of the Pillars of Hercules. This column, intersecting with the lines of the table, adds a certain monumentality to the subject's puny frame.

This portrait inaugurated Titian's association with the prince, who was to become his most important patron. At the time of their meeting in Milan, Philip had been exposed to very little contemporary Italian painting. Consequently, Titian seems to have toned down the more innovative and unusual elements of his style, which might have disconcerted the prince. The decorative details of Philip's parade armour, manufactured in 1550 by the Colman workshop of Augsburg, which survives in the Real Armería, Madrid, have been rendered very precisely, although other areas, particularly the reflections of the Prince's armour, do seem to dissolve before one's eyes. In general, the finish is higher than is usual for Titian, as was appropriate for a sitter accustomed to the greater surface detail of Habsburg court painters like Seisenegger. Philip nevertheless complained in a letter of 1551 to his aunt Mary of Hungary (herself a re-nowned collector of Titian's paintings) about a portrait of himself in armour by Titian – probably this portrait. If there had been more time, he said, he would have had Titian go over it again.

These doubts did not prevent Philip from commissioning further works from Titian, many noted for their stylistic and narrative innovation. Titian's portrait of the future king and emperor marks the beginning of an extraordinarily fruitful relationship between patron and artist, which was to produce both great secular paintings, including *The Death of Actaeon* (cat. 37), and emotive religious works such as *The Entombment* (cat. 31), and was to last for the rest of Titian's life.
CC

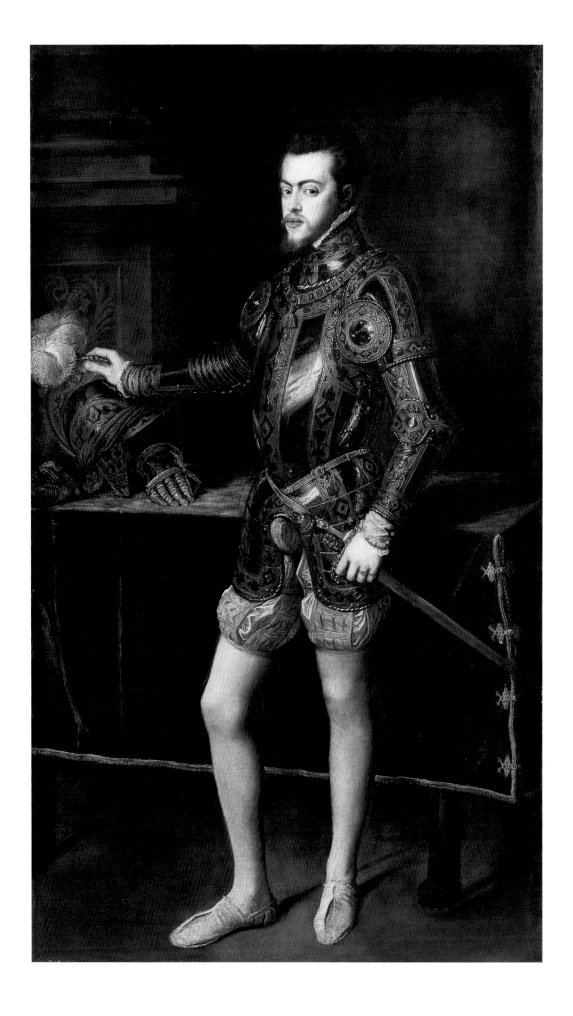

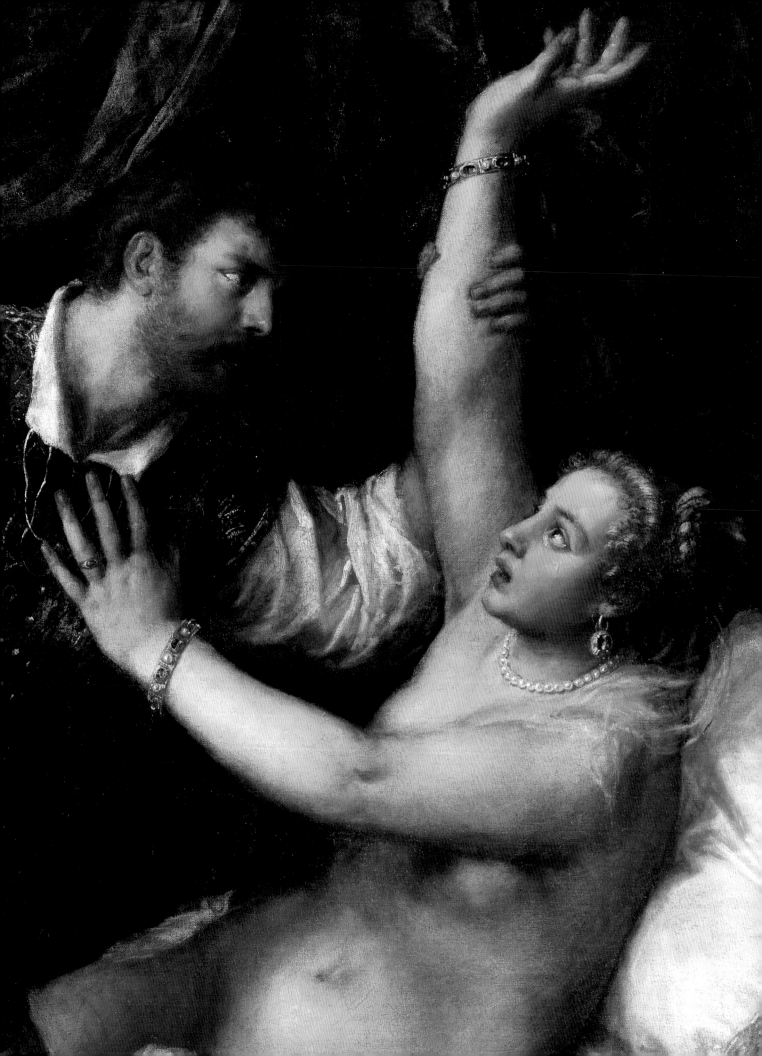

V LATE TITIAN

IN HIS INTRODUCTORY ESSAY (pp. 25–8), Charles Hope argues that in his earlier paintings for Philip II Titian perfected a style, and a standard of finish, with which he sought to conform for the rest of his life, and he regards as unfinished, or not ready to leave the studio, a number of relatively sketchy, freely brushed, monochromatic works, such as *The Death of Actaeon* (cat. 37) and *The Flaying of Marsyas* (fig. 63). In particular he does not accept that Titian underwent a self-conscious stylistic development, moving into a 'late style' reflecting a different, more introverted approach on the part of the artist in his extreme old age. This surely is right, but it is also true that Titian was capable of an extraordinary range of effects and sometimes violent emotion in the paintings of the last third or last quarter of his life, and that some of these effects were achieved with a remarkably free and highly 'expressive' brushwork.

Even before the last period of his life Titian would paint comparatively freely when the conditions were appropriate, for instance when the surface of the work was not intended for close scrutiny or when it was on a large scale. Works such as *The Presentation of the Virgin* (1534–8; fig. 11, p. 21), *The Vendramin Family* (about 1540–55; cat. 29), and *Charles V on Horseback* (1548; Prado, Madrid) are quite broadly painted. The Ancona *Crucifixion with Saint Dominic* (fig. 65 and fig. 76), which was sent to Ancona by 22 July 1558, and *The Annunciation* in San Salvatore in Venice, of about 1560–6, have numerous passages that are typical of this 'late style', for example, in the latter, the explosion of smouldering, impasto lilies.[1] Here the dim location in the churches for which these works were destined may have affected the level of finish Titian thought fit to apply. The same may also apply to *The Martyrdom of Saint Lawrence* now in the Gesuiti in Venice (1548–59), which in addition is a night scene, and therefore appropriate for broad, flickering brushwork. The fact that all these paintings left Titian's studio in his lifetime indicates that the loose stylistic effect was intended.

There is, nonetheless, a radical difference between the free manner of the Gesuiti *Saint Lawrence* and the re-working of the same composition in the *Saint Lawrence* in the Escorial (despatched 1567; fig. 75, p. 178). Here dripping slashes of paint seem to melt down the canvas, as if light has become icing. The monumental sculptural qualities of the former have been replaced with a flattening of depth by emphasising the texture of the surface. The stone pedestal has a tactile, waxy surface that almost bubbles across the canvas, and the halberds or spears, more numerous than in the Gesuiti picture, dramatically intersect this relief-like picture plane. It is possible that the repetition of the earlier composition encouraged Titian to vitalise the forms in this way, for this approach is anticipated in his second version of *The Entombment* (cat. 31), replacing a painting finished shortly before that had gone missing.

Even when one compares the later *Saint Lawrence* to a painting only a few years earlier, the 1559–62 *Rape of Europa* (fig. 15, p. 26), the stylistic evolution is again remarkable. The energy of the writhing forms is common to both, but the flaming swirls of drapery in the *Europa* that lick around the flesh have been replaced by glowing heat which kindles on flesh and liquifies stone. The sparkling whites that enliven irises, water and fish scales in the one become the fearful flashes of white in the eyes of men and beasts in the other. The force and energy, though consistent, is developed to an expressive climax in the later *Saint Lawrence*.

FIG. 63

TITIAN
The Flaying of Marsyas, about
1570–6
Oil on canvas, 212 × 207 cm
The Archbishop's Palace,
Kromeríz, O 107

FIG. 64

TITIAN and PALMA
GIOVANE (about 1548–1628)
The Pietà, completed by 1628
Oil on canvas, 378 × 347 cm
Gallerie dell'Accademia,
Venice, inv. 400

Vasari (or a source) visited Titian's studio in 1566 and in his *Life of Titian* the broad manner of Titian's later painting, his 'late style', is described. In the Ancona *Crucifixion* Vasari mentioned what he called stains or patches (*macchie*), forceful, striated and impasto applications of paint that are used alongside terser strokes. The few deft highlights on Saint Dominic's head and the broad earth tones that define Christ's feet (fig. 65) are remarkably similar to the way forms are suggested in unfinished works. It is possible that Vasari's account of Titian's late work was influenced by the writings of Aretino, who had already observed the expressive use of brushwork in Venetian art. In his letter of April 1548 to Andrea Schiavone, Aretino declared that both he and Titian had admired the 'informed swiftness' and 'intelligent execution' in Schiavone's well composed 'sketches of stories', but at the same time wished that these inventions were more diligently finished.

Comments on Titian's technique by his former studio assistant Palma Giovane are also recorded. He noted that Titian developed his compositions from a base of colour, gradually working up the details until the scheme became visually coherent. He reported that Titian's canvases were begun with 'strong strokes' and that he could 'convey in four strokes the promise of some beautiful figure'. This may help explain the often summary treatment of hands in many of his works: even in comparatively developed paintings such as the *Europa* the hands of the putti have been summarily blocked in. The *Marsyas* (fig. 63) is another example of a fluid base of colour being worked into a coherent narrative, incorporating details of significant attributes such as the dog's teeth, Apollo's wreath and Midas's crown.[2] What could be Titian's own signature appears on the rock in the right foreground, so this might be regarded as a completed painting. By contrast, other paintings such as *The Crowning with Thorns* (fig. 16, p. 27) and *The Death of Actaeon* (cat. 37) have no signature and are not known to have

left Titian's studio before his death, so we can only guess how close they may be to their final intended form.[3]

The case of Titian's *Pietà* (fig. 64), intended for his own tomb, is important. Titian seems to have finished its central section, but then decided to extend it, adding the saints on either side. As such Titian left it 'inchoate', and Palma Giovane finished it, according to the inscription on the painting.[4] Palma does not appear to have attempted to alter the general style or monochromatic appearance of the painting, which he left consistent with Titian's other 'late' work. His intervention displays none of the linearity characteristic of his own work (only the simplified pools of light on the descending angel, Jerome's cloak, and perhaps the insubstantial right-hand statue of Saint Helen, point to his authorship), and he must have decided to leave the painting in its present state because he believed it would be admired as it was. Some contemporaries certainly considered some works of this kind to be unfinished, though they were not necessarily well informed, and there were buyers for them.

Unlike those of other Venetian artists, whose heirs were able to continue their work, Titian's estate was sold off quite soon after his death, putting into circulation canvases in various states; some seem to have been brought by others to an 'appropriate' degree of finish, receiving harsher interventions than Palma felt necessary for the *Pietà*. But these may not have been regarded as autograph in the first place, for appreciation of Titian's late style is demonstrated not only by Palma but by its imitation by Jacopo Bassano, Andrea Schiavone and Dirck Barendsz. Vasari indicated that there were many imitators of Titian's late style, though we have very few identifiable examples. It is possible that the Vienna *Tarquin and Lucretia* (fig. 69, p. 164) was never touched by Titian. Undoubtedly, at the time of Titian's death there were works in diverse states of progress in his studio, including workshop paintings to which he had made alterations: the hazy Prado *Christ carrying the Cross* is a case in point. Charles Hope has raised the possibility that an assistant such as Emanuel Amburger, who was still working for the Vecellio family in 1580, could have generated 'Titian' paintings after his death from compositions in the workshop.

By any standards the achievements of Titian's last twenty years were remarkable: the pathos and the straining brutality of the Gesuiti *Saint Lawrence*, the boldness of the Ancona *Crucifixion* (fig. 65 and fig. 76, p. 180), the enchanted magic of *Diana and Callisto* (fig. 14, p. 25), the violent brilliance of *Tarquin and Lucretia* (cat. 36). These are the peaks of an energy wholly uncommon in such advanced years. Faced with the astonishing quality of these works, the status of Titian's other inventions (such as *Ecce Homo*, cat. 41, or *Virgin and Child*, cat. 35) may be challenged, but the inconsistency of his late production defies definitive division. DJ

FIG. 65
TITIAN
Detail of Saint Dominic from *Christ on the Cross with the Virgin, Saint John and Saint Dominic*, 1556–8
Oil on canvas, 375 × 197 cm
Pinacoteca Comunale (on temporary loan from the church of San Domenico), Ancona

31. *The Entombment*

1559

Oil on canvas, 137 × 175 cm
Museo Nacional del Prado, Madrid,
inv. 440

Select Bibliography: Crowe and
Cavalcaselle 1877, II, pp. 278, 289–92;
Tietze 1936, II, p. 296; Berenson 1957,
p. 188; Wethey I, pp. 90–1, no. 37; Hirst
1981, p. 158 (for Aretino's remarks); Paris
1993, p. 614, no. 253; Ost 1992; Jones 1993,
pp. 110, 114–5 (for Federico Borromeo);
Pedrocco 2001, p. 251, no. 207

Sent to Philip II in 1559 together with
the more carefully modelled *Diana and
Callisto* and *Diana and Actaeon* (figs. 13
and 14, pp. 24–5), this painting was a
replacement for a version lost in transit
two years earlier. The composition is
likely, therefore, to have been resolved in
the earlier version (which was perhaps
preserved in a tracing, see further
pp. 61–8), enabling Titian to focus on
the handling, which is characterised by
vigorous and engaging brushwork across
the picture surface, most noticeably in
the flashing sky and the mourning figure
sweeping towards Christ's body from
the right.

The relief of *The Sacrifice of Isaac* (an Old
Testament prefiguration of Christ's death)
on the sarcophagus is a kind of painterly
transcription of what we know of Titian's
drawing technique. It is a version in little
of the spotlight effect which skims across
the entire painting – on foreheads, noses
and shoulders. Here are signs of the
conflict between form and surface that
would develop in Titian's later paintings.
In many of Titian's works from the late
1560s onwards the surface highlighting
dominates – creating a kind of splashing,
gestural façade across the figures. Christ's
face, in particular, anticipates the manner
in which surface texture came to convey
sentiment and meaning in later works.
The highlights on the nose and cheekbone
are set against dark shadow, with broader

striations of light and dark defining the
shoulder bone. It may be that it was
because Titian approached this repetition
as a retouching exercise, energizing the
forms with added highlights, that the
result resembles his 'late' style. The
emphatic black lines defining the dress
of the woman in white can be matched
with similar sketchy details in the torso
of the Prado *Danaë* (fig. 61, p. 132), a later
version of the Naples *Danaë* (cat. 23).
White highlights on her fingertips and
virtuoso strokes that define her cuff
sustain the sense of spontaneity, as do
the thick, attacking strokes on the shroud
and the highlights on the yellow lining.

Titian painted numerous versions of *The
Entombment*, possibly including a later
version also in the Prado (fig. 32, p. 60).
Although the present painting re-works
motifs, such as the tucked-up cloak of the
man on the right, from the earlier
treatment in the Louvre (fig. 66), it
departs from it radically not only in style
but also in composition. While in the
Louvre picture the shroud strains to hold
the weight of the slung body, here it takes
on a broken, distressed rhythm. The relief
figure running behind Christ's white cloth

resonates with the 'three-handed' Mary
Magdalen above, as if he also participates
in the tragic event. This reinforces our
sense that the painting is about sacrifice
rather than redemption.

The device of twisting Christ's body
forward to present it to the viewer is a
reminder that the image might have
had a serious devotional function.
Michelangelo's advice to Pontormo when
he was working on a Spanish commission
was to show much blood and nails;
Titian's proffering of the bleeding hand
may well be a concession to a perceived
Spanish preference. By contrast, Aretino
recommended Sebastiano del Piombo
to Federico Gonzaga on condition that he
avoided stigmata and nails.

Titian's inventive imagery, so evident in
this work, might come under rigorous
scrutiny from those who sought textual
faithfulness in religious subjects. In
1626 even Cardinal Borromeo, who was
sensitive to Titian's use of loose brushwork
and admired his exposure of ground to
denote blurred distance, was unsettled by
Mary's youth in a version of this work.
DJ

FIG. 66
TITIAN
The Entombment, about 1516–26
Oil on canvas, 148 × 212 cm
Musée du Louvre, Paris, inv. 749

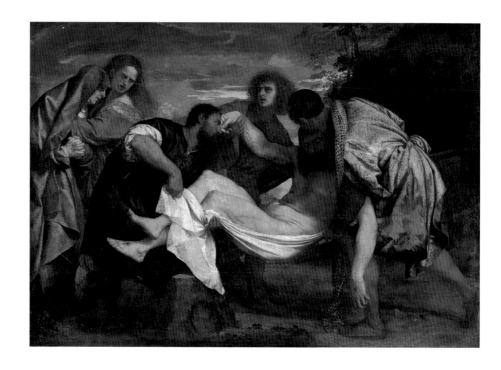

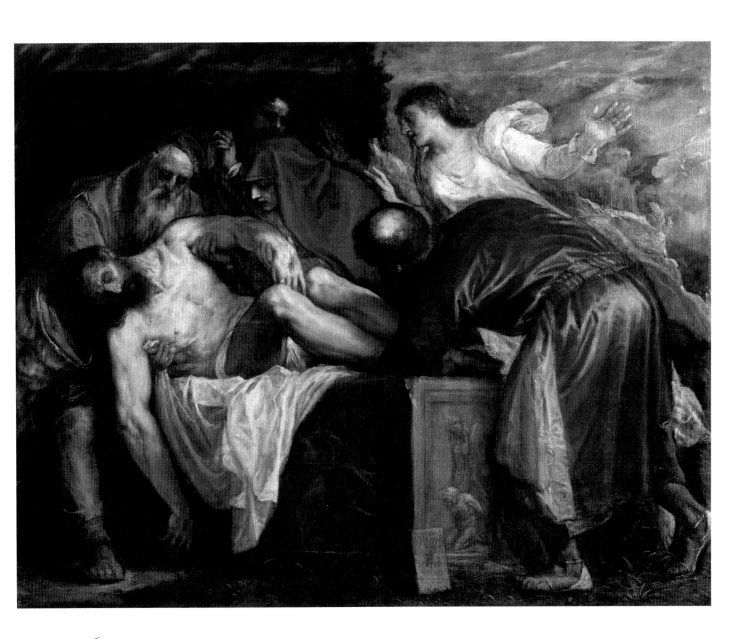

32. *The Tribute Money*
about 1545–68

Oil on canvas, 112.2 × 103.2 cm
The National Gallery, London, inv. NG 224

Select Bibliography: *Minutes of Select Committee of Enquiry* 1853, paras 9542–3, 9755 (doubts about status); Crowe and Cavalcaselle 1877, II, pp. 386–9 (rejected as by Titian); II, p. 537 (arrival in Spain); Ricketts 1910, p. 177 (largely genuine); Tietze 1936, II, p. 293 (workshop); Berenson 1957, p. 187 (workshop); Wethey I, p. 165, no. 148 (largely autograph); Gould 1975, p. 275 (partly workshop); Dunkerton 1999; Pedrocco 2001, p. 291, no. 254

The painting shows Christ interrogated by the Pharisees as to whether tribute should be given to Caesar (Roman ruler of Palestine) – a question designed to place Christ in a dangerous political position. Christ asked to see a coin and then asked whose image and name were on it. 'They say unto him, Caesar's. Then saith he unto them, Render therefore unto Caesar the things which are Caesar's; and unto God the things that are God's.'

The subject was rare in art. Titian first painted it in about 1516 for the door of a cabinet for medals and ancient coins in the private apartments of Alfonso d'Este, duke of Ferrara (patron of the Camerino, cat. 13–16). The subject was of special significance to the duke, who owed allegiance both to the Emperor (Caesar) and to the Church, and had the same episode represented on his gold coinage. The panel (fig. 47, p. 98) was very famous, and the present work may well have originated in a request for a variant on a larger scale – an hypothesis which receives some support from the X-radiographs, which reveal that the gold coin held here was originally clearly identifiable as Ferrarese. The more explicit gestures and the less intimate conception of the exchange are typical of Titian's work after about 1540: the *Ecce Homo* of 1543

FIG. 67
TITIAN
Detail of Christ from *Ecce Homo*, 1543
Oil on canvas, 242 × 361 cm
Kunsthistorisches Museum, Vienna, inv. GG 73

(fig. 67) makes a telling comparison. X-radiographs reveal compositional revisions characteristic of Titian and the great variety of handling may also be explained by his having worked on the picture over decades. He never resolved the problem of the apparently colliding arms. The drawing of Christ's raised hand is also weak – but in a way that is rather characteristic of Titian.

The picture was sent by Titian to Philip II of Spain shortly before 26 October 1568. The serene but authoritative features of Christ gave the painting a special celebrity when it hung in the Escorial, to which

Philip presented it in 1574. After its acquisition for the National Gallery in 1852 and for over a century thereafter the painting was doubted as an autograph work by the master, and it was even attributed to Paris Bordone in the Gallery's catalogue of 1929 – despite the signature, the royal Spanish provenance and the evidence that it was sent to Spain by Titian himself.
NP

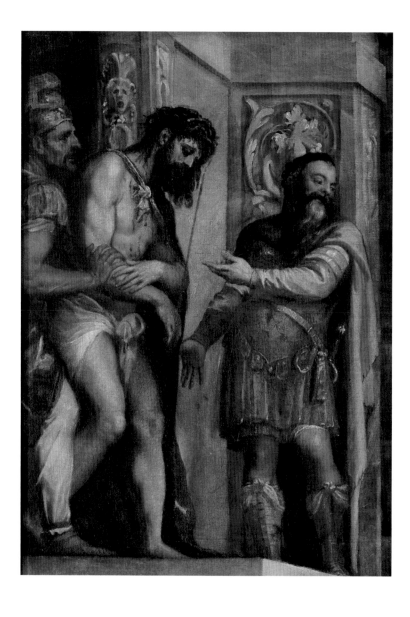

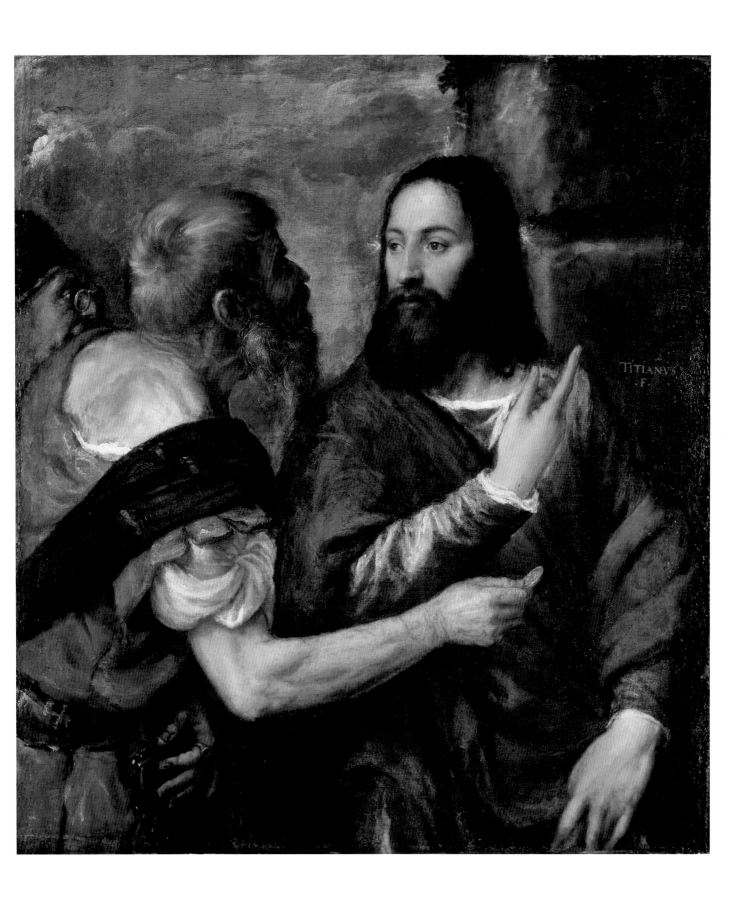

33. Self-portrait
about 1560

Oil on canvas, 86 × 65 cm
Museo Nacional del Prado, Madrid,
inv. 407

Select Bibliography: Crowe and
Calvacaselle 1877, II, pp. 62–3; Wethey II,
pp. 49–50, 145, no. 105; Freedman 1990,
pp. 71–2, 85–6, 96–8; Washington 1990,
p. 338, no. 64; Woods-Marsden 1998,
pp. 165–7; Pedrocco 2001, p. 288, no. 251

This is the later of Titian's two surviving
self-portraits, and probably of about the
same moment as the *Allegory of Prudence*
(cat. 34). It is realistic and far from
flattering. Like the old man in the *Allegory*
who has been identified as Titian, the
Prado portrait accentuates the sitter's
gaunt and hawkish features to an extent
almost verging on caricature. It has little
in common with the confident mood of
Titian's Berlin *Self-portrait* (cat. 28),
painted some considerable time earlier.

The Berlin portrait shows an elderly
but vigorous man. The contrast with the
muted mood of the present painting could
hardly be more marked. Here Titian stares
fixedly before him, as if lost in thought.
He is dressed simply, but expensively, in
black. The brush in his right hand is the
sole mark of his profession. A limited
range of dark colours – grey, black and red
– and the non-confrontational profile gaze

heighten the introspective atmosphere.
The white collar and the golden chain of
the Order of the Golden Spur strike the
only lighter notes.

Titian was extremely conscious of the way
others perceived him, and controlled it
first by minimising the release of personal
information, so that very little was known
about him (he was particularly vague
about his date of birth), and secondly
by the production of several portraits,
including this painting, which drew
attention to his advanced age and to his
high status. In all of them he is shown in
profile, a viewpoint normally reserved for
the most prestigious of sitters. As Jennifer
Fletcher argues (see pp. 39–40), this was
a deliberate strategy to enhance his
reputation.

These images intended for a wider
audience were based on the present *Self-
portrait*. When Titian licensed Cornelius
Cort to make an engraving after the *Gloria*

(Prado) in 1567, he had his likeness
in the original painting replaced by one
resembling this portrait. The present type
is closest of all to the self-portraits in two
altarpieces Titian designated for chapels
of great personal significance – in his
home town and in his adopted city. A
very similar figure in black cap and profile
appears as the donor in *The Virgin and
Child with Saints Titian and Andrew* that
he intended for the family chapel in Pieve
di Cadore. Its final appearance is barely
disguised in the Saint Jerome in the *Pietà*
(fig. 64, p. 152), which was to adorn his
resting-place in the Frari.
CC

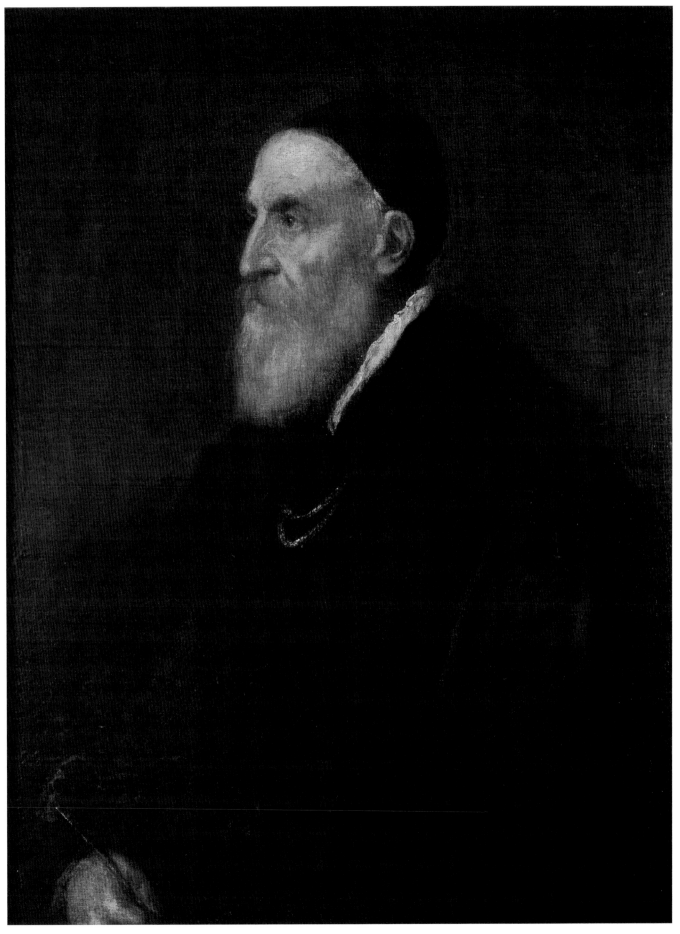

34. *Allegory of Prudence*
about 1550–60

Oil on canvas, 75.5 × 68.4 cm
The National Gallery, London, NG 6376

Select Bibliography: Hadeln 1924;
Panofsky and Saxl 1926; Berenson 1957,
p. 187; Wind 1967, pp. 260–1, n. 4;
Stuffmann 1968, p. 76; Panofsky 1969,
p. 198; Wethey II, pp. 145–6, no. 107;
Muraro 1984, pp. 291–310; Dülberg 1990,
pp. 56–8; Cohen 2000; Pedrocco 2001,
p. 281, no. 244

When first recorded, in Paris in the
eighteenth century, the painting was inter-
preted as a political allegory, involving the
precarious position of the Duke of Ferrara
poised between the great powers, but,
when he published it in 1924, von Hadeln
proposed that it was an illustration of the
Three Ages of Man. Panofsky and Saxl,
attending to the indistinct inscription,
noted that it was divided between the
three faces: *Ex Praete Rito* above the old
man; *Praesens Prudenter Agit* above the
central, middle-aged man; *Ni Futur
Actione de turpet* above the youth.
Together the texts must mean that the
present does well to profit from the past
lest future conduct go astray, and the faces
are thus identified as standing for past,
present and future. Prudence, the central
word, is the subject of the painting. The
Virtue was often represented with three
faces and in Valeriano's *Hieroglyphica* of
1556 the emblem of Prudence consists
of a triple head of dog, wolf and lion. In
Giordano Bruno's dialogues *De Gli Eroici
Furori* these animals (the dog always full
of hope, the wolf consuming the past, the
lion ready for action) participate in a
psychological drama such as is suggested
here by the tearful eyes and anxious
expression of the central face – a face
such as would not have been considered
appropriate in any orthodox portrait.
Cohen has advanced the theory that
the animals embody vices which need
controlling, but Bruno's text matches the
picture very well.

Most scholars (Wind is the only notable
exception) have accepted the painting
as autograph. The central head must cer-
tainly be by Titian. The profiles and the
animals are of lower quality and the
youthful profile is surely by the artist
responsible for the three children squeezed
into the left foreground of the Vendramin
family portrait (cat. 29). X-radiography
shows that there was originally a frame
with a continuous sinuous character
sketched in around the heads; also that the
profiles were originally different and that
the youth facing right was bearded; and
that the animals were afterthoughts (a
fringed collar is visible around the eye of
the wolf and the folds of a cloak may be
detected through the head of a lion).
Thus it is not certain that the meaning
which the painting now has was originally
intended by Titian. The painting may,
indeed, have been completed in his studio
and perhaps after his death.

Panofsky, in his later publications on the
painting, proposed that it was a personal
allegory concerning Titian's family and
heritage, with his son Orazio in the centre,
his kinsman Marco to the right and his
own portrait to the left. Many scholars
have found this persuasive, but the
likenesses are not close. There is, it is
true, some resemblance between the old
man's profile and Titian's self-portrait in
Madrid (cat. 33); if this was intended, it
might place the painting in a group of
works completed or improvised after the
artist's death.

As von Hadeln proposed, the painting
may well have been made as a *timpano*, a
type of stretched canvas cover made for a
canvas painting which became popular in
Venice in the sixteenth century. These were
often decorated with mottos and puzzles.
NP

35. *The Virgin and Child*
about 1565–70

Oil on canvas, 76.2 × 63.5 cm
The National Gallery, London, NG 3948

Select Bibliography: Crowe and
Cavalcaselle 1877, II, p. 428; Holmes 1929,
p. 195; Wethey I, p. 101, no. 54; Gould 1975,
pp. 283–4; Pedrocco 2001, p. 290, no. 253

Fading and abrasion may have reduced the
colour in the shadows of the Virgin's lilac
dress but both flesh and drapery in this
painting must always have been smoky in
hue as well as blurred in definition –
smoky, and yet 'lit as it were from within
by murky and fitful fires', as Holmes
expressed it, not long after the picture had
arrived in the National Gallery with the
Mond bequest. The infant Christ, with
flushed cheeks from eager suckling, has
the anatomically impossible but powerful
torsion first given to this subject by
Michelangelo. The Virgin, also of heroic
build, supports him with delicate fingers
and regards him with melancholy. This
painting is among the most intimate of the
artist's late works. As Gould noted, the
composition was repeated in reverse in
Titian's family's altarpiece in the Chiesa
Arcipretale of Pieve di Cadore. Despite the
radical character of Titian's handling this
painting was reproduced both as a
chiaroscuro woodcut, perhaps in the
sixteenth century, and as an engraving by
Pieter de Jode about 1630. NP

Juxtaposing Titian's *Virgin* with the
Accademia *Pietà* (fig. 69) reminds us just
how varied was Titian's approach to
image-making, although beside these two
the autograph status of the Vienna *Tarquin
and Lucretia* (fig. 68) seems doubtful. The
Virgin is almost corsetted within the
outlines of the drawing by Michelangelo
that is its source, while the *Pietà* seems to
be assembled with stick-like appendages
which feel their way into a plausible
position and then are rendered into
functional limbs. A few well-sited dark
lines define Christ's ribs and chest and
contain the white highlights of the
modelling. A similar process is repeated
for Actaeon in *The Death of Actaeon*
(cat. 37). Whereas in the *Pietà* Titian
experimentally creates a distance between
the mother and her son, in the *Virgin* the
two bonded figures emerge in one form
from a mauve haze. DJ

FIG. 68

WORKSHOP OF TITIAN
Tarquin and Lucretia, about 1575–80
Oil on canvas, 144 × 100 cm
Akademie der Bildenden Künste,
Vienna, inv. 1034

FIG. 69

TITIAN AND
PALMA GIOVANE
The Pietà, completed 1576
(detail of fig. 64, p. 152)

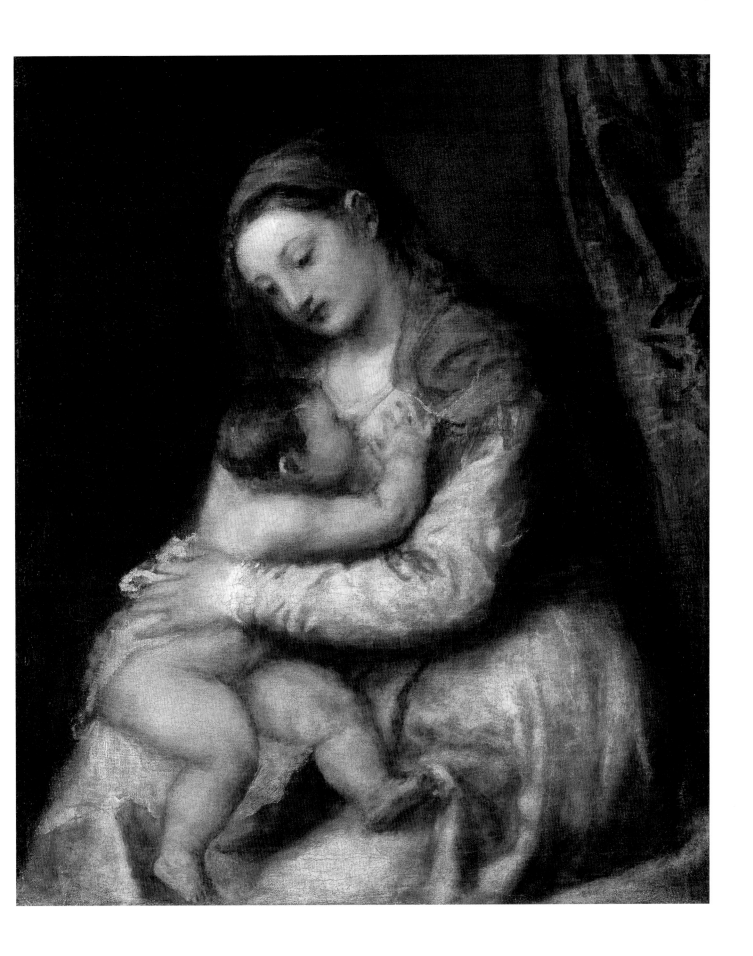

36. *Tarquin and Lucretia*
1569–71

Oil on canvas, 188.9 × 145 cm
Lent by the Syndics of The Fitzwilliam
Museum, Cambridge, inv. 914

Select Bibliography: Crowe and
Cavalcaselle 1877, II, pp. 391–2; Valcanover
1960, II, pp. 25, 51; Goodison and
Robertson 1967, pp. 172–5, no. 914; Wethey
III, pp. 180–1, no. 34; Hope 1980A,
pp. 149–57; London 1983, pp. 229–30,
no. 130; M. Jaffé and Groen 1987; Pedrocco
2001, p. 297, no. 260

Sent to Philip II of Spain in August 1571,
Tarquin and Lucretia depicts the passion
of a brutal story. Tarquin, who knew of
Lucretia's virtue from her husband's
boasts, forced her to submit to his desires
by threatening to kill not only her but her
slave boy, creating a scene of apparent
adultery. The presence of the slave in the
picture suggests that the account of the
story used was that in Livy's history *Ab
urbe condita*, although its drama is more
in keeping with Ovid's version of the
tale in the *Fasti*.

The signs of Lucretia's distress are
unmistakeable. Her fashionably white
complexion is flushed, and tears run down
her red cheeks. One may compare Titian's
Callisto (fig. 14, p. 25) and Andromeda
(fig. 70, p. 166). The baring of her teeth
is a further sign of distress, one that Titian
had used to powerful effect in his fresco
of *The Jealous Husband* in the Scuola del
Santo in Padua.

Faced with the prospect of Tarquin's
gleaming blade, Lucretia tries to retract
her right leg. Titian had used this gesture
of a leg pulling protectively inwards to
convey Christ's distress in his 1540–2
Crowning with Thorns (Louvre), so we
can assume such body language was well
understood. It is possible that Lucretia's
posture was inspired by the woman in the
Farnese *Bull*, an antique marble group
discovered in Rome in 1545. Tarquin's
almost contortionist twist was a favourite
posture among Renaissance artists, and
can be seen in a different rotation in
Titian's *Saint Peter Martyr* (fig. 8, p. 16).
Michelangelo's *Samson and the Philistine*,

much copied in Venice, is another
example.

The elevated status of the protagonists
has been exquisitely detailed. Tarquin's
rich doublet sparkles with gold thread,
some areas of it minutely described,
others blurred in the action. However, his
dropped stocking reveals the less civilised
element of his character. In a clever
conceit the embossed eye on Tarquin's
scabbard glistens back at the viewer in
front of a palpably textured green cloth.
Lucretia is beautifully bejewelled; her
fashionably curled hair suggests her
decorum is maintained despite what
awaits her. Her raised hand provides
a counterpoint to Tarquin's fist gripping a
dagger, which creates a brutal asymmetry
between their bonding forms. The vio-
lence is interjected with the sheer elegance
of the fingers of her raised hand, which
seem to call for divine intervention (recal-
ling that of Saint Lawrence, fig. 75, p. 178),
expressing all her vulnerability before such
palpable force. The graceful cascade of
sheets, the valance of shot greens and
mauves and the elegant pink slipper,
which Titian has signed, all underpin
Lucretia's dignity, status and beauty.

Cornelius Cort engraved the work under
Titian's supervision. His print, curiously,
was copied in the background of a print
by Jacob Matham to contrast with a
similar encounter between peasants. To
modern eyes the subject-matter presents
difficulties but for Titian and his contem-
poraries it was another excuse to depict a
beautiful naked woman. The popularity
of such subject-matter is illustrated in
Aretino's *Dialoghi*, where he describes a
courtesan who, struck on a cheek by a rich
official, reciprocated by painting a gash

on her cheek to convince all of her
injury and to shame her client into heavy
recompense. Titian used a minor
engraving as the basis of his own
composition; although he made some
changes (such as introducing Lucretia's
raised hand) the quality of his painting
lies more in its bravura of execution than
in its pictorial invention.

However distasteful the subject-matter,
Titian has created a potent image. Whilst
the version in the Musée des Beaux-Arts
in Bordeaux (perhaps a Spanish copy),
in which Lucretia turns her head away
and shouts, may be more realistic, Ovid's
account in the *Fasti* underlines the futility
of such responses. But Tarquin, as a result
of his evil deed, lost his kingdom.

The existence of the 'study' in Vienna
(fig. 68, p. 162) may enable us to visualise
the process of Titian's conception,
otherwise suggested to us only by Palma
Giovane's report that he 'blocked in his
pictures with a mass of colours, which
served as a bed or foundation for what he
wished to express and upon which he
would then build' (see further Jill
Dunkerton's essay, p. 56). Titian's *impresa*,
a bear licking her unformed cubs into
shape, became a metaphor for this
technique. In the Vienna canvas minimal
broad strokes are employed to indicate the
composition and the rudiments of
drapery. However, the uncertainty of form
and anatomy makes it likely to be the work
of an assistant or pasticheur in contrast to
the convincing blocking in of the
Fitzwilliam servant. Confrontation with
the more robust structure of *The Death of
Actaeon* (cat. 37) may help to resolve this
issue.
DJ

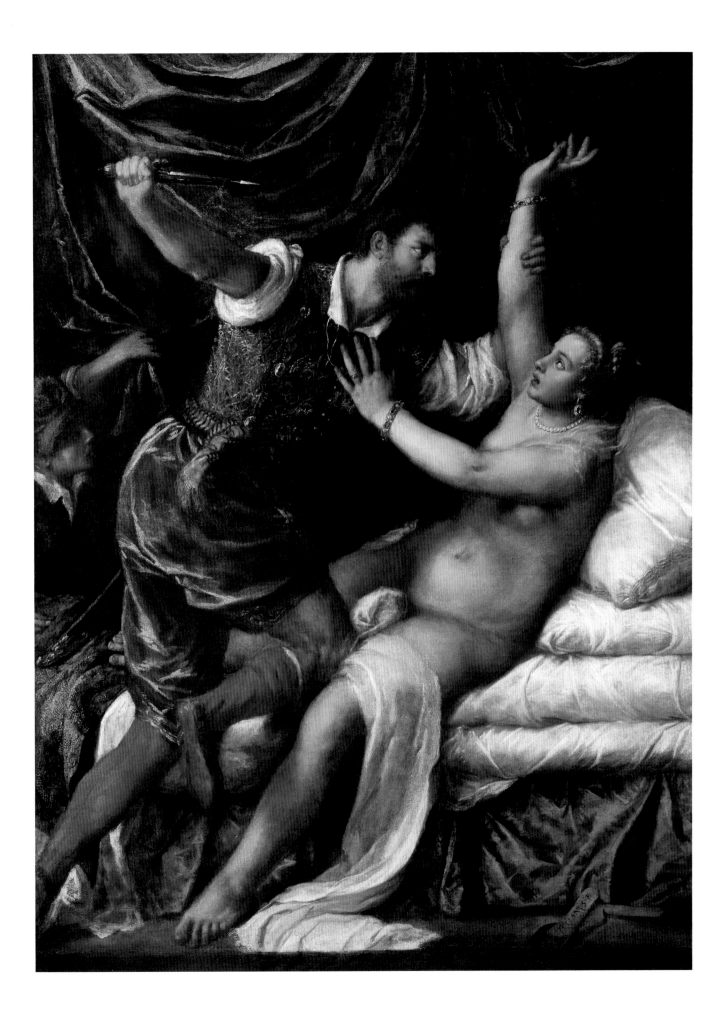

37. *The Death of Actaeon*
about 1565–76

Oil on canvas, 178.8 × 197.8 cm
The National Gallery, London, NG 6420

Select Bibliography: Keller 1969, p. 113; Wethey III, pp. 136–8, no. 8; Gould 1972, pp. 464–9; Gould 1975, pp. 292–97; Rearick 1996; Cocke 1999; Pedrocco 2001, p. 258, no. 213

Titian mentioned, in a letter of 19 June 1559 to his great patron King Philip II of Spain, that he had it in mind to paint '*Atheone lacerato da i cani suoi*' – Actaeon torn to pieces by his own hounds. Another subject mentioned in the same letter was *The Rape of Europa* (fig. 15, p. 26), which was completed in 1562. *The Death of Actaeon* was probably started soon afterwards. It was, however, never sent to Spain. The composition, with its large figure in an open pose occupying the foreground to the left and scene of flurried violence in the middle distance, finds an echo in the *Perseus and Andromeda* (fig. 70).

Titian is likely to have projected this painting as a companion of some kind to *Diana and Actaeon* (fig. 13, p. 24), which shows the hunter Actaeon at the moment of realisation that he has accidentally disturbed the bath of the goddess Diana and her nymphs. The goddess splashes water at him and invites him to tell the world what he has seen. Actaeon flees, surprised by his own speed, feels himself changed, sees reflected in a stream what has happened, finds he cannot speak and is killed by his own hounds. If Ovid's account is followed, then Diana would not be present, so the figure on the left has been interpreted as one of her nymphs, or as a 'personification of her vengeance' (Gould) – the latter theory receiving some support from the fact that she does not seem to have shot the bow she holds aloft. However, as Cocke has noted, some ancient sources do describe Diana as pursuing Actaeon – notably a sculpture by Apelles described in *The Golden Ass* of Apuleius, which depicted Actaeon hiding from the goddess who pursues him with her tunic blown back in the wind.

The numerous changes made to the painting by Titian are discussed elsewhere (see pp. 58–9). The question of whether – or to what extent – the painting was ever completed has been much debated. Gould considered that it was a finished painting and saw the absence of 'crimson draperies and ultramarine skies' as typical of the artist's late work. However, *Religion comforted by Spain*, completed in 1575, features scumbles of deep rose and blue. That painting has a similar composition, which was also much revised and worked on over a long period. Some scholars (notably Keller and Rearick) suppose that the head of the goddess was completed by another artist after Titian's death. The painting was described as 'not quite finished' in the 1630s, when it was purchased for the Marquis of Hamilton, and as unfinished (but beautiful) by Abraham Hume, who bought it in 1798 at the Orléans sale. When in Hume's possession, the painting was probably of special interest to artists and it surely influenced Constable's very large landscape sketches.
NP

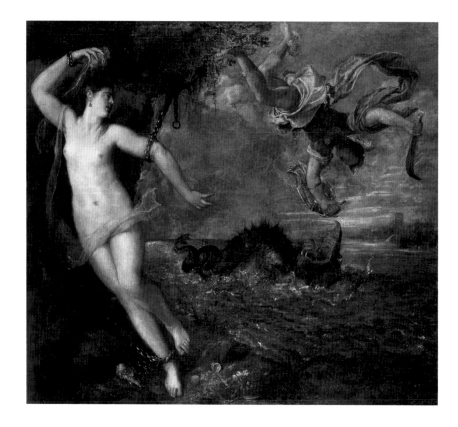

FIG. 70
TITIAN
Perseus and Andromeda, about 1556
Oil on canvas, 175 × 189.5 cm
The Wallace Collection, London, P11

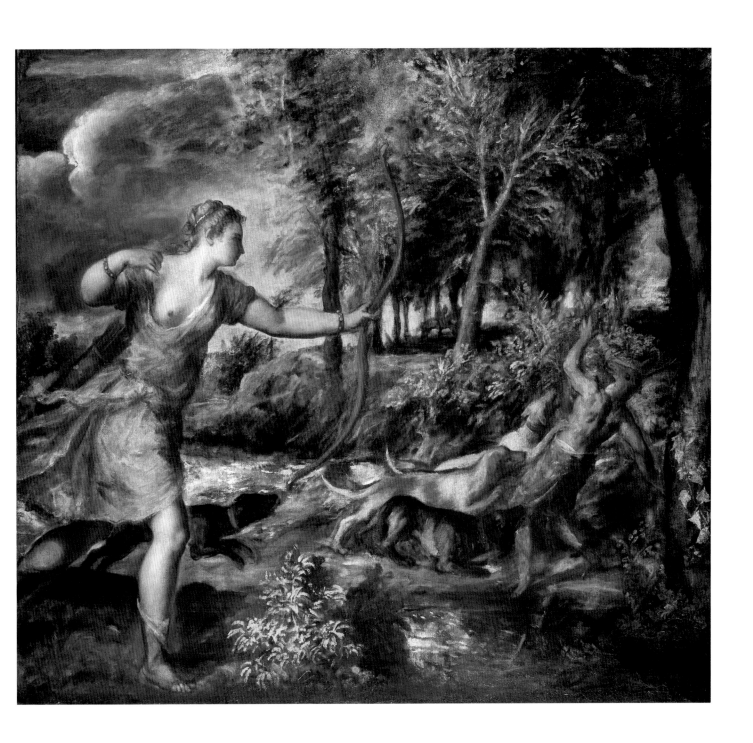

38. *Jacopo Strada*

1568

Oil on canvas, 125 × 95 cm
Kunsthistorisches Museum, Vienna,
GG 81

Select Bibliography: Crowe and
Cavalcaselle 1877, II, pp. 369–71; Wethey II,
pp. 141–2, no. 100; Jansen 1993; Pedrocco
2001, p. 289, no. 252

Jacopo Strada (1515? –1588) was born in
Mantua of a Netherlandish family. Known
mainly as a scholar, art collector, dealer
and antiquarian, he published a two-
volume work entitled *De consularibus
numismatibus* (On consular coins) in the
late 1550s, a sequel to his famous book on
the Roman emperors (Lyons 1553). In 1554
he went to Rome and worked for Pope
Julius III and Pope Marcellus II. From 1557
he worked for the Hapsburg emperors.

This portrait is intended to impress.
Strada, the rich and learned dealer,
is surrounded by exquisite objects
and captured as if he is unexpectedly
interrupted while enjoying his art; or
perhaps he is about to flourish the statue
he holds before the dazzled eyes of the
interlocutor on whom his gaze may be
fixed. As Michael Hirst has observed
(verbal communication), this pose, with
the arms stemming rather disjointedly
from the shoulders, strikingly recalls
the figure of Rizzardo VI offering his soul
on his tomb in a church (fig. 71) in
Serravalle (now Vittorio Veneto), which
Titian would have passed on his way to
Cadore. However one interprets Strada's
movement, the sense of momentary action
imbues the portrait with a vitality much
admired by Renaissance critics. Strada
may have been comparing the antique
Venus caressed by the fingers of his right
hand to some fine silver coins or 'medals'
(described in Latin and Italian by the same
word) on the table. Coins were particularly
valued in the Renaissance both as im-
mediate and tangible manifestations of the
ancient world and for their information
about ancient art. The coins emphasise the
sitter's learning and expertise in that field
and, together with the books, sculpture
and his sumptuous attire, suggest that this
is an expensive den that we are privileged

to enter. Dealers still aim to create the kind
of atmosphere that Titian here so strongly
evokes.

The painting was almost certainly made
in 1567-8, when Strada was in Venice in
an attempt to purchase for Albrecht V of
Bavaria the outstanding art collection of
Gabriele Vendramin, Titian's friend and
patron (see cat. 29). He did not in the end
succeed in subverting Gabriel's will, which
stipulated, despite his recognition that his
immediate heirs took little interest in
such things, that the collection should be
preserved intact in the family. Titian
may well have wondered whose interests
Strada's expertise would serve. A letter
from a rival dealer claims that Titian
shared his own low opinion of the man.

The painting is nevertheless a monument
to a painter's relationship with his dealer.
Artists tend to portray those that promote
them as powerful men, and the task is
undoubtedly tinged with ambiguity about
whose career is being better promoted, the
painter's or the dealer's. Both the *Strada*
and the *Aretino* can be read in this light.
But Strada's portrait, whatever Titian's

own feelings, called for a flamboyant
display, since it would be an advertisement
of his skills. The prominent signature
and the current of fur which encircles
Strada show how Titian conceived the task
before him. The cartouche proclaiming
the dealer's name, however, is not by
Titian's hand but it may have been added
by Strada even in Titian's own lifetime.
The cartouche breaks into the stepped
space that pushes Strada forward towards
us, looming over his table of riches, almost
claustrophobically larger than life.

X-rays show that Titian re-used a canvas
painted with a winged figure. The Strada
shows a much more impressive level of
painting than *The Tribute Money* (cat. 32),
which was completed in the same year.
Unlike the white highlights on Christ's
red sleeve which seem to be glazed on a
roughly modelled arm, Strada's sleeve
conveys real structure and the brushwork
is generally more attacking and decisive.
DJ

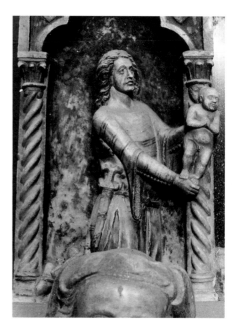

FIG. 71

ARTIST UNKNOWN
Rizzardo offering his soul,
detail of tomb of Rizzardo VI
da Camino, about 1335
Santa Giustina, Vittorio Veneto

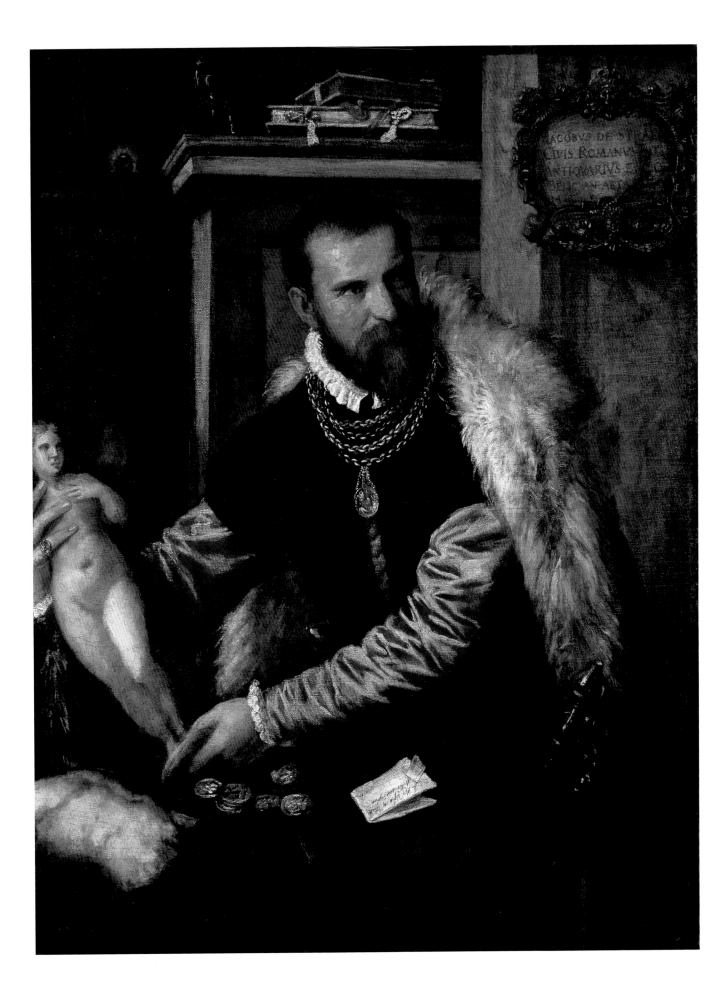

39. *Nicolò Zen*
about 1565–6

Oil on canvas, 123.2 × 96.5 cm
Kingston Lacy, The Bankes Collection,
Dorset / The National Trust

Select Bibliography: Vasari (1568), VII, p.
456; Wethey II, p. 138, no. 94; Sponza 1999;
Pedrocco 2001, p. 190, no. 135; Matthew
2002, p. 685

The identity of the sitter has been
established only recently. Large letters
written on the back of the original canvas
and now almost coming through across
the face represent an early (incorrect)
effort to name him. For some time
the sitter was identified as Francesco
Savorgnan, but has now, thanks to the
discovery of a labelled copy, been shown
to be Nicolò Zen, whose portrait by
Titian is mentioned by Vasari.

The patrician Nicolò Zen (or Zeno;
1515–1565), was a prominent figure among
the élite of sixteenth-century Venice. His
uncle Francesco had been a sponsor of
Serlio's books on architecture, and he
himself was the friend of Daniele Barbaro
(another of Titian's sitters), patron of
Palladio and editor of Vitruvius' *Ten Books
on Architecture*. The author of several
histories, Zen combined literary activity
with high office in the Venetian
government. He was one of the *savi* of
the Terraferma, responsible for Venice's
mainland territories, and served as a
member of the Council of Ten, or state
Cabinet, with responsibilities for the
Arsenal – crucial to the maritime defence
and economy of the city. As Charles Hope
has pointed out (verbally), both Zeno and

Barbaro are recorded as admiring the
work of Titian's pupil Irene da
Spilimbergo.

The portrait is laid out according to the
same formula as Aretino's (cat. 27), but
here the status of the sitter is emphasised,
notably in properties such as the script,
which testifies to Zeno's learning, and in
his dress, particularly the wide, fur-lined
sleeves worn only by Venetian noblemen.
As in other portraits, the hands are barely
blocked in and the energy of the stance
is mapped out in the structure of the
garments. Some details are carefully
defined, others abbreviated, for example
the sleeve above his left hand, where the
form is hardly suggested and our focus is
drawn instead to the almost legible writing
on the creased letter. This sleeve can be
contrasted with the concave sleeves in
The Vendramin Family (cat. 29) and the
more rudimentary, unfinished sleeve in
Pope Paul III with his Grandsons (fig. 62,
p. 138).

Zen's portrait was formerly dated to the
1540s, probably because it resembles
Aretino. That does not necessarily suggest
contemporaneous execution, for we
know that Titian was economical with his
inventions. It can also be aligned with
Titian's 1560s works such as *Jacopo Strada*

(cat. 38) and *Antonio Palma* (Gemälde-
galerie, Dresden). The new identification
encourages a dating of around 1560, for it
is tempting to imagine this picture might
have been painted at the very end of Zen's
career, when Titian was trying to secure
copyright for prints after his work from
the Council of Ten. Unfortunately we do
not know exactly when Zen served on the
Council, although he would always have
had connections with the governmental
group of patricians. The culmination of
his career was his election as Proveditore
of the Arsenale around 1565, which would
be an appropriate appointment to
celebrate. The redating of this work is
important, as Titian was a reluctant
portraitist after his experiences in 1548–50
with the Spanish court. Late portraits are
rare and probably indicate a special link
with the sitter.
DJ

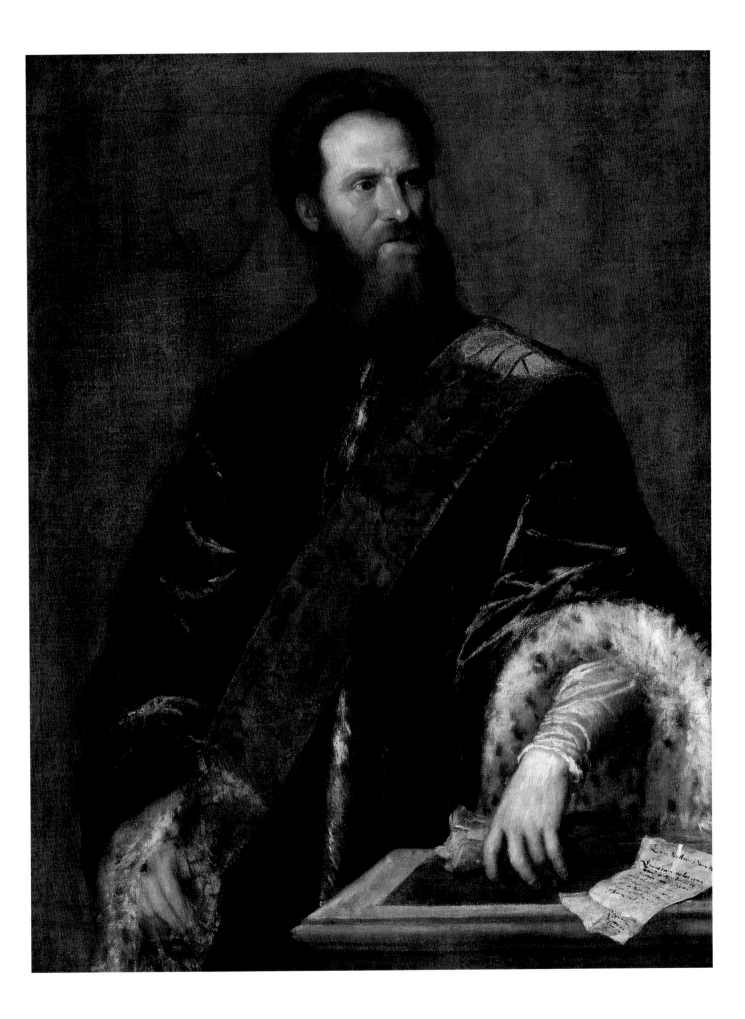

40. *Saint Jerome in Penitence*
1575

Oil on canvas, 184 × 177 cm
Monasterio de San Lorenzo de El Escorial,
Patrimonio Nacional, San Lorenzo,
inv. 10014689

Select Bibliography: Crowe and
Cavalcaselle 1877, II, pp. 333–4; Tietze 1936,
II, p. 288; Berenson 1957, p. 185; Wethey I,
p. 136, no. 108; Modena 1990, pp. 94ff. (for
Muziano); Paris 1993, pp. 621–2, no. 262;
Pedrocco 2001, p. 302, no. 265

This painting was sent to Philip II in
September 1575, together with *Religion
comforted by Spain* and *Philip II presenting
the Infante Don Ferdinand to Victory* (both
Prado, Madrid). We know that the *Religion*
had been in Titian's studio for more than
a dozen years and that *Philip II* was being
worked on in 1573, but can only guess
when and for how long Titian worked on
Saint Jerome.

Saint Jerome was a subject he had painted
several times before – in the Gonzaga
Saint Jerome (1531, Louvre) and the Santa
Maria Nuova *Saint Jerome* (Brera, Milan;
fig. 72). Cornelis Cort's engravings include
other versions, one dated 1565, and as
Cort's intention was (under Titian's
guidance) to present a selection of
Titian's most famous works (the San
Salvator *Annunciation*, *Saint Lawrence*,
Mary Magdalen, *Tarquin and Lucretia*,
Allegory of Brescia, *Diana and Callisto*,
Saint Margaret), the composition was
obviously seen as an important element
of Titian's oeuvre. Cort also engraved a
large number of other artists' depictions
of *Saint Jerome*. Girolamo Muziano seems
to have offered the subject to Cort in
many variations, as if his name saint was
his speciality, and there is a drawing by
Muziano in Rennes which is especially
close to this composition. As the subject
offered a chance to combine piety with
landscape it may have had a special appeal
to a northern engraver.

In this version, by contrast to the earlier
Milan painting, Saint Jerome is shown in
full daylight. More generally, Titian seems
to have favoured dawn and dusk settings
in his later works – as a comparison of the
1540–2 *Crowning with Thorns* (Louvre)
with the late treatment of the same
subject of around 1572–6 (fig. 16, p. 27)
demonstrates. Titian's 'late' brushwork
was perhaps more visually coherent in
low-light settings. The broad brushwork
around the skull in the Milan painting
contrasts with the more laboured and
realistic still life in this version. In this case
the choice of a daylight setting may
suggest that it is an earlier image
reworked.

The setting for this work, with a square
'window' into the landscape, was perhaps
inspired by Dürer's famous print of *Saint
Jerome*. The quality of the sky and the
glimpsed mountain is not, however,
overwhelming, even if the handling of the
trees and roots is everything one expects
from Titian's 'late' style. Particularly
dramatic are the slashed and 'bleeding'
trunks of the trees behind the crucifix.
The flora in the top corners are so freely
sketched that possibly Titian was expect-
ing an arched frame. Less impressive are
the lion and the silhouetted leaves, which
have no parallel in Titian's work. All the
paintings in this last shipment to Philip
have a certain awkwardness. In their
encasing, heavy drapery their figures
contrast with the eloquence of works
such as the *Tarquin and Lucretia* (cat. 36) –
whether this difference is the consequence
of Titian's great old age or of the
intervention of collaborators remains
open to debate.
DJ

FIG. 72

TITIAN
Detail of *Saint Jerome in Penitence*, about 1559
Oil on panel, 255 × 125 cm
Pinacoteca di Brera, Milan, Gen. 119

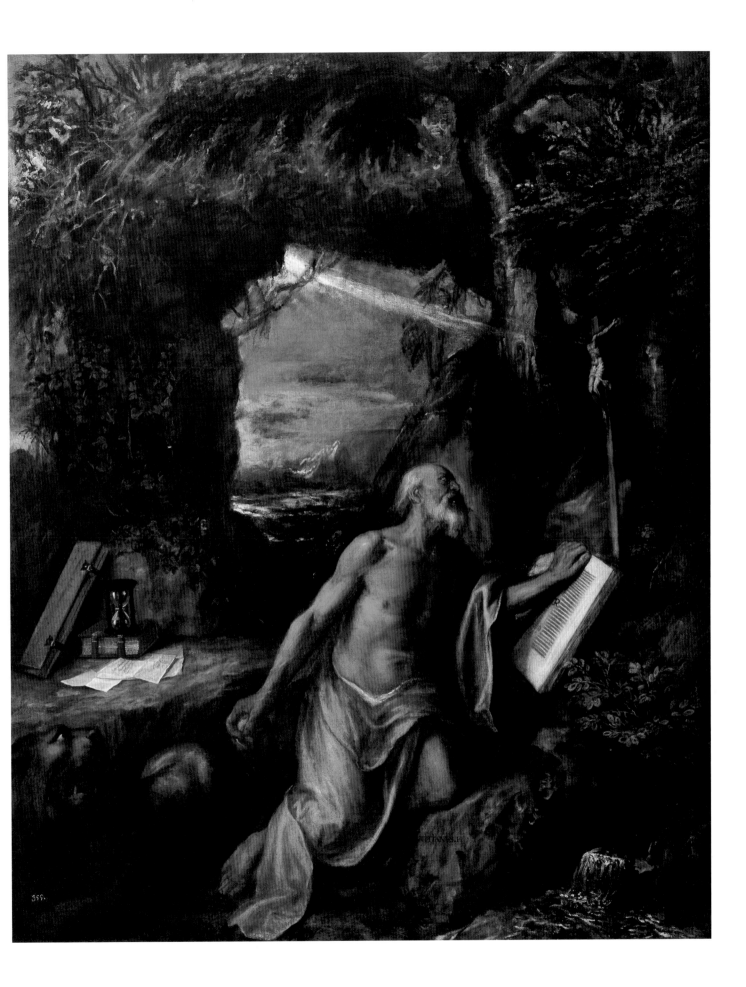

355.

41. *Ecce Homo*

about 1570

Oil on canvas, 109 × 92.7 cm
The St Louis Art Museum, St Louis,
Missouri, inv. 10.1936

Select Bibliography: Mayer 1935; Tietze
1936, II, p. 292; Tietze-Conrat 1946,
pp. 86–7; Berenson 1957, p. 90; Wethey I,
pp. 83–5, no. 28; Pedrocco 2001, p. 296,
no. 258

This painting is unfinished, most evidently
in the extreme sketchiness of the torch in
the left background. Tietze-Conrat sug-
gested that the picture was a preparatory
sketch which had remained in Titian's
studio on his death, serving as a model for
replicas. Indeed there are many copies of
this Christ, but this is perhaps testament
to its quality, rather than proving that it
had a workshop rôle. The higher level of
finish in some areas, particularly Pilate's
dress, suggests that it was not a sketch
and was merely unfinished. Wethey has
proposed that some details, such as
the boy and Pilate's dress, were finished
by assistants on Titian's death, but the
confident and expressive handling of
paint throughout suggests otherwise.

In this painting, Titian extended the icon-
like isolation of his earlier versions of the
theme, such as the Prado (1548) or Dublin
Ecce Homo (about 1560; fig. 73), to involve
a more comprehensive narrative.
The expressive, languid form of Christ's
hands has been repeated: seemingly
undeveloped, they might almost be mis-
construed as unfinished. The additional
figures, although not caricatures, have
been juxtaposed with Christ, hands bound
and crowned with thorns, in order to
enhance the emotion of the scene. The
corpulent jowls, redolent of excess and
satiety, are set against the angularity of
Christ's agonised features. A similar
composition occurs in an engraving of
1526 by a follower of Dürer, in which the
more gruesome attributes of the sub-
sidiary figures are emphasized, thus
illustrating the popular and literary belief
that evil was manifest in physical terms.

In contrast to the large Vienna *Ecce Homo*,
where Pontius Pilate is depicted as a

classical ruler, he is represented here in
quasi-Eastern dress. His features are based
on the bust of the so-called *Vitellius*, then
in the Grimani Collection. His long
fur-lined sleeve is similar in type to
contemporary Venetian signorial dress
and would have been recognised as a
symbol of status, as would the rich
brocade of his cape, although such
Venetian gowns did not have the gold
clasps or fur collar as seen on that of
Pilate. His dress, and luxuriant turban,
are a fanciful concoction, typical of
Venetian representations of biblical
settings from Carpaccio onwards.

The boy on the left, too, is dressed in a
contemporary manner, although his ear-
ring is a device often used by Titian to
denote 'foreign' status, notably in the
Dresden *Tribute Money* (fig. 47, p. 98).
Whilst he presents Christ with an ironic
smirk, Pilate is more solemn in
countenance. He raises his hand to the
crowd before him, a gesture serving to
express his desire to be absolved of
judgement: the Jews themselves, not the
Roman Empire, had sentenced Christ
to death.

As in the Escorial *Martyrdom of Saint
Lawrence* (fig. 75, p. 178), Titian has
exploited the narrative possibilities of a
night-time setting; the left side of Christ's
body is swathed in light, broad lashings
of white painterly 'icing' evoking the
intensity of the flame behind. His face,
however, falls in darkness; the darkened
sockets and lines below his eyes create a
haunting and haunted vision. By contrast,
the gleaming chains of Pilate's cloak, his
ring and turban-pin sparkle luxuriously
against the simplicity of Christ's cloak
(only the merest suggestion of crimson is
conveyed here), described with thick
ribbons of paint.

Tietze-Conrat noted that the boy re-
appears, inverted, in the *Martrydom of
Saint Lawrence* and consequently sug-
gested a dating around 1565. However,
a dating closer to Titian's death seems
more probable.
AB

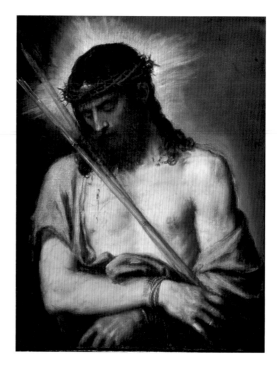

FIG. 73
TITIAN
Ecce Homo, about 1560
Oil on canvas, 73.4 × 56 cm
The National Gallery of Ireland,
Dublin, inv. 75

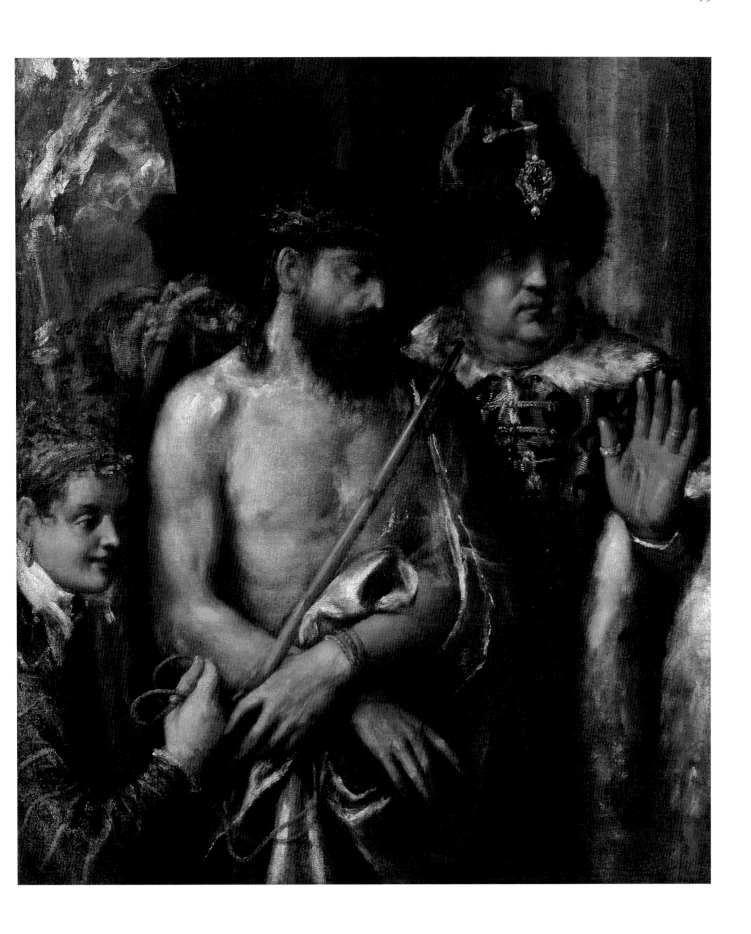

42. *Saint John the Baptist*
probably late 1560s

Oil on canvas, 190.6 × 114.8 cm
Monasterio de San Lorenzo de El Escorial,
Patrimonio Nacional, San Lorenzo,
inv. 10014726

Select Bibliography: Crowe and
Calvacaselle 1877, II, p. 253; Wethey I,
p. 137, no. 110; R. Valcanover in Paris 1993,
p. 579; García-Frías Checa 1999, pp. 145–51;
Balao González 1999, pp. 195–9; Pedrocco
2001, p. 278, no. 239

Titian's second surviving *Saint John the
Baptist* (see also cat. 20) is first mentioned
in an Escorial inventory of 1577 as a gift to
the monastery from Philip II. Wethey
argued that Titian sent it to Spain in 1574,
but there seems to be no primary evidence
to support this conclusion. Like Titian's
other paintings now in the Escorial,
Saint John the Baptist has long been
underestimated. Most commentators have
classed it either as a replica in poor con-
dition of the earlier *Saint John* (cat. 20),
or at best an original composition in
terrible condition.

However, recent restoration has revealed
the quality of the painting. In a moving
representation, Saint John's uplifted face is
illuminated with the divine light by which
he is informed of Christ's coming – a state
far removed from the more reserved and
classical mood of the first *Saint John*.
Titian achieved this more emotional effect
by adapting the structure and iconography
of the earlier composition to the successful
formula of his depictions of the penitent

Magdalen, one of the most popular
productions of his workshop. Not
only is Saint John's face in the Escorial
painting close to the St Petersburg *Penitent
Magdalen* of about 1560 (fig. 74), but
X-rays taken during the recent conserv-
ation demonstrate that it initially bore
an even closer resemblance. The saint's
right arm was clasped to his breast, and
the sweep of fur lining across his chest
mimicked the flow of the Magdalen's hair.

These resemblances might be taken as
evidence that the canvas had earlier been
used for a *Mary Magdalen*. However, the
dimensions of the Escorial painting make
this unlikely: it is roughly the same size

as the Venice *Saint John* and there is no
evidence (through prints or copies) that
Titian planned a full-length version of the
penitent Magdalen. It is more probable
that in the Escorial painting Titian inten-
tionally combined motifs from the two
earlier compositions to endow his second
Saint John the Baptist with greater mys-
ticism, fitting for the religious sensibilities
of the Most Catholic King.
CC

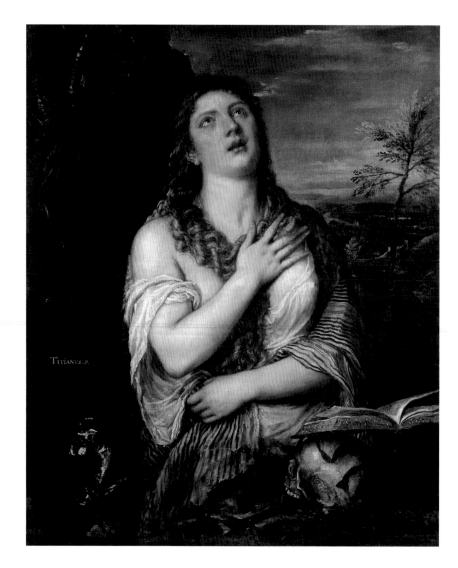

FIG. 74
TITIAN
The Penitent Magdalen, about 1561
Oil on canvas, 118 × 97 cm
The State Hermitage Museum, St Petersburg,
GE 117

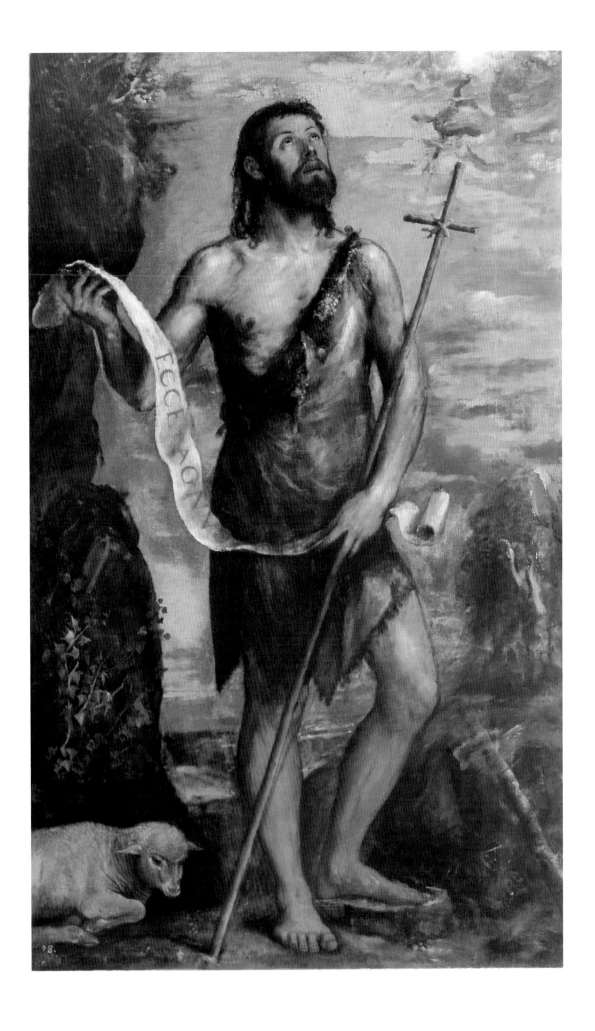

43. *Saint Sebastian, Hermitage*
about 1575

Oil on canvas, 210 × 115.5 cm
The State Hermitage Museum,
St Petersburg, GE 191 NOT EXHIBITED

Select Bibliography: Ridolfi (1648), I, p.
200; Bevilacqua 1845, pp. 35–6, no. 40;
Crowe and Cavalcaselle 1877, II, p. 423;
Suida 1933, p. 131; Tietze 1936, I, p. 291;
Berenson 1957, p. 187; Savini-Branca 1964,
p. 186; Fomicova 1967, p. 68; Wethey I, pp.
155–6, no. 134; Hope 1980A, pp. 161, 165;
Siebenhüner 1981, pp. 29, 31; Washington
1990, pp. 368–9, no. 75; Pedrocco 2001,
p. 299, no. 262; Anderson 2002, p. 671

In October 1581 the Venetian patrician
Cristoforo Barbarigo acquired Titian's
property in the Biri Grande, including,
so Ridolfi says, the *Saint Sebastian*. The
contract of sale, however, mentions no
moveable goods, and it must be assumed
that Titian's son Pomponio had already
sold the contents of the studio by separate
treaty. Having been refused by the
National Gallery, London, the Barbarigo
collection was acquired in 1850 by Tsar
Nicholas I, although the *Saint Sebastian*,
having been described as 'third rate', was
relegated to the storage rooms of the
Hermitage. By the end of the century the
picture's status had been reconsidered,
although Crowe and Cavalcaselle re-
mained unconvinced as to the condition
of the work and even wondered whether it
had been repainted. In fact the painting is
in a remarkably good state, although the
issue of possible 'finishing' after Titian's
death has been raised by some scholars.
The authoritative manipulation of
brushwork, however, and the ability to
describe form with the most broken of
strokes, suggest that the painting is fully
autograph. As Irena Artemieva has
informed me, the image was originally
conceived as a half-length, but Titian
added strips of canvas below and to the
right to make it up to full length.

Saint Sebastian bears many similarities to
the Escorial *Saint John* (cat. 42). Their
poses are not dissimilar, both sculptural in
conception, combining an element of
contrapposto with one leg bent. Both lift
their eyes towards the heavens, although
here the divine light source is not detailed
within the image, but instead is manifest
as an external force shining dramatically
on to the saint's naked form. His parted
lips and upward gaze recall Tullio
Lombardo's sculptural works from the
beginning of the century, although its
emotive angst (evident in the distinct
creasing of the brow) separates the tragedy
of this overtly Catholic piece from Tullio's
more meditative mood.

The unfinished state of the *Saint Sebastian*
is particularly evident in the cuirass that
lies at his feet, a reference to Sebastian's
rôle as an officer in the Praetorian Guard.
The imitation of musculature in the metal
is summarily evoked with feathered blocks
of paint, with the shoulder fringes merely
hinted at in bold striations of yellow. The
landscape and sky behind, feverish in its
painterly consistency and apocalyptic in
tone, heighten the saint's anguish. The
contrast of light and dark, here produced
by natural phenomena, is comparable
to the treatment of firelight in the night-
time setting of the Escorial *Saint Lawrence*
(fig. 75).

It is probable that the image was painted
for a Venetian patron. Saint Sebastian, as a
protector against the plague, would have
been called upon frequently during the
epidemic of 1575, which took nearly one
third of the population of Venice.
AB

FIG. 75
TITIAN
Detail of *The Martyrdom of Saint Lawrence*, 1567
Oil on canvas, 440 × 320 cm
Monasterio de San Lorenzo de El Escorial,
Patrimonio Nacional, San Lorenzo

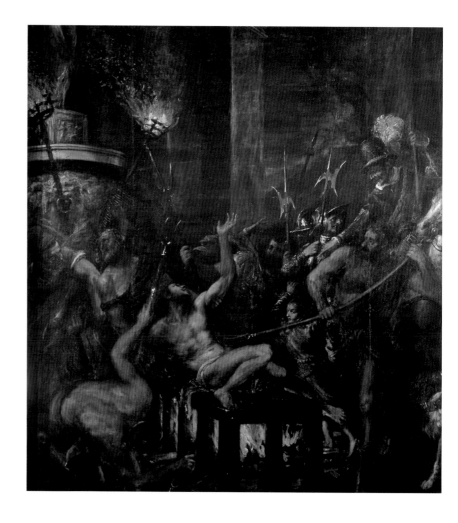

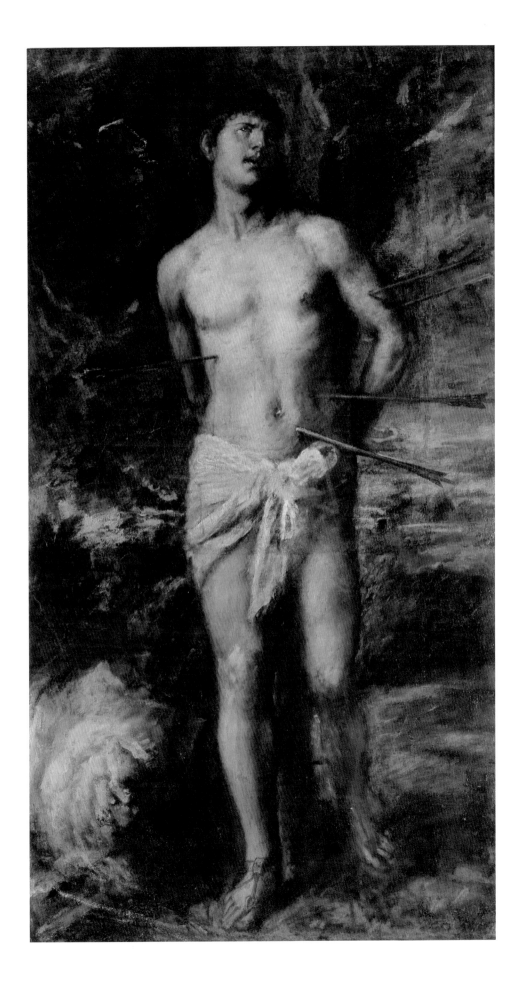

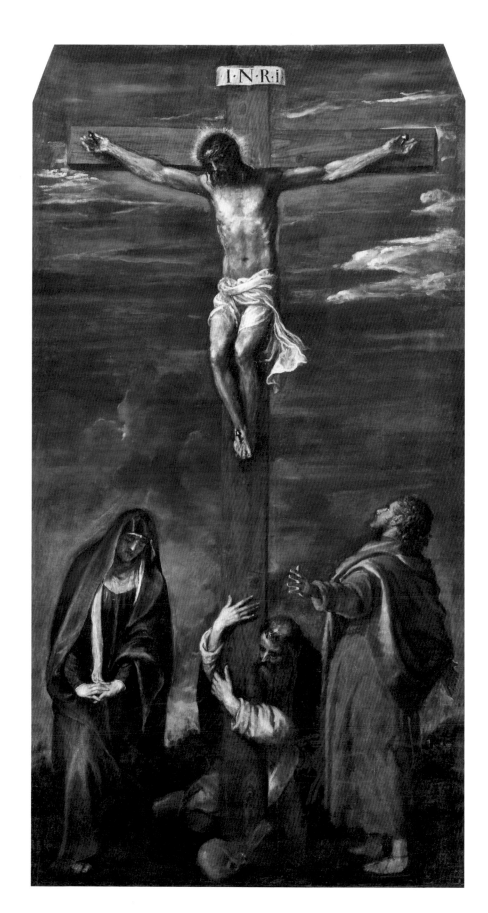

FIG. 76
TITIAN
Christ on the Cross with the
Virgin, Saint John and Saint
Dominic, 1556–8
Oil on canvas, 375 × 197 cm
Pinacoteca Comunale (on
temporary loan from the
church of San Domenico),
Ancona

BIBLIOGRAPHY

ACIDINI LUCHINAT 1998
C. Acidini Luchinat, *Taddeo e Federico Zuccaro*, 2 vols., Milan and Rome 1998

ADRIANI 1940
G. Adriani, *Anton Van Dyck: Italienisches Skizzenbuch*, Vienna 1940

ALLEN 1999
D. Allen, 'Some observations on Ercole de' Roberti as painter-draughtsman', *The Burlington Magazine*, CXLI, 1999, pp. xv–xxiv

ANDERSON 1977
J. Anderson, '"Christ carrying the Cross" in San Rocco: its Commission and Miraculous History', *Arte Veneta*, XXXI, 1977, pp. 186–8, n. 1.

ANDERSON 1997
J. Anderson, *Giorgione*, Paris 1997

ANDERSON 2002
J. Anderson, 'Titian's unfinished "Portrait of a Patrician Woman and her Daughter" from the Barbarigo Collection, Venice', *The Burlington Magazine*, CXLIV, no. 1196, 2002, pp. 671–9

ANDROSSOV 2002
S. Androssov, 'I rilievi di Antonio Lombardo nelle collezioni dell'Ermitage', *I Beni Culturali*, X, no. 1, 2002, pp. 3–12

Antwerp 1948
Antwerp, Musée Royal des Beaux-Arts, Catalogue Descriptif. Maîtres Anciens, Antwerp 1948

ARETINO
Ed. E. Camesasca, *Lettere sull'arte di Pietro Aretino*, 3 vols., Milan 1957–60

ARETINO 1965
P. Aretino, *I ragionamenti*, Bologna 1965

ARETINO 1972
Aretino's Dialogues, trans. R. Rosenthal, London 1972

ARTEMIEVA 2001
I. Artemieva, *Cinquecento Veneto: Dipinti dell'Ermitage*, exhib. cat., Pinacoteca, Bassano del Grappa 2001

AVERY 1999
V. Avery, 'Documenti sulla vita e le opere di Alessandro Vittoria (c. 1525–1608)', in *Studi Trentini di Scienze Storiche*, LXXVII, no. 1, 1999 (supplemento)

AVERY 2001
V. Avery, 'The House of Alessandro Vittoria Reconstructed', *The Sculpture Journal*, V, 2001

BACCHANALS 1987
Bacchanals by Titian and Rubens (*Nationalmusei Skriftserie*, n. s., 10), ed. G. Cavalli-Björkman, Stockholm 1987

BALAO GONZÁLEZ 1999
A. Balao González, 'Restauración de La Ultima Cena y San Juan Bautista de Tiziano del Real Monasterio de El Escorial', in *Tiziano Técnicas 1999*, pp. 193–9

BAMBACH 1999
C.C. Bambach, *Drawing and Painting in the Italian Renaissance Workshop. Theory and Practice, 1300–1600*, Cambridge 1999

BARELLA 2002
M. Barella, 'Il Palazzo di Corte dei duchi d'Este in Ferrara', in *Il trionfo di Bacco, Capolavori della scuola ferrarese a Dresda*, exhib. cat., ed. G. Weber, Ferrara, 2002, pp. 18–26

BATTILOTTI AND FRANCO 1978
D. Battilotti and M.T. Franco, 'Regesti dei committenti e dei primi collezionisti di Giorgione', *Antichità Viva*, XVII, nos. 4–5, 1978, pp. 58–86

BAYER 1999
A. Bayer, 'Dosso's Public: the Este Court at Ferrara', in *New York 1999*

BÉGUIN 1980
S. Béguin, 'A propos de la Sainte Conversation et de la Vierge au lapin de Titien du Louvre', in *Tiziano e Venezia 1980*, pp. 480–4

BELLUZZI 1907
G.B. Belluzzi, *Diario autobiografico*, ed. P. Egidi, Naples 1907

BERENSON 1897
B. Berenson, *The Central Italian Painters of the Renaissance*, New York 1897

BERENSON 1903
B. Berenson, *The Study and Criticism of Italian Art*, London 1903

BERENSON 1957
B. Berenson, *Italian Pictures of the Renaissance: A List of the Principal Artists and their Works with an Index of Places: Venetian School*, London 1957

BEVILACQUA 1845
G.C. Bevilacqua, *Insigne Pinacoteca della nobile veneta famiglia Barbarigo dalla Terrazza*, Venice 1845

BIERENS DE HAAN 1946
J.C.J. Bierens de Haan, *L'Œuvre gravé de Cornelis Cort, graveur hollandais 1533–1578*, The Hague 1946

BOBER AND RUBINSTEIN 1986
P.P. Bober and R. Rubinstein, *Renaissance Artists and Antique Sculpture*, Oxford 1986

BOCCARDO 1997
P. Boccardo, 'Ritratti di collezionisti e committenti', in *Van Dyck. Grande pittura e collezionismo*, exhib. cat., Palazzo Ducale, Genoa 1997, pp. 29–58

BODART 1998
D. Bodart, *Tiziano e Federico II Gonzaga. Storia di un rapporto di committenza*, Rome 1998

BODE ET AL. 1911
Ed. W. Bode, G. Gronau and D. Freiherr von Hadeln, *Archivalische Beiträge zur Geschichte der venezianischen Kunst aus dem Nachlass Gustav Ludwigs* (*Italienische Forschungen herausgegeben vom Kunsthistorischen Institut in Florenz*, IV), Berlin 1911

BONOMI 1886
G.M. Bonomi, *Il quadro di Tiziano della famiglia Martinengo Colleoni*, Bergamo 1886

BONORA 1994
E. Bonora, *Ricerche su Francesco Sansovino imprenditore librario e letterato* (*Istituto Veneto di Scienze, Lettere ed Arti, Memorie, classe di scienze morali, lettere ed arti*, LII), Venice 1994

BORTOLASO 1990
G. Bortolaso, 'Note su alcune opere comprese tra il 1542 e il 1576', in *Venice 1990*, pp. 385–7

BOSCHINI 1674
M. Boschini, *Le Ricche Minere della Pittura Veneziana*, Venice 1674

BOTTARI 1822
G. Bottari, *Raccolta di lettere*, ed. S. Ticozzi, 8 vols., Milan 1822–5

BOUCHER 1991
B. Boucher, *The Sculpture of Jacopo Sansovino*, 2 vols., New Haven and London 1991

BRAUNFELS 1980
W. Braunfels, 'I quadri di Tiziano nello studio Biri Grande (1530–1576)', in *Tiziano e Venezia 1980*, pp. 407–10

BREVAGLIERI 1995
S. Brevaglieri, 'Tiziano, le *Dame con il piatto* e l'allegoria matrimoniale', *Venezia Cinquecento*, X, 1995, pp. 123–60

BRIGSTOCKE 1993
H. Brigstocke, *Italian and Spanish Paintings in the National Gallery of Scotland*, Edinburgh 1993

BROWN 1980
Christopher Brown, *Second Sight*, exhib. cat., National Gallery, London, 1980

BROWN 2001
Clifford Brown, *Isabella d'Este e il mondo greco-romano*, New York 2001

BRUNETTI 1935
M. Brunetti, 'Una figlia sconosciuta di Tiziano', *Rivista di Venezia*, XIV, 1935

BURY 2001
M. Bury, *The Print in Italy 1550–1620*, exhib. cat., The British Museum, London, 2001

BUSCH 1973
R. von Busch, *Studien zu deutschen Antikensammlungen des 16. Jahrhunderts*, Tübingen 1973

CADORIN 1833
G. Cadorin, *Dello amore ai Veneziani di Tiziano Vecellio*, Venice 1833

CAINS 1999
Ed. C. Cains, *Three Renaissance Comedies*, Lewiston NY 1991

CAMPANA 1908
L. Campana, 'Monsignor Giovanni della Casa e i suoi tempi: vita privata', *Studi storici*, XVII, 1908

CAMPBELL 1990
L. Campbell, *Renaissance Portraits*, New Haven and London 1990

CAMPBELL 2003
C. Campbell, 'Titian's *Jacopo Pesaro presented by Pope Alexander VI to Saint Peter*', in *Dunkerton et al.* forthcoming

CAMPORI 1874
G. Campori, 'Tiziano e gli Estensi', *Nuova antologia di scienze, lettere ed arti*, ser. I, XXVII, 1874, pp. 581–620

CANNON-BROOKES 1977
P. Cannon-Brookes, *The Cornbury Park Bellini. A contribution towards the study of the late paintings of Giovanni Bellini*, Birmingham 1977

CANTELUPE 1964
E.A. Cantelupe, 'Titian's "Sacred and Profane Love" Re-examined', *Art Bulletin*, XLVI, 1964

CAROSELLI 1983
S.L. Caroselli, 'A Portrait Bust of Caterina Cornaro by Tullio Lombardo', *Bulletin of the Detroit Institute of Arts*, LXI, nos. 1–2, 1983, pp. 46–57

CAVALCASELLE AND CROWE 1878
G.B. Cavalcaselle and J.A. Crowe, *Tiziano, la sua vita e i suoi tempi*, 2 vols., Florence 1878

CHAMBERS ET AL. 1992
D. Chambers, J. Fletcher and B. Pullan, *Venice: A Documentary History 1450–1630*, Oxford 1992

CHRISTIANSEN 1987
K. Christiansen, 'Titianus (Per)fecit', *Apollo*, no. 301, 1987, pp. 190–6

CHRISTIANSEN 2000
K. Christiansen, 'Dosso Dossi's Aeneas frieze for Alfonso d'Este's Camerino', *Apollo*, CLI, 2000, pp. 36–45

CHECA 1992
F. Checa, *Felipe II: Mecenas de las artes*, Madrid 1992

CICOGNA 1824–53
E. Cicogna, *Delle iscrizioni veneziane*, 6 vols., Venice 1824–53

CLOULAS 1967
A. Cloulas, 'Documents concernant Tities conservés aux archives de Simancas', *Mélanges de la Casa de Velázquez*, III, 1967, pp. 197–288

COCKE 1999
R. Cocke, 'Titian the second Apelles: the "Death of Actaeon"', *Renaissance Studies*, XIII, no. 3, 1999, pp. 303–11

COHEN 2000
S. Cohen, 'Titian's London *Allegory* and the three beasts of the *Selva oscura*', *Renaissance Studies*, XXIV, no. 1, 2000, pp. 46–69

COLANTUONO 1991
A. Colantuono, '*Dies Alcyoniae*: The Invention of Bellini's *Feast of the Gods*', *Art Bulletin*, LXXIII, 1991, pp. 237–56

COLE 1995
B. Cole, 'Titian and the Idea of Originality in the Renaissance', *The*

Craft of Art. Originality and Industry in the Italian Renaissance and Baroque Workshop, Athens GA and London 1995, pp. 86–112

COOK 1900
H. Cook, *Giorgione*, London 1900

COOK 1905
'La collection de Sir Frederick Cook, Viscomte de Monserate', *Les Arts*, XLIV, 1905, pp. 5–6

COOK 1907
H. Cook, *Giorgione*, London 1900

COOK 1915
H. Cook, *The Portrait of Caterina Cornaro by Giorgione (finished by Titian)*, London 1915

CROWE AND CAVALCASELLE 1877
J.A. Crowe and G.B. Cavalcaselle, *Titian: His Life and Times*, 2 vols., London 1877

CUNNALLY 1999
J. Cunnally, *Images of the Illustrious: The Numismatic Presence in the Renaissance*, Princeton NJ 1999

DELAFORCE 1982
A. Delaforce, 'The Collection of Antonio Pérez, Secretary of State of Philip II', *The Burlington Magazine*, CXXIV, 1982, pp. 288–303

DOLCE (1557)
Dolce's Aretino and Venetian Art Theory of the Cinquecento, New York 1968

DÜLBERG 1990
A. Dülberg, *Privatporträts: Geschichte und Ikonologie einer Gattung im 15. und 16. Jahrhundert*, Berlin 1990

DUNKERTON 1994
J. Dunkerton, 'Developments in colour and texture in Venetian painting of the early 16th century', in *New Interpretations of Venetian Renaissance Painting*, ed. F. Ames-Lewis, London 1994, pp. 63–76

DUNKERTON 1999
J. Dunkerton, 'Observations on the conservation history and technique of "The Tribute Money" in the National Gallery, London', in *Tiziano Técnicas* 1999, pp. 109–16

DUNKERTON ET AL. 1999
J. Dunkerton, S. Foister and N. Penny, *Dürer to Veronese: Sixteenth-Century Painting in the National Gallery*, New Haven and London 1999

DUNKERTON ET AL. FORTHCOMING
Forthcoming publication by the Koninklijk Museum voor Schone Kunsten, Antwerp, with papers by

C. Campbell, by J. Dunkerton and M. Spring and by H. Dubois and A. Wallert on the restoration and technique of *Jacopo Pesaro being presented to Saint Peter by Pope Alexander VI*

DUNKERTON AND PENNY 1995
J. Dunkerton and N. Penny, '"Noli me tangere", Londra, The National Gallery', in *Rome* 1995, pp. 364–7

EDINBURGH 2001
Rembrandt's Women, exhib. cat., ed. J. Lloyd Williams, National Gallery of Scotland, Edinburgh, and the Royal Academy of Arts, London, 2001

FABBRI 2000
L. Fabbri, 'The Memory of Exiled Families: the Case of the Strozzi', in *Art, Memory and Family in Renaissance Florence*, ed. G. Ciappelli and P. L. Rubin, Cambridge 2000

FABBRO 1967
C. Fabbro, 'Tiziano e i Farnese e l'Abbazia di San Pietro in Colle nel Cenedese', *Archivio Storico di Belluno, Feltre e Cadore*, XXXIX, January –June 1967, pp. 1–18

FABBRO 1968
C. Fabbro, *Tiziano Vecellio*, Pieve di Cadore 1968

FEHL 1974
P. Fehl, 'The Worship of Bacchus and Venus in Bellini's and Titian's Bacchanals for Alfonso d'Este', in *Studies in the History of Art* VI, Washington, D.C., 1974, pp. 37–96

FERINO PAGDEN 2000
S. Ferino Pagden, 'The Ideal and the Natural: Images of Power', in *Carolus*, exhib. cat., Museo di Santa Cruz, Toledo, 2000, pp. 67–9

FERRARINO 1973
L. Ferrarino, *Tiziano e la corte di Spagna nei documenti dell'Archivio Generale di Simancas*, Madrid 1973

FIORENZA 2002
G. Fiorenza, 'Pandolfo Collenuccio's Specchio di Esopo and the Portrait of the Courtier', *I Tatti Studies*, IX, forthcoming 2002

FISHER 1977
M.R. Fisher, *Titian's Assistants During the Late Years*, New York and London 1977

FLETCHER 1992
J. Fletcher, '"Fatto al Specchio": Venetian Renaissance Attitudes to Self Portraiture', in *Fenway Court, 1990–1991*, Isabella Stewart Gardner Museum, Boston, 1992, pp. 45–60

FLORENCE 1978
Tiziano nelle gallerie fiorentine, exhib. cat., ed. M. Gregori, Palazzo Pitti, Florence, 1978

FOMICOVA 1967
T. Fomicova, 'I dipinti di Tiziano nelle raccolte dell'Ermitage', *Arte Veneta*, XXI, 1967, pp. 57–70

FOMICOVA 1992
T. Fomicova, *The Ermitage, Catalogue of Western European Painting. Venetian Painting, Fourteenth to Eighteenth Centuries*, Florence 1992

FORTINI BROWN 1997
P. Fortini Brown, *The Renaissance in Venice*, London 1997

FOSCARI 1935
L. Foscari, *Iconografia di Tiziano*, Venice 1935

FREEDMAN 1990
L. Freedman, *Titian's Independent Self Portraits*, Florence 1990

FREEDMAN 1995
L. Freedman, *Aretino through Titian's Lens*, University Park PA 1995

FREY 1930
K. and H.-W. Frey, *Der literarische Nachlass Giorgio Vasaris*, II, Munich 1930

FRIEDLÄNDER 1938
W. Friedländer, 'La tintura delle rose', *Art Bulletin*, XX, 1938, pp. 318–24

GARCÍA-FRÍAS CHECA 1999
C. García-Frías Checa, 'Analisi critico de dos obras restauradas de Tiziano en el Monasterio de El Escorial', in *Tiziano Técnicas* 1999, pp. 39–151

GARRIDO 2001
C. Garrido, 'El Emperador Carlos V a caballo en Mühlberg: estudio técnico', in *La Restauración de el Emperador Carlos V*, Museo Nacional del Prado, Madrid, 2001, pp. 118–21

GARRIDO AND DÁVILA 1985
M.C. Garrido and R. Dávila, 'La Virgen y el Niño con San Jorge y Santa Catalina de Tiziano. Estudio técnico y restauración', *Boletín del Museo del Prado*, XVIII, 1985, pp. 138–52

GENTILI 1991
A. Gentili, 'Giovanni Bellini, la bottega, i quadri di devozione', *Venezia Cinquecento*, II, 1991, pp. 27–60

GENTILI 1992
A. Gentili, 'Tiziano e il non finito', *Venezia Cinquecento*, IV, 1992, pp. 93–127

GHENT 1999
Carolus Charles Quint 1500–38, exhib. cat., Kunsthal de Sint-Pietersabdij, Ghent 1999

GIBBONS 1965
F. Gibbons, 'Practices in Giovanni Bellini's Workshop', *Pantheon*, XXIII, 1965, pp. 146–55

GINZBURG 1980,
C. Ginsburg, 'Tiziano, Ovidio e i codici delle figurazioni erotiche nel '500, in *Tiziano e Venezia* 1980, pp. 125–35

GIORGI 1990
R. Giorgi, *Tiziano. Venere, Amore e il Musicista in cinque dipinti*, Rome 1990

GOFFEN 1993
R. Goffen, 'Titian's *Sacred and Profane Love*: Individuality and Sexuality in a Renaissance Marriage Picture', in *Titian 500* 1993, pp. 121–44

GOFFEN 1997
R. Goffen, 'Sex, Space and Social History in Titian's *Venus of Urbino*', in *Titian's Venus of Urbino*, ed. R. Goffen, Cambridge 1997, pp. 63–90

GOLZIO 1936
V. Golzio, *Raffaello nei documenti*, Vatican City 1936

GOODISON AND ROBERTSON 1967
J.W. Goodison and G. Robertson, *Fitzwilliam Museum, Cambridge: Catalogue of Paintings*, Cambridge 1967

GOULD 1958
C. Gould, 'A Famous Titian Restored', *The Burlington Magazine*, C, 1958, pp. 44–8

GOULD 1961
'The Lady at the Parapet', *The Burlington Magazine*, CIII, 1961, pp. 335–40

GOULD 1966
C. Gould, 'Lorenzo Lotto and the Double Portrait', *Saggi e memorie di storia dell'arte*, V, 1966, pp. 43–51

GOULD 1972
C. Gould, '*The Death of Actaeon* and Titian's Mythologies', *Apollo*, XCV, June 1972, pp. 464–9

GOULD 1975
C. Gould, *The Sixteenth-Century Italian Schools*, The National Gallery, London 1975

GOULD 1976
C. Gould, *Titian as a Portraitist*, London 1976

GRONAU 1906
G. Gronau, 'Zwei Tizianische Bildnisse der Berliner Galerie: I. Das Bildnis des Ranuccio Farnese; II. Das Bildnis der Tochter des Roberto Strozzi', *Jahrbuch der königlichen preuszischen Kunstsammlungen*, XXVII, 1906, pp. 3–12

GRONAU 1925
'Concerning Titian's Picture at Alnwick Castle', *Apollo*, II, no. 9, 1925, pp. 126–7

GRONAU 1936
G. Gronau, *Documenti artistici urbinati*, Florence 1936

HADELN 1924
D. von Hadeln, 'Some little-known works by Titian', *The Burlington Magazine*, XLV, 1924, p. 180

HASKELL 1983
F. Haskell, 'Venetian Sixteenth Century Painting: The Legacy', in London 1983, pp. 47–8

HEINEMANN 1980
F. Heinemann, 'La bottega di Tiziano', in *Tiziano e Venezia* 1980, pp. 433–40

HILLS 1999
P. Hills, *Venetian Colour: Marble, Mosaic, Painting and Glass 1250–1550*, New Haven and London 1999

HIRST 1981
M. Hirst, *Sebastiano del Piombo*, London 1981

HIRST 1994
M. Hirst, *The Young Michelangelo* (*Making and Meaning*), exhib. cat., National Gallery, London, 1994

HOCHMANN 1992
M. Hochmann, *Peintres e commanditaires à Venise (1540–1628)*, Rome 1992

HOLBERTON 1986A
P. Holberton, 'La bibliotechina e la raccolta d'arte di Zuanantonio Venier', *Atti dell'Istituto Veneto di Scienze, Lettere ed Arti*, CXLIV, 1985–6, pp. 173–92

HOLBERTON 1986B
P. Holberton, 'Battista Guarino's Catullus and Titian's *Bacchus and Ariadne*', *The Burlington Magazine*, CXXVIII, May 1986, pp. 347–50

HOLBERTON 1987
P. Holberton, 'The choice of texts for the Camerino pictures', in *Bacchanals* 1987, pp. 57–66

HOLBERTON 1993
P. Holberton, 'The *Pastorale* or *Fête champêtre* in the Early Sixteenth Century', in *Titian 500* 1993, pp. 245–62

HOLBERTON 2003
'To Loosen the Tongue of Mute Poetry: Giorgione's Self-Portrait "as David" as a *Paragone* Demonstration', in *Poetry on Art. Renaissance to Romanticism*, ed. T. Frangenberg, Donington 2003, pp. 29–47

HOLMES 1914
C. Holmes, '*La Schiavona* by Titian' *The Burlington Magazine*, XXVI, 1914, pp. 15–16

HOLMES 1929
The National Gallery Catalogue, London 1929

HOPE 1971–2
C. Hope, 'The Camerino d'Alabastro of Alfonso d'Este', *The Burlington Magazine*, CXIII, 1971, pp. 641–50; CXIV, 1972, pp. 712–21

HOPE 1973
C. Hope, 'Documents concerning Titian', *The Burlington Magazine*, CXV, 1973, pp. 805–10

HOPE 1980A
C. Hope, *Titian*, London 1980

HOPE 1980B
C. Hope, 'Titian's rôle as official painter to the Venetian Republic', in *Tiziano e Venezia* 1980, pp. 301–5

HOPE 1980C
'Problems of interpretation in Titian's erotic paintings', in *Tiziano e Venezia* 1980, pp. 111–24

HOPE 1982
C. Hope, 'Titian's Portrait of Giacomo Dolfin', *Apollo*, CXV, no. 241, March 1982, pp. 158–60

HOPE 1987
C. Hope, 'The Camerino d'Alabastro. A Reconsideration of the Evidence', in *Bacchanals* 1987, pp. 25–42

HOPE 1988
C. Hope, 'La produzione pittorica di Tiziano per gli Asburgo', in *Venezia e la Spagna*, Milan 1988

HOPE 1990
C. Hope, 'Titian, Philip II and Mary Tudor', in *England and the Continental Renaissance. Essays in Honour of J. B. Trapp*, ed. E. Chaney and P. Mack, Woodbridge 1990, pp. 53–65

HOPE 1993A
C. Hope, 'The Early Biographies of Titian', in *Titian 500* 1993, pp. 167–97

HOPE 1993B
C. Hope, 'Tempest over Titian', *The New York Review of Books*, 10 June 1993, pp. 22–6

HOPE 1996A
C. Hope, 'Retrato ecuestre de Carlos V', in *Obras maestras del Museo del Prado*, Madrid 1996, pp. 59–71

HOPE 1996B
C. Hope, 'Some misdated Letters of Pietro Aretino', *Journal of the Warburg and Courtauld Institutes*, LIX, 1996, pp. 304–14

HOPE AND ASPEREN DE BOER 1991
C. Hope and J.R.J. van Asperen de Boer, 'Underdrawings by Giorgione and his circle', in *Le Dessin sous-jacent dans la peinture. Colloque VII: Dessin sous-jacent et copies*, Louvain-la-Neuve 1991, pp. 127–40

HOURS 1976
M. Hours, 'Contributions à l'étude de quelques œuvres de Titien', in *Laboratoire de Recherche des Musées de France: Annales,* 1976, pp. 12–15

HUMFREY 1993
P. Humfrey, 'The prehistory of Titian's *Assunta*', in *Titian 500* 1993, pp. 222–43

M. JAFFÉ 1966
M. Jaffé, 'The Picture of the Secretary of Titian', *The Burlington Magazine*, CVIII, 1966, pp. 114–26

M. JAFFÉ AND GROEN 1987
M. Jaffé and K. Groen, 'Titian's *Tarquin and Lucretia* in the Fitzwilliam', *The Burlington Magazine*, CXXIX, 1987, pp. 162–72

D. JAFFÉ 2001
D. Jaffé, 'New Thoughts on Van Dyck's Italian Sketchbook', *The Burlington Magazine*, XLIII, 2001, pp. 616–24

JANSEN 1993
D.J. Jansen, 'Antonio Agustin and Jacopo Strada', in *Antonio Agustín between Renaissance and Counter-Reform*, ed. M.H. Crawford, London 1993

JOANNIDES 1991
P. Joannides, 'Titian's *Daphnis and Chloe*. A search for the subject of a familiar masterpiece', *Apollo*, no. 352, June 1991, pp. 374–82

JOANNIDES 2001
P. Joannides, *Titian to 1518*, New Haven and London 2001

JONES 1993
P. Jones, *Federico Borromeo and the Ambrosiana*, Cambridge 1993

KAMINSKI 1998
M. Kaminski, *Tiziano Vecellio known as Titian*, Cologne 1998

KELLER 1969
H. Keller, *Tizians Poesie für Philipp II von Spanien*, Wiesbaden 1969

KIRBY AND WHITE 1996
J. Kirby and R. White, 'The Identification of Red Lake Pigment Dyestuffs and a Discussion of their Use', *National Gallery Technical Bulletin*, no. 17, 1996, pp. 56–80

KLAUNER AND OBERHAMMER 1960
Vienna, Kunsthistorisches Museum, Katalog der Gemäldegalerie, ed. F. Klauner and V. Oberhammer, Vienna 1960

KLINGER 1991
L.S. Klinger, *The Portrait Collection of Paolo Giovio*, diss. Princeton University, 2 vols., 1991

LANDI 1985
S. Landi, *The Textile Conservator's Manual*, London 1985, pp. 8–9

LAZZARINI 1983
L. Lazzarini, 'Il Colore nei Pittori Veneziani tra il 1480 e il 1580', *Bolletino d'Arte*, 1983, supplemento 5, pp. 135–44

LEHMANN 1989
S. Lehmann, 'Die Reliefs im Palazzo Spada und ihre Ergänzungen', in *Antikenzeichnung und Antikenstudium in Renaissance und Frühbarock (Akten des internationalen Symposiums 8.–10. September 1986 in Coburg)*, ed. R. Harparth and H. Wrede, Mainz 1989, pp. 221–63

LIVERPOOL 1995
Face to Face: Three Centuries of Artists' Self-Portraits, exhib. cat., ed. X. Brooke, The Walker Art Gallery, Liverpool, 1995

LONDON 1981
The Splendours of the Gonzaga, exhib. cat., ed. D. Chambers and J. Martineau, Victoria and Albert Museum, London, 1981

LONDON 1983
The Genius of Venice, exhib. cat., ed. C. Hope and J. Martineau, Royal Academy, London, 1983

LONDON 2001
James Gillray: The Art of Caricature, exhib. cat., ed. R. Godfrey, Tate Britain, London, 2001

LONGHI 1946
R. Longhi, *Viatico per cinque secoli della pittura veneziana*, Florence 1946

LORENZETTI 1980
G. Lorenzetti, *Venezia e il suo estuario*, Trieste 1980

LUCAS AND PLESTERS 1978
A. Lucas and J. Plesters, 'Titian's *Bacchus and Ariadne*', *National Gallery Technical Bulletin*, II, 1978, pp. 25–47

LUDWIG 1903
G. Ludwig, 'Neue Funde im Staatsarchiv zu Venedig', *Jahrbuch der königlichen preuszischen Kunstsammlungen*, XXIV, 1903, Beiheft

LUZIO 1890
Alessandro Luzio, 'Altre spigolature tizianesche', *Archivio Storico dell'Arte*, III, 1890, pp. 209–10

MANCINI 1998
M. Mancini, *Tiziano: Le corti d'Asburgo*, Venice 1998

MANDOWSKY AND MITCHELL 1963
E. Mandowsky and C. Mitchell, *Pirro Ligorio's Roman Antiquities*, London 1963

MATTHEW 2002
L.C. Matthew, '*Vendecolori a Venezia*: the Reconstruction of a Profession', *The Burlington Magazine*, CXLIV, 2002, pp. 680–6

MAYER 1935
A.L. Mayer, An Unknown *Ecce Homo* by Titian', *The Burlington Magazine*, LXVII, 1935, pp. 52–3

MAYER 1939
A.L. Mayer, 'Nicolò Aurelio: the commissioner of Titian's *Sacred and Profane Love*', *Art Bulletin*, XXI, no. 1, 1939, pp. 567–70

MEIJER 1981
B.W. Meijer, 'Titian Sketches on Canvas and Panel', *Master Drawings*, XIX, 1981, pp. 276–88

MICHIEL
[M.A. Michiel], *Notizia d'opere di Disegno*, ed. J. Morelli and G. Frizzoni, Bologna 1884

MODENA 1990
Disegno: Les dessins italiens du Musée de Rennes, exhib. cat., ed. P. Ramade, Musée des Beaux-Arts, Rennes, 1990

MOLINA 1999
I. Molina, 'Restauración del retrato de Felipe II con armadura', in *Tiziano Técnicas* 1999, pp. 47–51

MORASSI 1946
A. Morassi, 'Il Tiziano di Casa Balbi', *Emporium*, CIII, 1946, pp. 207–28

MOSCHINI-MARCONI 1962
S. Moschini-Marconi, *Gallerie dell'Accademia di Venezia. Opere d'arte del XVI secolo*, Rome 1962

MOZZETTI 1996
F. Mozzetti, *Tiziano, Ritratto di Pietro Aretino*, Modena 1996

MUCCHI 1977
L. Mucchi, 'Radiografie di opere di Tiziano', *Arte Veneta*, XXXI, 1977, pp. 297–304

MULLER 1989
J. Muller, *Rubens: The Artist as Collector*, Princeton NJ 1989

MURARO 1949
M. Muraro, 'Il memoriale di Zuan Paolo da Ponte', *Nuovo Archivio Veneto*, XLIV–XLV, 1949, pp. 77–88

MURARO 1984
M. Muraro, *Interpretazioni veneziane*, Venice 1984

NEFF 1985
M. Neff, *Chancellory Secretaries in Venetian Politics and Society 1490–1533*, diss. University of California, Los Angeles, 1985

NEPI SCIRÉ 1990
G. Nepi Sciré, 'Recenti restauri di opere di Tiziano a Venezia', in Venice 1990, pp. 109–31; also in English, but with some translation errors, in Washington 1990

NEPI SCIRÉ 1999
G. Nepi Sciré, 'Restauri e tecniche di Tiziano', in *Tiziano Técnicas* 1999, pp. 153–9

NEWTON 1988
S.M. Newton, *The Dress of the Venetians 1495–1525*, Aldershot 1988

NEW YORK 1999
Dosso Dossi. Court Painter in Renaissance Ferrara, exhib. cat., ed. P. Humfrey and M. Lucco, Metropolitan Museum of Art, New York, 1999

ORSO 1978
S. Orso, *Philip IV and the Decoration of the Alcázar of Madrid*, Princeton NJ 1978

OST 1992
H. Ost, *Tizian Studien*, Cologne and Vienna 1992

PALLUCCHINI 1969
R. Pallucchini, *Tiziano*, 2 vols., Florence 1969

PANOFSKY 1969
E. Panofsky, *Problems in Titian, mostly Iconographic*, London 1969

PANOFSKY AND SAXL 1926
E. Panofsky and F. Saxl, 'A Late Antique Religious Symbol in Works by Holbein and Titian', *The Burlington Magazine*, XLVII, 1926, pp. 177–81

PARIS 1993
Le Siècle de Titien, exhib. cat., ed. M. Laclotte, Grand Palais, Paris, 1993

PARMA 1995
I Farnese: arte e collezionismo, exhib. cat., Palazzo Ducale di Colorno, Parma, and Naples and Munich, 1995

PEDROCCO 2001
F. Pedrocco, *Titian*, London and New York 2001

PENNY 1999
N. Penny, 'Two paintings by Titian in the National Gallery, London. Notes on technique, condition and provenance', in *Tiziano Técnicas* 1999, pp. 109–16

PERGOLA 1964
P. della Pergola, 'L'inventario Borghese del 1693', *Arte Antica e Moderna*, XXVIII, 1964, pp. 451–67

PERRY 1980
M. Perry, 'On Titian's "borrowings" from ancient art: a cautionary case', in *Tiziano e Venezia* 1980, pp. 187–91

POUNCEY 1939
P. Pouncey, 'The Miraculous Cross in Titian's *Vendramin Family*', *Journal of the Warburg Institute*, II, 1938–9, pp. 191–3

RAVÀ 1920
A. Ravà, 'Il "Camerino delle Antigaglie" di Gabriel Vendramin', *Nuovo Archivio Veneto*, XXXIX, 1920, pp. 155–81

REARICK 1997
W.R. Rearick, 'Titian's Later Mythologies', *Artibus et Historiae*, XXXIII, 1996, pp. 23–67

REGGIO-EMILIA 1994
Fondazione Magnani-Rocca: Capolavori della pittura antica, exhib. cat., ed. V. Sgarbi, Reggio-Emilia, 1994

REINHARDT 1999
S. Reinhardt, *Tizian in England: zur Kunstrezeption am Hof Karls I*, Frankfurt am Main 1999

RICHTER 1934
G.M. Richter, 'Unfinished Pictures by Giorgione', *Art Bulletin*, XVI, 1934, pp. 272–90

RICHTER 1937
G.M. Richter, *Giorgio da Castelfranco, called Giorgione*, Chicago 1937

RICKETTS 1910
C. Ricketts, *Titian*, London 1910

RIDOLFI (1648)
C. Ridolfi, *Le Maraviglie dell'arte* (1648), ed. R. von Hadeln, 2 vols., Berlin 1914–24

RIDOLFI (1648)A
C. Ridolfi, *Le Maraviglie dell'Arte*, ed. G. Vedova, 2 vols., Padua 1835–7

G. ROBERTSON 1971
G. Robertson, 'The X-Ray Examination of Titian's *Three Ages of Man* in the Bridgewater House Collection', *The Burlington Magazine*, CXIII, December 1971, pp. 721–6

S. ROBERTSON 1988
S. Robertson, 'Honour, Love and Truth: An Alternative Reading of Titian's *Sacred and Profane Love*', *Renaissance Studies*, II, 1988, pp. 268–79

ROME 1995
Tiziano. Amor Sacro e Amor Profano, exhib. cat., Palazzo delle Esposizioni, Rome 1995

RONCHINI 1864
A. Ronchini, 'Delle relazioni di Tiziano coi Farnese', *Deputazione di Storia Patria per le Provincie Modanesi e Parmesi: Atti e Memorie*, II, 1864, pp. 129–46

ROSAND 1978
D. Rosand, *Titian*, New York 1978

ROSAND 1980
D. Rosand, 'Ermeneutica amorosa: Observations on the interpretation of Titian's Venuses', in *Tiziano e Venezia* 1980, pp. 375–81

ROSAND 1981
D. Rosand, 'Titian and the Eloquence of the Brush', *Artibus et Historiae*, III, 1981, pp. 85–96

ROSKILL 1968
M. Roskill, *Dolce's Aretino and Venetian Art Theory of the Cinquecento*, New York 1968

ROWLANDS 1996
E. Rowlands, *Italian Paintings 1300–1800: The Nelson-Atkins Museum of Art*, Seattle 1996

RUBINSTEIN 1986
R. Rubinstein, 'The Renaissance Rediscovery of Antique River-god Personifications', in *Scritti di storia dell'arte in onore di Roberto Salvini*, Florence 1986, pp. 257–63

RYLANDS 1992
P. Rylands, *Palma Vecchio*, Cambridge 1992

SALA 1817
A. Sala, *Collezione dei quadri scelti di Brescia*, Brescia 1817

SAMBO 1980
A. Sambo, 'Tiziano davanti ai giudici ecclesiastici', in *Tiziano e Venezia* 1980, pp. 383–93

SANDRART (1675)
J. von Sandrart, *Academie der Bau-, Bild-, und Mahlerey Kunste* (1675), ed. A.R. Pelzer, Munich 1925

SANUTO
M. Sanuto, *I Diarii*, ed. R. Fulin *et al.*, 58 vols., Venice 1879–1903

SARTORI 1955
A. Sartori, *L'Arciconfraternita del Santo*, Padua 1955

SAVINI-BRANCA 1964
S. Savini-Branca, *Il collezionismo veneziano nel '600*, Padua 1964

SCHUCHARDT 1851–71
C. Schuchardt, *Lucas Cranach der Alter: Leben und Werke*, Leipzig 1851–71

SHAPLEY 1979
F. Shapley, *National Gallery of Art, Washington: Catalogue of Italian Paintings*, Washington, D.C., 1979

SHEARMAN 1983
J. Shearman, *The Early Italian Pictures in the Collection of Her Majesty the Queen*, Cambridge 1983

SHEARMAN 1987
J. Shearman, 'Alfonso d'Este's Camerino', in *Il se rendit en Italie: études offertes à André Chastel*, Rome 1987, pp. 209–30

SHEARMAN 1992
J. Shearman, *Only Connect: Art and the Spectator in the Italian Renaissance*, Princeton NJ 1992

SIEBENHÜNER 1981
H. Siebenhüner, *Der Palazzo Barberigo della Terrazza in Venedig und Seine Tizian-Sammlung*, Munich 1981

SOHM 1991
P. Sohm, *Pittoresco. Marco Boschini, his critics, and their critiques of painterly brushwork in seventeenth- and eighteenth-century Italy*, Cambridge 1991

SONNENBURG 1999
H. von Sonnenburg, 'The seated portrait of Charles V', in *Tiziano Técnicas* 1999, pp. 99–107

SPONZA 1999
S. Sponza, 'Un dipinto di Tiziano riconosciuto: il ritratto di Nicolò Zono a Kingston Lacy', in *Pittura veneziana dal Quattrocento al Settecento: Studi di storia dell'arte in onore di Egidio Martini*, ed. G. Pili, Venice 1999, pp. 57–61

STINGER 1995
C.L. Stinger, *The Renaissance in Rome*, Bloomington 1985

STUFFMANN 1968
M. Stuffmann, 'Les Tableaux de la Collection de Pierre Crozat', *Gazette des Beaux-Arts*, LXXII, 1968, pp. 11–143

SUIDA 1933
W. Suida, *Tiziano*, Rome 1933

SUTHERLAND 1993
B.D. Sutherland, 'Nine reasons why Titian's *il Bravo* should be re-titled the Arrest of Bacchus', *Venezia Cinquecento*, VI, 1993, pp. 35–52

TAFURI 1985
Ed. M. Tafuri, *Venezia e il Rinascimento*, Turin 1985

THOMPSON 1956
S.H. Thompson, 'The Literary Sources of Titian's *Bacchus and Ariadne*', *The Classical Journal*, L, no. 1, 1956, pp. 259–64

THOMSON DE GRUMMOND 1975
N. Thomson de Grummond, 'VV and Related Inscriptions in Giorgione, Titian and Dürer', *Art Bulletin*, LVII, 1975, pp. 346–56

TICOZZI 1817
S. Ticozzi, *Vite dei pittori Vecellj di Cadore*, Milan 1817

TIETZE 1936
H. Tietze, *Tizian: Leben und Werk*, 2 vols., Vienna 1936

TIETZE 1954
H. Tietze, 'An Early Version of Titian's *Danae*. An Analysis of Titian's Replicas', *Arte Veneta*, VIII, 1954, pp. 199–208

TIETZE AND TIETZE-CONRAT 1944
H. Tietze and E. Tietze-Conrat, *The Drawings of the Venetian Painters in the 15th and 16th Centuries*, New York 1944

TIETZE-CONRAT 1946
E. Tietze-Conrat, 'Titian's Workshop in his Late Years', *Art Bulletin*, XXVIII, 1946, pp. 76–88

TITIAN 500 1993
Titian 500 (*Studies in the History of Art*, 45), ed. J. Manca, Washington, D.C., 1993

TIZIANO E VENEZIA 1980
Tiziano e Venezia, Convegno Internazionale di Studi, Venezia, 1976, Vicenza 1980

TIZIANO TÉCNICAS 1999
Tiziano. Técnicas y restauraciones, Actas del Simposium Internacional celebrado en el Museo Nacional del Prado los días 3,4 y 5 junio de 1999, Madrid 1999

VALCANOVER 1960
R. Valcanover, *Tutta la pittura di Tiziano*, 2 vols., Milan 1960

VALLADOLID 1999
La época de Carlos V y Felipe II en la Pintura de Historia del Siglo XIX, exhib. cat., ed. C. Reyero, Museo Nacional de Escultura, Valladolid, 1999

VASARI (1568)
G. Vasari, *Le vite dei più eccellenti pittori, scultori, ed architettori* (1568), ed. G. Milanesi, 7 vols., Florence 1906

VASARI (1568)A
G. Vasari, *Le vite dei più eccellenti pittori, scultori, ed architettori*, ed. R. Bettarini and P. Barocchi, 6 vols., Florence 1966–87

VECELLIO 1590
C. Vecellio, *Degli Habiti Antichi et Moderni de diverse parti del Mondo*, Venice 1590

VENICE 1990
Tiziano, exhib. cat., Palazzo Ducale, Venice, 1990

VENTURI 1900
A. Venturi, *La Galleria Crespi in Milano*, Milan 1900

VENTURI 1928
A. Venturi, *Storia dell'arte italiana*, IX, Milan 1928 (25 vols., Milan 1901–39)

VOLLE 1993
N. Volle *et al.*, 'La restauration de huit tableaux de Titien du Louvre', *Revue du Louvre*, XLIII, no. 1, 1993, pp. 58–80

VOLTELINI 1892
H. von Voltelini, 'Urkunden und Regesten aus dem k. und k. Haus-, Hof- und Staats-Archiv in Wien', *Jahrbuch der Kunsthistorischen Sammlungen des Allerhöchsten Kaiserhauses*, XIII, 1892, pp. XXVI–CLXXIV

VOLTOLINA 1998
P. Voltolina, *La storia di Venezia attraverso le medaglie*, 3 vols., Venice 1998

WASHINGTON 1976
Titian and the Venetian Woodcut, exhib. cat., ed. D. Rosand and M. Muraro, National Gallery of Art, Washington, D.C., 1976

WASHINGTON 1990
Titian, Prince of Painters, exhib. cat., National Gallery of Art, Washington, D.C., 1990

WESTON-LEWIS 2000
A. Weston-Lewis, *A Companion Guide to the National Gallery of Scotland*, Edinburgh 2000

WETHEY I
H.E. Wethey, *The Paintings of Titian I. The Religious Paintings*, London 1969

WETHEY II
H.E. Wethey, *The Paintings of Titian II: The Portraits*, London 1971

WETHEY III
H.E. Wethey, *The Paintings of Titian III: The Mythological and Historical Paintings*, London 1975

WILDE 1932
J. Wilde, 'Röntgenaufnahmen der "Drei Philosophen" Giorgiones und

der "Zigeunermadonna" Tizians', *Jahrbuch der kunsthistorischen Sammlungen in Wien*, VI, 1932, pp. 141–54

WILDE 1974
J. Wilde, *Venetian Art from Bellini to Titian*, Oxford 1974

WILSON 2001
C. Wilson, *St. Joseph in Italian Renaissance Society and Art: New Directions and Interpretations*, Philadelphia 2001

WIND 1967
E. Wind, *Pagan Mysteries in the Renaissance*, Oxford 1967

WIND 1969
E. Wind, *Giorgione's Tempesta*, Oxford 1969

WOOD 1990
J. Wood, 'Van Dyck's "Cabinet de Titien". The contents and dispersal of his collection', *The Burlington*

Magazine, CXXXII, 1990, pp. 680–95

WOOD 1994
J. Wood, 'Van Dyck and the Earl of Northumberland. Taste and Collecting in Stuart England', in *Van Dyck 350 (Studies in the History of Art*, 46), ed. S. Barnes and A. Wheelock, Washington, D.C., 1994

WOODS-MARSDEN 1998
J. Woods-Marsden, *Renaissance Self Portraiture: The Visual Construction of Identity and the Social Status of the Artist*, New Haven and London 1998

ZAPPERI 1990
R. Zapperi, *Tiziano, Paolo III e i suoi nipoti*, Turin 1990

ZAPPERI 1991A
R. Zapperi, 'Cardinal Farnese, Giovanni della Casa and Titian's *Danaë* in Naples', *The Journal of the Warburg and Courtauld Institutes*, LIV, 1991, pp. 159–71

ZAPPERI 1991B
R. Zapperi, 'Tiziano e i Farnese: aspetti economici del rapporto di committenza', *Bolletino d'Arte*, LXVI, 1991, pp. 39–48

ZARNOWSKI 1938
J. Zarnowski, 'L'atelier de Titien. Girolamo di Tiziano', *L'Art ancien. Revue d'Archeologie et d'Histoire de l'Art*, 1938, pp. 107–29

ZIMMERMAN 1901
H. Zimmerman, 'Zur richtigen Datierung eines Portraits von Tizian', *Mitteilungen des Instituts für oesterreichische Geschichtsforschung*, VI, *Ergänzungsband*, 1901, pp. 830–57

NOTES

NOTES ON THE ESSAYS

TITIAN'S LIFE AND TIMES (pp. 9–28)

1 Sartori 1955, p. 67. Francesco served under Serafino da Cai and Macone, fighting at Verona and Vicenza (Ticozzi 1817, p. 321). Serafino was killed at Padua in October 1513 (Sanuto, XVII, cols. 170, 187); Macone and his troops participated in the siege of Verona in 1517 (*ibid.*, XXIII, col. 463), and were presumably with the rest of the army at Vicenza in 1515 (*ibid.*, XX, cols. 316–7).

2 Documents concerning Dorotea's marriage to Matteo Soldano are in Venice, Archivio di Stato (hereafter ASV), Giudici del Proprio, Vadimoni, registro 25, pp. 41r–44v. Her name is often given incorrectly as Caterina: see, for example, Crowe and Cavalcaselle 1877, I, p. 38.

3 She must have been the mother of Titian's nephew Giovanni Alessandrini, a notary first recorded in Venice in 1546. Giovanni's sister Cecilia married in 1551 (Treviso, Archivio di Stato, Notarile, Prima serie, busta 571 (Onofrio Cittolini), protocollo 1551–2, pp. 181r-v); his

other sister, Lucia, married in 1555 (*ibid.*, busta 860 (Silvio Cittolini), protocollo 1558–9, p. 22v).

4 It is often suggested that Titian worked at the Fondaco in 1509, but no explanation has been offered why the Venetian government, which was anxious to complete the building as soon as possible, would have allowed the decoration to take so long, especially as the scaffolding required for Titian's paintings would have hindered access to the shops on the side façade, for which the leases were auctioned in May 1508 (ASV, Provveditori al Sal, busta 63, registro 7, p. 79r). The external frescoes were still unfinished on 1 August 1508 (Sanuto, VII, col. 597).

5 Anderson 1977, pp. 187–8, n. 1.

6 Vasari reported to Cosimo de' Medici on 20 January 1565 that the first two parts of the *Lives* had been printed, and that the printers would continue with the third part (Frey 1930, II, p. 144). The fact that printing had begun implies that the entire text was ready in some form. But the *Life* of Titian was not printed before 1567 (Vincenzo Borghini to Vasari, 28 January 1567; *ibid.*, pp. 291–2).

7 Hope 1980A, p. 26: Pesaro was away from Venice from early 1503 until 1506, but thereafter seems to have remained there.

8 Hope 1980A, p. 28.

9 Hope 1993B, pp. 25–6; Holberton 1993, pp. 255–8.

10 Titian spent 76 days in Ferrara in 1524, with two companions, and 109 days in 1529, mostly with six companions (Hope 1987, p. 39, n. 13; Campori 1874, p. 600, n. 1). It is likely that during the first visit he completed and installed *The Andrians* and during the second he repainted the landscape of Bellini's *Feast of the Gods* (cat. 15). but it is just possible that he repainted Bellini's picture in 1524 and painted *The Andrians* during his later visit.

11 The information is contained in depositions submitted in 1550 to establish that the marriage had taken place, presumably to confirm the legitimacy of Pomponio and Orazio: see Ludwig 1903, pp. 115–17.

12 She is mentioned in a letter from Charles V to Ferrante Gonzaga of 5 June 1548 (Guastalla, Biblioteca Maldottiana, Fondo Gonzaga, busta 2, no. 220, p. 12).

13 Crowe and Cavalcaselle 1877,

II, p. 510. Given the date of her marriage, Lavinia was almost certainly born after 1530; and it was presumably with the prospect of her marriage in mind that the legitimacy of Pomponio and Orazio was established in 1550 (see above, note 11). Titian was already concerned about Lavinia's dowry in September 1549 (see Crowe and Cavalcaselle 1877, II, pp. 193–4).

14 Brunetti 1935, p. 183, nos. I, II.

15 The duke's portrait was begun at the end of April 1536 and completed by 9 October (see Hope 1980A, p. 78; *Lettere scritte al signor Pietro Aretino*, Venice 1551, I, p. 316). That of the duchess was completed by the autumn of 1537 (Hope 1996B, p. 311). It must have been begun during her visit to Venice from 16 September 1536 to 18 April 1537 (see Benedetto Agnello to Federico Gonzaga, 17 September 1536 (Mantua, Archivio di Stato, Archivio Gonzaga [hereafter ASMN/AG], busta 1466), and same to same, 17 April 1537 (ASMN/AG, busta 1471)). Eleonora did not return to Venice until 22 October 1537 (same to same, 23 October 1537 (ASMN/AG, busta 1471)).

16 On 16 January 1538 Guidobaldo, travelling secretly from Camerino in defiance of a papal interdict, was at Lugo, near Imola (Belluzzi 1907, pp. 78–80), and by 22 January was in Venice (Benedetto Agnello to Federico Gonzaga, 22 January 1538, in ASMN/AG, busta 1472). He left on 22 February (same to same, 23 February 1538, ibid.). His previous visit to Venice had been from 27 April 1527 to 12 February 1528 (Sanuto, XLIV, col. 564; Giambattista Malatesta to Federico Gonzaga, 6 and 14 February 1528 (ASMN/AG, busta 1462)). Guidobaldo sent a servant to collect the portrait and the 'naked woman' on 9 March 1538. He returned with the portrait on 14 April. On 1 May Guidobaldo wrote to Venice, asking that Titian should not sell the other picture to someone else, since he was determined to raise funds to pay for it, and this the artist agreed to do. In the correspondence there is no suggestion that the picture was unfinished, or that it had been commissioned by Guidobaldo; and it is unrealistic to suppose that Titian would have painted both the portrait and the 'naked woman' from scratch after Guidobaldo's arrival in Venice in late January of the same year.

17 In 1598 a Milanese gentleman asked the then duke of Urbino for a copy of 'the naked woman by Titian', a request granted on the condition that he did not reveal who had given it to him, since it was 'a lascivious painting' which the duke only kept because it was by Titian: see Gronau 1936, pp. 112–13.

18 See Hope 1993A, pp. 173–4.

19 For the testimony of three of the canons of Santo Spirito, including their replies to a series of some twenty-three written questions submitted by Titian's lawyer, see Sambo 1980, pp. 389–93. Since these questions concerned the artist's competence and diligence, it is inconceivable that they would not have included specific allusions to the ceiling paintings, had these existed.

20 See Vatican City, Archivio Segreto Vaticano, Archivio della Nunziatura di Venezia, II, registro 7, pp. 86v, 91r, 94v–95r, 100r, 102r, 108r, 108v, 115r, 120r. The nature of the dispute is not specified, but it hinged on the admission as evidence, in support of Titian, of a letter written by the previous prior

of the monastery. Once this point was conceded, the proceedings ceased.

21 Hope 1990, pp. 53–9.

22 Ibid., pp. 60–5.

23 Busch 1973, p. 341, n. 87; Hope 1980A, pp. 127 and 142, n. 14; Voltelini 1892, p. XLVII, no. 8804.

24 Longhi 1946, p. 65; Pallucchini 1969, I, pp. 168–69, 313, with the proposal that the landscape is late.

25 Valerio made his will on 14 March 1576 and died shortly before 25 February 1577 (Bode et al. 1911, pp. 156–8).

26 She was certainly still alive on 20 January 1574: see Treviso, Archivio di Stato, Notarile, Prima serie, busta 965 (Patrizio Moscon), protocollo 1573–4, pp. 177v–178r.

27 Brunetti 1935, p. 183, no. II.

28 For two instances, dating from 1568, see Bonora 1994, p. 16, n. 15 (without indication of date).

29 For a summary of the main points of the dispute, see Fabbro 1968, pp. 126–7. For the involvement of the Dossena family, see ASV, Avogaria di Comun, registro 2063 (16 September 1577).

30 For Cornelio's property in 1578, see Fabbro 1968, p. 127. For sales of property by Pomponio, see ASV, Notarile, Atti, busta 3112, pp. 456r–457r, 559r–560r, and busta 3113, pp. 14v–15v; also Cadorin 1833, pp. 25 and 101–2, doc. R.

TITIAN AS A PAINTER OF PORTRAITS (pp. 29–32)

1 For the French text of the letter see Campbell 1990, note 129, p. 272. The portrait showed Philip II wearing a doublet trimmed with white wolf fur. See Hope 1990, p. 54. For a workshop version of this type in the Prado see Wethey II, p. 131, no. 83.

2 Wethey II, p. 127, no. 78, for the criticism in Philip's letter sent from Augsburg on 16 May 1551 to his aunt Maria of Hungary in Spanish and in English translation. For arguments as to which portrait was sent see Hope 1990, pp. 55 and 59. Hope argues that it was not Philip II in Armour (cat. 30) but an inferior version, as in the Prado portrait the armour is well painted and finished.

3 Aretino's letters are an essential source for his involvement with Titian and portraiture. The most useful edition is ed. E. Camesasca, Lettere sull'arte di Pietro Aretino, 3 vols., Milan 1957–60 (cited hereafter

simply as Aretino). Freedman 1995 is less reliable.

4 For Aretino's letters of January 1544 and May 1545 in which he boasts that his portrait has been sculpted in lead, bronze, gold and silver and painted on wood, canvas, paper and walls and that he appears on palace façades, comb cases, mirrors and plates see Aretino II, letters CLXXVI, p. 14, and CCXXXIV, p. 73.

5 Ibid., II, letters XXXII, p. 14, and CCXXXIV, p. 73.

6 For a detailed study of the Pitti portrait see Mozzetti 1996. For Aretino's comments made in April and October 1545 see Aretino II, letters CCXVIII, p. 60, CLXIV, p. 106, and CCLXV, p. 107.

7 The last doge to be portrayed by Titian was Francesco Venier in 1555. For Titian's duties and rewards in state service see Hope 1980B.

8 For permission to export grain see Charles V's letter to Pedro de Toledo in 1536, in Mancini 1998, p. 147, no. 21. For Titian legitimating a curate's bastards in Cadore in 1568 see Cavalcaselle and Crowe 1878, II, p. 381.

9 For Titian's love of Venice and reluctance to leave it see the imperial envoy Lope de Soria's letters to Francisco de los Cobos in January and February 1535, in Mancini 1998, pp. 142–3, nos. 14 and 15. For Titian's relationship with the Habsburgs see Hope 1988, pp. 49–78.

10 For Charles V's preference for portraits see Hope 1980A, p. 78.

11 For the destruction of portraits of Habsburg women listed in the inventory of Maria of Hungary, see Wethey II, pp. 202–3, no. L-24.

12 These include Cornelia Malaspina, painted for de los Cobos at the request of Federico Gonzaga, in Wethey II, p. 201, no. L-22, and Bodart 1998, pp. 71–4; Elizabetta Querini for Giovanni Della Casa, in Wethey II, p. 204, no. L-26, and in Vasari (1586), VII, p. 456, with a quotation from Della Casa's sonnet. For the portrait of Diego de Mendoza's mistress mentioned by Aretino see Aretino I, letter CLIII, p. 225.

13 Vasari (1568), VII, p. 50, and Roskill 1968, p. 192.

14 Hope 1980A, p. 32.

15 Vasari (1568), VII, pp. 428 and 454. Vasari refers to an early portrait very like a Giorgione of a Barbarigo friend in a doublet 'di

raso inargentato' (of silk with silver decoration). He also lists portraits of Francesco Assonica, who was godfather to a Titian child, and Francesco Sinistro.

16 Ibid. and Wethey II, pp. 102–3, no. 39. This portrait is in the De Young Memorial Museum, San Francisco. The letter is inscribed Di Titiano Vecellio singolare amico. It should, however, be noted that in Titian's portrait of Andrea dei Franceschi in the Detroit Institute of Arts a paper is also held in the left hand.

17 For portraits of Aretino see Wethey II, pp. 75–6, nos. 5 and 6, and Aretino II, pp. 211–19. For Bembo and Andrea dei Franceschi's portraits see Wethey II, pp. 82–3, nos. 15 and 16, and pp. 100–2, nos. 34 and 35. Two portraits by Titian are mentioned in dei Franceschi's will: see Neff 1985, p. 34. For Jacopo Pesaro as a donor see Wethey I, p. 101, no. 55, and p. 152, no. 132.

18 For Bembo's criticism see Golzio 1936, pp. 42–3. The double portrait is now in the Doria Pamphilj Gallery in Rome. It was seen in Bembo's Paduan house by Marcantonio Michiel: Michiel [1884], p. 45.

19 For Alfonso's interests see Bayer 1999, pp. 27–9. For the lost Raphael cartoon see Campbell 1990, p. 62.

20 See Avery 2001, p. 26, n. 151.

21 For Titian and northern types see Campbell 1990, pp. 234–6.

22 On Federico Gonzaga's relationship with Charles V see Bodart 1998, pp. 55–70.

23 On the promised benefice and problems relating to it see Zapperi 1990, pp. 27–37, and Zapperi 1991B, pp. 39–48.

24 The exchange is proposed by Aretino to Alessandro Trasontino in 1540, Aretino I, letter XCV, p. 154.

25 For Bembo's promise of future favours see Wethey II, p. 83, no. 15.

26 The circumstances are described by a rival dealer, Niccolò Stoppio, in a letter of 29 February 1568 to Johann Jacob Fugger: see Zimmerman 1901, p. 850; translation in Hope 1980A, p. 160.

27 Vecellio 1590, fol. 61.

28 The damage to the horse is reported by Cristoph Amberger, who repaired it at Titian's request as he had already packed his painting equipment: Mancini 1998, pp. 172–3, no. 51.

29 Discarded portraits of other sitters have been detected beneath

Pietro Aretino (cat. 27) and *Philip II in Armour* (cat. 30).

30 For Gabriele's art collection Ravà 1920, pp. 155–81.

31 Garrido 2001, pp. 118–21.

32 Mancini 1998, p. 171, no. 50.

33 For the inscription proving an early Urbino provenance, see London 1983, p. 291, no. D71.

34 For perceptive comments on this drawing see Campbell 1990, p. 182.

35 Bodart 1998, p. 304, no. 256.

36 Aretino I, letter CVIII, p. 176.

37 For Del Vasto's career see the entry by C. de Caro in *Dizionario biografico degli Italiani*, IV, Rome 1961, p. 612. At this time he was Governor of Milan, whence came Titian's imperial pension. Aretino dedicated his *Life of Saint Catherine* to him.

38 For the iconography see Panofsky 1969, pp. 74–9. For the suggestion that the *adlocutio* form was chosen by the Marchese's secretary, Paolo Giovio, and arguments that no episode from his life is alluded to, see Hope 1996A, p. 67.

39 Del Vasto's request was conveyed by Aretino to Capitan Palazzo in Brescia on 15 February 1541: Aretino I, letter CXII, pp. 180–1. For Aretino's elaborate description of 20 November 1540 see letter C, p. 162.

40 For the Louvre portrait see Paris 1993, pp. 574–6, no. 166.

41 For example, he boasted that his portrait of Cornelia Malaspina, whom he never saw, and which he would finish in ten days, would be better than the portrait upon which it was based, and that those who knew her would believe that he had painted her from life more than once: see Bodart 1998, p. 216, no. 62.

42 Ronchini 1864, p. 130.

43 For the Louvre portrait of Francis I see Paris 1993, p. 578, no. 169, and Wethey II, p. 102, no. 37.

44 It is known only in a copy: Wethey II, p. 200, no. L-20. The prototype was probably by Scrots and is described by Aretino as '*di trivial penello*': see Aretino II, letter CLXXII, p. 9.

45 This portrait is in Naples. See Zapperi 1991A, pp. 160–3 and 171.

46 Gronau 1936, p. 98, and Campbell 1990, pp. 144–9. Most scholars consider the portrait in the Pitti to be a workshop product.

47 The portrait is lost. See Muraro 1949, p. 88.

48 Gronau 1906. For the location of the Strozzi and Titian houses see Lorenzetti 1980, pp. 354–5.

49 Aretino passed Titian's instructions to the courier: see Aretino II, letter CDXLIV, p. 235. The dyestuff from kermes, *grana*, was used in the preparation of lake pigment as well as for dyeing; it was used in the plumes on Charles's helmet and on his horse, see Garrido 2001, pp. 124 and 128–30.

50 Michelangelo did not reproduce the features of Lorenzo and Giuliano de' Medici in their tomb statues as he claimed that in the distant future no one would know if they had looked any different: see N. Martelli, *Il primo libro delle lettere*, Florence 1546, fol. 49, cited in Campbell 1990, p. 247, note 10.

51 Vasari (1568), VII, pp. 440 and 459.

52 Titian is described as '*persona trattabile e dolce*' (an amenable and sweet-natured person) in 1542 in a letter addressed to Cardinal Alessandro Farnese: see Ronchini 1864, p. 130 and Hope 1980A, p. 86.

53 For his promise to paint all the Farnese '*fino alle gatte*' (including the cats), conveyed by Giovanni della Casa to Cardinal Farnese in September 1545, see Campana 1908, pp. 382–3, and Campbell 1990, p. 266, note 99, for an extract.

54 This was reported to the duke of Urbino: see Gronau 1936, document LIII, p. 98.

55 For Charles V confiding in Titian, as reported by Della Casa, see Hope 1980A, p. 110.

56 Hope 1980A, pp. 116–17, for criticism of the bored Archduchess Catherine's portrait, 'which resembled her as much as a wolf does an ass'.

57 As she had left Bologna Titian offered to follow her to Nuvolara and, if Federico Gonzaga judged her portrait, which he had not made from the life, unsatisfactory he would redo it: see Bodart 1998, pp. 71–81 and 216, no. 62.

58 Wethey II, p. 112, no. 55.

59 Bottari 1822, V, pp. 253–6.

60 Zimmermann 1901, p. 850; translation of Stoppio's letter in Hope 1980A, p. 160.

61 For Titian's workshop see Fisher 1977.

62 Mancini 1998, p. 170, no. 50.

63 For an account of just such a procedure see Sonnenburg 1999, pp. 99–104. Titian made it clear to Granville that the replica of a portrait of Philip II that he had ordered would only be partly by his hand, 'as is my custom': Mancini 1998, p. 201, no. 78.

64 Gronau 1936, pp. 86–7. Titian's painting is in a private collection in New York. See Wethey III, p. 25. The prototype was probably the engraved classical gem that Vasari saw in the Duke's collection: see Vasari (1568), VII, p. 444.

65 For Strada's writings on numismatics see Cunnally 1999, pp. 26ff. The pentimento is noted in Wilde 1974, p. 223.

66 Mancini 1998, p. 174, no. 52.

67 For a perceptive analysis of the differences see Campbell 1990, p. 135, and Ferino Pagden 2000. The two portraits were the subject of a conference, *Tizian versus Seisenegger*, held in the Kunsthistorisches Museum, Vienna, in September 2000.

68 I am indebted to the late Professor Gianni Aquilecchia for this observation. The attack which occurred in Rome in 1525 is reported in Mazzuchelli's *Life of Aretino*. See Aretino III, p. 28.

69 Campbell 1990, pp. 185–90, and Wethey II, p. 95, no. 27.

70 As noted by Campbell 1990, p. 239, and Molina 1999, p. 49 (for the recovery of the patch of light previously obscured).

71 M. Jaffé 1966, p. 114, and p. 116, pl. 8.

72 For the dogal sleeve see Newton 1988, p. 12. Aretino, writing to Jacopo Sansovino, argues that a greeting from 'these noble sleeves' is worth more than a gift from bishops: Aretino I, letter LI, p. 82.

73 For Zen's historical writings, career and involvement with architecture see Tafuri 1985, pp. 3 and 183, and Voltolina 1998, I, p. 572, no. 540.

74 For Ranuccio's portrait in the Kress Collection, Washington, see Shapley 1979, pp. 483–5. For Jacopino del Conte's portrait see Zapperi 1990, pp. 57–8.

75 See Gronau 1906 and Fabbri 2000, p. 256.

76 For a general survey see Foscari 1935. Cranach lists an untraced portrait of Titian in his accounts: see Schuchardt 1851–71, I, pp. 206–8. An unidentified portrait by Veronese belonged to the sculptor Vittoria: see Avery 1999, p. 359.

77 Despite the arguments presented in this catalogue, I do not believe that *A Man with a Quilted Sleeve* (cat. 5) is a self-portrait, for the clothes are very sumptuous, the demeanour aristocratic, the colouring and bone structure so very different from later self-portraits, in which Titian does not show himself as though looking into a mirror.

78 This view is forcibly expressed in Freedman 1990, p. 82, and more cautiously in Woods-Marsden 1998, p. 163.

79 Niccolò Massa reports his interview with Titian in his *Facile est inventis addere*, Venice 1556: see Cicogna 1824–53, VI, p. 805.

80 In 1542 Aretino praises Titian's *Clarissa Strozzi*: '*certo che il pennel vostro ha riserbati i suoi miracoli ne la maturità de la vecchiezza*' (undoubtedly your brush has kept its miracles for the ripeness of your old age): Aretino I, letter CXLV, p. 217. In November 1547 Juan Hurtado de Mendoza informed Charles V that as Titian was old and the weather bad he would delay his departure from Venice: see Mancini 1998, p. 167, no. 146. In 1568 Titian, writing to Philip II, refers to '*mia ultima vecchiaia*': see Mancini 1998, p. 292, no. 173; and corresponding with the Farnese in 1567 to '*questa mia ultima età*': see Ronchini 1864, p. 141.

81 Vasari (1568), VII, p. 458.

82 For Gabriele's art collection see Ravà 1920, pp. 155–81. For the tondo, a workshop product once in the Kaufmann collection in Berlin but now in a private collection in Rome, see Fletcher 1992, pp. 55 and 60, n. 69.

83 Hope 1990, p. 56, and Woods-Marsden 1998, p. 164 and pl. 104.

84 On Venetian family workshops see Fortini Brown 1997, pp. 52–8.

85 For this print, which is based on a Titian design, see Washington 1976, p. 202, no. 45.

86 For Cort's engraving see Bury 2001, pp. 91–2, no. 55. In 1567 Titian sent impressions to Philip II, Margaret of Parma, Alessandro Farnese and the Dutch humanist Lampsonius. For Titian's letter to Charles V, of 10 September 1554, in which he writes that if the inclusion of Vargas displeases him it can be easily changed by any painter, see Mancini 1998, p. 250, no. 108.

87 A. Persio, *Trattato dell'ingegno dell'huomo*, Venice 1576, fol. 97; translated by Hope 1980A, pp. 169–70.

88 Vasari (1568), VII, p. 459.

89 In February 1568 the dealer

Niccolò Stoppio claimed that Titian's sight was poor, that his hand trembled and that he was delegating the execution of works to Emmanuel Amburger: see Zimmerman 1901, p. 850, and Hope 1980A, p. 151, for a translation. In 1569 the municipality of Brescia complained that Titian had left the execution of its ceiling paintings for the town hall to assistants: see Wethey III, p. 225, no. L-1.

90 Muller 1989, p. 95.

91 For George Frederick Watts's self-portrait, painted in 1904 and now in the Watts Gallery, Compton, see Liverpool 1995, p. 108, no. 55. Watts wears a skullcap, his beard is shaped like Titian's and his academic robes are arranged to resemble Venetian dress.

92 B. Shahn, *The Shape of Content*, Cambridge MA 1957, p. 116.

93 Alan Bennett, *A Question of Attribution*, London 1989. For the triple portrait, Wethey II, p. 183, no. X-113, and Shearman 1983, pp. 268–71, no. 294.

94 Lope de Soria to Francisco de los Cobos, 3 September 1533: see Mancini 1998, p. 136, no. 5.

95 Ridolfi (1648)A, I, p. 233. For depictions of the anecdote, see Valladolid 1999, pp. 53–5.

96 Haskell 1983.

97 Orso 1978, p. 89.

98 Adriani 1940, fol. 19, and D. Jaffé 2001, pp. 616–24.

99 Wood 1990.

100 Wood 1994, p. 284.

101 For Rembrandt's paintings of Flora and argument as to whether Saskia is the model, see Edinburgh 2001, nos. 27, 36 and 119.

102 London 1999, p. 173, nos. 53 and 54.

103 On English responses to Titian see Reinhardt 1999.

104 For a detailed study of this print see London 2001, no. 47, p. 86.

105 Wood 1994, p. 284.

106 The quotation is taken from Titian's well-known letter to Philip II in which he congratulates him on his marriage and explains why he has chosen to show Venus from the back in his *Venus and Adonis*: see Cavalcaselle and Crowe 1878, II, p. 193.

107 Aretino II, letter DCLXII, p. 436.

TITIAN'S PAINTING TECHNIQUE (pp. 44–59)

1 (pp. 44–7) For a general account of the sixteenth century, with bibliography, see Dunkerton *et al.* 1999, esp. ch. 9; also Dunkerton 1994. For diagrams showing textile weaves see Landi 1985, pp. 8–9. For the Venetian palette see Lazzarini 1983, Matthew 2002; for that in *Bacchus and Ariadne*, Lucas and Plesters 1978, especially pp. 37ff.; for red dye-stuffs used for textiles and lake pigments see Kirby and White 1996. For some examples of Titian's underdrawings see Meijer 1981; Nepi Sciré 1990; for the technique of *The Tribute Money* Dunkerton 1999.

2 (pp. 48–9) For early works with similar underdrawings see Hope and Asperen de Boer 1991, p. 131 and pl. 71a–b ('*The Gypsy Madonna*', cat. 1); Garrido and Dávila 1985, esp. pp. 139–44. For a fuller discussion of the technique of Titian's early works in the National Gallery see Dunkerton *et al.* forthcoming.

3 (pp. 50–1) For the original publication of the X-radiograph see Gould 1958, but for a re-interpretation following the making of new X-rays (now supported by infra-red reflectography) – see Dunkerton and Penny 1995; for essays on the techniques of several other early works see Rome 1995.

4 (pp. 56–7) See M. Jaffé and Groen 1987.

5 (pp. 58–9) For Palma's account of the elderly Titian at work see Boschini 1674, pp. 16–17; for discussion of sixteenth-century attitudes to paint handling and 'finish' see Sohm 1991, ch. 1; for 'finish' in late works by Titian see Rosand 1981; Gentili 1992; Penny 1999, and here pp. 150–79. For the materials in some of Titian's later paintings see Bortolaso 1990.

TITIAN'S REPLICAS AND VARIANTS (pp. 60–68)

1 I would like to thank Keith Christiansen, Gabriele Finaldi and Ana González Mozo for their suggestions and revisions of this essay. On Titian's replicas, Tietze-Conrat 1946, pp. 76–88, and Tietze 1954, pp. 199–208, are essential reading. For an interpretation of Titian's originality, see Cole 1995, pp. 92–4.

2 Joannides 2001, pp. 158–9. Again *The Virgin and Child* in the Accademia, Venice (inv. 1359) is painted over a saint – probably Saint Catherine of Alexandria, given the similarity of the figure to the Saint Catherine in the Prado (inv. 447) attributed to Titian.

3 Surviving replicas are in the Castle Museum, Prague, and the Museu National d'Arte Catalunya, Barcelona; see Wethey III, pp. 162–5.

4 It is significant that the earliest documentary reference to replicas, dating from 1520, involved the duke of Ferrara: Tietze 1954, p. 200.

5 Mancini 1998, pp. 380–1.

6 The Prado *Virgin and Child* is usually dated to around 1520. A copy in Hampton Court (inv. 632) has been regarded as a workshop product but could be a copy of an earlier lost version on which Titian based the Prado painting, or a workshop replica that takes up ideas explored in the initial design of the original.

7 '*Otro retrato de medio cuerpo arriba, de una veneciana bestida de raso blanco, con bordaduras de oro, en la mano derecha un aventador de palma y una punta de una hoja verde en los pechos; es de mano del Ticiano*' (Archivo de Palacio, Sección Administración, Legajo 738; typescript copy at the Museo del Prado).

8 '*Quella che è patrona assoluta dell'anima mia e che è vestita di giallo*' (Cloulas 1967, pp. 238–9).

9 '*Quanto a lo que Vuestra Alteza envió a mandar en el enviar de los retratos, Titian me ha dado el primero, el qual envío con este correo. Del mismo se han sacado otros dos que, a mi parescer, no están tan propios, pero están bien, y estarán mejor como salgan de la postrera mano, porque cada día lo va Titian afinando; y creo estarán del todo acabados de aquí a pocos días*' (Cloulas 1967, p. 212).

10 Luzio 1890, III, p. 210.

11 Cloulas 1967, p. 203.

12 Joannides 2001, p. 39.

13 Hope 1980A, p. 154.

14 '… *se ne avuto ritenuto alcuno disegno*' (Crowe and Cavalcaselle 1877, I, p. 90).

15 Bierens de Haan 1946, p. 9.

16 Braunfels 1980, pp. 407–10.

17 Ridolfi (1648), p. 207.

18 Tietze and Tietze-Conrat 1944, pp. 6–13; Bambach 1999, p. 101.

19 Wethey III, pp. 142–3.

20 Zarnowski 1938, pp. 126–8, first proposed the idea that Titian traced his compositions on to the canvas. See also Christiansen 1987, p. 195.

21 Meijer 1981, pp. 279–81.

22 Hope 1980A, pp. 155–6, and Hope 1991, p. 132.

23 On the series see Hope 1980A, pp. 118–21, and Rosand 1980, pp. 376–7. Joannides has recently suggested the possibility of a Venus and Cupid painted around 1520 and similar in structure to the lost original of 1545 that is known through the fragment of a work produced by the artist's workshop (Akademie der Bildenden Kunst, Vienna): Joannides 2001, pp. 181–2.

24 Cannon-Brookes 1977; Bambach 1999, p. 101.

25 To the testimonies of Jacopo Strada and Niccolò Stoppio should be added that of Guzmán de Silva, who wrote in 1575 referring to certain works commissioned from Titian, that 'even though the works are not as I should like, I mean what has to be done anew, they will still be his, because although the bodies are not entirely his the souls will be, and that is what will give them life': Mancini 1998, p. 417.

26 Respectively, Brocklesby Park: 169 × 211 cm, Louvre: 169 × 244 cm; Fitzwilliam Museum: 150 × 197 cm, Metropolitan Museum: 157 × 205 cm; Prado: 67 × 77 cm, Hermitage: 66.5 × 73.1 cm (original size before enlargement: Fomiciova 1992, pp. 344–5). The Magdalen sent to Philip II measured 117 × 98 cm, almost the same as the Hermitage (118 × 97 cm) and the Capodimonte (128 × 103 cm) versions.

27 Gentili 1991, p. 37.

28 Hope 1980C, p. 121.

29 Ridolfi (1648), p. 194.

30 Titian's paintings of Venus in general and of Venus and a musician in particular have sparked a passionate debate between those who see them as charged with symbolic meaning (among them Brendel, Panofsky and, more recently, Rosand and Goffen), and

those who regard them as erotic images lacking any deeper significance (Ost, Zapperi and particularly Hope). The respective stances are summarised in Hope 1980C and Goffen 1997. No. 420 does display, however (see Giorgi 1990, pp. 103–12), a combination of elements that seem significant.

31 This painting has been attributed a matrimonial character that becomes less apparent in the replicas, some of which, such as the Prado *Salome*, are autograph (Brevaglieri 1995, pp. 123–6, 143).

32 J. Urrea in Washington 1990, p. 356.

33 Gibbons 1965, pp. 146–55.

34 Tietze 1954, p. 202.

35 Tietze-Conrat 1946, p. 76; Fisher 1977, pp. III-XII. Orazio died very shortly after his father.

36 'He estado en la casa del iano y cada día me confirmo más en que no se puede esperar mucho de lo que agora haze sino en el hecho, lo qual tiene tan a recaudo que es menester harta destreza para verlo' (Mancini 1998, p. 412).

37 In March 1550 Titian explained to Granvelle that the copy of the portrait of Prince Philip he was sending him was not entirely by his hand (Ferrarino 1977, pp. 34–6).

38 Titian signatures have not been studied. Nevertheless, it appears that the formula *Titianus fecit* is used for works of diverse quality while *Titianus Aeques Caesarius* is reserved for clearly autograph works.

39 Delaforce 1982, pp. 724–51.

NOTES ON THE CATALOGUE

FOUNDATIONS (pp. 70–73)

1 See further Hope 1993A.

2 The sense of urgent, broad strokes which is characteristic of all Titian's work would also encourage the idea of his early employment in façade painting.

3 Wilde 1974, p. 107.

4 *Ibid.*, p. 122–3; Joannides 2001, p. 175–6.

5 Aretino 1965, p. 224. According to Hirst 1981, p. 95, sidelong glances were also inviting.

ALFONSO D'ESTE'S CAMERINO (pp. 110–13)

1 Raphael stopped painting when he heard that the local court painter Pellegrino da San Daniele was painting the same subject, *Bacchus returning from India*; this may have been the sixth subject.

2 Three or four pictures by Dossi could have fitted in a row on the main walls. See Christiansen 2000. There is a payment to Dossi in 1522, and another in 1524 (for the ceiling fragments now in the National Gallery).

3 Titian originally thought *The Worship of Venus* was to go beside the Bellini, but the description of the theft notes it at the '*capo*' or head of the room (see Hope 1987,

p. 25). The 1598 *stima* estimates the room as 18 × 8 Ferrarese feet, and the room with the reliefs at 6 ½ × 14 Ferrarese feet. Arch. Marco Barella has found a later *stima* and has shown me physical evidence to support these dimensions for the second room; see also Barella 2002.

4 In Ovid's *Fasti*, III, the story of Hippolytus is introduced by reference to the constellation Anguitenens (Snake-holding): it is therefore just possible that the 'Laocoön' figure in *Bacchus and Ariadne* incorporates a reference to Alfonso's brother Ippolito I or son Ippolito II.

5 Androssov 2002, p. 10.

6 Ravà 1920, translated in Chambers *et al.* 1992, pp. 428–9.

7 Androssov 2002, p. 4.

8 Allen 1999, p. 37.

9 Mandowsky and Mitchell 1963, p. 122, no. 142, pl. 7. This relief is similar in style and iconography to Antonio Lombardo's reliefs. For Alfonso's sister Isabella's collection see Brown 2001.

THE 1530S: LANDSCAPE (pp. 113–15)

1 Letter from Taddeo Albano to Isabella d'Este dated 8 November 1510.

2 Giles Robertson argues that an authentic and varied replica of a lost picture is known through a Lefevre engraving (the engraver's standard of accuracy in reproducing paintings is high): see Robertson 1971.

3 In Paris 1993, pp. 306–7, Ballarin dates it to 1506–7, which seems sound.

4 Padovanino's copies in the Academia Carrara, Bergamo, may give us a clue as to how to 'read' these paintings. The *Bacchus* was already involved in a cleaning controversy in the 1840s.

5 A copy by Parmigiano in Darmstadt (Joannides 2001, p. 181, n. 6, fig. 160) suggests that the invention of the nude goes back to the 1520s, but the painting may be a re-working of the idea some twenty years later.

TITIAN IN THE 1540S (pp. 128–31)

1 Roskill 1968, pp. 94, 238.

2 Titian's *Gloria* is a response to Michelangelo's *Last Judgment*. His Prado *Agony* is testing the telescopic compositions of the 1550s (but already anticipated in northern prints, where the focus is often in the background).

3 Aretino to Titian, quoted Crowe and Cavalcaselle 1877, II, p. 114.

4 Freedman 1995, p. 101, citing a letter of 12 Feb 1547 from Vasari to Benedetto Varchi.

5 *Ibid.*, p. 89, quoting Campbell 1990, p. 222.

6 Cains 1999, p. 256.

7 See also Rowlands 1996, pp. 167–78.

8 Freedman 1995, p. 108: 'The motif of a child with a dog has an earlier history. Filippino Lippi used it in his Carafa Chapel, S. Maria Sopra Minerva, Rome, and Rosso depicted a boy grasping a dog in *Aeneas fleeing Troy*, Fontainebleau'.

9 Aretino II, pp. 217–18, letter CXLV, 6 July 1542.

10 Aretino II, pp. 145–6, letter CCCXXVI.

11 Campbell 1990, pp. 236–9.

LATE TITIAN (pp. 150–3)

1 Hope 1993A, p. 172, draws attention to Ridolfi's remark that this painting was damaged by overcleaning.

2 The drapery of Midas, like that in the Escorial *Saint Lawrence*, is crudely painted by an assistant.

3 The strong sense that Christ's cloak forms an exoskeleton, and the way his garment trails down the steps, suggests it is a finished painting.

4 See Hope 1990.

PHOTOGRAPHIC CREDITS

Alnwick Castle, Northumberland
Collection of the Duke of Northumberland © Photo: The Northumberland Estates, Alnwick Castle cat. 22; fig. 43

Ancona, San Domenico
© Comune di Ancona. Photo: Gaetano Apicella fig. 76
© Photo: SCALA, Florence fig. 65

Antwerp
© Koninklijk Museum voor Schone Kunsten, Antwerp cat. 3

Berlin
Gemäldegalerie © Staatliche Museen zu Berlin. Bildarchiv Preussischer Kulturbesitz. Photo: Gisela Helmkampf / Jörg P. Anders cat. 24 (detail p. 134); Photo: Jörg P. Anders cat. 28

Birmingham
© The Barber Institute of Fine Arts, The University of Birmingham fig. 51

Boston, Massachusetts
© Isabella Stewart Gardner Museum, Boston fig. 15

Cambridge
Courtesy of the Hamilton Kerr Institute and the Fitzwilliam Museum, University of Cambridge. © Hamilton Kerr Institute, University of Cambridge fig. 29A

Lent by the Syndics of The Fitzwilliam Museum. © The Fitzwilliam Museum, University of Cambridge. Photo: The National Gallery, London cat. 36 (detail p. 44, 56, 150); fig. 29B, 29C, 29D

Detroit, Michigan
© The Detroit Institute of Arts. Photo: 1983 fig. 42

Dresden
Gemäldegalerie Alte Meister. © Staatliche Kunstsammlungen Dresden. Photo: Klut figs. 34, 45, Photo: Klut/Estel fig. 47

Dublin
© Courtesy of the National Gallery of Ireland, Dublin fig. 73

Edinburgh
Duke of Sutherland Collection, on loan to the National Gallery of Scotland. © National Galleries of Scotland. Photo: Antonia Reeve, Edinburgh cat. 8 (detail p. 70); figs. 13 (detail p. 130 fig. 57), 14, 46

Florence
Gabinetto dei Disegni e delle Stampe. © Photo: SCALA, Florence – licensed by the Ministero per i Beni e le Attività Culturali fig. 19

Galleria degli Uffizi. © Photo: SCALA, Florence – licensed by the Ministero per i Beni e le Attività Culturali cat. 11, figs. 9, 18

Galleria Palatina, Palazzo Pitti. © Photo: SCALA, Florence – licensed by the Ministero per i Beni e le Attività Culturali cat. 27

Kingston Lacy
The Bankes Collection, Dorset. © The National Trust, London. Photo: John Hammond cat. 39

Kroměríz
© The Archbishop's Palace, Kroměríz fig. 63

London
The British Museum. © Copyright The British Museum, London figs. 8, 21

The National Gallery. © The National Gallery, London. cats 2 (detail p. 49), 4, 5, 7 (detail p. 50), 13, 19, 29 (detail pp. 42, 147), 32, 34, 35, 37 (detail p. 58). figs. 24A, 24C, 24D, 24E, 24F, 25A, 25C, 25D, 25E, 26B, 26C, 26D, 27A, 27C, 27D, 30A, 30B, 30C, 30D, 30E, 48. Images made by Rachel Billinge, Rausing Research Associate figs. 24B, 25B, 26A, 27B

On loan to the National Gallery, London from the Halifax Collection © Courtesy of the owner. Photo: The National Gallery, London cat. 6

The Wallace Collection. © The Wallace Collection, London fig. 70

Madrid
© Museo Nacional del Prado, Madrid. cats. 14, 16 (detail p. 100), 30 (detail p. 30), 31 (detail p. 60 fig. 31), 33; figs. 17, 20, 32, 37, 38, 55, 59, 61. Tracings by Ana Gonzáles figs. 33, 36

Milan
Pinacoteca di Brera. © Photo: SCALA, Florence – licensed by the Ministero per i Beni e le Attività Culturali fig. 72

Munich
Alte Pinakothek. © Bayerische Staatsgemäldesammlungen, Munich. Photo: Kunstdia-Archiv

Artothek, D-Weilheim fig. 16

Naples
Museo Nazionale di Capodimonte. © Photo: SCALA, Florence – licensed by the Ministero per i Beni e le Attività Culturali figs. 28B, 28E, 62 (detail p.54). © Soprintendenza Speciale per il Polo Museale di Napoli cats. 23 (detail p. 128), 26 (detail p. 54), figs. 28A, 28C, 28D

Oxford
Ashmolean Museum. © Copyright in this Photograph Reserved to the Ashmolean Museum, Oxford fig. 54; Photo: The National Gallery, London cat. 21

Padua
Scuola del Santo. © Photo: SCALA, Florence fig. 3 (detail p. 10)

Paris
Musée du Louvre. © RMN, Paris cat. 18; figs. 5, 56, 66

Parma
Corte di Mamiano di Traversetolo. © Fondazione Magnani-Rocca, Corte di Mamiano di Traversetolo, Parma cat. 9

Private collection
© Sold at Sotheby's 21 June 1978. Untraced collection. Photo: Witt Library, London fig. 22. © Photo Courtesy of the owner figs. 49, 50. © Credited to the Trustees of the Rt. Hon. Olive, Countess Fitzwilliam's Chattels Settlement, by permission of Lady Juliet Tadgell. Photo: Countrywide Photographic, Kent fig. 23

Rome
Galleria Doria Pamphilj. © Arti Doria Pamphilj, Rome fig. 41

Museo Galleria di Villa Borghese. © Soprintendenza Speciale per il Polo Museale Romano cat. 10 (detail p. 95)

Pinacoteca Capitolina. © Pinacoteca Capitolina, Rome. Photo Antonio Idini Studio Fotografico fig. 40

Saint Louis, Missouri
© The Saint Louis Art Museum cat. 41

San Lorenzo
Monasterio de San Lorenzo de El Escorial. © Patrimonio Nacional, Madrid cats. 40, 42; fig. 75

St Petersburg
The State Hermitage Museum. © Photo: Bridgeman Art Library, London fig. 52. © With permission from The State Hermitage Museum, St Petersburg cat. 43; figs. 39, 44, 74, Photo from *Titian 500* edited by Joseph Manca, Washington, D.C. fig. 53

Vatican City
Vatican Museums. © Musei Vaticani, Archivio Fotografico Musei Vaticani Photo: M. Sarri fig. 60. © Photo: SCALA, Florence fig. 58

Vittorio Veneto
Santa Giustina. © Photo: Fondazione Giorgio Cini, Venice. Courtesy of the author fig. 71

Venice
Gallerie dell'Accademia © Photo: SCALA, Florence – licensed by the Ministero per i Beni e le Attività Culturali fig. 64 (detail p. 162 fig. 69). © Soprintendenza Speciale per il Polo Museale, Veneziano. Photo: Osvaldo Böhm cats. 17, 20; figs. 2, 11 (detail p. 112)

San Giovanni Elemosinario. © Soprintendenza Speciale per il Polo Museale, Veneziano. Photo: Osvaldo Böhm fig. 10

Santa Maria della Salute. © Photo: SCALA, Florence fig. 12 © Soprintendenza Speciale per il Polo Museale, Veneziano. Photo: Osvaldo Böhm fig. 4

Santa Maria Gloriosa dei Frari. © Soprintendenza Speciale per il Polo Museale, Veneziano. Photo: Osvaldo Böhm figs. 6, 7

Scuola di San Rocco. © Soprintendenza Speciale per il Polo Museale, Veneziano. Photo: Osvaldo Böhm fig. 1

Vienna
© Gemäldegalerie der Akademie der Bildenden Künste in Wien fig. 68. © Kunsthistorisches Museum, Vienna cats. 1, 12, 38; figs. 35, 67

Washington, D.C.
© National Gallery of Art, Washington, D.C. Board of Trustees. Photo 2002 cat. 15; Photo: Lee Ewing 2002 cat. 25 (detail p. 2)

INDEX